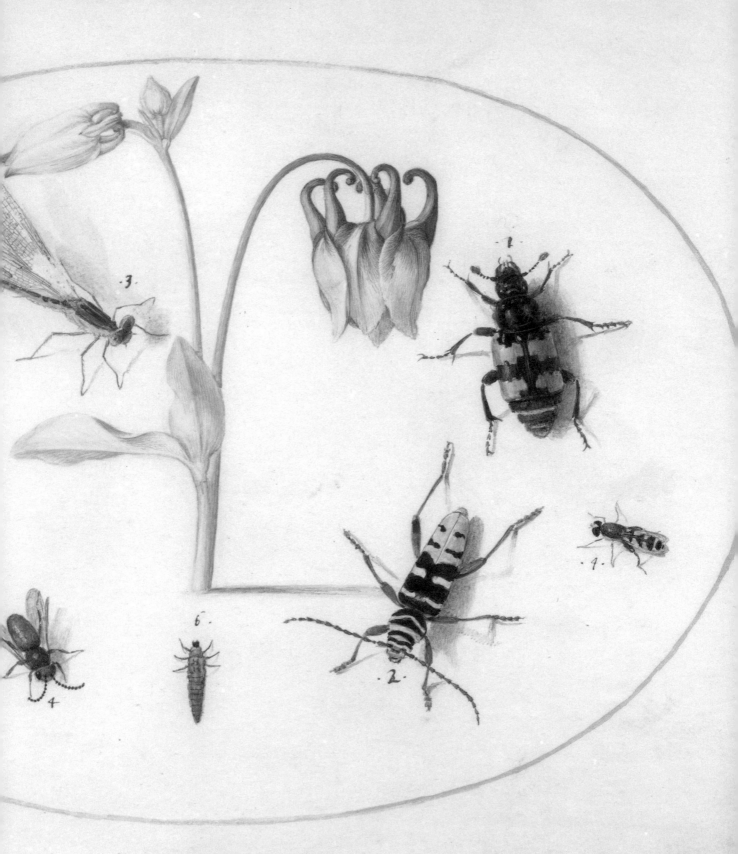

MARISA ANNE BASS

INSECT ARTIFICE

*Nature and Art
in the Dutch
Revolt*

PRINCETON UNIVERSITY PRESS

PRINCETON AND OXFORD

In loving memory of
Frieda Dennison Finkelstein

Published by Princeton University Press, 41 William Street, Princeton, New Jersey 08540
In the United Kingdom: Princeton University Press, 6 Oxford Street, Woodstock, Oxfordshire OX20 1TR

press.princeton.edu

JACKET ILLUSTRATIONS (FRONT) Plate 35 *Ignis* (detail), Folio LIII. Joris Hoefnagel, the *Four Elements*,
1570s–1600. Watercolor and gouache, with oval border in gold, on vellum, 14.3 × 18.4 cm (approximate).
National Gallery of Art, Washington, DC, Gift of Mrs. Lessing J. Rosenwald. © National Gallery of Art,
Washington, DC. (BACK) Plate 30 *Ignis* (detail), Folio XVI. Joris Hoefnagel, the *Four Elements*, 1570s–1600.
Watercolor and gouache, with oval border in gold, on vellum, 14.3 × 18.4 cm (approximate). National Gallery
of Art, Washington, DC, Gift of Mrs. Lessing J. Rosenwald. © National Gallery of Art, Washington, DC.

ILLUSTRATIONS IN FRONT MATTER p. i, detail of pl. 33; p. ii, detail of pl. 38; p. vi, detail of pl. 1; p. xii,
detail of pl. 39

ISBN 978-0-691-17715-1

LIBRARY OF CONGRESS CONTROL NUMBER 2018946997

British Library Cataloging-in-Publication Data is available

Published with the assistance of the Frederick W. Hilles Publication Fund of Yale University

Design by Jenny Chan / Jack Design

This book has been composed in Janson Text and Avenir Next

Printed on acid-free paper. ∞

Printed in China

10 9 8 7 6 5 4 3 2 1

CONTENTS

ELEPHANTVS INDICVS NON CVRAT CVLICES

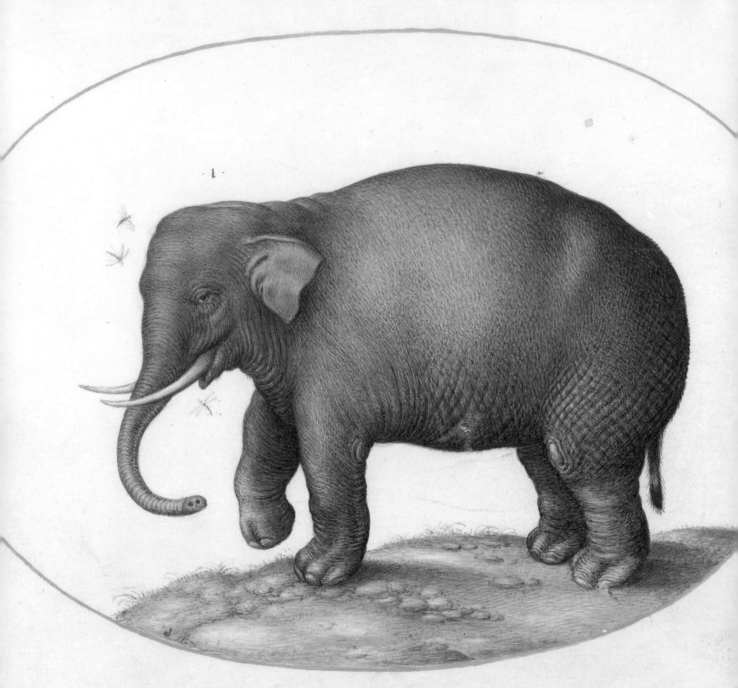

This is a book about deceptively small things. It is a book about miniatures and manuscripts in the era of print and a context of war, and about the exchanges that took place within and around them. The technological advances and transnational expansions of early modernity, which entice us today as analogues to our own global and technology-driven culture, are only one side of the story. The works that concern me here were products of slow, patient, and deeply considered labor. In the hands of their makers and owners, they were objects of sustained contemplation. They accrued value through their circulation among intimate publics both defined by, and distinguished from, the commercial and political spheres surrounding them. ¶ At the heart of this book are four manuscripts known today as the *Four Elements*. Each volume measures just over fourteen by eighteen centimeters, and each was designed to be held and studied close up. Together, they house a stunning and eccentric assemblage of knowledge about the natural world. For their creator, Joris Hoefnagel, the making of these volumes was the constant of his adult life. Their miniatures and accompanying texts record studies undertaken over almost three decades, and travels that took him from his hometown of Antwerp far afield across Europe. So far as we know, he continued to engage with the project up until his death in 1600. ¶

For a long time thereafter, Hoefnagel's manuscripts all but disappeared from the historical record.[1] They resurfaced only firmly in the nineteenth century, when their itinerary becomes traceable through various private collections in Europe. They were then purchased in the mid-twentieth century by Lessing J. Rosenwald, a Philadelphia patron of the arts, who presented them as a gift to his wife. Only after 1987, when she bequeathed them to the National Gallery of Art in Washington, DC, did Hoefnagel's volumes find a home in a public collection. There they remain among the museum's most guarded treasures. Mrs. Rosenwald stipulated that only a curator may turn their folios, which is done today most often with a delicate metal wand. The result is that they are beautifully conserved and will remain so, but the experience of feeling their weight in one's hands and perusing them freely remains—as it always was—the province of the rare few. ¶ The material history of the *Four Elements* volumes is complex, and will be explored more closely in the chapters that follow, but there are a few things to know from the outset. Each of the four volumes includes a title page that places its collection of natural subjects within the project's eponymous theme: insects for fire (*Ignis*), mammals and reptiles for earth (*Terra*), fish and crustaceans for water (*Aqua*), and birds for air (*Aier*). Nonetheless, this organization is less straightforward than it appears. The volumes have been rebound. And almost all the folios have been renumbered, which immediately raises questions about their transformations over time, by either Hoefnagel or a later owner, or both. ¶ Unlike a typical illuminated manuscript, the *Four Elements* uses roman numerals to refer to openings rather than folios; in each case, Hoefnagel illuminated and inscribed only one side of the parchment. The design of each opening includes a recto with an ovular miniature, often with text above and below it, and an opposing verso on paper ruled for the inclusion of additional inscriptions. For convenience throughout, I refer to the individual volumes under their Latin names (*Ignis*,

Terra, Aqua, Aier) and to individual miniatures by their Roman numerals (e.g., Folio LX). I illustrate both the verso and the recto of each opening, as the texts that Hoefnagel included are essential to understanding the miniatures with which they share the page. ¶ Selections from Hoefnagel's *Four Elements* are reproduced in this book to scale, in full color, and (when possible) in sequence—with the goal of sharing their contents with a wider audience. But my greater aim is to place these volumes in the complex historical context of their making, to consider why Hoefnagel made them at all, and to demonstrate their importance for understanding the larger motivations that shaped Netherlandish creative and intellectual endeavor during its period of greatest transformation: the turbulent decades of the late sixteenth century. ¶ *Insect Artifice* is meant as a sequel to my previous book, *Jan Gossart and the Invention of Netherlandish Antiquity* (Princeton University Press, 2016), which sought to recover the dialogue between local antiquarianism and mythological painting in the early sixteenth-century Low Countries. However different in subject this book may seem, it too reflects my investment in recuperating the intersections between creative and intellectual pursuit fundamental to the history of the early modern Netherlands. From Gossart to Hoefnagel, we move from a close-knit courtly milieu to the broader urban and mercantile stage. We move from the moment when the notion of an intellectual community first took shape to a moment when it faced disintegration. We confront the impact of iconoclasm, war, and emigration on a new generation of Netherlandish scholars and artists as they sought to understand the relationship between past and present, between natural history and human history, and to do so under conditions fraught with urgency and fear. ¶ In my own labor of producing this book, I have incurred many debts. My first acknowledgment must go to Ginger Hammer and Gregory Jecman at the National Gallery of Art, who over the course of several years patiently turned for me the folios of Hoefnagel's manuscripts again and again, and shared each time my renewed awe at their contents. I give my deepest thanks to curators Meg Grasselli and Andrew

Robison, who graciously allowed for the making of proper digital photographs of Hoefnagel's manuscripts, which had never been done before. Their assistant Mollie Berger, who worked with the photographer to complete the project, has my sincere gratitude as well. ¶ My research has been supported by several generous grants. The first was a Grete Sondheimer Fellowship at the Warburg Institute in 2012, where it was a pleasure to learn from Elizabeth McGrath, Paul Taylor, and my fellow fellows. A second fellowship at the Scaliger Institute of Leiden University in 2013 allowed me to delve into the world of early modern friendship albums, where I was grateful for the support and kindness of Anton van der Lem, Ernst-Jan Munnik, and Kasper van Ommen. A summer fellowship the subsequent year at the Huntington Library was no less valuable in giving me time to study another crucial manuscript produced in Hoefnagel's circle and to explore the library's rich collection of early modern books. ¶ I was honored to receive membership at the Institute for Advanced Study in Princeton during my sabbatical in 2015–16, provided by the Herodotus Fund, where I completed much of my writing and benefited from the conversation and feedback of many, including Yve-Alain Bois, Margaret Graves, Jonathan Israel, Heinrich von Staden, and especially Rhodri Lewis, who graciously read an earlier draft of this book in full. I thank Washington University in St. Louis, my former institutional home, for granting and supporting this leave. In the summer of 2016, as a visiting fellow at the Max Planck Institute for the History of Science in Berlin, I had the pleasure of sharing my research as part of the "Global Knowledge Society," organized by Wijnand Mijnhardt and Sven Dupré, and within a working group overseen by Thijs Weststeijn. Finally, a spring fellowship at the Netherlands Institute for Advanced Study in Amsterdam allowed me the time and space to shape the manuscript into final form. I am grateful to Timothy Barringer for helping ensure that I could take this leave during my first year in the History of Art Department at Yale University, and for the support of the Dean's Office and my fellow faculty in New Haven. ¶ As my work progressed over the past years, exchanges with many other colleagues and friends informed my thinking and writing: Stijn Alsteens, Paul Barolsky, Karel Bostoen, Anne-Laure Van Bruaene, Michael Cole, Regan White Craig, Karl Enenkel, Frank Fehrenbach, Robert Felfe, Steven Frankel, Sietske Fransen, David Freedberg, Denise Gill, Anne Goldgar, Christine Göttler, Anthony Grafton, Hanneke Grootenboer, Gijs van der Ham, Matt Jolly, Koenraad Jonckheere, Eric Jorink, Thomas DaCosta Kaufmann, Matt Kavaler, Joseph Koerner, Karin Leonhard, Emily Lodish, Carolina Mangone, Alexander Marr, Tine Meganck, Walter Melion, Andrew Morrall, Nadine Orenstein, Peter Parshall, Mark Pegg, Yolanda Rodriquez Pérez, Bret Rothstein, Larry Silver, Pamela Smith, Paul Smith, Claudia Swan, Madeleine Viljoen, William Wallace, Ittai Weinryb, Jessica Wolfe, Christopher Wood, Joanna Woodall, Carolyn Yerkes, and, as ever, Hugo van der Velden. I must also recognize the foundational scholarship on Hoefnagel by Lee Hendrix, Thea Vignau-Wilberg, and again Thomas DaCosta Kaufmann, whose work I build upon throughout. I offer particularly effusive thanks to Anthony Grafton and Peter Parshall for serving as such insightful readers of the manuscript and for the richness of their advice and critique, and to Tony again for his scrutiny of my

transcriptions and translations. Warmest thanks goes to Robert Kirk for sharing his avian expertise, and to Grant Brown, Michael Chinery, Jefferson Graves, Richard Lewington, and David Shuker for helping me to identify Hoefnagel's insect specimens. I thank my former research assistant Hannah Waldman for her aid in hunting down Hoefnagel's textual sources. Opportunities to present my research at Berlin's Kupferstichkabinett, Princeton University, Cambridge University, the Newberry Library, Northwestern University, the University of Hamburg, the Rijksmuseum, the Bard Graduate Center, and the University of North Carolina at Chapel Hill were formative as well. The production of this book would not have been possible without the generous funding of a Samuel H. Kress Mid-Career Research and Publication Fellowship from the Renaissance Society of America, the Hilles Publication Fund of Yale's Whitney Humanities Center, and Yale's History of Art Department. It would have been equally unimaginable without the excellent staff at Princeton University Press, especially Lauren Lepow, Steven Sears, and Pamela Weidman. Above all, I feel blessed and beyond grateful to have Michelle Komie as an editor; her grace, wisdom, and understanding have guided me at every step. ¶ Unless otherwise indicated, all translations in this book are my own. Modern editions of classical texts are listed in the bibliography only when I have explicitly used or adapted the translations that they provide. The many references to Desiderius Erasmus's *Adagia* in my endnotes are all given to the volume, book, and number of the original adage itself. All biblical translations are from the Douay-Rheims version. ¶ Finally, a word on this book's dedication. When I was sixteen, my grandmother gave me a photograph album of my relatives from Lithuania, where her mother had been born. It was one of the very few things that my great-grandmother had brought with her as an immigrant to America, when she and her husband fled on the eve of World War II. Within its embossed leather binding, each photo was pasted to rough brown cardstock that had become brittle over the course of so many decades. My great-grandmother would have known the names of those relatives, but she passed away before she could have told me. They all died during the war. The vulnerability of the past always undergirds the study of history, and it makes the fragile remnants of the past more precious. Long before I did, Hoefnagel had learned this lesson well.

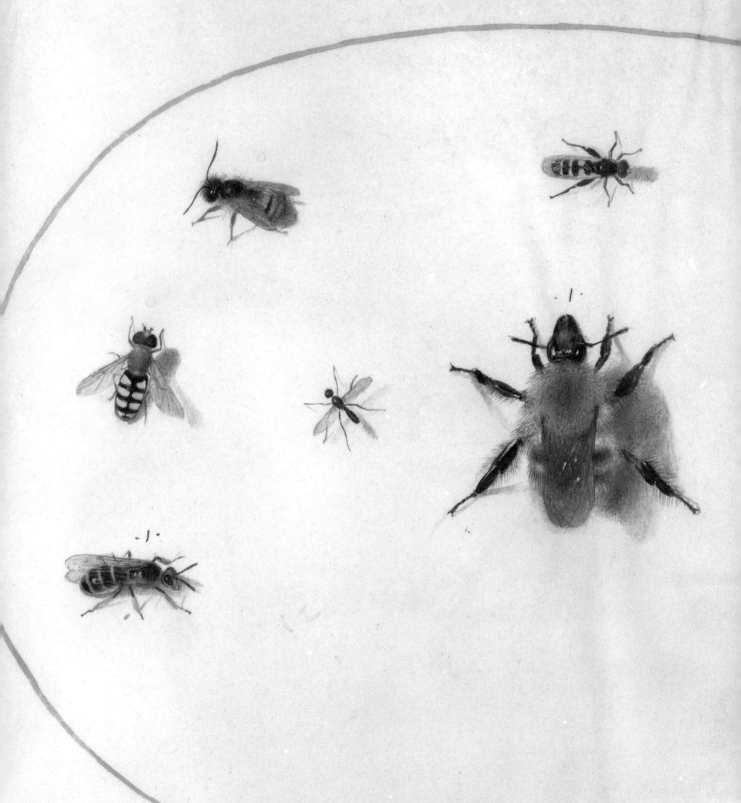

Antwerp in Metamorphosis

Among all the signs of God's providence and power, of which countless indeed have shown forth in recent times from this our Belgium, truly none stands out more glaringly than the metamorphosis of Antwerp. For what greater thing can be said or imagined than that this city seems to have become the most perpetual and secure abode in which Spanish tyranny has affixed itself?—*Bonaventura Vulcanius to Johannes Junius*[1]

The history of art and intellectual life in the Low Countries pivots on a crisis and a rebel cause. The Dutch Revolt emerged in the 1560s as a civil uprising against Spanish imperial rule. It grew into the first successful fight for political and religious freedom of the early modern period. Yet the early decades of conflict with Spain were uncertain at best, and they left their psychological scars on the population who witnessed the war's seismic destruction and dispersal of culture. When the Leiden professor Bonaventura Vulcanius decried this metamorphosis in his letter to the Antwerp burgomaster Johannes Junius, he was speaking of an upheaval that seemed to him all the more devastating in its resulting stasis: the imposition of Spanish tyranny on his native land.[2]

Vulcanius did not chance upon the word "metamorphosis" to describe this narrative arc. Inscribed again and again throughout the margins of one of his personal manuscripts, in which he preserved a copy of this letter, is a fragment from the opening lines of Ovid's *Metamorphoses*: "Before there was sea and earth and the sky that covers everything, the face of nature was the same throughout the whole world: only chaos" (fig. 1).[3] The verse, sometimes crossed out or partially erased, registered his dismay over the miseries of war that he often describes at the center of the page. As Vulcanius would have known, Ovid goes on in that first chapter of the *Metamorphoses* to recount the creation of humankind.[4] He describes us as the beings in whom Nature's chaos finally resolved, and who—unlike other animals—inclined our heads not down to the earth but rather upward toward the heavens. And so we remained, pure and without vice, until the corruptive ages of Silver and Bronze.

Vulcanius strained to imagine a time when humanity was untouched by vio-
lence and discord, but his imagination failed him. The revolt had shaken his faith in
a fundamental tenet of moral philosophy. The notion of human exceptionalism,
first expounded by Ovid's Hellenistic forefathers, scarcely seemed valid at a time
when the human condition had fallen to such a deplorable state.[5] Among Vulcanius's intel-
lectual compatriots, the very concept of a "golden age" appeared ever more vanishing over
the years that the conflict with Spain unfolded. Was Ovid right to say that humanity once
existed in exceptional harmony with nature? Nature's laws of change seemed instead to
forever pit vice against virtue, ignorance against knowledge, baseness against honor.[6] The
merchant-scholar Jacob Coels surmised that "if a golden age is nothing other than that de-
scribed by Ovid, in which 'spring was eternal,' and in which 'rivers flowed now with milk,
now with honey,' it is certainly to be sought beyond this world, and sought there alone."[7]

At the same time, Vulcanius's language is visceral
and emotive, and his attempt to make sense of the revolt
through signs and portents was as unscholarly as it was
aligned with popular sentiment.[8] Take the artist and
rhetorician Hieronymus van der Voort, whose verses vil-
ified the pestilent Spanish as "locusts who devour all that
is green" and railed against their transformation of the
Low Countries into a barren wasteland.[9] Or the Antwerp
diarist Godevaert van Haecht, who mapped Spain's harsh
edicts against the Netherlands onto events in the firma-
ment: the fearsome lightning, which struck the abbey
church at Middelburg in January 1568 and destroyed Jan
Gossart's famous early sixteenth-century altarpiece, af-
firmed for him the war's epic scale as a battle fought in
the heavens as on earth.[10]

FIG. 1

Most significant of all is what Vulcanius shared
with each of his contemporaries mentioned above: the
impulse to counter the destruction of war through a productive fervor of scribbling, versi-
fying, and chronicling. In his effort to process the ramifications of the revolt, he looked to
the other side of Janus-faced Nature: the capacity for creation and renewal that she be-
stowed as a virtue upon all her creatures. The catharsis that Vulcanius sought in his per-
sistent return to Ovid's opening line, or that van Haecht experienced in the keeping of his
diary, derived from the power of repetitive making and doing. The very act of engaging in
generative material practice offered a means to recuperate from loss, and to reestablish
faith, against the backdrop of a radically unstable world order.

This book grounds its exploration of that practice and its historical contingency in an
individual case at once anomalous and exemplary: the life and works of the Antwerp-born
polymath Joris Hoefnagel (1542–1600).[11] Hoefnagel too experienced the revolt's transfor-
mations of his native Low Countries. He turned repeatedly to ancient writers and the scrip-
tures in an endeavor to comprehend the metamorphoses of his personal circumstance and
the larger historical events surrounding him. Most significantly, however—and more than
any other member of the Netherlandish community during these fraught years—Hoefnagel

responded by immersing himself in a ceaseless study of the natural world. His oeuvre provides an exceptional window into what, why, and how nature signified in his wartime context, and into the ways that war gave new purpose to the creative act itself.

My title, *Insect Artifice*, takes its inspiration from Hoefnagel's endeavors as artist, poet, and microhistorian *avant la lettre*. I use "artifice" primarily in its original sixteenth-century meaning as referring to artistry and ingenuity, but also in its more modern association with trickery and cunning.[12] Hoefnagel was an artificer in both senses. He was a master at disguising his thought and beliefs under a veil of emblems and allusions that only his true friends might fully grasp. He employed art as an encrypted means of communication. Hoefnagel was also an ingenious master of miniature painting in an age of print, whose works represent the last great flowering of the Netherlandish tradition of manuscript illumination.

At the same time, Hoefnagel employed his chosen medium in ways, and under circumstances, that set him apart from his precursors. His most seminal manuscript production—and the one most central to this book—is his work now known as the *Four Elements*: a four-volume compendium of the natural world comprising some three hundred miniatures and over a thousand accompanying inscriptions.[13] Executed on parchment in watercolor, gouache, and gold, its illuminated folios are as stunning in their preciousness as they are replete with learning and observation. Hoefnagel's meticulous depictions of animals, plants, and insects across the volumes would seem to position him as a natural historian and founding father of protoscientific inquiry.

Yet the *Four Elements* manuscripts share far more with Vulcanius's private volume of letters, poems, and Ovidian jottings than their splendid execution and descriptive mode of representation might suggest. In both content and design, they suggest neither a luxury commission nor a work motivated by objective aims. They suggest instead a project of ruminative invention: the product of a mind racked by troubles but buoyed up by the guidance of Nature herself. I argue throughout that Hoefnagel found in the making of the *Four Elements*—in the manual processes of collecting, inscribing, painting, and pasting—a stimulus for his contemplative engagement with nature as both subject and site of inspiration.

And in this pursuit, insects came to have pride of place. Although Hoefnagel's oeuvre reveals his interest in all manner of natural species, his representations of nature's most minuscule beasts are the most remarkable achievement of his career, and certainly the one for which he became best known. The *Ignis* volume of the *Four Elements*, the storehouse of his insect studies, was conceived decades prior to any published treatise on the subject. In his manner of enlivening these curious creatures on the page, Hoefnagel was far less interested in classification than he was in staging uncanny relations between subject and viewer, between the insect kingdom and humankind, and in recognizing the insect as an artificer in its own right.

Hoefnagel's Folio LXIX of *Ignis* is a case in point (Pl. 39). A congregation of bees and wasps seem to buzz with life despite their organized composition within the ovular frame. Their depiction to scale; the shadows they cast; the translucence of their membranous wings; the fuzz and reflective sheen of their bodies—all give us the sense that if we reached out to touch them, they might really be there. The verses in purple ink surrounding the miniature declare that these busy creatures "harbor great spirits in tiny breasts" and that

"they all have one job, and one respite from labor."[14] Through this excerpt from Virgil's *Georgics*, Hoefnagel positions the bees as exemplary in their communal industry. At the same time, he represents them each as independent actors, united by symmetry yet divided by spatial disunity—some at flight, others resting against the flat parchment surface, and others perching as if on a receding ground plane. This tension registers in the second pair of inscriptions surrounding them, penned in red capitals, which declare that "there is no honey without bile; there is no rose without thorns."[15] Bees may be models of virtue, but they also sting. Both insect and man are double-sided in nature, and disharmony always lurks behind their endeavors to establish order.

Here "insect artifice" describes more than Hoefnagel's own artistic production or approach to his subjects. It speaks to the way that individuals pursue their life as small units within a larger and ever-changing world. The metaphor of the bee that persisted from the writings of Homer, Virgil, and Seneca, and remained ubiquitous throughout the early modern period, figures the insect both as an actor endowed with singular ingenuity and as a participant in a larger sociopolitical body.[16] The tension between the itinerant bee and his belonging within the hives between which he travels parallels the way that Hoefnagel and his compatriots navigated the ramifications of war. As individuals within a now-unstable polity, they were compelled to fall back on their natural defenses: the arts of concealment, adaptation, invention, and reinvention of self. The backdrop of civil strife was what motivated Virgil to figure the bee as a model for overcoming political discord. So too for Hoefnagel, the pursuit of knowledge was inextricable from the revolution underway in the country that always and ever remained his home, however far he traveled from its shores.

ICONOCLASM AND REVOLT

The Revolt of the Netherlands had its first roots in mounting spiritual unrest that had begun in the wake of the Protestant Reformation.[17] From the 1520s onward, the rising adherence to the new faith was met with significant efforts by Emperor Charles V—the first Habsburg ruler of the Netherlands—to curb its foothold in the region.[18] In 1555, when Charles abdicated power to his son King Philip II of Spain, a still more vehement campaign against Protestant factions began under Philip's staunch direction. As the Spanish Inquisition emerged with newfound force, members of the Netherlandish nobility took on the guise of "Beggars" (*Geuzen*) and brought a plea to the local government in 1566, then headed by regent Margaret of Parma.[19] The nobles called for an end to religious persecution and to Spain's external infringement on their privileges and authority. Although their request was granted, the reprieve would prove short-lived.

The momentary change following the Beggars' petition had an immediate and unanticipated effect: the rapid spread of Calvinist open-air preaching across the Low Countries. The growing allegiance to this more radical faith culminated a few months later in the Iconoclastic Fury of 1566, when Calvinists instigated the rapid and wide-scale destruction of works of art from Antwerp to the northern Netherlands.[20] Philip II responded in kind by sending his general, Ferdinand, Duke of Alba, with troops to crush the uprising and reestablish his Catholic sovereignty.[21] Although aged and reluctant to leave Spain, Alba duly followed orders.

FIG. 2. Anonymous, *The Throne of the Duke of Alba*, 1569. Engraving, 22.5 × 28.5 cm. Rijksmuseum, Amsterdam.

Soon after his arrival, Alba initiated his so-called Reign of Terror, which involved the inquisition and execution of prominent noblemen and Reformist sympathizers, the gross taxation of local citizens, and much-maligned signs of Spanish dominion.[22] The latter included, most scandalously, the construction of a citadel along Antwerp's waterfront for the Spanish troops, which Alba crowned with a monumental bronze statue representing himself as conqueror of the rebellious Low Countries (see fig. 49).[23] Cast by the Netherlandish sculptor Jacques Jonghelinck from cannons that Alba had captured in a victory against the rebel army, it proved a monument to the general's hubris. In 1573 Philip called him back to Spain, recognizing that Alba had done more harm than good for stability in the region, and ordered the statue swiftly removed. This was only the first chapter in a conflict that would escalate into the Eighty Years' War and continue well into the seventeenth century. The formation of the Dutch Republic would be its ultimate result. But the first decade of the revolt defined the narrative of the war more than any other, and gave rise to a body of images that established its rhetoric and ideologies for long thereafter.

Among the propaganda prints produced during the revolt's earliest years is an anonymous engraving from 1569 that expresses the growing anti-Spanish sentiment in the Low Countries and foreshadows the tenor of Vulcanius's later letter to Junius (fig. 2).[24] Here Alba is the central target: the scapegoat for all Spain's cruelties. The general sits in ornate armor on a throne mockingly labeled "Behold the rod of God" (*ecce virga dei*). Beside him, the bishop Antoine Perrenot de Granvelle is blowing the empty air of a bellows into his ear.[25] A devil, to whom Granvelle is chained at the waist, holds a papal tiara and a crown over the bishop's head, signifying that he is a corrupt mouthpiece for the dictates of Spain's Catholic king.

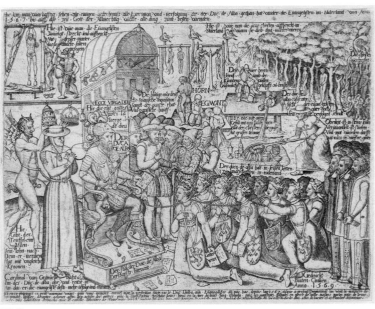

FIG. 2

A group of women shackled to Alba's throne personify the subdued provinces of the Low Countries. Among them, the foremost figure displays an open book inscribed "The word of God" (*Gottes wort*). She bears witness that the true faith is that of the persecuted in the hellscape of the print's upper register: the spiritual martyrs and dissenting nobles indicted under Alba's regime. The dukes of Horn and Egmont, whose infamous execution took place in the public square of Brussels in 1568, appear prominently at its center.[26] As the blood of the beheaded martyrs flows off the executioners' platforms, it feeds a lake where the pillaged riches of the nation are fished out to enrich the coffers of Spain. Meanwhile, the men of the Netherlandish governing body stand as unmovable herms on the far right, covering their

mouths in forced silence. The print as a whole affirms that although the revolt may have had its origins in religious dissent, it quickly grew into a war that was about something far more complex: a hydra of economic, spiritual, and political oppression.

FIG. 3. Frans Hogenberg, *The Iconoclasm of 1566*, c. 1566–70. Etching, 20.9 × 28.1 cm. Rijksmuseum, Amsterdam.

Images like the 1569 propaganda print are those most often used to tell the story of the Dutch Revolt, as they refer explicitly to its major events and attest to how the outcry over Spanish atrocities—both real and exaggerated—shaped the construction of its history.[27] In many ways, the revolt is the first conflict that motivated the formation of what would constitute a political image in the course of subsequent modernity, and it has been compellingly described as a "paper war" in its proliferation of both printed images and written pamphlets.[28] The propagandistic image, however, is only one form of politically sentient art, and only its most obvious manifestation.[29]

The broader historiography of art in the Low Countries during the latter half of the sixteenth century—to the extent that it acknowledges the revolt's ramifications at all—has focused on how the 1566 Iconoclastic Fury transformed artistic production and art theory, and on the polemical debates it spawned about decorum in religious works of painting and sculpture (fig. 3).[30] The numerous treatises written both before and after the Council of Trent—by Catholic and Protestant authors alike—not only set forth a range of iconographical prescriptions but also gave rise to stylistic experiment. Likewise, the emergence on the Antwerp art market of new visual genres like landscapes and market scenes, which had begun even before the iconoclasm, found new impetus in its wake.[31]

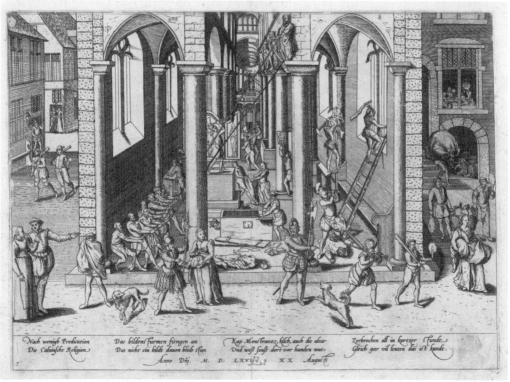

FIG. 3

Yet the iconoclastic attacks alone did not motivate the transformations in the Netherlandish art and culture of this period. Under Philip's rule, the vehement campaign against Reformist factions in the region not only fomented the revolt itself but also meant that many Netherlanders found themselves divided by faith and compelled into exile for fear of persecution.[32] The impact of the Spanish Inquisition and heresy trials, the devastation of the region's economy by excessive taxation and wartime turmoil, and the resulting waves of emigration out of the Low Countries all had an equally powerful effect on how individual artists, merchants, and intellectuals reconceived their identities and practices in this period.[33]

I aim to move beyond a narrative of wartime privations that emphasizes their deleterious effect on creative and intellectual pursuit, and to consider the ways that they motivated, however paradoxically, new strands of knowledge and modes of engagement.[34] In seeking to recover the personal stories of tragedy, displacement, and rebirth that arose in the revolt's wake, I look beyond the propaganda prints produced by both sides and the church altarpieces targeted by iconoclasts. I take up the approaches to organizing and processing the experience of war that manifest themselves in works of a very different kind.

The many quiet and guarded ruminations that unfolded in the space of Netherlandish albums, letters, drawings, and miniatures across the later sixteenth century were entwined with the ever-growing ubiquity of print. In an age of inquisition, the retreat into manuscript culture provided a fertile field as much for personal contemplation as for exchange and preservation: a means to reinforce the bonds of friendship and scholarship that the war threatened to sever.[35] Embedded in the works produced in this context are a wealth of oblique reactions to the revolt. They carry a metadiscourse about establishing common ground through shared experience rather than shared religion, about reuniting in defiance of spiritual discord and political dissent.[36] In sum, they reveal how the war became a generative stimulus, and how the act of making could reemerge as a positive endeavor in the face of loss. In the minds of Hoefnagel and his colleagues, the two opposing and cyclical trajectories of nature—toward destruction and toward growth—mirrored the plights of the present.

MUTABLE NATURE AND CRUEL FORTUNE

For the contemporary understanding of nature in the Netherlands, the rise of natural history is a crucial starting point. The development of this pursuit in the early modern period was very much a pan-European phenomenon, stimulated by the exchange of discoveries and specimens across borders.[37] Two seminal early publications—the Swiss naturalist Conrad Gesner's *History of Animals* (1551–58) and the German botanist Leonhart Fuchs's *Remarkable Commentaries on the History of Plants* (1542)—not only crystallized the emergent field but also paved the way for mobilizing visual illustration as a means of imparting knowledge about plant and animal species.[38] Yet it was precisely during the 1570s, as the revolt began to play out in full force, that both artists and scholars in the Netherlands took up inquiry into the natural world. The emergence of this interest was not a coincidence.

The primary topos in the sixteenth- and seventeenth-century study of animal, insect, plant, and mineral specimens was a belief that the study of nature provided a means to come closer to God. Through a multiconfessional emphasis on reading the Book of Nature, contemporary scholars framed their queries into the natural world far less as a matter of

objective interpretation than as the pursuit of spiritual guidance.[39] This accounts for the prominence given to moral, proverbial, and emblematic wisdom within natural history treatises of the period.[40] Central to early modern natural philosophy at large was the notion that animals and humankind belonged to the same chain of being. According to Pico della Mirandola, humankind's distinguishing feature was our ability to "fashion" (*effingere*) ourselves on the model of any and all of nature's forms.[41] His point was not that we were the center of the universe, but rather that all God's creations—from the most savage beast to the smallest insect—had something to teach us.[42]

The cultivation of natural-historical knowledge so came to be perceived as an antidote to the revolt's destructive forces. Communal labor toward understanding nature's cycle of life and regeneration suggested the possibility of salvation for humanity during troubled times. Perusing the 1576 treatise *On the History of Plants* by the Netherlandish botanist Matthias de l'Obel, one might never suspect any such motivation underlying the work's creation. Its elegant compositions of carefully observed specimens—displayed from flower to root, and from bud to full bloom—are glossed by reference to ancient authors and origin stories of the local gardens from which l'Obel's studies derived.

Yet as l'Obel writes in the introduction, his project was inseparable from the context of its making. He opens by lamenting that he cannot but "weep pious tears" over the plight of his homeland, "torn apart so miserably and inimically by this detestable and wretched civil war."[43] The Muses, who had fled Greece and assembled in the verdant Low Countries so long ago, now found themselves thwarted by hostility and violence. This was all the more grievous given that the southern Netherlands was "the most celebrated emporium of all Europe" and a region "most fertile with brilliant minds, who excel in every branch of art and knowledge (*artium et scientiarum*)."[44] L'Obel even goes on to equate the calamities of the revolt with the inhospitable northern climes that compelled his countrymen to band together in their horticultural endeavor:

> However unsuitable this tract of northern sky may be for nourishing innumerable plants, because of the savagery of the frosts and long winters, and the unbroken, lasting, and oppressive storms of the sky, and its damages; nonetheless, it is the industry of its inhabitants—their assiduity and unyielding diligence in safeguarding more tender plants from the aforementioned troubles—through which no species can be found in the whole world that is not reared and eminently nourished here by new arts, enormous labor, and the tireless works of the most celebrated heroes and illustrious men, with no expense spared. Whence not without cause I may offer foremost praise to the Netherlanders in better cultivating knowledge of plants, a most ancient study and one most worthy of the greatest men.[45]

L'Obel's celebration of ingenuity and scholarship in his native land depends on the rhetoric of transformation. The effort to further knowledge of the natural world brought hope that the fertile minds of the Low Countries might continue to give rise to new learning, that the region might again become a welcoming home to the Muses. The pursuit of the "most noble arts" alone promised asylum from the ravages of war.[46]

Here I return to Vulcanius's well-chosen word "metamorphosis" as the motif that binds the personal and psychological upheaval of wartime to the cycle of nature. In Ovid's poem, metamorphoses result from conflict or negative impulses—Arachne's losing battle with Minerva or Narcissus's idle passion for his own image—but their resolution is double-sided. Saved from suicide, Arachne is transformed into a spider, while the stricken Narcissus is reborn as a flower. In any metamorphosis, there is continuity within change. The traces of the past linger in the new forms and identities that result.

Individuals caught in the crossfires of the revolt found their own lives in a state of metamorphosis. Those who chose emigration had to forge a new notion of belonging defined by adaptation to unfamiliar conditions.[47] Those who remained behind in the Netherlands faced a parallel necessity of acclimating to the turbulent changes around them, and, in some cases, of dissimulating their true faith in the public realm.[48] The common denominator was a sense of loss and forced change that drove the reinvention of identity, whether individual or communal. Their native ties to the Netherlands were neither forgotten nor abandoned, but rather reconfigured in relation to a now-distant or inimical homeland.[49]

In this process of reinvention, Ovid emerged as the poet of the moment. The popularity of the *Metamorphoses*, which had endured throughout the Middle Ages, only grew across the sixteenth century. The moralizing renditions of Ovid's poem that dominated its interpretation in the medieval period were coupled with philosophical and humanistic readings. The Augsburg scholar Johannes Sprengius, in the introduction to his 1563 interpretive edition, summed up the emergent sixteenth-century understanding of the *Metamorphoses* as "a lustrous mirror of human life," which revealed God's command "over the transformations of human affairs, fickle fortune, and all mortal circumstance."[50]

Nor was Ovid known to his sixteenth-century readers as the author of the *Metamorphoses* alone; he was also the foremost exponent among ancient writers for overcoming the misery of exile through the exercise of ingenuity.[51] Across the early modern period—and well beyond the Low Countries—Ovid's exilic poetry, written after his banishment from Rome to the Black Sea, offered a paradigm of personal metamorphosis in which the poet figured his own natural talent (*ingenium*) as the vehicle through which to rise above the machinations of human affairs.[52] On the one hand, Ovid laments that "the face of [his] own fortunes can be reckoned among those transformations (*mutata*)" of which he had sung at the height of his career back in Rome.[53] Yet like l'Obel after him, the poet also employs the harsh setting of the Black Sea as a foil against which his divinely inspired genius continues to thrive. He takes comfort that, with the continued aid of the Muses, his poems might ensure his fame beyond the grave.[54]

Ovid thus embodied a belief shared by sixteenth-century scholars and naturalists alike: that the course of life, death, and afterlife was beyond human control, and belonged only to the sway of Nature. During the early decades of the war in the Low Countries, the pursuit of natural philosophy, natural history, and the cultivation of natural talent cohered in a desire to comprehend this mysterious and mutable power, "the signs of God's providence and might" shown forth in the visible world. Herein lies the story of the metamorphosis of nature in the Dutch Revolt, and of Hoefnagel's place within it.

ART AS REFUGE

Hoefnagel, while still a child, was thwarted in his pursuit of art. Born to a family of merchants in Antwerp and reared to take up the familial trade, he is said to have vented his stifled yearning to draw through desperate scribbles in dust on the floor and doodles in chalk on the attic walls.[55] It took a distinguished household guest to witness those doodles and convince Hoefnagel's parents to let the boy pursue the art to which Mother Nature disposed him, albeit alongside his other studies.

Although Hoefnagel's first biographer, Karel van Mander, loved to fabricate stories of artistic origins such as this one, his account is not all fiction. What van Mander tells us of Hoefnagel's later life is born out in his oeuvre, namely, that Hoefnagel began to pursue a full-fledged artistic career only when he was well past his youth.[56] Hoefnagel's father was a prominent merchant in Antwerp who dealt in tapestries, jewels, and other luxury goods.[57] Through him, Hoefnagel entered the world of the southern Netherlands at the height of its strength and prosperity. He came of age in a metropolis where artists like Frans Floris and Pieter Bruegel the Elder led flourishing careers, and which Hieronymus Cock and Christopher Plantin had transformed into the center for print and book publishing of early modern Europe. He saw the great town hall, completed in 1564, rising up on Antwerp's central square—a model of Renaissance architecture in the North and a monument to the city's creative and commercial achievement.[58] In short, he knew Antwerp before its fall.

Hoefnagel's early years exposed him to an international culture of exchange, travel, and intellectual pursuit. His earliest known drawings were the fruits of these ventures during the early 1560s, when he studied at the universities of Orléans and Bourges in France and journeyed to Spain on business.[59] Even among the Antwerp mercantile elite, Hoefnagel was notable in having both acquired and fully employed his university education. His knowledge of ancient and contemporary literature pervades his art and writings, and allowed him to foster close friendships with scholars at home and abroad. Van Mander singles out Hoefnagel's skill at reading and writing Latin verse, linking him to the larger Renaissance tradition of artist as poet.[60] Even in his youth, Hoefnagel was more than a merchant; he engaged in the sharing of cultural capital as much as he participated in networks of trade.

Then came the Iconoclastic Fury and the dawn of Alba's reign. In 1568 Hoefnagel left his hometown, now occupied by Spanish troops, for a yearlong reprieve in England. There his first extant manuscript grew out of a reflection on the downfall of Antwerp, the plight of its mercantile community, and the imperiled future of Netherlandish artistic tradition.[61] In London, he was surrounded by fellow merchants and artists—many of them Protestant—who had fled the revolt for better prospects across the Channel. Hoefnagel himself was not yet ready to emigrate permanently, though that time was close at hand. As he began to contemplate what it meant to pursue the making of art posticonoclasm, Hoefnagel turned his mind to the works of Bruegel, whose explorations of nature and human nature would come to haunt his own. He may have met the elder artist in person before his departure, but near the time of his return, Bruegel passed away (d. 1569), and Hoefnagel was left to grapple with his legacy.

The inception of the *Four Elements* belongs to the subsequent decade, after Hoefnagel returned to Antwerp and began to create his earliest extant miniature paintings. The first

dated miniature in the volumes themselves is from 1575, which indicates that, at least by this year, his collection of material had already begun—even if the project did not yet have a name or coherent form (Pl. 3). Van Mander reports that Hoefnagel received from an unnamed Netherlandish artist his first box of watercolors while abroad at the Spanish port of Cádiz, and took instruction from fellow Antwerp painter Hans Bol when he returned from his travels.[62] Nothing short of precocity accounts for how quickly Hoefnagel mastered the medium, and we will see that he later claimed himself to be an autodidact (see fig. 14). Nonetheless, it makes sense that he would have sought study under Bol, who was versed in miniature painting and a devoted follower of Bruegel in his own landscapes and peasant scenes.[63] Additionally, several of Hoefnagel's compositions in the *Four Elements* relate to those in a handful of surviving albums and collections of nature studies by Bol and other artists then circulating in Antwerp.[64] He thus benefited from a larger milieu of interest in natural history, both at the time and over the decades to follow.

Had Hoefnagel remained in Antwerp for the rest of his career, his study of the natural world might never have developed into one of greater urgency. But the major turning point in Hoefnagel's life was still to come. In November 1576, a band of Spanish soldiers, frustrated over lack of pay and ceaseless battles, ransacked Antwerp. According to van Mander, Hoefnagel's family was among those who lost their wealth to the foreign plunderers in the much decried event that became known as the Spanish Fury.[65] The ramifications were both political and personal. For Hoefnagel, his hometown was now even less secure than it had been before and offered meager prospects for rebuilding his mercantile career. The exigencies of war demanded that he leave the Netherlands behind.

And so in the following year, 1577, Hoefnagel set off for Italy in the company of his close friend the Antwerp cartographer Abraham Ortelius, presumably in the hope of finding new commercial opportunities farther south. Hoefnagel also brought along a handful of miniatures on their journey, including the early stages of the *Four Elements*, which perhaps were as yet only a collection of loose studies or folios.[66] Van Mander writes that during a sojourn in Munich, the two friends were received at the court of Duke Albrecht V of Bavaria, who was so impressed upon seeing Hoefnagel's portraits of himself and his wife, and "a small piece of parchment with little animals and trees in gouache," that he not only requested to purchase the latter miniature but asked Hoefnagel to enter his service permanently.[67] The story compellingly suggests how Hoefnagel's nature studies served as a calling card for his rare abilities as a miniaturist and helped to launch his transformation from itinerant merchant to émigré artist.[68]

After completing his Italian travels with Ortelius in late 1578, Hoefnagel returned to Munich to take up his new position. He remained in court service through Albrecht's reign and into that of his successor, Wilhelm V of Bavaria.[69] During these years, he produced miniatures and manuscript illuminations for other patrons as well—most notably, a program of illuminations in a splendid Roman Missal commissioned by Archduke Ferdinand II of Tirol, which took Hoefnagel almost a decade to complete.[70] Nor did he abandon his mercantile ways but began to collect and deal in old master drawings—an interest that he sustained for the rest of his life.[71] He also continued to work on the *Four Elements*. The project seems to have benefited significantly from the contacts and resources that court afforded him, even if he had to pursue it alongside commissions and obligations to his

patrons. The last dated miniature in the volumes, which belongs to the year 1589 (*Terra*, Folio XXXIX), places the development of the manuscripts well into his Munich period. But his death in 1600 is the only secure terminus ante quem, and there is every reason to surmise that Hoefnagel continued to engage with the project under the auspices of his final patron.

This last court appointment resulted from yet another change in Hoefnagel's fortunes. When new Counter-Reformation strictures under Wilhelm V required all members of the Munich court to make an open profession of faith, Hoefnagel was dismissed for failing to sign the credo. Having lost his position at Munich, Hoefnagel sought the protection of Emperor Rudolf II, who was known for his welcoming stance toward wartime emigrants from the Low Countries.[72] In 1591, Hoefnagel joined a coterie of many other exceptional artists and scholars who had been lured into Rudolf's employ under similar circumstances.[73] During these late years, he moved between Frankfurt and the imperial courts in Prague and Vienna, and he illuminated two calligraphic manuscripts that were already in the emperor's possession.[74] His son and fellow artist Jacob Hoefnagel also entered Rudolf's service and helped to perpetuate his legacy even after his father's death through the production of prints and miniatures inspired by his works. Jacob, unlike his father, became an avowed Protestant during his tenure abroad.[75]

Rudolf's avid collecting of art and natural curiosities, for which he was already well known at the time, also fueled his interest in and eventual purchase of the *Four Elements*. When he acquired them is less certain, all the more so since they do not appear in the 1607–11 inventory of his collection.[76] Van Mander writes that Rudolf paid Hoefnagel one thousand gold crowns for the volumes, but even this report cannot be accepted without question, as it is accompanied by a still more dubious assertion: that Hoefnagel explicitly produced the manuscripts on the emperor's commission.[77] As Lee Hendrix has already pointed out, to accept van Mander's statement accords neither with the dates of the miniatures found within the *Four Elements* nor with the content and nature of the volumes as a whole.[78] Most conspicuously, it does not accord with the fact that the manuscripts lack any indication of a commissioner or dedicatee, unlike those which Hoefnagel produced for Rudolf and other patrons during his career.[79] So van Mander's biography, while quite detailed and reliable overall, should be taken as incorrect on this point, and its author as comparably less well informed about Hoefnagel's final years.[80] What matters about this episode is that the *Four Elements* underwent their most significant repurposing within Rudolf's ambit, becoming not only prized collector's objects but also models for many subsequent artists and scholars engaged in the study of nature.[81] This afterlife and audience went well beyond what Hoefnagel could have foreseen for his project at the outset.

Hoefnagel's later career as a court artist nonetheless continues to define and delimit the majority of scholarly studies on his works, and on the *Four Elements* in particular. We are told that his miniatures celebrated the power of human artifice to emulate nature's wondrous creations, and did so in the context of collector's cabinets abounding in other works of art and naturalia. We are told that they redounded to the credit of their courtly owners through their virtuosity and learning.[82] All of this may be true, to some extent, of his final years. Yet the problem is this: the prevailing narrative emphasizes the conclusion of Hoefnagel's story at the expense of his beginnings. It brushes aside the hardships that

Hoefnagel declared fundamental to his own course of life, and which have only recently been recognized as definitive both of his works at the Rudolphine court and of those produced by his fellow Netherlandish émigrés who also made a home there.[83]

If we follow instead the larger arc of van Mander's narrative, we find that his account of Hoefnagel's early career places the upheaval of the revolt front and center. Of all the artists whose lives van Mander surveys, he opens Hoefnagel's biography alone with direct reference to the plight that was essential to his creative formation:

> I find that a better custom prevails among us Netherlanders than is in use with other peoples—namely that parents, even when empowered by wealth, often get their children to learn one or another art or trade early in their youth; that can be wonderfully useful, especially in times of war and emigration. For we find that cruel fortune, the bane of this world, has less power over art than over riches, and that the art which one has learned in one's youth is often the last resort in necessity and a refuge of consolation to avert the shipwreck of oppressive poverty. How true this is was discovered by the gifted Joris Hoefnagel of Antwerp.[84]

This book takes up van Mander's notion of art as refuge and of poverty as a metaphor, one that refers not just to the loss of material wealth but also to the impoverishment of culture, which in turn motivates and undergirds cultural renewal. Tracing the trajectory of Hoefnagel's career prior to his tenure at Rudolf's court reveals that his drive as an artist arose directly from his experience of war and emigration. It reveals that the courtly sphere proves a false point of reference for uncovering the real impetus behind Hoefnagel's art, which is far less about the curiosity cabinet and far more about a concern for the fragility of knowledge itself. To understand this concern demands looking not to the later history of its reception, but to the archive of his works themselves, the crucible of his learning and experience, which carries with it the story of Hoefnagel's wartime displacement and preservationist efforts.

Finally, a word on Hoefnagel's spiritual allegiances, in light of his emigration from Antwerp and subsequent departure from Munich in 1591. Never in Hoefnagel's life or works did he openly espouse any one religious stance. For this reason, he has often been described as an irenicist who followed Desiderius Erasmus in his disavowal of spiritual dogma and pursuit of an ethical path to virtue.[85] Hoefnagel has likewise been associated with the Neo-Stoic movement fostered by the Netherlandish humanist Justus Lipsius in response to the confessional conflict of the revolt.[86] As a revival of ancient Stoicism inflected by Christian teachings, it was a movement focused on active virtue. This meant not only taking action to improve one's own condition but also aiding others in their quest to live by the universal guidance of nature alone (*sola natura*).

No less dominant has been the body of past scholarship linking Hoefnagel to the Family of Love (*Huis der Liefde*): a contemporary reformist movement in the Low Countries founded by Hendrik Niclaes on the principle that true piety consisted of inward faith and communal devotion.[87] The affinity of this movement with Neo-Stoic philosophy has been said to have invested it with particular appeal among individuals like Hoefnagel and his friend Ortelius. However, recent studies have convincingly dispelled the myth of

widespread allegiance to Niclaes's ideology.[88] While Hoefnagel's works do display some affinity with the ideas of Erasmus and Lipsius, any connection to the Family of Love should be dismissed as speculative at best.

Hoefnagel unquestionably adopted an irenic view on the war in hoping for peace and seeking a way out of contemporary discord. Yet this does not really address the matter of his faith. That many of his friends were openly Protestant, and his own son later a member of that faith, is certainly suggestive. But even his dismissal from Wilhelm's court provides no firm evidence, as a refusal to sign a religious credo is only a negative statement and not in itself a tacit vote for the opposing camp. Given that Lipsius—despite his Neo-Stoic reflections and expedient movement among Protestant circles for many years—proved an ardent Catholic in the end, I am wary of asserting too strongly that Hoefnagel was one thing or another, let alone that he was a neutralist outright.[89] I am even more skeptical of attempting to recover a system of belief in his works, which record the process of thinking through questions of religion and politics far more than they express firm convictions. To bear oneself "discreetly and prudently," as Lipsius himself wrote, was tantamount to surviving troubled times.[90] Hoefnagel was a master at doing just that.

Part 1 begins with Hoefnagel's intellectual biography, as told through his personal mottoes, and then turns to address his place within the larger Netherlandish community of artists, merchants, and scholars whose plights and pursuits were fundamentally shaped by the war. I focus on the genres that most closely informed Hoefnagel's approach to the manuscript medium as a space of inquiry and identity formation: the emblem book, the atlas, and the friendship album. In the process, I endeavor to show how the revolt impacted the contemporary understanding and development of those genres themselves. In part 2, this foundation provides the ground on which to reinterpret the aims and content of the *Four Elements*. The conceptions of art, nature, and their respective histories, which emerge across the volumes, reflect the concerns that drove Hoefnagel's turn to image making in the first place. The tensions between observation and imagination, between nature as object of inquiry and Nature's ineffable power, are the most recurrent themes. I address Hoefnagel's work for Rudolf II only in passing and touch just briefly on his collaborations with his son Jacob in those later years. This is not a monographic study of Hoefnagel's oeuvre; rather, I attempt to reconstruct the larger world of thought and experience to which he belonged, even while aware that the writing of history is itself an act of artifice.

The *Four Elements* emerges in this alternative narrative as the site where Hoefnagel returned again and again to grapple with nature through art—not for its own sake, but for the sake of understanding the tensions and transformations around him. Within the space of his manuscripts, Hoefnagel sought to safeguard art and knowledge from the enemy forces that threatened them from the outside, and to create a body of work immune to iconoclasm and inquisition. Above all, Hoefnagel struggled with the same doubt that kept surfacing for Vulcanius at the margins: the question of how to emerge from war with sustained hope for a second life.

THE HAMMER
AND THE
NAIL

Hoefnagel's Shoes

Hoefnagel conceived scale and significance in obverse relation to one another. He granted the most minute things the greatest weight—whether the wings of a dragonfly, shells scattered along the shoreline, or a few words jotted at the bottom of a parchment page. To see this as myopic would be to miss the point. Hoefnagel sought the forest through the trees, striving through his meticulous miniature worlds to grasp the higher power from which he understood all creations of art and nature to derive. Hoefnagel's personal mottoes and devices speak to the tensions underlying this pursuit. Across his works, there is nowhere that Hoefnagel more deftly conveyed the nature of his own creative and intellectual transformations than in the little self-referential phrases and symbols he inscribed along their margins. And there is nowhere better for this book to begin.

The personal device had long served among the means through which Renaissance individuals fashioned their identity and displayed their wit. In the Netherlands, the practice first emerged with members of the nobility and in the context of the late medieval court. The dukes of Burgundy used their mottoes to adorn everything from suits of armor to the hilts of swords and tableware.[1] When Jan van Eyck inscribed the motto *als ik can* ("as best I can") on his works, he was at once proclaiming his endeavor for painterly excellence and participating in the vernacular literary culture esteemed by his Burgundian patrons.[2] Well into the sixteenth century, Emperor Charles V's Latin motto *plus ultra* ("still further")—an embodiment of his global ambitions—remained ubiquitous in the ceremonial imagery and pageantry of his reign.[3]

At the same time, scholars across Europe also began to employ mottoes to their own ends. They derived inspiration as much from the courtly realm as from classical aphorisms, vernacular proverbs, and the study of Egyptian hieroglyphics.[4] The Latin word *symbolum*, by which humanists most often referred to their mottoes, reflected the more arcane nature of the devices they chose, which tended to express not so much outward aspirations as inner qualities. Hoefnagel belongs within this erudite tradition. Among the earlier Netherlandish painters, van Eyck's adoption of a personal motto found few emulators. By Hoefnagel's lifetime, especially in his native Antwerp, the motto's rise to prominence reflected a growing

FIG. 4. Quentin Massys, *Portrait Medal of Desiderius Erasmus*, 1519. Cast bronze, 10.6 cm in diameter. Historisches Museum, Basel.

realm of exchange among artists, scholars, and rhetoricians. Yet even this context does not quite account for the dexterity and inventiveness that Hoefnagel brought to the genre.

The best precedent for understanding Hoefnagel's engagement with the motto is the legacy of Desiderius Erasmus, who inaugurated the practice among humanists in the Low Countries.[5] Erasmus took his personal device of Terminus, god of boundaries, from a ring set with an ancient gem that was gifted to him in 1509.[6] He paired the image of the god with the motto *cedo nulli* ("I yield to none") and employed it most prominently on the ring that he used to seal letters to his vast international network of correspondents.[7]

Erasmus's enemies, however, took the motto as a sign of his arrogance, presuming that the line "I yield to none" was spoken from the scholar's own mouth. Prompted by this attack, Erasmus wrote a letter of "apology" in 1528, countering that his detractors had failed to recognize the relationship between the motto and the image: it was Terminus, not Erasmus, who was speaking.[8] By the late 1520s, the assertion of unyieldingness may have seemed too akin to Martin Luther's stance against the Catholic faith, from which Erasmus was at pains to distance himself.[9] His device, he claimed by contrast, reflected his ruminations on the brevity of life, a theme signaled by the second motto, "Death is the ultimate boundary of things," which he had already in-

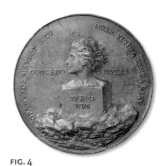

FIG. 4

cluded together with Terminus on his 1519 portrait medal designed by Quentin Massys.[10] On the reverse of the medal, where the variant motto *concedo nulli* frames the bust of Terminus, the words align directly with the god's mouth—as if he were indeed their speaker (fig. 4). Yet by virtue of being a double-sided object, the medal also undermines Erasmus's case. From front to back, the juxtaposition of Terminus's profile with the scholar's own affirms the ambiguity that was inherent in the motto from the beginning.

And for Erasmus, this was really the point. In his same letter of apology, he writes that in mottoes, "one should always try to discover some enigma, which is meant to elicit the conjectures of those who see it," and explains that he chose Terminus as his device "because it had a double attraction: on the one hand, the allusion to an old and celebrated history; on the other hand, the obscurity that is proper to mottoes."[11] By evoking the fundamentally heuristic nature of the category, Erasmus was not just thumbing his nose at his critics. He was also reminding his audience of the fundamental appeal of the genre that he employed: its obscure rather than overt revelation of meaning.

The conflict roused by Erasmus's device reveals that mottoes were not isolated exercises of erudition but were understood as contingent on the circumstances of their reception. It is within this framework that we should approach interpreting how Hoefnagel employed his devices in both private works and widely disseminated prints. From the beginning, he fashioned himself as a humanist on Erasmus's model—a learned observer of the world and incisive negotiator of the diverse publics with which he sought to engage. Hoefnagel's mottoes not only chart a history of thought; they put us in his shoes as he traveled from troubled Antwerp to foreign shores.

UNTIL I AM FORGED

Shoes mattered to Hoefnagel for a simple reason: they were part of his name. The word *hoefnagel* in Dutch refers to the nail (*nagel*) used to attach a horseshoe to the animal's hoof (*hoef*). Neither nail nor horseshoe is an especially glamorous piece of equipment with which to foster association. Precisely for this reason, Hoefnagel exploited the unlikeliness of these objects to the fullest extent. On a superficial level, he employed them as rebuses for his signature. But far more powerfully, Hoefnagel represented the horseshoe and nail as analogues for his experience in the world, as embodiments of the struggles of a subject who was constantly being formed in relation to the object of his labors. In the annals of art history, Vincent van Gogh's paintings of shoes prompted a well-known exchange, in which Meyer Schapiro and Jacques Derrida in turn exposed the pitfalls of "reading" an artwork biographically.[12] Yet it was Martin Heidegger, the initiator of this debate, whose insights are most relevant here.[13] The making of self and the physical making of art are inseparable in Hoefnagel's body of work. His tools, in Heidegger's terms, are laid out on the ground of every picture. And through their representation, Hoefnagel reveals the fundamental nature of things that he was always striving to understand.

The first point to note is how discerning Hoefnagel was about when and where he employed his devices. On the illuminated frontispieces of each volume of the *Four Elements*, Hoefnagel simply painted his initials dangling from foliate threads surrounding the title itself: a "G" for the Latinized spelling of his first name, *Georgius*, and an "H" or combined "HF" for *Hoefnaglius fecit* (or *faciebat*) on the opposing side (fig. 5). Otherwise, Hoefnagel did not initial any of the individual folios now contained within the manuscripts, aside

FIG. 5. Joris Hoefnagel, Title page of *Terra*, from the *Four Elements*, 1570s–1600. Watercolor and gouache, heightened with gold, on vellum, 14.3 × 18.4 cm (approximate). National Gallery of Art, Washington, DC, Gift of Mrs. Lessing J. Rosenwald.

FIG. 5

FIG. 6. Joris Hoefnagel, *Seal and Beaver, Folio XII*, 1570s–1600. Watercolor and gouache, with oval border in gold, on vellum, 14.4 × 19.5 cm. Staatliche Museen, Kupferstichkabinett, Berlin.

from one exceptional case in *Aier* discussed below. The four manuscripts in the National Gallery survive today in modern leather bindings, which give no clues as to their original constitution, but the frontispieces surely date to the moment that Hoefnagel first brought the sheets together. Perhaps this was already in Antwerp or later on at the Bavarian or Rudolphine court, where the project began to receive a more formal audience.

Adding to the frustrated codicological history of the *Four Elements* is the group of related rectos that survive today as loose sheets.[14] Some of these were likely removed by Hoefnagel himself, others at a later date in the volumes' history.[15] However, they all bear the original folio numbers that Hoefnagel inscribed on the rectos, and a few sheets show traces of text worn off from the opposite verso: clear evidence that they once belonged to the manuscripts.[16] Almost all the roman numerals within the extant bound volumes have been scratched out, and the folios renumbered, presumably to account for the shifts in content over time. Three loose sheets from the project now divided between Berlin and Paris speak to Hoefnagel's involvement in at least a handful of these alterations, as they all share a common feature: he appended his *hoefnagel* to each of the excerpted miniatures in question.

The first of the Berlin miniatures shows a seal and a beaver marooned on a shallow island, their forms juxtaposed with two conches on the beach in the foreground (fig. 6).[17] The conch on the left, to which a piece of red coral has affixed itself, strangely echoes the creatures' tails. There is an affinity between the mammalian and molluscan specimens on display: all of them wayfarers who drift between land and sea. The animals both cast shadows on the still water, and they seem to ignore the gilt "G" coiled around a nail

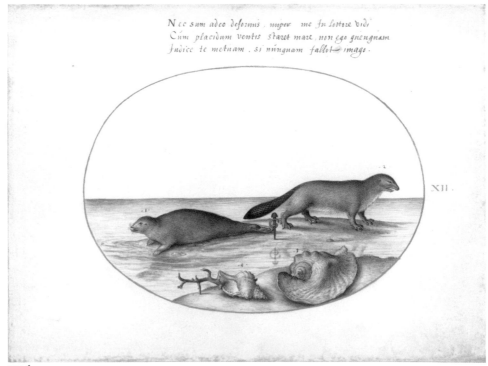

FIG. 6

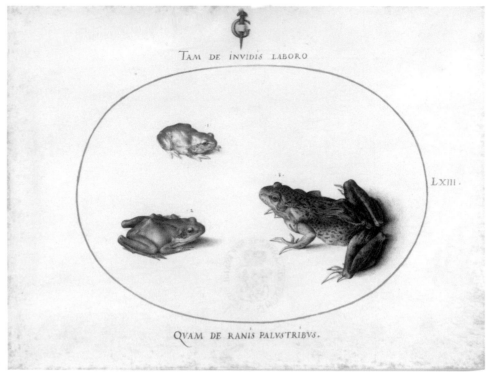

FIG. 7

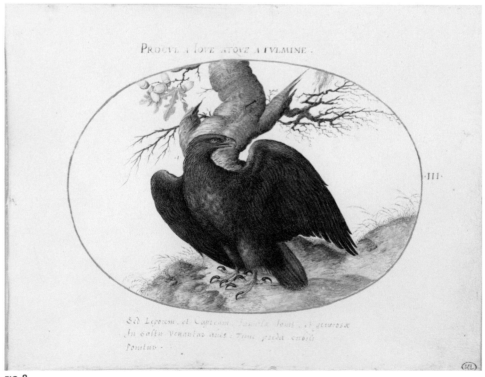

FIG. 8

between them, which likewise leaves its silhouette on the glassy shallows. The inscription above, adapted from Virgil's *Eclogues*, derives from the lament of a scorned lover: "Nor am I so unsightly. I looked at myself on the shore the other day, when the sea stood still from the wind. I would not fear judgment from anyone, if the image never lies."[18] The first-person voice of the lines lends subjectivity to Hoefnagel's represented subjects—the seal, beaver, shells, and the nail itself. By taking on Virgil's words, Hoefnagel speaks wittily to the paradox of the nail: a piece of unsightly equipment that embodies his own capacity of self-reflection and dissimulation. He fears judgment from no one as he conceals himself in plain view, reminding us—as ever—that images are not the straightforward reflections that they seem.

The second sheet in Berlin expands on this theme (fig. 7).[19] A trio of frogs engage in a standoff, as the empty space between them—like the pause that follows a heated argument—leaves us to wonder just what they have been going on about. Again, the inscription provides an answer, but this time, its first-person voice is directed at them from outside. Hoefnagel has adapted one of Erasmus's *Adages* as his own, and lest there be any doubt as to the personal valence of the phrase, he drives home the connection with the "G" and the nail pierced through an illusionistic cut in the parchment at the top of the miniature.[20] "I worry less about the envious than about frogs in a marsh," Hoefnagel tells us, as he jabs the point of the nail menacingly down at the word "envious" (*invidis*) below.[21] Just as Erasmus conceded to no one, least of all his enemies, Hoefnagel shows that he does not let his detractors get the better of him. Through the combination of text and symbol, Hoefnagel fills in the blank of his own composition by insinuating that he himself is the object of the frogs' ceaseless croaking.

Hoefnagel stages a still more complex defense in a recto now in Paris: the last of the signed loose sheets from the *Four Elements* and formerly Folio III in the *Aier* volume (fig. 8).[22] Here the fearsome eagle of Jove is his central subject, and he accentuates the angularity of the mighty bird's talons and beak both through the jagged oak tree positioned behind it and through the god's red lightning bolt, which pierces the image space from above.[23] The tree looks as though it has been struck by lightning; the only growth from its otherwise barren branches is the cluster of oversized acorns opposite the thunderbolt, which emphasize the further association between Jove and the mighty oak.

To interpret this sheet requires understanding its former context within *Aier*, where it was preceded by a miniature that still preserves its original labeling as Folio II (Pl. 10).[24] Not only is the latter signed and dated—a combination unique among the folios still found within the volumes; it is also more explicitly political than any other extant miniature belonging to the *Four Elements* as a whole. Between two eagles stands a carved block of stone bearing an inscription from Philip II's pivotal triumphal entry into Low Countries in 1549. Hoefnagel would have found the text in a published account of the entry by the Spanish humanist Juan Calvete de Estrella, which immortalized the moment of Philip's announced inheritance of the region from his father and Holy Roman Emperor Charles V. Addressing Charles, the inscription opens by proclaiming the Jovian eagle the king among birds and as such, perfectly suited to carry the emperor's arms and to crown his scepter.[25] It concludes with the line that Hoefnagel quotes: "The shields of others will carry timid doves; those [eagles] of yours [alone] fit the shield of magnanimous Caesar."[26]

Far from endorsing these lines, the composition that Hoefnagel constructed around them does violence to their association of magnanimity with Habsburg rule. By sundering the imperial double eagle in two, Hoefnagel might be taken to evoke the division of power upon Charles's death between Philip and the emperor's brother Ferdinand I—a division designed to allow for greater ease of dynastic control and expansion. The ascending eagle, which turns its head eastward, wears around its neck the *Bindenschild* of the House of Austria, which was among the prime territories that Ferdinand came to govern as Holy Roman Emperor. The standing eagle in turn looks westward toward Philip II's Spain and realms of conquest beyond. At foreground center is the stone that Hoefnagel inscribed with the date of 1576: the same year that the Spanish Fury led to the Pacification of Ghent—a decree that called for the expulsion of the treacherous Spanish troops from the Netherlands, the condemnation of Alba's harsh measures, and the reestablishment of the good governance upon which Charles's transfer of the region to Philip was premised.[27] The noble intentions of the 1549 triumphal entry aside, Hoefnagel's miniature suggests that the expansion of Habsburg domain to both east and west had brought more discord than unity; that it had exposed the hollow promises behind the pursuit of global dominion. The adage "An eagle in the clouds" (*Aquila in nubibus*), with which Hoefnagel titled the miniature, even referred according to Erasmus not only to great things that are difficult to achieve but also to "the empty hopes of empire."[28]

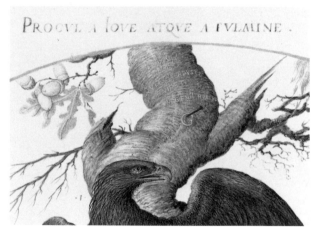

FIG. 9. Detail of Fig. 8.

FIG. 9

This tension extends to the folio now in the Louvre, its single eagle poised in a stance somewhere between its precursors on Folio II—no longer at rest but not yet at flight. Above the bird's dramatic profile, a gilt "G" attached to the tree trunk by a *hoefnagel* casts an illusionistic shadow against the bark (fig. 9). Surrounding it is an inscription scarcely noticeable at first owing to its subtle gilded lettering, which dates the miniature to the year 1577 and locates its making "in the garden of genius" (*in genii hortulo*). Still farther above the nail, Hoefnagel has also hidden a verse derived from Ovid's *Tristia*, which clarifies his meaning and reads in its full context:

> Though I may be banished, as I am, to the edge of the earth,
> My wrath will still stretch out its hands to you from here.
> All my rights, if you do not know, Caesar has left me,
> And my only punishment is to lose my country.
> Even my country, if she remains unharmed, I hope from him:
> *The oak scorched by Jove's bolt often grows green again.*
> And at last should I have no means of vengeance,
> The Muses will give me strength and their weapons.[29]

There can be little doubt as to why Hoefnagel evoked this passage in tandem with his signature. Recall that in 1577, he fled the Low Countries together with Ortelius and went

FIG. 10. Jan Sadeler I, *Portrait of Joris Hoefnagel*, 1592. Engraving, 14.8 × 8.2 cm. Rijksmuseum, Amsterdam.

FIG. 11. Jan Sadeler I, *Portrait of Joris Hoefnagel*, 1591. Pen, red chalk, and black chalk on paper, 18.2 × 13.2 cm. Kunsthalle Bremen, Bremen.

into self-imposed exile. Ovid, speaking to an unnamed enemy in these verses, reflects on his banishment from Rome by Emperor Augustus, asserting that through his art and the help of the Muses, he will have his revenge. Hoefnagel likewise draws a parallel to his experience of suffering under Philip II's rule in the Netherlands.[30] The verse that he quotes on the resurgence of the oak conveys both hope of rejuvenation and a conviction that wrongs will be righted in the end. By the logic of the composition, his eponymous nail takes the place of the god's weapon. Art, Hoefnagel shows us, is his means of resurgence in the face of loss.

Although we cannot be certain when Hoefnagel added the "G"s and the nails to these three miniatures, the absence of the *hoefnagel* from any folios of the bound volumes makes it most plausible that these were a later addition. Hoefnagel may have introduced them when he excerpted the pages for his own private keeping, sold them, or presented them as gifts to close friends who would have understood their personal nature. The addition would have served to transform them into independent works of art, derived yet distinct from the *Four Elements* volumes. Unfortunately, we have no record for the early provenance of any among the surviving loose rectos, but in the case of the Louvre miniature at least, the encoded allusion to Philip II's reign seems to presume a sympathetic viewer—one invested not just in the seal of Hoefnagel's authorship but also in the nuances of his changing identity.

Hoefnagel conceived a very different kind of audience for his most straightforward motto, and the first that I will consider here: *dum extendar*, or "until I am forged." This device surfaces only in works produced following his flight from Antwerp and refashioning as a court artist, beginning after 1577. Through this motto, Hoefnagel made explicit to a broader audience the essence of what he had implied with his signatory nails in the intimate works discussed above. However, his mode of communication is in this case far more strategically constructed. By representing his identity as something always in process, Hoefnagel ultimately dissembles as much as he reveals.

In 1592, the Netherlandish artist Jan Sadeler produced an engraved portrait of Hoefnagel, an image that culminated a friendship fueled by their shared experience as émigrés and their mutual investment in the study of nature (fig. 10). Hoefnagel and Sadeler overlapped for a handful of years at the Munich court of Duke Wilhelm V of Bavaria, where Sadeler took up a position as court engraver in 1587 after himself having fled the Low Countries.[31] The engraving has its origins in a drawing that the latter produced as a gift for Hoefnagel one year earlier: an intimate likeness accompanied by Sadeler's personal motto and inscribed with a rumination on *amicitia* (fig. 11).[32] Yet in adapting the portrait for print and public dissemination, Sadeler replaced his motto with Hoefnagel's own, and in a manner that suggests the latter's close involvement.

At the summit of the engraving is Hoefnagel's motto *dum extendar*, paired with an image of a hammer striking a nail on an anvil. Hoefnagel

FIG. 10

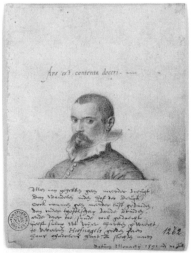

FIG. 11

adapted the motto from a play on the meaning of his name, evoking the process by which the *hoefnagel* was crafted. Sadeler places the device between the prefix and root of the verb, together with two dashes after the "ex-" that mark the word's division but also visually accentuate the force of the hammer. There is no missing the connection between text and image here. The phrase *dum extendar* crops up in later emblem books with the same picture of the hammer striking a nail, and with commentary that clarifies what Hoefnagel's invention came to signify for its subsequent interpreters. In George Wither's 1635 compendium of emblems, the attendant verses read:

> For, by *Afflictions*, man refined growes,
> And, (as the *God* prepared in the *Fire*)
> Receiveth such a *Forme* by wrongs and blowes,
> That hee becomes the *Jewell* we desire.
> To thee therefore, *Oh God*! My prayers are
> Not to be freed from Griefs and Troubles quite:
> But, that they may be such as I can beare,
> And, serve to make me precious in thy Sight.
> This please me shall, though all my Life time, I
> Betweene thine *Anvill* and the *Hammer*, lie.[33]

The image of man shaped by harsh circumstance, and ultimately saved by God's transformative hand, was surely what first drew Hoefnagel to this particular motto. His identification with the nail that lies between the anvil and the hammer signaled his endurance as an individual who had lived through the revolt in his native land and emerged the stronger for it. Claude-François Ménestrier's later seventeenth-century treatise on personal mottoes explains that the device *dum extendar* was most apt "for a person who has resolved to suffer so that he might advance."[34] Again, this explication depends on Hoefnagel's own use of the motto to describe his stance toward exile: in order to earn a livelihood and freely pursue the learned arts, he had no option but to leave his homeland behind.

Over a decade prior to the 1592 portrait, Hoefnagel himself produced for print a remarkable exegesis of the *dum extendar* motto, which was published in Braun and Hogenberg's highly popular and widely circulated *Civitates orbis terrarum*, or *Atlas of the Cities of the World* (fig. 12).[35] The engraving depicts the famed sulfurous crater in the southern Italian region of Pozzuoli outside Naples; the site, known as Solfatara or the Forum Vulcani, is still a tourist destination today. As the latter name suggests, it had been associated since antiquity with the forge of Vulcan—a connection not incidental to Hoefnagel's choice of scene.[36] Although the preparatory drawing for the print does not survive, both a sketch that Hoefnagel made in situ and an independent miniature dated to 1578 suggest that he designed the composition shortly after settling in Munich and just following his trip with Ortelius through southern Italy (figs. 13–14).[37] In comparing the drawing, miniature, and print, we can see how Hoefnagel began by capturing the landscape itself and then moved to make more prominent the figures included as staffage, so as to animate the site and guide the viewer's reaction to it.

In the engraving, a well-dressed woman on the left strolls with a servant trailing behind her, while two men at center stand in awe at the bubbling steam, which indexes the

geological forces at work beneath the crater's surface. Another woman, who arrives in a palanquin, is peeking out from behind its curtains; she has likely come to reap the benefits of the healing sulfur described in the print's accompanying text.[38] Farther in the background, a horse-drawn carriage makes an ill-advised trek across the crater, while clusters of men stoke the smoldering ground as they harvest the sulfurous rocks for transformation into medicinal unguents.[39] The steam takes on a phantasmagoric quality as it emerges from the lumps of sulfurous rock strewn across the valley.

Hoefnagel arranges for us to encounter this wondrous landscape through an elaborate frame that includes two oversized horseshoes pinned with jutting nails to its upper corners and, below, two allegorical figures who pound into our heads the significance of his personal device. A nail, inscribed with his Latinized name, *Georgius*, lies prostrate on an anvil adorned with the phrase *dum extendar*. On the left, a hybrid male identified variously as Ignorance or Avarice emerges from the curving frame with a human torso and a donkey's head, munching on thistles as he beats the nail before him.[40] On the right, female Envy with sagging breasts and Medusan hair pursues the same toil; she is entwined by a bramble bush, which snakes across the anvil and below the nail itself.

Far more explicitly than with the envious frogs in the Berlin miniature, Hoefnagel situates himself as the object under attack and champions his creative pursuit as an act of defiance. Hoefnagel's allegorical figures might be interpreted in relation to the recent history of image breaking; indeed, the donkey-headed man emerged just a few decades later as the paradigmatic image of the ignorant iconoclast.[41] In Frans Francken II's early seventeenth-century

FIG. 12

Kunstkammer, two such men lurk ominously in a painting cut off by the frame on the far right (fig 13).[42] Yet Francken negates and overpowers their actions through his own bounteous display of art and naturalia—above all through the diverse flowers assembled in the vase at the end of the table. As the vibrant blooms encroach on the bodies of the iconoclasts, Francken celebrates the triumph of art over the vanity of time and the generative power of nature in the face of mindless destruction. He even signs "Frans Francken invented this" (*F[rans] Frank[en] in[venit]*) directly below the scene in question, as if to say that the iconoclasts are here only a representation, just another picture within a painting chock-full of so many others. Hoefnagel's half-animate, half-ornamental figures of Ignorance and Envy are no less attenuated by the fact that they are part of a frame of his own devising, embodied here only so he might show just how futile their efforts ultimately are.

　　If we step back and consider Hoefnagel's frame as a whole, it fits the very definition of a *parergon*: a compositional element external to the *ergon* (or central subject), which nonetheless is integral to it.[43] The volcanic crater is Nature's miraculous forge, in which sulfur transmutes between liquid, solid, and vaporous forms. Hoefnagel's iron nail and horseshoes are the product of human labor and the forge of the artist.[44] Inspired by the natural forces at work at the Forum Vulcani—and by the model of the fire god himself—Hoefnagel positions his art as the window through which we encounter the artistry manifest in the visible world. He unites *ergon* and *parergon* through the metamorphic element that was as essential to the formation of a volcanic crater as to his own creative act.[45]

　　In the 1578 miniature of the Forum Vulcani, Hoefnagel made this connection himself when he penned the Greek word for "autodidact" (αυτοδίδακτος) immediately following his signature. The word closes a long inscription that circles around the image and emphasizes that its "miraculous sulfur cliffs" are here "genuinely and most accurately depicted from life."[46] The implication is that insofar as Hoefnagel was a self-taught artist, it was wondrous Nature alone who served as his teacher and guide. But we need not rely on implication. Another of Hoefnagel's mottoes says exactly this and, unlike *dum extendar*, comments not on external hardship, or the physical labor of making, but instead on the inner capacities that allowed him to persevere in the face of both.

FIG. 13. Joris Hoefnagel, *Forum Vulcani, The Hot Springs at Pozzuoli*, c. 1577–78. Pen and brown ink with traces of black chalk on paper, 18.8 × 29.3 cm. National Gallery of Art, Washington, DC, Ailsa Mellon Bruce Fund.

FIG. 14. Joris Hoefnagel, *Forum Vulcani, The Sulphur Springs of Solfatara near Pozzuoli*, 1578. Watercolor on vellum, 16.2 cm in diameter. Staatliche Museen, Kupferstichkabinett, Berlin.

FIG. 13

FIG. 14

NATURE HIS TEACHER

FIG. 15. Frans Francken II, *A Collector's Cabinet*, 1619. Oil on panel, 56 × 85 cm. Koninklijk Museum voor Schone Kunsten, Antwerp.

The motto *natura magistra* ("nature his teacher" or "nature his mistress"), which Hoefnagel inscribed in various permutations across works from the first decade of his career, predates the known instances of *dum extendar* and surfaces in a diverse set of contexts. As the motto that embodies his creative beginnings, it is more prospective and earnest than its counterpart discussed above. Central to its meaning is the early modern concept of *ingenium*—a term borrowed from the Roman rhetorical tradition and used in contemporary discussion of the visual arts to describe an individual's natural talent and creativity.[47] The meanings and connotations of *ingenium* were nonetheless multiple, and increasingly so across the sixteenth century. It might refer to a person's clever wit or deceitful cunning, or be used to describe the qualities of an actual device created by an engineer.[48] Most broadly and most relevant here, the word signified something like the innate capacity that all creatures—both human and nonhuman—possessed to varying degrees, and which they might use to good and bad ends alike. In Christopher Plantin's 1573 Dutch dictionary, *ingenium* is given as the Latin counterpart for "the understanding that one has by nature."[49] At its simplest, Hoefnagel's motto might well translate along these lines, though his application of the phrase in context is more revealing than any single definition.

FIG. 15

Hoefnagel's first known independent miniature, dated to 1571, seems to have been the debut of his *natura magistra* motto (fig. 16).[50] Its provenance is obscure, but the density and self-referentiality of its imagery points to Hoefnagel's having created it either for himself or for a knowing friend. The allegorical scene depicts two headless men who are fighting naked before a gathered crowd and against the backdrop of an expansive landscape. Within the crowd, Hoefnagel offers an ethnographic catalogue of peoples and costumes from diverse nations, thus signaling that the message of the miniature applies to how he perceived the condition of the entire civilized world.[51] The details of dress also serve to mask Hoefnagel's lack of dexterity in depicting the human figure, which the rag-doll quality of the nude fighters lays bare. Here his claim to being an autodidact is borne out in the tension between his naive handling of the body and the ambitions revealed in his complex compositional design.

An important clue to the understanding of the miniature's central narrative is a line adapted from two passages of Virgil's *Aeneid*, which is inscribed in gilt letters on a plaque above: "Awful Greed for gold and dreaded Lust for honors, what mortal sins do you not gather together?"[52] The text identifies the two combatants as allegories of Avarice and Ambition and likewise glosses the motivations of their gawking spectators. Through this reference, Hoefnagel points to the useless violence resulting from the vices he personifies, much as he later did with the allegorical figures that frame his depiction of the Forum Vulcani. Hoefnagel's intentions may have been less to indict the commercial world at large than to comment on recent economic and political events. The year 1571, to which the miniature dates, saw the institution of Alba's Tenth Penny tax and its immediate denunciation as a sign of Spain's imperial greed and ambition to place the Netherlands under its yoke.[53]

However universal Hoefnagel's message, it is hard to overlook its resonance with the mounting tensions in his homeland. The spilled money bag, fallen sword, and shield at the fighters' feet encapsulate the very heart of the conflict.

The border of the miniature further complicates the understanding of the scene at its center. The corners contain four vignettes that progress clockwise from childhood and youth to old age and death. Infancy is depicted as a baby free-falling from a cloud of chaos, its head just cresting over and beyond the circular frame. Hoefnagel seems to be imagining back to the chaos of creation, to a time when humankind was still unformed and uncorrupted. In the opposite circle, representing youth, a portrait (perhaps of Hoefnagel himself, or of the miniature's recipient) speaks to the knowledge that follows after the infant's fall.[54] "Man ages" (*vir senescit*) reads the laconic text beside the likeness. The figure looks directly out at us, aware of his belonging in a contentious human realm.

Yet if the progression from birth to adulthood is one of decline, the cycle of human existence resolves in natural rejuvenation. The contemplative man who embodies old age in the lower right is countered by the skeleton in the opposing left corner, whose condition is glossed by the phrases "the dead man rots" (*mortuus putescit*) and "hope revives" (*spes reviviscit*). Hoefnagel embodies this juxtaposition of death and resurrection through the sheaves of wheat surrounding the skeleton, which shed their seeds on the barren earth in promise of renewed growth. Here are the seeds of yet another of Hoefnagel's personal devices, "another hope for life," which will crop up in his works a few years later (see fig. 69).

By the time we have circled outward to the motto with which Hoefnagel quietly signed the miniature at the bottom of the page, it has become clear that the real subject is not the allegory at center but Hoefnagel's own creative struggles—a structure that presages his view of the Forum Vulcani from several years later. The three words *artis natura magistra* ("nature, the mistress of art") bring the entire world of the picture together.[55] The phrasing echoes Cicero's famous evocation of "history, the mistress of life" (*historia . . . magistra vitae*) in his dialogue *On Oratory*, in which the speaker argues that only the art of eloquence gives immortality to the past.[56] Hoefnagel nonetheless hews closer to Ovid than to Cicero here. Placing himself within the natural cycle of things, Hoefnagel suggests that his exercise of ingenuity depends on Nature's guidance as he seeks to rise above and beyond the troubles of the present. Nature's protean powers of transformation and regeneration surpass the machinations of human affairs, overcoming the envious who hasten blindly, driven by greed and lust. In a passage from Ovid's *Remedia amoris*, he chides the envious who assail not only his own poems but even the *ingenium* of Homer, asserting that their efforts to curb his creative drive will never succeed.[57] Watch out, Ovid tells his detractors: "you are in too much of a hurry, and even now many poems take hold in my mind."[58] Like Ovid, Hoefnagel employs his *ingenium* to rebuke the empty threats of the violent mob. The entire miniature figures his nascent exercise of natural talent as motivated both by Nature as source and by the war that drove him to use it.

Two years later, Hoefnagel produced another independent miniature that combines his *natura magistra* motto with an even denser visual program (fig. 17).[59] A vista of the Spanish city of Seville is engulfed by a tapestry-like border embodying the natural treasures of the world. Exotic fruits, plants, and creatures both real and imaginary crowd the space of the composition with a delectable yet almost indigestible amount of detail. Once again,

Hoefnagel reflects on the transnational culture of trade that defined his historical moment, and he uses the brutalities of global conquest as an allegory for the harsh measures of Philip II in the Low Countries.[60] Seated on the barge representing the Spanish kingdom in the lower right is a sympathetic depiction of two black slaves surrounded by a pile of goods, their nakedness and chains an index of their cruel subjugation.[61] The crowned letter "P" that adorns the sides of the barge refers to the king whose comparable efforts to subjugate the Netherlands had brought so much strife to the region. The opposing barge embodies the continent of America in all her riches and "uncultivated" wonder, which Spain likewise sought to catholicize and claim as her own. On its bow is a cross and a banner displaying the *plus ultra* device of Philip's father, Charles V. As the flag flutters on the winds of imperial expansion, the promise of that motto seems all too overweeningly fulfilled (fig. 18).

Yet as the two barges approach collision, Hoefnagel tacks on an alternative course. Immediately following his signature at the base of the miniature are the words *natura sola magistra* ("nature his only teacher"). Echoing the Stoic dictum that one should follow nature alone (*sola natura*) in one's moral and spiritual pursuits, his motto points beyond the confrontation staged in the pictorial realm above.[62] Hoefnagel dedicates the miniature "to the greatest and best god, the giver of art" (*artis largitori deo optimo maximo*), a phrase that he punctuates with a row of votive candles and smoking incense along the composition's lower frame. In a world replete with bounteous goods, natural resources, and diverse creatures, the only true ruler is the divine creator, and the most precious gift of all, the capacity to create.

But who is the "greatest and best god" addressed here? Situated amidst the words of his dedication are not one but two deities: a double source of inspiration. We see the goddess Minerva standing armed and clad in gold, with an owl as companion to her left. To either side of her feet the phrase "divine Minerva, from the head of Jove" (*e cerebro Iovis diva Minerva*) winds down two cornucopias, whose abundant flowers spill out over Hoefnagel's signature. Meanwhile, below the cornucopian frame, a peaceful landscape surmounted by the Hebrew name for God (יהוה) hovers in a cloud that wafts around Minerva's perch. Whereas the goddess has all the trappings of a cult statue, the God of Christianity is visible only through the ethereal word and the realm of natural creation.

The affiliation of ancient and Christian wisdom certainly parallels the founding aims of Neo-Stoicism—not to mention those of much Renaissance moral philosophy.[63] Yet rarely does one see that parallel so directly visualized on the page. Minerva's liminal status between the world of the frame and that of the combat staged above gives her secondary status within the schema of the miniature. For all that the composition displays a *horror vacui* in its superabundance of detail, the tiny uninhabited landscape of land, sky, sea, and fiery sun is Hoefnagel's ultimate contemplative destination: a representation of nature in its elemental state before the intervention of commerce, conquest, and war. *Natura sola magistra* is about more than the understanding and talent with which Hoefnagel was endowed by birth. It is about the active effort of seeking the invisible power inherent in the visible world, of looking past the human realm to something greater, and, above all, about striving through art against the constraints of fortune.[64] Hoefnagel's inscription of the verb *faciebat* ("he was making it") in the imperfect tense is even perfectly centered below that pristine landscape. Hoefnagel's modest stance toward his own imperfect creation acknowledges his place in a world where God alone wields the reins.[65]

FIG. 16

FIG. 16. Joris Hoefnagel, *Allegory
of the Struggle between
Avarice and Ambition*, 1571. Pen
and black ink and gouache,
heightened with gold, on
vellum, mounted on panel,
16.7 × 21.4 cm. Private collection.

FIG. 17. Joris Hoefnagel, *View
of Seville*, 1573. Watercolor and
gouache, heightened with gold,
on vellum, mounted on panel,
21.7 × 32.3 cm. Royal Library of
Belgium, Brussels.

FIG. 18. Detail of Fig. 17.

FIG. 17

FIG. 18

Unlike the 1571 *Allegory*, the miniature of Seville has a documented provenance, one that brings us back to the story van Mander tells of Hoefnagel's first encounter with Duke Albrecht V. It was among the works that Hoefnagel brought with him from Antwerp on his 1577 journey with Ortelius, and one that Albrecht purchased for his collection.[66] Not only does the Seville miniature end up in Albrecht's inventory; it is also mentioned explicitly— even before Ortelius and Hoefnagel arrived in Munich—by the learned doctor Adolphus Occo III, who wrote a letter urging the duke to welcome them to his court. Occo says of Ortelius, "He will show you marvelous pictures of a kind that I do not think I have ever beheld, especially one of Seville so artfully delineated that it nearly defies seeing."[67]

Despite the hyperbole of this description, which is typical of much humanist prose, it captures the wonder for Hoefnagel's virtuosic works within the discourse of the courtly sphere. Occo was himself a collector and connoisseur of ancient coins: small artifacts that warranted close study as much as miniatures did. In the effusive dedication of his 1579 numismatic treatise to Albrecht, Occo evokes a tripartite process of seeing, perceiving, and understanding that happens in the encounter with objects of this kind, and which sheds light on his appreciation of Hoefnagel's "marvelous" picture.[68] The challenge that such a work posed was worth it, as knowledge was the promised reward.

So many courtly commissions of the later sixteenth century were created precisely with this sort of reception in mind. Yet the most remarkable aspect of the whole Munich episode is that Hoefnagel never anticipated it. He was making works like the Seville miniature, and those for his *Four Elements* project, before he knew that a noble patron would ever lay eyes on them. Indeed, it is not unreasonable to ask what all this attention meant to Hoefnagel, outside of the job security it provided. He had labored over the creation of those early miniatures for no other profit than the understanding that he alone might derive from them, for no other purpose than his own.

GUIDED BY GENIUS

Shortly after settling in Munich, Hoefnagel would abandon his *natura magistra* motto entirely. This decision suggests that the device was closely tied to his early formation in Antwerp, and shows an awareness that Albrecht's courtly milieu demanded a reconfiguration of his identity as both artist and émigré. His reasons for forsaking *natura magistra* already begin to emerge from the two final instances of its use: a 1578 city view of Landshut from Braun and Hogenberg's *Civitates* and an independent miniature dated 1579—both works dedicated to Albrecht and made explicitly on his behalf. Both also presage the last and final motto that Hoefnagel adopted, and which he had devised no later than his eventual departure from Munich: *genio duce*, or "genius as his guide."

Hoefnagel's view of Landshut shows the city's situation along the River Iser, nestled among verdant vineyards and surmounted by the castle of Trausnitz—then home to Albrecht's son and soon-to-be successor Wilhelm V (fig. 19).[69] The sleeping figure passed out on the hill to the right, stupefied by the contents of the jug beside him, offers a humorous embodiment of the site as one of unperturbed leisure. Braun's accompanying text describes Wilhelm's palace as a paradisiacal home for nature, art, and the discourses that both inspire. On the grounds of Trausnitz, Braun writes, "one observes a variety of exotic fruits from the most generous trees, as well as strange herbs; plants and flowers brought

FIG. 19. After Joris Hoefnagel, Landshut, from Georg Braun and Frans Hogenberg, *Civitates orbis terrarum*, 1572–1617. Engraving. Bijzondere Collecties, Amsterdam, OTM: HB-KZL XI B 6,7.

from Italy, Spain, and France arranged in labyrinthine garden beds; and topiary works—glistening with a diversity of flowers and fruits, and miraculous industry."[70] Adorning this space, moreover, "are the most artful figures of sculpture and painting," which reveal the great passion that fueled the garden's creation.[71] In terms of literary precedent, one thinks immediately of Erasmus's colloquy "The Godly Feast," in which the pursuit of learning finds stimulus in the observation of both living nature and its painted representation.[72]

More significantly still, Braun concludes the passage by citing Hoefnagel as his source for the account of Landshut, and by revealing that this tranquil domain now supports the latter's peace-loving pursuits:

> Joris Hoefnagel, merchant of Antwerp, just sent us the description (*descriptionem*) of this city. He was born to the arts of peace and not of war. Fleeing the rumors of Belgium, and having wandered through Italy, he put himself under the protection of the peace-loving Duke Albrecht of Bavaria. To the art of miniature painting, with which nature alone (*sola natura*) miraculously endowed him, he now peaceably devotes his work.[73]

Within the larger history of sixteenth-century book production, it is remarkable for a designer of images to be singled out so expressly within the publication where his works appear. As we will see, this reflects the unique role that Hoefnagel played in Braun and Hogenberg's cartographic project.[74] For now, what matters is the content of Braun's encomiastic aside: a veritable history of Hoefnagel's life up to that point, told in part through evocation of the latter's motto (*sola natura*). The story pivots on his flight from the war-torn

FIG. 19

FIG. 20

FIG. 20. Joris Hoefnagel, *Allegory of the Rule of Duke Albrecht V of Bavaria*, 1579. Gouache on vellum, 23.5 × 18 cm. Staatliche Museen, Kupferstichkabinett, Berlin.

Netherlands but is as much about metamorphosis as it is about continuity: Hoefnagel was born to the peaceable arts, even if he was not always at liberty to pursue them. It is striking how much this passage prefigures the opening of Hoefnagel's later biography in the *Schilderboeck*; one can readily imagine that van Mander would have been drawn to the authority of a primary source from his subject's own lifetime, and to Braun's compelling rhetoric of firsthand rapportage.

On the inscription plaque at the base of his city view, Hoefnagel dedicates the work to Albrecht and signs "with virtue as his guide, nature his teacher" (*virtute duce, natura magistra*). The phrase *virtute duce* appears nowhere else in Hoefnagel's oeuvre, but the directional movement implied by the use of word *duce* suggests that he was already moving beyond his formative years as a self-taught artist in Antwerp—still following the teachings of nature even as his life was shifting course. Having borne up against the trials of war, he has now been led by the virtue of his art to a new home abroad, where he professes to be guided not in opposition to negative external forces but instead under the auspices of ducal patronage, through which learned culture flourishes naturally. In refashioning himself as a court artist, Hoefnagel understood the need to appeal to his patrons' own sense of identity by way of defining his own.

Hoefnagel's 1579 independent miniature for Albrecht expounds on this process of self-fashioning and on the imagery of his *descriptio* of Landshut from one year earlier (fig. 20).[75] Its central scene depicts the Muses of geometry and music in a well-ordered garden, carrying cornucopias full of lilies as they stroll beneath an olive tree. The garden embodies the realm of peace that Braun—through Hoefnagel's own communications—had so vividly described. In fact, Hoefnagel iterates his view of Landshut in the lower register of this miniature, juxtaposing it with a profile view of Albrecht's home city of Munich in the register above. He thus links father to son as ideal rulers whose courts offered a haven from the troubled shores that Hoefnagel had left behind, and whose achievements he flatters in turn.

At the same time, Hoefnagel suggests that the artist stands on the fringes of the peaceful garden of courtly life. It is not enough for him to observe and take pleasure in the natural world; he must also strive, on his own terms, to employ the knowledge derived from nature's realm. In the parergonal frame surrounding the 1579 miniature, Hoefnagel has hung symbols of the visual arts and music, with allusions both to himself and to Albrecht's court composers Orlando di Lasso and Cipriano de Rore; the latter were fellow Netherlanders transplanted from their home.[76] The monkey in the lower left corner and a parrot in the lower right—creatures who imitate, respectively, through sight and sound—further allude to the origin whence representation derives. *Natura magistra* is inscribed after Hoefnagel's signature at the base of the image, below and between these two animals. For painter and musician alike, court was their home and means of a livelihood, but only Nature provided the source and directive for their respective arts.

The monkey also embodies a clue to the stance that Hoefnagel began to take toward his creative endeavor abroad. The animal apes the pose of a counterpart in Pieter Bruegel the Elder's eerie painting of two chained monkeys overlooking the harbor of Antwerp (fig. 21).[77] Bruegel's monkeys might evoke the cruel dualities of commerce and transatlantic trade that Hoefnagel allegorized in his Seville miniature.[78] More fundamentally, they

represent the mutable state of those tethered to the earthly realm: one hunched and turned away in abjection, the other alert and smiling out at us. Both are meticulously copied in the animal album of Hoefnagel's teacher Hans Bol on two successive folios, each with a few lines of the windowsill indicating that the latter artist drew from the original composition (figs. 22–23).[79] Hoefnagel may have known Bol's miniatures, Bruegel's painting itself, or both. It matters little. Because where Bol saw a nature study to copy, Hoefnagel saw a reflection on the human condition. Within his miniature, the imitative creature not only comments on his borrowing but also becomes something of an alter ego for the artist himself. No longer in chains, Hoefnagel overlooks a vista where nature and art reign free, and yet he still places himself in the margins. Far from his embattled hometown, he remains ever conscious of the city and artistic tradition that he left behind.

Hoefnagel's second alter ego in the miniature inhabits the space just above: a little owl (*Athene noctua*) perched atop the helmet of Minerva, with whom the bird had been associated since antiquity. The painters' palettes tied around the helmet show the goddess's warlike nature reined in by the arts of peace. The same theme extends to the paradoxical coat of arms below the owl, which is composed of artists' tools—pen, brush, mallet, chisels, compass, and rulers—positioned together so as to form the shape of a crossbow and arrows. The caduceus in its right talon completes the figuration of the owl as Hermathena, the combination of Athena's bellicosity and wisdom with the mystical artistry of Hermes.[80] Throughout the collar surrounding the shield, Hoefnagel has interspersed little shells filled with pigment, much like those that he would have used as he painted the miniature itself. Between them, six capital letters that form the Latin word *virtus* position the virtue of art as a shield against the hardships Hoefnagel might yet endure. As the monkey looks back, the all-seeing owl looks forward to an uncertain future.

Indeed, we know that Hoefnagel's peaceful circumstances in Munich did not prove permanent. Just over a decade later, in 1591, he would be forced to seek out a new protector in Rudolf II, driven away by the strong Counter-Reformation fervor of Wilhelm's later

FIG. 21

FIG. 21. Pieter Bruegel the Elder, *Two Chained Monkeys*, 1562. Oil on panel, 19.9 × 23.3 cm. Staatliche Museen, Gemäldegalerie, Berlin.

FIG. 22. Hans Bol after Pieter Bruegel the Elder, Chained monkey (fol. 67), from *Icones quorundam animalium quadrupedium nativam formam referentes*, c. 1573-1593. Watercolor on vellum. The Royal Library, Copenhagen, Denmark.

FIG. 23. Hans Bol after Pieter Bruegel the Elder, Chained monkey (fol. 68), from *Icones quorundam animalium quadrupedium nativam formam referentes*, c. 1573-1593. Watercolor on vellum. The Royal Library, Copenhagen, Denmark.

FIG. 22　　　　　　　　FIG. 23

reign. Just as he was leaving Munich behind, Hoefnagel would debut the motto *genio duce*—a device already nascent in the inscription *virtute duce* on his 1578 view of Landshut. That this debut took place within Sadeler's engraved portrait discussed above not only affirms the importance of that print but also gives weight to its dating one year after Hoefnagel's move to Rudolf's court. We discover *genio duce* embedded in Sadeler's dedication below his friend's likeness, and positioned in counterpoint to the *dum extendar* device at the engraving's summit:

> Joris Hoefnagel of Antwerp, having embraced the more delightful art of painting,
> with genius as his guide (*genio duce*), advances [that art] to the point that he finds
> favor with the greatest princes: Albrecht and Wilhelm of Bavaria, Ferdinand of
> Austria, and the august Emperor Rudolf himself.[81]

What is happening here is more than a shift in tutelary spirit from nature as teacher to *genius* as guide. This is a motto about Hoefnagel's relation to his life at court, to his continued itinerancy, and about what those circumstances meant for his pursuit of art. *Genio duce* appears both in works that Hoefnagel made for now-distant friends like Ortelius and in those he produced on commission for Rudolf—its meaning less tethered to one specific time and place than his earlier *natura magistra* motto.[82]

In classical antiquity, *genius* could refer to the spirit of a particular family or region (*genius loci*), the embodiment of the spirit and natural inclinations of an individual, or a cosmic god who controlled the destiny of humankind from each man's birth onward.[83] *Genius* for Horace was "the god of human nature" (*naturae deus humanae*): the fellow traveler whose directive power over our lives was inescapable.[84] In both ancient and Renaissance memorial culture, *genius* was the liminal spirit that guided the soul from this world to the next.[85] Yet the figure of *genius*—as an inspiring and numinous agent external to oneself—was not always distinct in the sixteenth century from the concept of innate natural talent. Indeed, *genius* and *ingenium* were sometimes used interchangeably to refer to an individual's singular capacity for creation. Derived therefrom were the nascent Renaissance figurations of artistic *genius* that more closely accord with (but are still not equivalent to) our modern sense of the word.[86] Pico della Mirandola already speaks in his treatise on imitation (1512–13) of following one's "own *genius* and natural propensity," and throughout Erasmus's dialogue *The Ciceronian* (1528), he employs both terms in reference to inborn natural ability.[87] By the early seventeenth century, the German philosopher Rudolf Goclenius offered—among the word's many potential significances—that *genius* could refer to the singular nature with which each person was endowed at birth.[88] All this terminological slippage begs the question of how much Hoefnagel's *genio duce* motto signaled a reorienting of his artistic identity.[89]

The writings of the Italian art theorist Giovanni Paolo Lomazzo have been offered in past scholarship as the best point of reference for understanding Hoefnagel's motto.[90] In his seminal 1590 treatise *Idea of the Temple of Painting*, Lomazzo wrote that "he who knows his own nature (*il suo genio*), and follows it, easily reaches the supreme excellence in that part for which he is predisposed," and offered Raphael as the prime example of someone who excelled by achieving this self-knowledge at an early age.[91] Lomazzo's use of the term is in

the service of explaining whence an artist's individual style derives, and is closest to Goclenius's definition above. This is precisely how Hoefnagel's nephew—the great seventeenth-century scholar and diplomat Constantijn Huygens—would later interpret his uncle's motto in his own autobiography. Huygens refers to Hoefnagel's *genius* as the source for the latter's precocious and "inimitable faculty" in miniature painting and even borrows *genio duce* to describe the inspiration for his own early poems—a clever homage to his maternal lineage.[92] Already in 1592, Hoefnagel's son Jacob

would also appropriate the phrase on the title page of a print series after his father's designs, which he produced at age nineteen, evoking *genius* as the guiding spirit in this ambitious undertaking of his youth.[93]

Yet the moment when Hoefnagel adopted *genio duce* as a motto was at a mature stage of his career, when the matter of developing his personal style would seem to have been largely moot. In this light, it seems worth considering other points of reference somewhat closer to home, beginning with Hoefnagel himself.[94] His earliest use of the word *genius*—independent of his motto—appears in his 1577 miniature of an eagle discussed above, in which the phrase "in the garden of *genius*" suggests a generative locus of inspiration like that of the Parnassian abode of the Muses—a fertile domain untethered from any one specific locus in the earthly realm (see fig. 9). Such an evocation fits the moment of Hoefnagel's flight from Antwerp expressed so powerfully in that miniature. The garden of *genius* is nowhere in particular and therefore can be evoked anywhere

FIG. 24

the now-itinerant artist might find himself. His *genius* inspires irrespective of site or circumstance, but, unlike his *ingenium*, it is not an engine purely in his mind but a force that mediates between his inner exertions of creativity and a higher sphere.

The motto *virtute et genio* of the contemporary Netherlandish botanist Carolus Clusius helps to elucidate this distinction, particularly in its elaborated form within Jacques de Gheyn II's portrait of the scholar (fig. 24).[95] "We did not implore virtue and *genius* but rather Christ, who bestows on us these and *ingenium* besides," reads the inscription below Clusius's likeness, which is situated within the imagined space of a niche framed by cornucopian nymphs and diverse naturalia. The text proclaims that virtue, inspiring spirit, and natural talent are not the ends but the means through which Clusius strives to understand the greater power that underlies the visible manifestations of God's creation. The copia of terms employed in the sentence functions to distinguish *virtus*, *genius*, and *ingenium* as related but conceptually unique notions, even if all derive from the same divine source.[96]

Clusius, who had been working at the Vienna court since 1573, may have been among the new contacts that Hoefnagel made during his later years abroad, particularly during his time in Frankfurt.[97] More securely documented, however, is the friendship that he formed with the Munich-based scholar Anselmus Stockelius, who served at the courts of both Albrecht and Wilhelm V. Stockelius declared the artist among his "most intimate of

friends" in a letter to Ortelius from 1584; he also dates their first meeting to when Hoefnagel and the cartographer passed through en route to Italy in 1577.[98] Stockelius composed a laudatory poem to accompany Hoefnagel's view of Munich in the *Civitates*, and Hoefnagel reciprocally employed Stockelius's verses in his own *Four Elements* manuscripts—an honor he bestowed on no other friend.[99]

All this bears on the fact that Stockelius was prone to throwing about the words *genius* and *ingenium* in his writings, particularly when it came to extolling his Bavarian patrons and their cultivation of the arts. In the dedication preceding his 1575 poem on the metamorphosis of Narcissus and Echo, Stockelius proclaims to the duke, in florid prose, the transformative benefits of the work before him:

> So may you cease for a short while from the management of more heavy affairs; ease your *ingenium* grown weary from serious business; indulge in the relaxation of your mind; defer further toils; partake an hour in repose; reconcile yourself with your *genius*, restore yourself to yourself, and in reading my poem, be free from cares.[100]

Like Clusius, Stockelius distinguishes between *ingenium* and *genius*: one an inner quality that can be willfully eased, the other an external entity with which one must be reconciled—or, in Lomazzo's terms, one that must be understood (*conosce*) by its possessor. Still more crucially, Stockelius shows us the traction that the concepts of innate talent and divine inspiration had in the rhetoric surrounding art at the Munich court. Just how much was Hoefnagel's final motto designed to appeal in these circumstances? The recondite world of *natura magistra*, which embodied Hoefnagel's early inner trials and reflections, may have been less appropriate to a realm in which an artist's identity was imbricated with the demands of his patrons.

Sadeler's dedication in the 1592 portrait certainly suggests as much. Hoefnagel's compulsion to take on a performative role at a succession of courts abroad is presented by Sadeler as the other side of the coin to his embrace of art as a full-time profession. To reap the benefits of peace required that Hoefnagel concede some measure of the creative liberty he had enjoyed as a merchant and self-made artist. He may have escaped the clutches of war, but still he faced the pressures of adapting in order to survive. In this sense, *genio duce* was a motto that accorded with how Albrecht, Wilhelm, and Rudolf each envisioned their courts: spheres of influence and inspiration for the artists who surrounded them.[101] Hoefnagel may have come into their service already forged by years of struggle and independent pursuit, but he had to perform as if their patronage had transformed him anew. The truth, of course, was otherwise. Long before he was compelled to place himself under courtly auspices, he had found in patience a means to endure the force of the hammer's blows—inspired by nature as teacher and *genius* as guide to keep making sense of his being in the world.

The Good Herb Patience

Emblems give form to ideas through a complex of word and image.[1] They required the reader to simultaneously engage as viewer, and to think on the page in a way that no other genre of the sixteenth century so insistently demanded. This challenge was central to their appeal. So infectious was the foundational emblem book of Andrea Alciato, first published in 1531, that it gave rise to thousands of others over the next two centuries.[2] Even within a few decades of the genre's inception, emblems had become a means to encode and debate anew central questions of moral, spiritual, and political concern. Controversies of culture, which were often too fraught for unmediated expression in the public sphere, were reconstituted in print and openly shared.

The sudden ubiquity of emblem books led to a great diversity in their design and use. Beginning in the late 1560s, Hoefnagel participated in a key chapter in this history, when he and many of his Netherlandish colleagues began to discourse through emblems across the revolt's confessional divides.[3] The humanist Johannes Sambucus, whose seminal 1564 *Emblemata* was among the first emblem treatises published in the Low Countries, helps to explain why the genre was suited to this end (see fig. 82).[4] In the preface to his work, Sambucus offers a corrective to the way modern scholars once strictly defined an emblem as a tripartite combination of titular motto (*inscriptio*), image (*pictura*), and subscript in verse or prose (*subscriptio*).[5] He says nothing about a standardized organization of parts on the page, but instead devotes his efforts to explaining what he perceives to be a flexible and dynamic mode of communication.

Recalling the term's derivation from the Greek word for tiles and mosaic inlay, Sambucus declares the emblem a fundamental truth enshrouded in allegory, which was designed to rouse the mind and senses of its audience. Emblems for him are "pictures and images that can more truly be called symbols, or tokens (*tesserae*) in other words."[6] The messages embedded in them are at once "more obscure than problems and dilemmas, while clearer than enigmas."[7] With the Latin word *imago*, Sambucus means to include not only the visual component of an emblem but also the accompanying texts; both are integral to making "visible" its concealed message. In short, an emblem for Sambucus does not pose a direct question, nor is it as enigmatic as an independent motto—to recall Erasmus's explanation of

FIG. 25. Joris Hoefnagel, Title page from *Patientia*, 1569. Red chalk on paper. 29 × 42.5 cm. Bibliothèque Municipale, Rouen.

the latter genre.[8] Rather, a range of questions and potential answers is already opened up by the emblem's combinatory form, ready to be engaged by those patient enough to put together the pieces.

Nearly every work of art that Hoefnagel created owes a debt to emblematics, and in every case, he made the genre his own. His very first manuscript work to survive is a folio-sized album of emblems: twenty-four red-chalk drawings and accompanying poems grouped under the title of *Patience* (*Patientia*) and dated to 1569 (fig. 25).[9] It is a remarkable object in both scale and content. Hoefnagel created the manuscript during a temporary flight to England, reflecting at a distance on the troubles that he had hoped to leave behind, but which nonetheless seemed to follow him abroad. Across its pages unfolds what is among the earliest and most visceral accounts of the mounting Dutch Revolt and impact of the Spanish Inquisition— and one more revealing of Hoefnagel's experience of the war than any other work he ever made.

FIG. 25. Joris Hoefnagel, Title page from *Patientia*, 1569. Red chalk on paper. 29 × 42.5 cm. Bibliothèque Municipale, Rouen.

Each folio of *Patience* takes the format of an image combined with a title and verse commentary below. But the drawings dominate through their strangeness and the amount of space they occupy on the page. And in difference to the emblems published by the likes of Alciato or Sambucus, which aimed at universal exemplarity and broad appeal, Hoefnagel's compositions are manifestly personal in nature and grounded in the contemporary plight he shared with his compatriots. This is not to say that the boundary between the personal and the universal was never elided in printed emblem books; authors often appended dedications honoring friends and colleagues to those published within their treatises, and Sambucus notably did this quite often.[10] Nonetheless, there is a coherence to both the making and messaging of Hoefnagel's album that sets it apart. Whereas Sambucus had to rely on artists to design the woodcuts in his treatise, which often resulted in an unintended disconnect between text and image, Hoefnagel produced everything—verses, drawings, even the title page—with his own hand.[11]

Hoefnagel's volume belongs, in one sense, to a larger contemporary body of diaspora art and literature created by Netherlandish émigrés in this period, a corpus that capitalized on a freedom of expression unthinkable in the inquisitional climate back home. It is difficult to imagine that Hoefnagel would have dared to produce *Patience* while still in Antwerp, where it might easily have gotten him into trouble with the Spanish authorities. Contemporary works that arose under similar circumstances abroad, even if published, often appeared anonymously. Such was the case with the 1569 treatise *The Beehive of the Roman Catholic Church ('Bijenkorf')*, written by Philips van Marnix van Sint-Aldegonde— a Calvinist scholar and future member of William of Orange's cabinet—when exiled from the Netherlands that same year.[12] This is a useful comparison as much for its contemporaneity as for its difference in intent. Whereas Marnix's virulent satire deploys direct critique of Catholic vices and the Spanish occupation of the Netherlands, Hoefnagel's *Patience* is

conciliatory rather than overtly political. His work emblematizes the present circumstances, but he does not aim to contribute to the larger debate between the warring Catholic and Protestant factions.

For this reason, *Patience* has often been interpreted less as a political work than as an emblem book with a profoundly Neo-Stoic bent.[13] If one were to seek a counterpart to Hoefnagel's *Patience* within this domain of philosophical writing, the obvious choice would be Justus Lipsius's 1584 *On Constancy*: a dialogue on how to cope with war that unfolds among friends in a serene and flowering garden.[14] Here nature and the discourse of friendship provide salutary guidance in uncertain times, and truer direction than organized religion or politics.[15] Lipsius's protagonist begins by expressing his desire to flee his troubled country but is ultimately counseled to find inner peace and strength of mind, and to seek example in the divine order governing the natural world. Lipsius explicitly names Patience the "true mother of Constancy," defining the virtue as the willing and ungrudging sufferance of whatever fate befalls a man.[16] Yet while Hoefnagel's volume parallels this contemplative arc quite closely, it is not only less programmatic in message but also predates Lipsius's foundational treatise by a decade and a half.

Indeed, unlike the treatises of Marnix and Lipsius, *Patience* was a manuscript never intended for publication, and Hoefnagel thus had no compulsion to adhere to any one philosophical or political point of view. His very choice of the emblem as structuring principle was motivated by his desire to do the opposite, to produce a work that derived from his own experience a transconfessional rumination on wartime struggle and endurance. Even Hoefnagel's verses within the album—written variously in Dutch, French, and Spanish— echo the diversity of the transnational world to which he belonged as a merchant. Spain itself is presented from different viewpoints, and the impact of the revolt is shown across socioeconomic classes and professions. The volume's eponymous virtue applies as much to a penniless youth as to a condemned heretic, and there are even moments of humor interspersed among images and poems expressing grave misfortune. *Patience* is above all an experiment in medium and form, one exemplary of how emblems in Hoefnagel's circle were not just arcane demonstrations of erudition but a fertile ground for the shared cultivation of thought and invention.

GHEEST *AND* FANTASIJEN

When Hoefnagel left for England in 1568, his ostensible purpose was to pursue ventures on behalf of the family business, but it was surely also a means to seek respite from the turmoil at home. In London, he joined a growing expatriate community of Netherlandish merchants, artists, and scholars who had crossed the Channel in search of greater religious freedom and economic opportunity.[17] It was this community that formed the setting for the creation of *Patience*, specifically Hoefnagel's friendship with the learned Protestant merchant Johannes Radermacher, who had settled in England in 1567 and soon became an elder of the Dutch Reformed Church there.[18] Radermacher was born in Aachen but like Hoefnagel had launched his mercantile career in Antwerp, where his religious views had presumably made his continued residence untenable. Like Hoefnagel, he was also far more than a merchant. His many friendships with Netherlandish artists, poets, and scholars defined him as much as did his commercial endeavors.[19] Among Radermacher's first activities

FIG. 26. Joris Hoefnagel, Sonnet and dedication to Johannes Radermacher, from *Patientia*, 1569. Red chalk on paper. 29 × 42.5 cm. Bibliothèque Municipale, Rouen.

upon emigrating to England was the writing of a grammar of the Dutch language aimed at fostering dialogue between two countries that politics had so closely entwined.[20]

Hoefnagel opens *Patience* by thanking Radermacher for having inspired his volume's creation (fig. 26). Hoefnagel's homage has two components—a Dutch sonnet and a dedication in Latin prose—which complement one another in their rhetoric. The prose text is the more straightforward place to begin and provides, among other details, the date of the volume's completion:

> To Johannes Radermacher, a singular patron of all the noble branches of liberal art and knowledge, and my best friend: on account of friendship and gratitude for those exercises of my *ingenium*, which cut through the vexing injustices, odious frustrations, and misfortunes of an adverse time—amidst what is (by God's willing power) a communal calamity and affliction brought on by the rivalries that have risen up between the King of Spain and the Queen of England. He [Radermacher] dispelled sickness and sorrow from my mind, and restored and raised me up. Joris Hoefnagel dedicates and gives this gift in London, in the year of our Lord 1569, on the 1st of May, as his most observant friend.[21]

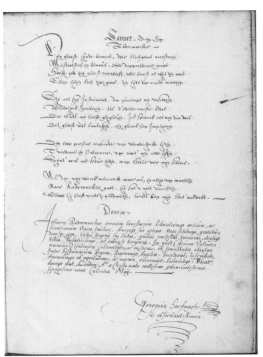

FIG. 26

Hoefnagel presents *Patience* as reciprocation for Radermacher's friendship, which had lifted his spirit and healed his misery. The immediate cause of Hoefnagel's suffering is directly named: the conflict regarding the freedom of Anglo-Dutch trade that had reared its head that year between King Philip II and Queen Elizabeth.[22] As a side effect of the unrest in the Netherlands, it was a sign that the consequences of the revolt threatened to disrupt commercial stability on an international scale. As Hoefnagel's dedication avows, those circumstances had thwarted his own commercial endeavors that year.

More evocative still is the Dutch sonnet that Hoefnagel inscribed above his prose, which elaborates on the impetus behind the manuscript's creation, and does so in the vernacular that Radermacher himself highly valued. The poem constitutes the most direct statement that Hoefnagel ever made on the source of his artistic inspiration, which he locates in his own inner suffering:

> [My] spirit (*gheest*) was troubled, restrained by the body,
> Distrusting and anxious from great apprehension.
> [But] God roused [my] spirit quickly out of its misery;
> No suffering is so great that time cannot reduce.
> With you as his instrument who came to visit me,
> To offer a friendly invitation to the noble and pure art

That God gave me, I sprang as if from the dead,

With [my] spirit full of fantasies (*fantasijen*), and set it to work.

Considering the present course of these astonishing times,

Perseverance and patience are needed from all sides.

Being myself in the same misery, I took this as my subject.

Now then, my work finished, albeit rough and of little impact,

Goes to Radermacher. He will not scorn you

Because he thinks as a friend; show him my open heart.[23]

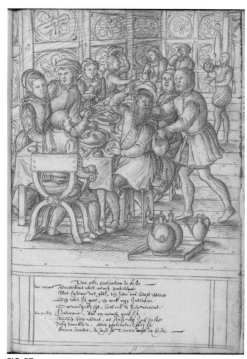

FIG. 27. Joris Hoefnagel, "The Best of All Patient People," from *Patientia*, 1569. Red chalk on paper. 29 × 42.5 cm. Bibliothèque Municipale, Rouen.

Much as in the Latin text, Hoefnagel proclaims Radermacher an instrument of divine will whose "friendly invitation" provided consolation and a means to face the anxieties caused by the "astonishing times" in which they lived. Not only does Hoefnagel express the belief that patience is a necessity in times of war; he also demonstrates the need for friends who can join together under difficult circumstances, and who, like Radermacher, will look with sympathetic heart and mind upon his endeavors. Hoefnagel's final drawing in *Patience* embodies this joining together through a dinner gathering of friends and couples: the best of all contexts in which to embrace the volume's titular virtue (fig. 27).[24] In the foreground, the bearded man removing his hat and the friend rushing toward him (perhaps Radermacher and Hoefnagel themselves) emblematize the warmth and respite found within the room's paneled walls—a sentiment in marked contrast with the scenes pictured throughout the rest of the volume.

Yet the progression that Hoefnagel charts in his sonnet also leads beyond friendship to "the noble and pure art" that derives from God alone. He describes Radermacher as a kind of heavenly intercessor, whose invitation awoke his spirit (*gheest*) so long weighed down by physical suffering. Describing a progression not unlike the trajectory of Karel van Mander's biographical narrative, Hoefnagel insists that only through the trials of wartime did he come to realize the innate artistic ability that God had bestowed upon him. In many ways, this statement combines the messages conveyed by all Hoefnagel's primary mottoes—*dum extendar, natura magistra*, and *genio duce*—even if he does not yet explicitly employ them here.

Hoefnagel's repetition of the word *gheest* throughout the sonnet is a crucial one. "Mind" or "spirit" is its simplest translation, but Hoefnagel's use of *gheest* also parallels the reference to the exercises of his *ingenium* in the accompanying Latin dedication. The ability with which he is endowed by nature, and his process of unlocking its potential, are the real subject of these verses. The con-

FIG. 27

temporary art-theoretical distinction between works created *uyt den gheest* ("from the spirit") and those produced *naer het leven* ("from the life") underlies his choice of terms.[25] As Hoefnagel tells it, the drawings and poems in *Patience* are the products of a mind inspired by firsthand experience of the revolt; they are invented rather than documentary. Hoefnagel makes this point emphatic by describing his *gheest* as "full of fantasies" (*fantasijen*), evoking

FIG. 28. Joris Hoefnagel, "Patience," from *Patientia*, 1569. Red chalk on paper. 29 × 42.5 cm. Bibliothèque Municipale, Rouen.

FIG. 29. Pieter van der Heyden after Pieter Bruegel the Elder. *Patience*, 1557. Engraving, 33.4 × 43 cm. British Museum, London.

FIG. 30. Cornelis Anthonisz., *Patience*, before 1553. Woodcut, 21.4 × 26.8 cm. Rijksmuseum, Amsterdam.

the Renaissance conception of imagination as a place in the mind brimming with images culled from sensory experience, and which in turn propelled the generation of new thoughts and visual creations.[26] Works that emerged *uit den gheest*, among which Hoefnagel professes that the *Patience* volume belongs, harnessed the imagination's double-edged powers as a seat of inspiration but also as an engine that produces more sinister fantasies. The word *fantasijen* in Dutch could itself refer to both creative imaginings and mental agonies.[27] It thus perfectly suits the project that it describes: an album of drawings that constitutes a psychological response to the violent war emerging in his homeland.

Hoefnagel's interpretation of patience as a theme, beginning with the volume's first drawing, stands out from other visual personifications of the virtue produced in the sixteenth-century Netherlands, where many such images emerged within the context of the reform movement (fig. 28).[28] Hoefnagel portrays Patience in a manner that belies her usual position as an unequivocal model of Christian behavior—for instance, as she appears in a 1557 engraving designed by Bruegel: pious and calm amidst a sea of devilish creatures, Boschian encampments, and corrupt ecclesiastical figures (fig. 29).[29] Hoefnagel's young female Patience, by contrast, sits bare-breasted and shackled on the ground as the aged dame Hope directs her prayers heavenward. Patience follows with her

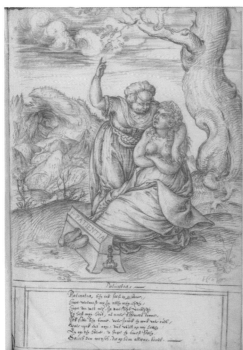

FIG. 28

FIG. 29

FIG. 30

eyes, but she clenches her body in consternation: arms folded, brow furrowed, and knees pressed tightly together. An earlier sixteenth-century woodcut by Cornelis Antonisz. like-wise shows Patience looking up toward God with folded arms, but the cross in her hand and her resolute contrapposto again differ notably from Hoefnagel's agitated figure (fig. 30).[30] Despite the inscription on her shackle box, Hoefnagel endows Patience with a physical form that projects the very opposite of the virtue she is meant to embody, and which seems even more at odds with the message she voices through the poem below:

> I am Patience personified.
> Hope consoles me in all my sufferings.
> Hope cheers me up in my sadness.
> She lifts my heart completely towards heaven.
> I sit here as an exemplum for both young and old,
> Rich and poor; therefore take note of me.
> And place your hope and consolation in the Lord;
> Blessed is the person who builds on Him alone.[31]

If we take Hoefnagel at his word, then his representation of the virtue has to be un-derstood to convey not the antithesis of Patience but rather the struggle required to achieve it under duress, and the difficulty of retaining hope when all seems lost. What seems at first a disjunction between text and image turns out to be the real truth of the matter, which the emblematic format allows to be gradually revealed. Patience's tense posture mirrors the opening lines of Hoefnagel's poem to Radermacher describing his own struggle to rise above the hindrances of his fearful and anxious body. Patience, as Hoefnagel personifies her, is not an abstract Christian virtue but instead yet another victim of present circum-stance. Even she has to endure hardship in order to achieve spiritual consolation, and even she cannot do it alone. Just as Hoefnagel needed Radermacher's friendship, so too Patience relies on Hope at her side.

Equally significant is the anthropomorphic landscape that surrounds the two virtues in Hoefnagel's drawing, its forms congruent with the posture and movement of their en-twined bodies. The sinuous tree behind Patience mirrors with its curving knotted trunk the clenching of her crossed arms. The tendril-like hills of the landscape morph and flow like the folds of Patience's skirt, and the highest cliff in the background curves and gestures like Hope's upraised arm. Amidst this barren expanse of land, with only scant leaves on the tree above and patchy vegetation in the distance, a few weeds to either side of Patience's feet have fought their way out of the inhospitable soil and taken root. Through all these details, Hoefnagel suggests that the struggle for patience in adversity is not only a basic component of the human condition but also inherent in the metamorphoses of nature itself.

BRUEGEL, ANTWERP, AND THE ENEMY

Throughout the remaining twenty-three drawings in the volume, Hoefnagel's emblematic representations shift from the external world of nature to the internal world of the city. On the one hand, this aspect of *Patience* reflects the itinerary of Hoefnagel and Radermacher as merchants and emigrants of the revolt, whose movements spanned across the three

FIG. 31. Joris Hoefnagel, "The Patient Expelled," from *Patientia*, 1569. Red chalk on paper. 29 × 42.5 cm. Bibliothèque Municipale, Rouen.

FIG. 32. Philips Galle after Pieter Bruegel the Elder, *Justice*, from the *Virtues*, c. 1559-60. Engraving, 22.5 × 29 cm. Metropolitan Museum of Art, New York.

geographical regions directly portrayed in the album: England, the Netherlands, and Spain. Yet more than any other locale, Hoefnagel's emblems are steeped in the cultural and socioeconomic environment of Antwerp, the city that he and Radermacher knew most intimately. Hoefnagel draws on the contemporary works of Antwerp rhetoricians and artists to explore the frictions that surfaced in her urban and surrounding rural spheres as a result of the war.[32]

Crucial within this body of reference is Hoefnagel's reckoning with the example of Pieter Bruegel the Elder, whose works emerge here for the first time as a touchstone for his own. A well-known line from van Mander relates that Bruegel, on his deathbed, asked his wife to destroy certain of his works that were "too caustic or derisory, either because he was sorry, or because he was afraid that on their account she would get into trouble or might have to answer for them."[33] The answering would have been to the Spanish Inquisition that confiscated innumerable books and works of arts deemed heretical in these years. Van Mander's story suggests that Bruegel's surviving works are not those in which he expressed his most direct response to the incipient revolt but instead those in which any underlying message was carefully mitigated.

FIG. 31

The anecdote has spurred attempts to interpret several of Bruegel's extant paintings, drawings, and prints as complex political allegories. Most results of those efforts have proven unconvincing, nor is there space in the present book to pursue this question further.[34] Yet the recollections of Bruegel's art in *Patience* leave little doubt that Hoefnagel understood them as a powerful vehicle for expressing the urgent concerns of the present, and suggest that his contemporaries may well have felt the same. Hoefnagel takes Bruegel's pictorial worlds as a lens through which to contemplate the ramifications of a war that Bruegel himself—who died in September 1569—was spared from seeing unfold in full.

In several of his drawings, Hoefnagel figures Antwerp as a stage for the recent events of the revolt, emphasizing the disjunction between its scenography and the plights of its actors. The long vistas of Antwerp's streets, which had been newly planned during the first half of the sixteenth century, were meant to evoke classical beauty and ordered civilization.[35] Hoefnagel repeatedly emphasizes how Alba's military and inquisitional measures corrupted this ideal. In his emblem of "The Patient Expelled," the sharply receding urban space exaggerates the isolation of a family cast out of their home (fig. 31).[36] The accompanying text explains that the family are victims of the war who have been banished from the Netherlands by the Inquisition.[37] The wife buries her

FIG. 32

head in her skirts; the children cry; and the husband looks imploringly out at the viewer, brushing his sleeve with his hat as if to show he truly has nothing left except patience and hope in God.

The culprits of this injustice are two well-dressed men in the middle ground: a city official and his secretary. The latter dutifully holds out an inkpot for the former, who is hunched over a meticulous inventory that he is scribbling of the family's paltry possessions. The official's absorption in his task recalls the posture of the legal administrators in Bruegel's *Justice*—the most paradoxical image in his series of the *Virtues* (fig. 32).[38] In Bruegel's composition, the scribes are so consumed with their paperwork that they seem oblivious to the landscape of violent punishment extending from the foreground into the distant landscape behind them. Justice may be a virtue, but those who enact it are not necessarily virtuous by association.

In another of Hoefnagel's episodes set within the city, the dense surrounding buildings afford little chance of escape for "The Patient Merchant" being ransomed in the foreground (fig. 33).[39] As he reaches for his sword and looks warily at his antagonist, the merchant speaks through Hoefnagel's verses for the plight of his entire community, to which both the artist and Radermacher belonged:

> We merchants are in a bad way.
> We bring princes and countries to prosperity.
> Our trade brings prosperity everywhere.
> Now they come and confiscate our goods,
> Even ransom our persons.
> Through war, controversy, or such quarrels,
> Have Patience, the Lord will reward us one day.
> God gives, God takes, it is all the Lord's will.[40]

The resentment of war and its assault on commercial productivity surfaces more than once in Hoefnagel's volume. It is a lament that reverberated throughout Antwerp in these years, not least in the polemical songs of the anti-Spanish rebels known as *geuzenliederen* ("beggar's songs"), which were distributed as cheap pamphlets in the city streets and later published and preserved in compendia. The parallel between the message of Hoefnagel's accosted merchant and one such song is particularly revealing:

> Mourn with us loudly,
> You people, large and small,
> See how it is being lost:
> Antwerp, the beloved city.
> The merchants clamor;
> They make such a great protest.
> They would like to have trade again,
> But it seems to me this will not be.
> Where did one ever hear it said
> That there was so pleasant a city

FIG. 33. Joris Hoefnagel, "The Patient Merchant," from *Patientia*, 1569. Red chalk on paper. 29 × 42.5 cm. Bibliothèque Municipale, Rouen.

FIG. 34. Joris Hoefnagel, "The Patient Lover," from *Patientia*, 1569. Red chalk on paper. 29 × 42.5 cm. Bibliothèque Municipale, Rouen.

Where commerce had utterly fallen
And been scorned completely.
Where every lover once triumphed,
To see his beloved pleased.
Commerce once flourished there,
But now we sit in grief.[41]

The condition of forced immobility evoked in the beggar's song—of sitting in grief rather than engaging in industry—becomes a recurrent refrain in Hoefnagel's *Patience* volume as a whole. With the exception of the friendly dinner gathering in the last drawing, Hoefnagel never depicts his human figures engaged in positive or productive activity; often, even if they are not shackled like Patience herself, they seem stuck in place. The analogy in the beggar's song between Antwerp and a scorned lover also finds a parallel in another drawing within the album: an image of one such pathetic paramour. Leaning on a stoop ornamented with devilish heads, which ape his frustrated profile, he sighs through the verses below over his troubles with the fairer sex. Yet as he stares idle and despondent down the street before him, it may as well be the city herself for which he pines (fig. 34).[42]

Less humorous but no less satirical is Hoefnagel's dramatic depiction of a Spanish soldier guarding Antwerp's city walls (fig. 35). As the soldier proclaims through the first-person text below, he had departed for the Low Countries under the misconception that it was a "golden world" but found instead that it was frozen solid.[43] The shivering Spaniard, whose hunched posture makes him look rather desperate to relieve himself, appears in further isolation against the backdrop of the urban landscape receding behind him. The contrast between his physical difficulties and the seeming pleasure exhibited by Netherlanders

FIG. 33

FIG. 34

skating on the canal below underscores that the soldier is in a place where he does not belong. He too has suffered a loss of agency as a result of the ongoing war.[44]

Here again Hoefnagel speaks to the troubles brewing in Antwerp during the revolt's early years. The armed men guarding the walls above the skaters create a sense of unease, particularly as the smoke billowing from the cannon in the distance—and the rifle of the soldier in the foreground—suggest that both weapons have been recently fired. It is not implausible that Hoefnagel was thinking back to Bruegel's 1558 *Ice Skating before the Gate of St. George*, with its latent tensions not only among the skaters but also between the Antwerp's citizens and the imposing gate built under Charles V's imperial direction (fig. 36).[45] The pointing man with his arm around a woman in the bottom right of Hoefnagel's drawing echoes the indexical gesture of the gawking figure in the right corner of Bruegel's own composition, who mocks a man fallen prostrate on the unforgiving ice. The relation between the individual and the metropolis in Hoefnagel's drawing shows him adapting the implicit ambiguities of Bruegel's work into something far more overt.

Hoefnagel's drawings of the landscape outside Antwerp's walls likewise suggest that the aftershocks of the war rippled beyond the city streets. In his drawing titled "Patience in Adversity," a man narrowly escapes shipwreck and flees to shore against turbulent waves and pelting rain (fig. 37).[46] Hoefnagel boldly depicts the storm with quick choppy lines shooting down from the top of the folio. The man's clasped hands and upturned eyes suggest that he has put his faith in God, in counterpoint to the drowning figure in the background whose flailing arms betray his imminent fate. The churning waves and violent rain recall Bruegel's drawing of the seas just off Antwerp's harbor, in which the small island with empty gallows and a torture wheel casts a decidedly ominous mood over the scene (fig. 38).[47]

FIG. 35. Joris Hoefnagel, "The Patient Soldier," from *Patientia*, 1569. Red chalk on paper. 29 × 42.5 cm. Bibliothèque Municipale, Rouen.

FIG. 36. Frans Huys after Pieter Bruegel the Elder, *Ice Skating before the Gate of St. George*, 1558. Engraving (first state), 23.2 × 29.9 cm. Metropolitan Museum of Art, New York.

FIG. 35

FIG. 36

FIG. 37. Joris Hoefnagel, "Patient in Adversity," from *Patientia*, 1569. Red chalk on paper. 29 × 42.5 cm. Bibliothèque Municipale, Rouen.

FIG. 38. Pieter Bruegel the Elder, *Storm*, c. 1559. Pen on paper, 20.2 × 29.9 cm. Courtauld Institute of Art, London.

FIG. 39. Simon Novellanus (attributed to) after Cornelis Cort, *Shipwreck with Nude Virtus*, c. 1595. Engraving, 21 × 33 cm. Rijksmuseum, Amsterdam.

The danger of shipwreck—both actual and metaphorical—is everywhere implied, even if not depicted. By comparison, Hoefnagel's composition is explicit in its message; his is the ultimate image of halted movement, in which neither the vessel's passengers nor its commercial goods reach the shore, save one desperate and isolated survivor.

It is far from implausible that Hoefnagel would have known Bruegel's harbor drawing. An inscription on a view of Messina from Braun and Hogenberg's *Civitates* refers to its design having been found among the autograph studies by Bruegel in Hoefnagel's possession.[48] Further evidence that Hoefnagel owned a cache of Bruegel's drawings is his own publication of two among the latter's landscape compositions, together with two shipwreck scenes designed by Cornelis Cort.[49] The series of four etchings, issued around 1595, reflects the outward posture that Hoefnagel had come to adopt at Rudolf's court in contrast to that of his earlier years. To one of Cort's compositions, Hoefnagel added a fleeing figure on the shore who recalls his drawing from *Patience* of over two decades earlier (fig. 39).[50] The figure, now a woman, holds above her head a caduceus sprouting an olive branch. The Stoic dictum "All that is mine I carry with me" is inscribed below her feet.[51] Here the pursuit of wisdom and peace offers guidance irrespective of what perils await.

FIG. 37

FIG. 38

FIG. 39

FIG. 40

FIG. 41

FIG. 42

FIG. 43

FIG. 40. Joris Hoefnagel, "The Patient Commoners," from *Patientia*, 1569. Red chalk on paper. 29 × 42.5 cm. Bibliothèque Municipale, Rouen.

FIG. 41. Pieter Bruegel the Elder, *Summer*, 1568. Pen on paper, 22 × 28.6 cm. Kupferstichkabinett, Hamburger Kunsthalle, Hamburg.

FIG. 42. Joris Hoefnagel, "Patient on Reflection," from *Patientia*, 1569. Red chalk on paper. 29 × 42.5 cm. Bibliotheque Municipale, Rouen.

FIG. 43. Jan Massys, *Flora*, 1559. Oil on panel, 113.2 × 112.9 cm. Hamburger Kunsthalle, Hamburg.

No such surety yet manifests in *Patience*, especially in Hoefnagel's other moments of dialogue with Bruegel. In his drawing titled "The Patient Commoners," he addresses the revolt's impact on the peasants whom his artistic predecessor so often took as his subject (fig. 40).[52] One shepherd raises his hands in prayer while the other sits in doleful contemplation, his oversized sheep shears discarded at his feet and jutting out over the space of the frame. Through the verses below, the two men lament how the poor people suffer when princes desire to go to war, complaining that "they prefer to whip the world in a frenzy" rather than to care for their subjects.[53] Hoefnagel's composition bears a striking relation to Bruegel's 1568 drawing of *Summer* showing peasants working and taking refreshment under the hot sun (fig. 41).[54] In particular, Hoefnagel's seated shepherd with outstretched leg and discarded shears parallels Bruegel's peasant who has laid down his scythe to quench his thirst. Yet Hoefnagel's drawing is self-conscious and subversive of its Bruegelian model. His shepherds are not resting from toil but seem to have abandoned their livelihood completely: a suspension of labor analogous to that experienced by Hoefnagel's city merchant. At the same time, the absurd heft of the shepherd's shears not only renders labor an impossibility; it also signals the object as out of place and, by extension, as an allusion to be discovered by the discerning viewer.

Allusions to Hoefnagel's own mercantile travels finally carry the emblematic world of *Patience* from the Netherlands to Spain: the root of the economic and spiritual troubles explored across the volume. In the first of two sequential drawings, Hoefnagel again provides a moment of comic relief by showing a hapless young man who is "Patient on Reflection," holding up his empty purse in despair as he sits alongside a brook with the picturesque Spanish harbor of San Sebastián beyond him (fig. 42).[55] "I am young, in the flower of my age," declares Hoefnagel's penniless subject, "but all is nothing if I don't have money!"[56] His setting, pose, and delicately crossed legs make him look like a disconsolate nymph or a dejected Flora—the very opposite of Jan Massys's 1559 rendition of the latter subject, where the goddess auspiciously holds up a cluster of carnations over a distant view of Antwerp (fig. 43).[57] Hoefnagel's youth may be in the flower of his age, but he is hardly flourishing, and the contrasting beauty of his surrounds only emphasizes the point.

Hoefnagel wrote the first-person poem accompanying this drawing in French, reflecting the proximity of the western coastal town to France's border and its importance as an international trading hub. But given that this is the only identifiable landscape in *Patience*, San Sebastián may have been important to Hoefnagel in some personal respect as well—whether because of his merchant dealings there, admiration for its natural prospect, or perhaps some loss of fortune experienced in his own early years. Hoefnagel returned to the harbor rather obsessively in his oeuvre; it appears in the lower register of his 1571 allegory of Ambition and Avarice (see fig. 16), in a later composition from the *Terra* volume of the *Four Elements* (see Pl. 7), and in a view that he produced for Braun and Hogenberg's *Civitates*, where he embodies the name of the site through the saint's corpse strung up and shot through with arrows on the far left (fig. 44).[58] The description within the atlas explains that the formation of land surrounding the harbor made it a particularly safe haven for ships carrying goods from abroad.[59] Yet Hoefnagel's inclusion of the martyr's body in an otherwise peaceful vista evokes the latent threat of violence, whether from the savage seas beyond the harbor or from religious persecution on land.

The latter is the subject of the next consecutive emblem in *Patience*: a drawing of a man wearing a sanbenito, the garment adorned with St. Andrew's cross that the Spanish forced heretics to wear as a form of public humiliation (fig. 45).[60] Behind the condemned heretic, another man riding up the hill behind him tips his hat dutifully at a roadside crucifix. Through this juxtaposition, Hoefnagel underscores the consequences of diverging from the sanctioned devotional path during times of inquisitional fervor.[61] The accompanying text further relates this message to the plight of merchants such as Radermacher and himself, whose business dealings in Spain forced them to navigate these difficult circumstances:

> Reflect on me, all you who trade in Spanish lands.
> It is the Inquisition.
> In this manner the holy office outfits them.
> They humiliate those who do not rule their tongues well,
> And bring into want many fine persons
> With no opportunity for complaints.
> The sanbenito you must wear for it.
> "Mouth closed, Purse closed." That is the world's device.[62]

In the last line of this passage, Hoefnagel quotes the refrain of Cornelis Crul, an Antwerp merchant and author of the previous generation. Crul's poem "Mouth closed, purse closed" (*Mond toe, borse toe*), written before the onset of the revolt, anticipated the dangers of open confession and trade that Hoefnagel and Radermacher now confronted urgently.[63] This embedded textual reference, as with those to Bruegel's works elsewhere, seems designed to further rouse Radermacher's reflection on histories both within and external to the bound world of the album itself. So too the closed posture of Hoefnagel's heretic, with his clenched knees and crossed hands, echoes the consternated pose of Patience in the volume's opening image. Hoefnagel emphasizes the need to retreat inward, and to reflect on the recent past, in order to endure the continued inflictions of outward punishment.

FIG. 44. After Joris Hoefnagel, San Sebastián, from Georg Braun and Frans Hogenberg, *Civitates orbis terrarum*, 1572–1617. Engraving. Bijzondere Collecties, Amsterdam, OTM: HB-KZL XI B 6,7.

FIG. 44

FIG. 45. Joris Hoefnagel, "The Patient Sanbenito," from *Patientia*, 1569. Red chalk on paper. 29 × 42.5 cm. Bibliothèque Municipale, Rouen.

The somatic experience of *Patience* offers both a mirror and an antidote to this stance. On the one hand, the strange corporeality of the figures who inhabit its folios—almost all of them in tense, twisted, and unstable poses—refract their unease back onto the viewer; they warn that keeping one's mouth and purse closed in the public sphere remained a necessity. Yet for Radermacher, Hoefnagel, and their close friends, turning the pages of *Patience* also offered an invitation into an intimate realm guarded against this troubled circumstance, an opportunity to commune over their shared struggle and liberate their spirits momentarily. The folio format of the album marks out a space for discourse through its large scale, while the manuscript medium itself creates—if not the promise—then the illusion of a safe haven for thought and exchange. No matter

FIG. 45

how dire the conditions of the individuals whom Hoefnagel pictures, his ultimate aim is to point the way out of misery.

On the volume's final page, Hoefnagel concludes with another poem that expresses how far his troubled *gheest* had traveled. It is a message derived from Radermacher's own personal motto *bonis in bonum*: an expression of trust in God's benevolence toward his faithful followers.[64] We may think things are hopeless, Hoefnagel iterates again and again: "yet God has sorted this out already; for the good all comes good."[65] He counsels that we should "take care to study in the books of the Lord's creation."[66] Doing so reveals that there is a larger plan, a divine reasoning that we must accept even if we may never fully understand it.

If you are tested by God with many miseries,
realize that it is for good reason. God knows the purpose
for which humankind was created
with diverse sensibilities, adorned like a flower—
it is God who has gathered us all together.[67]

A REMEDY FOR EVERYONE

For Hoefnagel, the process of making *Patience* was perhaps even more important than the final product. On the title page of the album, Hoefnagel frames the entire project in a manner that reveals it to be an epitome of that same virtue. Together with his dedicatory sonnet to Radermacher on the second folio, the title page may have been the last component of the volume that Hoefnagel completed (see fig. 25).[68] In the final stanza of his dedication, Hoefnagel describes the work as already finished; the change of drawing medium from red chalk to ink and wash also sets the title page apart.

The inscriptions on the title page are, at one level, a classic defense of art in the face of its critics. At the bottom of the page, just above the date 1569, Hoefnagel cites the Latin phrase *Ne sutor ultra crepidam* ("Let the shoemaker not judge beyond the shoe"), words allegedly spoken by Apelles when a humble cobbler dared to critique the artist's representation of footwear.[69] The message conveyed is that those ignorant of art should not presume to understand it, let alone meddle in an artist's creative process. Here, the line from Apelles takes the place of Hoefnagel's own signature and plays wittily on the allusion to the humble

horseshoe embedded in his name. Hoefnagel's verses at the top of the title page likewise echo the defensive stance he often adopted in his later use of the nail as self-referential device:

FIG. 46. Arnout Nicolaï after Pieter van der Borcht, Illustration of "Patientie," from Rembert Dodoens's *Cruijdeboeck*, 1554. Woodcut. Rijksmuseum, Amsterdam.

> When painters and poets do whatever the spirit devises,
> Nobody should feel offended or bothered by what they do.
> Nobody should pay them mind, except in a general way,
> Whatever his class, his condition, country, or tongue.
> And I exclude no one from the word so often tried:
> That good herb patience is needed by everyone.[70]

The assertion that painters and poets should be left alone to pursue "whatever the spirit devises" recalls not only Hoefnagel's emphasis on *den gheest* in his dedicatory sonnet to Radermacher but also Horace's famous lines in defense of art.[71] Yet it is hard to imagine that Hoefnagel meant this reference merely to evoke a classical topos. Given the iconoclasm that he had just witnessed back in Antwerp, to defend art against ignorant critics was as natural a response as it was necessary. And to produce art in the face of such oppressive circumstances, as Hoefnagel does throughout the *Patience* volume, was the ultimate cure.

In this respect, the poem's final two verses are the most revealing. In referring to the virtue of patience as a "good herb," Hoefnagel evokes the word's secondary association with the plant *Rumex patientia*, known in Dutch as *Patientie*, which was used as a healing agent in

FIG. 46

sixteenth-century Europe. In the contemporary herbals of Leonhart Fuchs and Rembert Dodoens, *Rumex* is said to cure everything from scorpion bites to a toothache, above all various ailments of the stomach.[72] The verb *proeven* that Hoefnagel employs in the penultimate line can mean "to try" but also "to taste" or "to savor" and implies that patience is a virtue which one strives to achieve, yet also a substance which one physically ingests and applies to the body. The plant, as depicted in Dodoens's herbal, has thick roots, a cluster of low leaves, and stalks of inconspicuous yellow flowers (fig. 46).[73] It is tempting to speculate that Hoefnagel intended a reference to this herb with the persistent crop of weeds situated at Patience's feet in the volume's first drawing.

Regardless, he surely meant the double meaning of patience as both virtue and natural remedy in his representation of the volume's title. Here Hoefnagel takes to its logical conclusion the visualization of the album's conceit in emblematic form. In a muted palette of brown and greenish tones, the word "patience" comes alive in knotted branches, whispery roots, and sprouting leaves. Even though uprooted from the earth, like Hoefnagel and Radermacher uprooted from their home, the virtue to which they aspire continues to grow. Persistent study in the books of God's creation offered hope for healing and salvation in the face of the enemy that plagued them.[74] As Lipsius would later put it, Patience is "the very root from which depth springs up the fairest oak [of Constancy]."[75]

The intricate skill with which Hoefnagel enlivens the letters of the title page, with minimal color yet the softest modeling and finest lines, shows that he—in contrast to so many figures depicted within the volume—has neither laid aside his tools nor succumbed to grief. Instead, he has followed the direction of his natural talent and the inspiration derived from his anguished fantasies, allowing the product of his patient labor to unfold in both word and image.[76] In doing so, he reveals something crucial about himself and his works to come. *Patience* tells us unequivocally that Hoefnagel was first drawn to nature out of misery and fear over the war that gripped his native land, and that he discovered in nature the truest analogy for his own spirited acts of creation.

CHAPTER 3

The *Genius* of Place

An atlas charts the environments where the events of history take place. The very phrase "to take place" signals how much our understanding of event and locality are crucially linked.[1] On the face of it, to map the urbanized world was to celebrate the monumental achievements of humanity. Sixteenth-century cartographers saw the representation of a city's constructed space (*urbs*) as a means to reveal the true nature of the *civitas*, or commonwealth of citizens, who inhabited it.[2] But even in the midst of this endeavor, there was no escaping that both city and commonwealth depended on the ever-changing landscapes at their foundations. According to the ancient concept of *genius loci*, the sites of nature have a mind of their own and a powerful sway over the way we build upon them. The German cartographer Sebastian Münster acknowledged as much in the extended title to the Latin edition of his *Cosmography* (1550), purporting to describe not only the inhabited world but also the *terrae ingenia*: "the natural dispositions of the land" itself.[3]

The first great city atlas of the early modern period—the *Civitates orbis terrarum*, or *Atlas of the Cities of the World* (1572–1617)—belongs to a moment when the technology and commerce of mapping were growing rapidly.[4] Beginning in the sixteenth century, new innovations in mensuration and the construction of convincing perspectival views coincided with the expansion and increasing sophistication of book publishing, which allowed for the larger-scale illustrations and higher production values that atlases demanded.[5] The quality and number of views represented across the six volumes of the *Civitates* were as unprecedented as the project's ambition—albeit woefully underrealized—to chart the major urban centers of the world even beyond the confines of Europe.[6]

Indeed, there was a significant gulf between the work's rhetoric of progress and the realities that undergirded its making. The learned Catholic theologian Georg Braun edited and oversaw the publication in his hometown of Cologne, but he first met his collaborator, the Netherlandish engraver Frans Hogenberg, during a pivotal sojourn in Spanish-occupied Antwerp between circa 1566 and 1568. When Hogenberg fled the Low Countries under suspicion of Protestant heresy soon thereafter, he joined Braun in Germany.[7] There they began work on the atlas in earnest, with Antwerp's recent transformation by war still strongly in mind. By no coincidence, Hogenberg's visual history of the revolt, including the

earliest representation of events like the 1566 iconoclasm and the Spanish Fury, was among his first works produced upon settling abroad (see fig. 3).[8] Nor did Braun readily forget what he had witnessed of these events; even decades later, he wrote lamenting the damage that religious disunity could inflict on the urban environment.[9] Antwerp surfaces as a site of memory across the *Civitates*, embodying the commonplace that Braun evokes in his preface to book 5: "From such great overthrow and ruin of so many cities, we should understand that all things in the world which garner our admiration are subject to the fluctuation and instability of change.[10]

But the specter of the metropolis looms large in the atlas for another reason, and here we come again to Hoefnagel. He and his close friend Abraham Ortelius were Braun and Hogenberg's most significant interlocutors for the project, both of them born in Antwerp and united by her intellectual community. Ortelius had started out as an illuminator and dealer in maps, but quickly fashioned himself into a formidable scholar and networker on the international stage.[11] Ortelius's *Theatrum orbis terrarum*, or *Theater of the World* (1570), was the hallmark of this achievement; his atlas—at once global and transhistorical in scope— provided Braun and Hogenberg with the direct model for their own endeavor, not least because Hogenberg was engaged in producing engravings for both works simultaneously.[12] By the time book 3 of the *Civitates* was published, the Netherlandish humanist Dominicus Lampsonius saw fit to praise the city atlas as the true pendant to Ortelius's *Theatrum*, pro- posing that they together formed a veritable "amphitheater" of the known world.[13]

Yet as much as the *Theatrum* and *Civitates* had in common, the focus of each project remained distinct. Ortelius had revived Ptolemy's ancient model of chorography in com- bining detailed maps of countries and continents with informative descriptions of their history and attributes.[14] Chorography, by definition, focused not on the big geographical picture but instead on the description of the world through its smaller details.[15] The *Civitates* took this model a step further still by zooming in on the enmeshed realm of civili- zation: on cities and the distances between them. As Braun acknowledges in his preface to book 3, traveling was a perilous venture, suitable for neither the weak nor the faint of heart. In his volumes, the virtual journeyer "may wander the widest expanse" without any fear of exposure to moral turpitude or misfortune, following the paths set out by the atlas's vir- tuous and learned contributors.[16]

Hoefnagel charted these itineraries, by his own example, throughout the *Civitates*. Over the years of the work's production, Braun relied on numerous draftsmen to send him drawings that Hogenberg could translate into print.[17] Hoefnagel was foremost among them, as well as the most idiosyncratic.[18] His close involvement in the atlas, which spanned the last three decades of his life, was marked by an insistently subjective approach. Hoefnagel's views invite us to feel the dust from the road, his shaky footing on a treacherous slope, but above all the ineffable vastness of a world far larger than any one person, building, or town. His interventions over time redefined Braun's project as a compendium of indi- vidual perspectives rather than a systemic whole.[19]

When Svetlana Alpers wrote of a "mapping impulse" in the art of the early modern Netherlands, she referred to the painter as a surveyor whose pictorial surfaces always imply description achieved through observation, whose works are driven by the "assemblage" of de- tailed knowledge about the world.[20] Although Hoefnagel may be counted among the earliest

Netherlandish artists who explored the kinship between mapping and picturing, his views also serve within the *Civitates* to undermine the notion of a single period eye. His travels, first as a merchant and then as an émigré, led him to emphasize the relativity of his observations, to offer them not as a survey but as a guide for thinking through the mutability of human and natural history. Hoefnagel's impulse to map was always tempered by an awareness that his own worldviews could at best serve as prompts for the journeys of others. The *ars apodemica*, or art of travel, was transformed in his hands from method to modeled experience.[21]

A TRAVELER'S ALBUM

The first volume of the *Civitates* opens with a dedicatory poem, preceding Braun's own preface, that provides a panorama of the work in literary form. Composed by the Antwerp city secretary Alexander Grapheus, it unfolds as a dialogue between two characters— Thaumastes and Panoptes—whose names combine to embody the desire for universal knowledge of the world's most marvelous sites.[22] Peering through parting clouds, they assay from above the regions represented in the atlas, admiring the glorious personae of individual cities as well as the generative spirit of their topographical surrounds.[23] Every citizen commonwealth and feature of the landscape is recognized to have its own animating force, a *genius* that uniquely gives each place life.[24]

Yet already in the second stanza, Thaumastes casts his eyes upon a city in peril. "Divine Antwerp," famed in recent times as "the most pleasing nymph in the wide region of Europe" and celebrated for her flourishing scholarship, art, and refinement,

> Now lies squalid, stripped to the utmost of all charm,
> A shapeless likeness, overcome with filth and sluggishness,
> Her hair cut, her face scarcely resembling that of a virgin,
> Mutilated in such shameful ways. Here, troubled to his depths,
> The ever-flowing Scheldt conceals his placid head beneath the waves.[25]

Grapheus has evoked the topoi of urban encomium only to reveal their collapse of meaning.[26] In decrying the rape of Antwerp's *civitas*, Grapheus refers to the consequences of the revolt and Spanish occupation of the metropolis.[27] The assault on Antwerp's body politic not only portends her fate but also has a visceral impact on her surrounds. The city's violation leads to the retreat of her tutelary spirit, the personified River Scheldt, whose waters had first brought her prosperity as a channel for trade. Not even Nature can endure the damages of human conflict. Nor, it seems, could Grapheus. In 1572, the same year that his poem was published, he abandoned his secretarial post and fled the Inquisition for Cologne, following in the footsteps of Hogenberg and so many other Protestant émigrés from the Netherlands.[28]

On the one hand, Grapheus's encomium embodies the cartographic ideals of the atlas as a whole. Its panoptic survey corresponds to the most common technique employed across its pages: the ichnographic, or bird's-eye view, which captures from a high elevation both the urban grid and the surrounding landscape.[29] As with a strict ground plan, maximum visibility is the primary aim underlying this mode of chorographic representation—an aim that Braun himself endorses in his preface to book 1.[30] Take the important trading center of

Frankfurt, the view of which Hogenberg based on an earlier map by Conrad Faber showing the city's 1552 besiegement by Protestant troops (fig. 47).[31] In its reworking for the *Civitates*, Hogenberg removed all signs of battle to render the view universal and divorced from any one moment in time. What he preserved was Faber's highly legible composition showing Frankfurt's streets and major architectural features, as well as its topographical relation to river and countryside.

But Hogenberg also recognized the limitations to this approach, and nowhere more so than in his view of Antwerp from 1572. The latter not only echoes the city's representation in Grapheus's poem but also emphasizes precisely what his view of Frankfurt obscured (fig. 48).[32] We see Antwerp from the south, a perspective that foregrounds the citadel rebuilt by the Duke of Alba as a garrison for the Spanish troops. At its center his infamous statue stands visible, casting an ominous shadow even in miniature. The plaque in the lower right—like a news print reporting on a recent event— describes the citadel's reconstruction and reprises the text inscribed at the base of Alba's monument (fig. 49). Braun's accompanying description focuses on the devastating impact of Alba's rule over the city, particularly with respect to the war's economic repercussions. In meaningful paradox, Braun employs a military metaphor to describe Antwerp's former glory: "This emporium—rich and renowned to all Europe— whose squares were once barely able to hold its crowded armies (so to speak) of goods, inhabitants, and merchants, now hardly has a merchant in sight; silence, mourning, and horror have dominion over all."[33] The tension between the idealizing effect of the bird's-eye perspective and Braun and Hogenberg's mutual insistence on the repercussions of the revolt encapsulates their efforts to produce a city atlas that preserved the sites of civilization without whitewashing their fraught histories. In the case of Antwerp, they could not ignore the immediate present.

Significantly, Antwerp is the only metropolis represented by not one but two complete perspectival views across the volumes of the *Civitates*, the second reworked by Hoefnagel himself and published over two decades after Hogenberg's own (fig. 50).[34] The city is now seen from the west, Alba's statue long gone from the citadel, and the fortifications of the latter again redesigned.[35] Still more notable is the change in tenor of the appended text. Three poems written by the Anglo-Flemish scholar and diplomat Daniel Rogers—along with one by the French humanist Joseph Scaliger—have been resurrected from the early 1560s to adorn the map's lower register.[36] The verses sing of Antwerp as a new Rome, celebrating its thriving economy and inventive culture; in short, they revive the memory of the prewar city where Hoefnagel was raised. The view is not dated, and the precise moment of its making is uncertain, but the accompanying texts are clearly meant to monumentalize Antwerp as a free commonwealth, a place whose memory will endure outside of time.

The question follows as to why Hoefnagel executed only one map of this kind, but otherwise—and throughout his work for the atlas—exhibited a far greater concern for the *genius* of place than for cities themselves. Hoefnagel's remaining views are all "stereographic" prospects conceived from the perspective of the ground-level observer. Although this too was an established mode of mapping urban space, Hoefnagel pushed the approach to an extreme. In his compositions, nature so often overpowers the built environment in prominence that the distinction between map and landscape blurs. His was an alternative

FIG. 47

FIG. 48

solution to the tension that Braun and Hogenberg encountered in their project, and to comprehend its origins requires a bit of detective work.

Van Mander reports that Hoefnagel embarked on extensive travel in his early years and "made a very large book of all the unusual things that he found or saw," including customs, festivities, and feats of engineering, and that "he drew all cities and castles from the life, all sorts of clothing and manners, which one can see in a published book of printed cities."[37] The second book to which van Mander refers is clearly the *Civitates*, but the first can only be a manuscript of notes and studies that Hoefnagel made on his journeys, motivated—at least initially—by curiosity alone and not by the demands of an anticipated publication.

No travel album by Hoefnagel's hand survives, but it is certain that he made at least one of them. Hoefnagel backdated several of his designs for the atlas with dates as early as 1561—years before Braun and Hogenberg's plans had materialized. These compositions represent locales from two specific regions: France, where he attended university from 1561 to 1562; and Spain, where he traveled for his mercantile endeavors from about 1563 to 1567. Hoefnagel also kept a record of his journey to Italy with Ortelius from 1577 to 1578, as evidence within the volume affirms. Not only did his studies produced on-site form the basis for later visual contributions to the *Civitates*; mining the texts of the atlas allows us to reconstruct the nature of the observations that Hoefnagel must have penned alongside his drawings, many of which Braun subsumed into his own written descriptions.

What van Mander describes as "a very large book" was certainly not large in physical scale but rather in the expanse of its content. From a practical standpoint, the albums that Hoefnagel carried with him on his travels would have been of a portable size. Other albums and ego-documents from the period provide a point of reference.[38] The

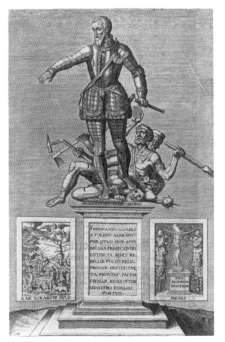

FIG. 49

FIG. 50

sketchbook of the Netherlandish artist Maarten van Heemskerck, in which he famously recorded the locales, monuments, and sculptures that he encountered in Italy during the 1530s, measures about thirteen by twenty-one centimeters.[39] Hoefnagel's drawing of the Forum Vulcani, which served as the starting point for the view of that site later engraved by Hogenberg, is on a piece of paper that is only slightly larger; this sheet, which is approximately nineteen by twenty-nine centimeters, may have once belonged among pages sketched on his Italian journey (see fig. 13).

Hoefnagel's quick study of the Forum Vulcani counts today as a rare survival suggestive of the works produced on his travels. In their absence, we must rely on the primary body of material that has come down to us: a collection of the preparatory drawings he provided to Hogenberg for engraving.[40] The elaborate landscapes, costumed figures, framing devices, and inscription plaques that are precisely planned out in these images must have resulted from a process of working up either a sketch or a combination of multiple sketches into a final composition. Yet even in the finished works are embedded clues as to the nature of those that came before them.

Within a handful of views from the *Civitates*, Hoefnagel represents himself drawing and notating in an album of the kind to which van Mander refers, and which accords with the scale of the Forum Vulcani drawing. Among these is a panorama of the landscape surrounding the Spanish town of Las Cabezas de San Juan (fig. 51).[41] Hoefnagel sits on a rock with his back to the viewer as he scribbles in an album cradled comfortably in his left hand, and supported perhaps by his unseen left knee. The detail is more legible in the preparatory study that Hoefnagel made for Hogenberg than in the resulting engraving, as the seam of the bound atlas directly bisects the book that Hoefnagel depicts himself holding (fig. 52).[42] It was not an unusual tactic for creators of sixteenth-century panoramic drawings to manifest their status as eyewitnesses, though here observation and facture carry equal weight.[43] The presence of the album in Hoefnagel's hand attests not only to the firsthand accuracy of the image but also to the time expended, labor exerted, and distances traversed in the transmission of his studies from manuscript to print. Over thirty years elapsed between Hoefnagel's initial sketch and the engraving's publication in book 5, as the prominent date of "1565" included in the composition informs us.[44]

Yet Hoefnagel is also asserting a claim in relation to the site of Las Cabezas itself, which goes beyond a concern for touting the history of the image's making. The invitation to look over his shoulder encourages our eyes to travel beyond him, past the cliff and through the broken fence. There we encounter, on the left, a cluster of travelers on the road to Seville (*camino de Sevilla*); another figure herding livestock up the hill to the town; and, on the right, a third lone wayfarer whose destination remains indeterminate. Whereas the lines of Hogenberg's engraving render static the transition from foreground to background, Hoefnagel's preparatory drawing shows his signature way of sketching masses of earth like mounds of rising dough, as if the whole world were the Land of Cockaigne.[45] His own body, except for his hat tipping over the cliff's crest, is subsumed by the undulations of the bluff on which he has perched in order to best capture the view. We sense his affinity with the landscape far more than with the town. The wayfarer with his walking stick, who wears a wide-brimmed hat much like Hoefnagel's own, implies the wanderings that the latter undertook in order to settle upon this site, and the next journey he will make once his sketch is done.

FIG. 51

FIG. 52

FIG. 51. After Joris Hoefnagel, Las Cabezas de San Juan, from Georg Braun and Frans Hogenberg, *Civitates orbis terrarum*, 1572–1617. Engraving. Bijzondere Collecties, Amsterdam, OTM: HB-KZL XI B 6,7.

FIG. 52. Joris Hoefnagel, *Las Cabezas de San Juan*, 1565. Pen and brown ink with brown and blue wash on paper, 14.4 × 48.4 cm. Albertina, Vienna.

A view of Regensburg attributed to his son Jacob Hoefnagel, also published in book 5, provides a telling comparison (fig. 53).[46] Jacob, who continued his father's work on the atlas, here emulates the latter's practices and self-presentation.[47] On a hill overlooking the city, Jacob stands confidently, turned away from us, with the same sort of album in his hands. Aside from his father, Jacob is the only contributor to Braun and Hogenberg's atlas who presented himself in this fashion, yet the effect does not quite equal that which the elder Hoefnagel achieved in his view of Las Cabezas. Regensburg, after all, was a major imperial city, as the double eagle and evocation of Emperor Rudolf II in the frame above make evident, and the represented panorama is quite a standard one. Nor does Jacob's figure suggest a real absorption in capturing the landscape before him, as he only poses with a book rather than actually drawing in it. The exceptional quality of the Las Cabezas view emerges starkly by contrast: Hoefnagel has asserted his identity as artist, observer, and traveler not in relation to a great city or an imperial patron but, instead, by devoting his attentions to a town that is a mere blip on the map.

Las Cabezas is one among several comparable views of comparably minor places that Hoefnagel contributed to the atlas, and it exemplifies one of the crucial ways that he intervened in the *Civitates* as a whole. The inclusion of a sleepy Spanish town in an atlas that professed to map the major urban centers of the world is far from self-explanatory, and it speaks above all to the deference that Braun showed toward Hoefnagel's contributions. It was not just that Braun admired the vividness of the latter's early travel drawings; when he describes the *Civitates*, in his preface to book 3, as a vehicle for virtual travel, he shows himself to have embraced the rhetoric of Hoefnagel's own recorded wanderings. By giving way to the latter's impulse to represent not only destinations but also the interstices of landscape

FIG. 53. After Jacob Hoefnagel, Regensburg, from Georg Braun and Frans Hogenberg, *Civitates orbis terrarum*, 1572–1617. Engraving. Bijzondere Collecties, Amsterdam, OTM: HB-KZL XI B 6,7.

FIG. 53

and roadway that bind them together, Braun allowed into his published volumes something truly original within the history of cartography up to that point. Hoefnagel's panoramic views, interspersed among more looming monuments of civilization, simulated for readers the duration and physical act of the journeying as it had never been pictured before.

It is here that we begin to recognize the importance of the descriptions that Hoefnagel provided to Braun along with his drawings. Braun seems to have traveled little once he started work on the atlas, consumed as he was by his ecclesiastical duties in Cologne.[48] He even pleads in the preface to book 2 for his readers to help fill in the gaps. "Whoever finds it insufferable that his homeland has been omitted," he writes, "I ask in earnest that he, moved by love [of his country], transmit a depiction of that place to us, and with honorific mention of his name, we will take care that it be engraved by Hogenberg's artful hand."[49] Yet despite Braun's promise to honor the names of those who contributed visual material, he was consistent in doing so neither with the images nor when it came to the content of his accompanying descriptions.[50] Although he refers to his sources on several occasions in the text, and even to Hoefnagel among them, there are many other instances when he does not, even when the specificity of his information strongly implies firsthand experience.

The short unattributed description of Las Cabezas is one such case, as it so closely accords with Hoefnagel's panorama that it is hard to imagine that the artist was not responsible for providing its content. Even through this brief passage, the site emerges as a palimpsest of histories both man-made and natural:

> That Las Cabezas was once a great city, the rubbish and vestiges of its walls reveal; now by farming and by the things that the generosity of the earth brings forth, it sustains the necessities of life. Back then, it was also a regular passage of merchants and travelers, who still frequent this road from Seville to Cádiz and Sanlúcar. And because Las Cabezas sounds like "heads" [in Spanish], the locals here offer this praise in their native tongue: "nothing is done by counsel of the king without the heads [of Las Cabezas]." This they pleasing ascribe, by metonymy, to themselves.[51]

An antiquarian interest in the remnants of the town's past is here countered by praise for a return to the land, the fertility of which Hoefnagel's image captures so well. The message is unmistakable: when a city falls from prominence, nature takes over. The notion that Las Cabezas is no longer a place to go but a place passed through likewise parallels Hoefnagel's depiction of the travelers and herder in the middle ground of his composition. Most striking of all, however, is the reference to the popular saying of the place, which plays on the affinity of its name with the Spanish word for "head" (*cabeza*). Hoefnagel inscribed the Spanish phrase directly on the rock upon which he sits and draws, committing to memory a town that now nobody except him seems to stop and appreciate.

The simultaneous focus in Braun's description on the *genius* of the land, the ancient past, and telling anecdotal detail accords with the accounts of other places for which Hoefnagel is explicitly named as his source for information. The most salient examples derive again from Hoefnagel's time in Spain and presumably from the written observations that he made either in a separate album or alongside his drawings. A representative case,

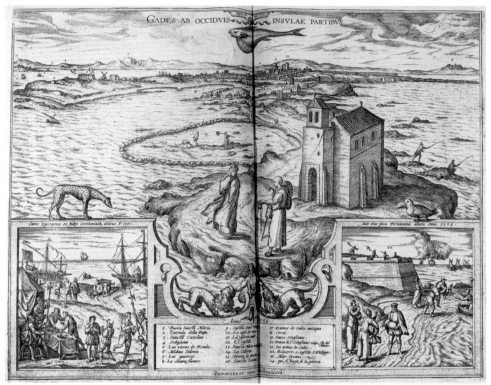

FIG. 54

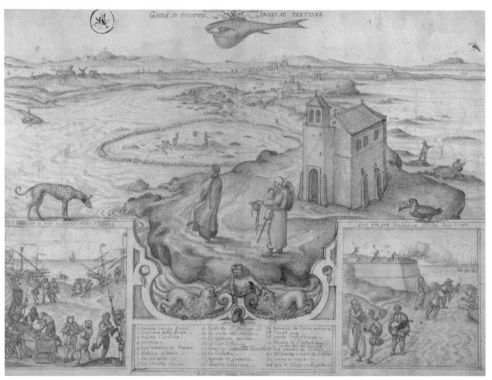

FIG. 55

FIG. 54. After Joris Hoefnagel, Cádiz from the Western Side of the Island, from Georg Braun and Frans Hogenberg, *Civitates orbis terrarum*, 1572–1617. Engraving. Bijzondere Collecties, Amsterdam, OTM: HB-KZL XI B 6,7.

FIG. 55. Joris Hoefnagel, *Cádiz from the Western Side of the Island*, 1564. Traces of chalk, pen and brown ink, and watercolor on paper, 36.2 × 49 cm. Albertina, Vienna.

FIG. 56. Detail of Fig. 54.

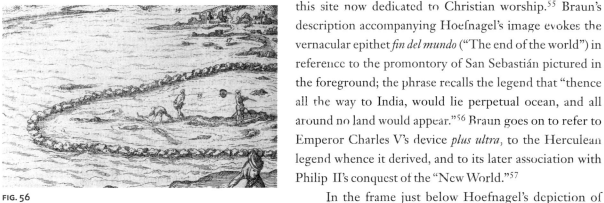

FIG. 56

which deserves prolonged attention, is the site that Hoefnagel represented more fully than any other in the *Civitates*: the southern peninsula of Cádiz.

Four distinct views of the peninsula, spread across three engravings, together appear between book 1 and book 5 of the atlas.[52] We should remember that while in Cádiz, according to van Mander's biography, Hoefnagel received his first box of watercolors from a Netherlandish painter and attempted his first work in that medium: a depiction of the harbor town itself.[53] One thinks immediately of Hoefangel's 1573 miniature of Seville, and it may be that van Mander confused the two places in his account (see fig. 17). Regardless, there is still good reason to surmise that Cádiz was a site formative to the way Hoefnagel conceived the interrelation of his travels, nature studies, and awareness of Spain's increasing power on the transnational stage.

Hoefnagel's view of Cádiz from the west, published in book 5, is perhaps the most revealing of his captivation with the place (fig. 54, fig. 55).[54] A key southern port for global trade near the Strait of Gibraltar, it was also the harbor from which Christopher Columbus sailed on his self-proclaimed voyage of discovery. Even further back in time, it was said that Hercules had erected his twin columns here to mark the end of the earth, and that the pagan deity Hercules Magusanus had been worshiped by the ancients on this site now dedicated to Christian worship.[55] Braun's description accompanying Hoefnagel's image evokes the vernacular epithet *fin del mundo* ("The end of the world") in reference to the promontory of San Sebastián pictured in the foreground; the phrase recalls the legend that "thence all the way to India, would lie perpetual ocean, and all around no land would appear."[56] Braun goes on to refer to Emperor Charles V's device *plus ultra*, to the Herculean legend whence it derived, and to its later association with Philip II's conquest of the "New World."[57]

In the frame just below Hoefnagel's depiction of San Sebastián and its humble chapel—the prominent cracks in its walls attesting to its age—Hercules appears wrestling two lions whose tails thread through holes in the scroll-work. The club of Hercules, which emerges with phallic fortitude through another opening below the hero's torso, emphasizes the rhetoric of power and conquest with which the history of Cádiz was so entwined. The club also points to the inscribed date of "1564," the year that Hoefnagel presumably recorded his first studies of the locale. As with his view of Las Cabezas, Hoefnagel acts the antiquarian as he interweaves the port's many layers of mythic, devotional, and imperial history.

Yet for Hoefnagel, the tie that binds these histories is the natural disposition of Cádiz itself. The dramatic angle from which he depicts the slender stretch of land shows his impulse to capture the topography that made it such an important contact point between Europe and the wider world. At the same time, he dwells on more particular signs of the site's local *genius*. In the left middle ground, Hoefnagel depicts the "new mode of fishing" invented by the enterprising inhabitants (fig. 56). He shows how they captured the ocean's bounty by cordoning off a region of shallows with rocks, waiting for the tide to recede, and then scooping up fishes with their bare hands. Braun writes in his accompanying

description that this is "most delightful to see" especially because they accomplish their purpose "without hook or net."[58] Again, the proximity of text to image is striking. Hoefnagel depicts a muscular fisherman reaching into the water, his posture echoing the wrestling Hercules in the foreground, while an idle man nearby—with a now-useless net slung over his shoulder—unbuttons his trousers and relieves himself. The subsequent view in this volume of the *Civitates*, also by Hoefnagel, further details the seasonal celebration between May and early June that accompanied the harvesting of tuna in Cádiz, including the collaborative effort to drag the fishes ashore, the roasting of the meat, and the burning of their bones for use in fertilizer.[59]

At the summit of his view of Cádiz from the west, Hoefnagel encapsulates all this activity by hanging from a ribbon an especially large specimen of tuna, together with an inscription proclaiming that the creature was "captured here in 1564." The fish marks the apex of a triangle within the composition, the other two corners of which are occupied by a spotted greyhound sent to Cádiz from the "West Indies" in 1565, and a Peruvian toucan brought to these shores in 1578.[60] The significantly later date for the toucan's arrival (almost a decade and a half after the year with which Hoefnagel signed the composition) may indicate that he received notice of the bird secondhand and incorporated it later as he combined his own firsthand sketches into a final design.[61] Material evidence for this method of working is provided by Hoefnagel's surviving preparatory drawing, in which the figure of the greyhound was actually executed on a separate sheet of paper and then pasted onto the surface of the larger image (fig. 55).[62] We see Hoefnagel adding bits and scraps of information over time, transforming his view into a proto-collection of diverse objects whose histories met on Cádiz's shores.

From the tuna to the greyhound and toucan, Hoefnagel thus figures again the relation between the local and the global that marked the history of the site as a whole. The latter two animals, whose lives originated in the distant Americas, embody the world beyond the reaches of the isle's westernmost point, beyond the metaphoric pillars of Hercules. At the same time, the animals serve to draw the viewer's eye to two vignettes framed in the bottom corners of the sheet. Both picture activity happening on the eastern side of the peninsula, which is seen only at a distance in the panoramic view itself, and both speak to the complex human encounters that arise as a result of transnational commerce. As in his *Patience* album, Hoefnagel appears again to be working through the contradictions of his own mercantile experience in Spain: a country that promised wealth and opportunity, but which came to threaten both the freedoms of its inhabitants and those of his own homeland. Yet unlike the immediacy of response that *Patience* documents, Hoefnagel's view of Cádiz—from first sketch to publication circa 1596—encompasses decades of personal reflection and political change.

In the harbor scene in the bottom left, pairs of wayward men and convicted criminals line up at a gambling tent to cast their fortunes on the table of the *Alquasil de Corte*, a legal administrator for the crown.[63] Braun explains that the winner of the game achieves liberty and coin, while the loser is conscripted as an oarsmen on one of Philip II's triremes destined for either the Americas or some other distant realm. It was thus that Spain manned ships to undertake these voyages when they were short on laboring bodies. This game of exploiting the destitute and leading them into servitude paints a harsh picture of Spanish conquest.[64]

Hoefnagel holds up a mirror to the consequences of Spanish imperial cruelty that reflects back on his experience of war in the Netherlands.

By contrast, the scene in the bottom right shows a negotiation founded on earnest exchange rather than deceit, and reflects the kind of open transaction that Hoefnagel remembered more fondly. A group of Spanish and Netherlandish merchants ply their trade unperturbed by the soldiers atop the fortress of St. Philip, who busy themselves firing cannons at distant ships. War may be proximate, but trade has not yet come to a standstill. Braun again draws on Hoefnagel's firsthand reconnaissance to explain what is taking place:

> Here the elegant and pleasing hand of Hoefnagel, the most excellent miniaturist,
> has portrayed the way that the Spanish barter with the seafaring Hollanders
> ever-present on the isle of Cádiz, who no more know the Spanish language than
> they do Dutch. And nevertheless, they sell them their wares—in which the Spanish
> delight—without engaging any middleman, by indicating the price of their
> merchandise with raised fingers, and so lift as many fingers as they value their
> goods to be worth in *reales*.[65]

Lacking a common language, the merchants resort to gesture in order to convey their meaning. Although Braun explicitly praises Hoefnagel's "elegant and pleasing hand" as an artist, he knew that when his draftsman first captured this site on paper, he belonged among those traders themselves. His business travels offered a window onto Spanish culture that few of his fellow Netherlanders shared, and they allowed him to present a more nuanced picture of the land that his countrymen so often and unequivocally maligned. Hoefnagel's double dexterity as miniaturist and merchant, his simultaneous attention to local detail and the wider transnational sphere, was as essential to his depiction of Cádiz as to all his contributions to the *Civitates*. Although Hoefnagel must have provided a great bulk of the information that Braun relates in his written account of the Spanish harbor, it is telling that the latter chose to credit his source in this specific passage. From Hercules to the local fishermen, the gambling sailors to the busy traders, Braun recognized that Hoefnagel portrayed the world as constantly made and remade through encounters between past and present, local and foreign, nature and humankind.

WONDERS OF NATURE

Hoefnagel's view of the Forum Vulcani has already demonstrated his interest as much in the *genius* of natural sites as in the divine artistry inherent within nature at large (see fig. 12). This interest emerges already in his earliest contributions to the *Civitates*. A decade and a half before his 1578 visit to Solfatara, he produced two views of towns in southern Spain that show his persistent fascination with sites forged by nature: Alhama and Antequera. Published sequentially within book 2 of the atlas, both chart a path to understanding Hoefnagel's approach to the Netherlandish landscape tradition and to the representation of place as simulated experience.

The image of Alhama is dated to 1564, the same year as his view of Cádiz from the west, though here Hoefnagel's compositional approach is quite distinct (fig. 57). At first, one registers simply fold upon fold of mountainous terrain, jagged cliffs giving way to

valleys, and distant peaks melding with lofty clouds that almost obscure the high horizon line in the distance. Alhama emerges gradually amidst the precipitous slopes, its walls carved from and upon the rocky surrounds. Only the massive church rising at center gives any individuality to the town's profile, and it seems almost that nature rather than human industry was responsible for laying its foundations.

The foreground contains the most signs of human activity, as here Hoefnagel shows the reason for Alhama's fame: the hot springs that flow from the surrounding mountains, which, like the Forum Vulcani, attracted visitors from all parts. A building with baths emitting steam from their roofs appears nestled below the cliff on which clusters of men, women, and children are seen to come and go. On the far right, three figures emerging below a fruit tree—a man leading a mother and her child on a donkey—immediately recall a very familiar group of wanderers: Joseph, the Virgin Mary, and the infant Christ on the Flight into Egypt. Any viewer accustomed to the fantastically rocky landscapes produced by the preceding generation of Netherlandish painters would almost expect to see an idol falling from the opposite cliffs (fig. 58).[66] Yet Hoefnagel borrows the conventions of this iconography as much to assert difference as to signal continuity. The contemplative realm that he seeks to create is not devotional in the way of Joachim Patinir's foundational invention of landscape as a space for reflecting on biblical narrative; rather, Hoefnagel is concerned with producing an image that conveys God's numinous presence in a place observed with his own eyes.[67] Braun's accompanying text guides the reader/viewer to approach Alhama with this notion in mind:

> The locale lacks nothing in the way of delight, with regard as much to the abundance of sun as to the loftiest precipices and cliffs of its mountains, and to its valleys and streams. Indeed, the abundant fonts of hot springs here transcend in nearly infinite ways all that derives from God and nature's gifts. They are warmed by a singular and mysterious wonder of nature, quite spontaneously and without any intervention of Vulcan's artifice.[68]

The passage begins with the standard topos of Alhama as a *locus amoenus* but quickly moves to more uncharted territory. The true wonder lies beneath the earth where the hot springs originate. Braun, citing Aristotle's *Meteorology*, goes on to suggest that they may be heated either by "sulfurous veins" or by "subterranean fires," but he leaves the question open in implicit acknowledgment of the limits to human knowledge on the subject.[69] By explicitly denying that Vulcan's artifice plays any role in this phenomenon, Braun parallels the rhetoric of the falling idol.[70] The image made by human hands is no match for the transcendent powers of the divine *artifex*, just as the miraculous landscape of Alhama surpasses anything derived from an artist's imagination.

Here again, it is worth considering the extent to which Braun collaborated with Hoefnagel on the content of his written description, given the traction of these ideas in the latter's wider oeuvre. Hidden in the foreground left of his view of Alhama is a lizard creeping in the rocks below a barren tree (fig. 59). A miniature from Hoefnagel's *Terra* volume in the *Four Elements* sheds light on the creature's identity; depicted in a similar rocky setting are two spiny-footed lizards (*Acanthodactylus erythrurus*) native to the

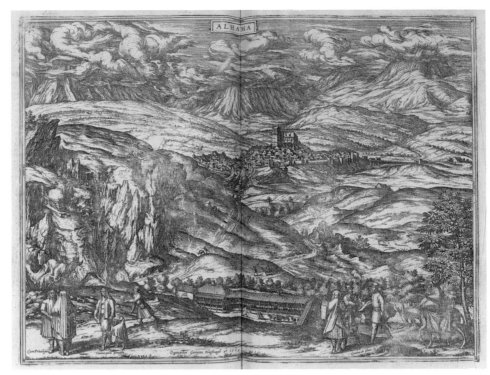

FIG. 57

FIG. 58

mountainous region of the Iberian Peninsula where Alhama was located—one slinking along a ledge and the other emerging from its hiding place below (Pl. 6). That Hoefnagel encountered the creature firsthand on his Spanish travels, and even sketched it for the first time in his album, seems far from implausible. The accompanying quotation from Proverbs, which Hoefnagel includes above, resonates with the discussion of Alhama's landscape.[71] The figure of Wisdom declares that she was brought forth even before "the mountains with their huge bulk," at a time when God "had not yet made the earth, nor the rivers, nor the poles of the world." Although mediated through the lens of scripture rather than Aristotelian thought, the message is fundamentally the same as in Hoefnagel's view of Alhama: humankind can only glimpse, but never fully understand, the wisdom intrinsic to the natural world.

On the next page of book 2, the *descriptio* of Antequera offers further exegesis on this theme and affirmation of Hoefnagel as its ultimate source (fig. 60). At the conclusion of his text, Braun explicitly cites his draftsman when he declares, "Nearly everything here above I received in Dutch from the most excellent man Joris Hoefnagel, maker of the image [that follows]."[72] Hoefnagel himself affirms the unity between word and image with a plaque in the lower right corner of his composition, which describes how the town resides "on a thoroughly charming site, with an abundance of salt, stone quarries, and praiseworthy pots."[73] This rather delightful list of qualities speaks to the particular *genius* of the locale that both Braun's text and Hoefnagel's image endeavor to convey.

As with his view of Alhama, Hoefnagel distinguishes little between the surrounding countryside and the town that stretches across the middle ground, its sprawling rooftops

FIG. 59. Detail of Fig. 57.

FIG. 60. After Joris Hoefnagel, Antequera, from Georg Braun and Frans Hogenberg, *Civitates orbis terrarum*, 1572–1617. Engraving. Bijzondere Collecties, Amsterdam, OTM: HB-KZL XI B 6,7.

FIG. 59

FIG. 60

and walls melding into the seam between mountain and valley. Two local inhabitants in hirsute vests, who frame the giant earthen pot at foreground center, seem to have emerged from that sprawl only to provide a human scale against which to measure this object's remarkable size. Such vessels, as the accompanying text explains, were crafted in Antequera for preserving all manner of drink and foodstuffs, and the contents of a single pot could support a family for an entire year.[74]

Yet however admirable the skill required to fire such an impressive artifact, Hoefnagel places it front and center foremost as a point of contrast. The man-made object pales in comparison to the resources forged by the landscape itself. Braun's text (which again gives voice to Hoefnagel's observations) first offers praise for the salt produced in the distant cliffs. Cooked "by the heat of the sun" rather than "with the aid of artificial fire," Antequera's generation of the mineral proves superior to the nonnatural production of salt in Saxony and Zeeland.[75] Braun then dwells at length on the still more marvelous deposits of limestone found in the mountains, which Hoefnagel depicts with such swelling forms that they seem to heave with an internal life force. Echoing the hollow of the earthenware vessel in the foreground is the dark crevice of a stone quarry in the mountain beyond, its yawning mouth almost threatening to swallow up the town below. As Braun explains:

> Also in these same mountains are inexhaustible quarries, from which the most excellent stones are excavated, suitable for adorning the most sumptuous works and edifices. However, what is wondrous is that by some miracle of nature, this stone retains a sort of sleeping fire within itself. This may indeed be much easier for us to admire than to examine and understand (for the diversity of natural things is unknown to us, as not only Aristotle, but the very truth of things asserts). It pleased St. Augustine to offer judgment on this kind of stone and lime in *On the City of God* (Book XXI, chapter 4). In this chapter, he surveys with pleasing narration many things for which human ingenuity seems unable to give an account.[76]

Braun goes on to cite a lengthy excerpt from this chapter of Augustine's treatise.[77] For Augustine, the mysterious qualities of limestone demonstrate that the paradoxes of nature are but a weak reflection of the far greater and truly unfathomable paradox of God.[78] Augustine dwells on the strangeness of the element of fire, which burns bright yet turns most things black. Belying its association with demonic forces is the fact that fire seems to reside in both charcoal and limestone like the inner soul of man, indubitably present yet inexplicable all the same.

It comes as little surprise that Braun as a theologian would be steeped in the writings of the great church father and disdainful of Aristotle's assertions about natural causes—even despite citing him as an authority elsewhere. Nor was his disdain without precedent, as the German humanist Georg Agricola had already taken issue with the Aristotelian account of subterranean metal formation a few decades earlier.[79] One can readily imagine Braun and his draftsman dialoguing on these questions. Hoefnagel's approach to depicting Alhama and Antequera shows him employing a mode of visual inquiry akin to that of Augustine's rhetoric, and one which will resurface in the *Ignis* volume of the *Four Elements* as well.[80] The act

of making visible, with great vividness and detail, exposes God's worldly presence as both apprehensible and incomprehensible in turn.

Hoefnagel's concern with the limits of his own perception brings us to the best-known and most discussed of his designs for the *Civitates*: the views derived from his journey from Rome through southern Italy with Ortelius, subsequent to his flight from Antwerp and just prior to his establishment in Munich. As with the groupings of Hoefnagel's Spanish vistas elsewhere, these sites published together in book 3 allow the virtual traveler to follow a progressive route with the turning of the volume's pages. Yet rather than the lone draftsman perched on a hilltop, our guides are now a pair of friends whose mutual encounters figure the communal and contemplative experience of viewing that the atlas modeled as a whole.[81]

Hoefnagel places himself and Ortelius within nearly all these compositions, emphasizing not only their shared physical trek down Italy's western coast but also the trail of ancient sources that inspired their wanderings. Banderoles and plaques with quotations from these texts frame their encounters with wondrous sites described in classical myth and history. The later books of Virgil's *Aeneid*, recounting the hero's arrival and settlement in Latium, are their most frequent point of reference. At the Gulf of Gaeta between Rome and Naples, the verses hovering in the sky above their heads tell that Aeneas's nursemaid gave the harbor its name when she was laid to rest there (fig. 61).[82] As we look over the shoulders of the two men standing in the foreground, it almost seems that we have caught a fragment of their conversation. As Ortelius and Hoefnagel traveled ever farther from the Low Countries, the epic journey of Aeneas from embattled Troy to foreign shores must have seemed more than a little resonant with their own recent experience of war.

The testing of received knowledge also appears elsewhere in this sequence, and especially in Hoefnagel's views of the Cumaean Sibyl's storied haunts outside Naples (fig. 62). In

FIG. 61. After Joris Hoefnagel, Gaeta, from Georg Braun and Frans Hogenberg, *Civitates orbis terrarum*, 1572–1617. Engraving. Bijzondere Collecties, Amsterdam, OTM: HB-KZL XI B 6,7.

FIG. 61

the upper segment of the page, Hoefnagel stands with Ortelius on the shore of Lake Avernus—nearby the mythic entrance to the Underworld—sketching and conversing simultaneously. As the text at their feet explains, the two men are "observing that this lake is not birdless (ἄορνος) today," a reference to the site's Greek name and to Virgil's tale that its hellish fumes suffocated any hapless fowl who flew across its surface.[83] The birds peacefully resting on the waters beyond affirmed the gulf between myth and reality. So too with the scene below, where another legend—that any creature immersed in the waters of Lake Agnano would perish instantly—is disproven through trial with several hapless dogs. When they were dipped in the stagnant pool, Hoefnagel records that the poor creatures emerged still breathing, even despite the sinister frogs and serpents said to bubble below the surface.[84]

Yet among Hoefnagel's Italian views, one in particular stands out for the confrontation it stages between a site and a source of a different kind. The view in question represents hilly Tivoli outside Rome, the mythic birthplace of the Tiburtine Sibyl—whose ruined temple Hoefnagel pictures and labels with an "A" just below the town itself (fig. 63). Nonetheless, he gives over the greater part of the composition to landscape rather than ruins and buildings. He and Ortelius are descending the steep slope in the foreground left, leaning on walking sticks as a guide urges them on. Two sculptures of Egyptian herms from Emperor Hadrian's nearby ancient villa frame the inscription in the lower corner and represent yet another stop already made on their tour—presumably just before they visited the town itself.[85]

The text supported by the statues speaks to the progressive path of their sightseeing, as it explains that the waters labeled with the letter "B" below are those of the Teverone River, and that now "Abraham Ortelius and Joris Hoefnagel are eagerly going to see its miraculous nature and quiet egress (like a pool) beneath the huge cliffs, on 1 July 1578."[86]

FIG. 62

The precise date adds to the sense that Hoefnagel's view offers the equivalent to a diary entry, which captures a seminal moment on the journey of two individuals. Meanwhile, another lone traveler with a walking stick in the distant middle ground, and a pair of journeymen traversing the road in the upper right, reveal that Ortelius and Hoefnagel followed only one among the possible routes through the region. Hoefnagel's views, as he always reminds us, are not absolute but the product of subjective experience.

The particular fame of this image rests on its reference to an even earlier traveler from the Low Countries who recorded the "miraculous nature" of the river's source. A second view in the lower right—depicted as if on a separate piece of paper pinned onto the surface of the page—shows the destination that Hoefnagel and Ortelius are so eager to behold (fig. 64). This representation of the waterfall below Tivoli anticipates the site where the travelers will soon arrive. At the same time, it looks back to an image already in circulation: Bruegel's *Tiburtine View* from the engraved series of *Great Landscapes* (c. 1555–56), published by Hieronymus Cock and derived from the artist's own journey across the Alps in the early 1550s (fig. 65).[87] Hoefnagel's illusionistic treatment of the sheet sets it apart as a distinct object, but he makes no mention of Bruegel. Rather, Hoefnagel signs on the curled upper left corner (*deping[ebat] Georgius Hoefnagle*), and he emphasizes the point three times over with his eponymous nails that hold the image in place.

Did Hoefnagel seek to deceive us into thinking that Bruegel's view of the waterfall was his own? Or was he catering to the connoisseur who would take pleasure in recognizing his emulative sleight of hand? Neither explanation satisfies. We might compare Hoefnagel's operation here to that which Bruegel performed with his *Big Fish Eat Little Fish* (1556), an

FIG. 63. After Joris Hoefnagel, Tivoli, from Georg Braun and Frans Hogenberg, *Civitates orbis terrarum*, 1572–1617. Engraving. Bijzondere Collecties, Amsterdam, OTM: HB-KZL XI B 6,7.

FIG. 63

FIG. 64. Detail of Fig. 63.

FIG. 65. Johannes and Lucas van Doetecum after Pieter Bruegel the Elder, *View of Tivoli (Prospectus Tyburtinus)* from *The Large Landscapes*, c. 1555-56. Etching and engraving, second state, 30.9 × 42.6 cm. Metropolitan Museum of Art, New York.

FIG. 66. Pieter van der Heyden after Pieter Bruegel the Elder, *Big Fish Eat Little Fish*, 1557. Engraving, first state, 22.9 × 29.6 cm. Metropolitan Museum of Art, New York.

engraving inscribed not with Bruegel's own name but with that of Hieronymus Bosch (fig. 66).[88] The deception was as much a marketing strategy as a means to expose Bruegel's invention as distinct from his predecessor's hellish fantasies. This monumentalized representation of a proverb, unmistakably grounded in the real and contingent world of human affairs, looked all the newer in relation to what had come before.

Bruegel's clever original (disguised as an imitation) made sense at a moment—still early in his career—when the Antwerp art scene was not yet shaken by iconoclasm, when the cycle of tradition and innovation in the history of Netherlandish art had not yet been ruptured by war. Even a few decades later, Hoefnagel was living in radically altered times. His present, in its profound uncertainty, transformed his approach both to viewing in the now and to understanding his relation to the past. Hoefnagel did not simply redraw Bruegel's composition as a placeholder for his own experience of the site; he recorded the natural wonder himself, and he wants us

FIG. 64

FIG. 65

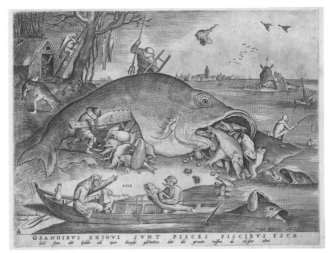

FIG. 66

to know it.[89] Hoefnagel's larger vista of Tivoli not only situates the waterfall in context; his depiction of the particularities of the buildings, the bend of the river in the distance, and the materiality of the surrounding rock formations all insist on convincing the viewer that they are true to life. Yet Hoefnagel's ultimate point is not that his image is more accurate. The rhetorical categories of *imitatio* and *emulatio* fail to account for what is happening in his view of Tivoli because his work is premised on a different question entirely: whether an artist could ever really record the truth of the visible world. Faced with what Ernst Gombrich called the "spell" of an existing representation, Hoefnagel looked with altered eyes and saw in the *Tiburtine View* an index of his own fallibility.[90]

In Bruegel's *inventio*, rapids and cliffs meld together like a jumble of viscera. We wait expectantly for the large branch jutting into the falls to plunge into the chaos below. A rocky outcrop to the right of the cascade, and just below the windswept tree, even seems to transmogrify into a monstrous fish spitting water from its gaping mouth.[91] It calls to mind van Mander's line about how Bruegel "swallowed all those mountains and rocks" encountered on his journey across the Alps and, "upon returning home, regurgitated [them] onto canvas and panels, so faithfully was he able, in this respect and others, to follow Nature."[92] Nonetheless, and despite the figure of the artist in the foreground of Bruegel's composition, we are not convinced that all of this is purely *naer het leven*.[93] Reality and fantasy intertwine the way they do in so many Netherlandish landscapes of the earlier sixteenth century, and elsewhere in Bruegel's oeuvre.[94] That which he observed from Nature has been digested through the tract of his own natural inclinations.

By contrast, all is quieted in Hoefnagel's rendition of the scene. The figure of the artist has disappeared, replaced by the facticity of the sheet itself, its edges crinkled by handling and excerpting from the travel album where we imagine Hoefnagel first recording it. He leaves no doubt that he and Ortelius had Bruegel's print in mind as they shuffled down the hill from Tivoli. Like the Virgilian banderole in the view of Gaeta, the tromp l'oeil image pinned to the page is a record of thought as much as of place. But for Hoefnagel, the *Tiburtine View* was his initial source for a still more miraculous source in nature, and the experience of viewing the latter overwhelmed the former. Hoefnagel signs the sheet insistently not just because he recorded the site as he saw it, but also because he followed Bruegel's lead to a different conclusion. His representation of the marvelous waterfall untangles observation from fantasy and, in doing so, destabilizes the encounter between human subject and the natural world.

Modernity's gradual construction of nature as viewed from a distance, and in dualistic relation to culture, made it a realm perceivably within humankind's grasp. For the anthropologist Philippe Descola, the beginnings of this "modern production of nature" are implicit already in the expansive landscape vistas of Bruegel and his followers, which dramatize the cognitive space between observer and subject.[95] The same could not be said for Hoefnagel. In his view of Tivoli—even more radically than in his earlier views of Alhama and Antequera—he acknowledges the *genius* intrinsic to this site, and the entire natural world, as greater than his capacity for either imagination or understanding. He breaks the illusion of distance by collapsing his two views of Tivoli on top of each other, by insisting the picture is only a picture, and by representing himself not engaged in the study of a

FIG. 67. Simon Novellanus(?) after Pieter Bruegel the Elder, *River Landscape with Mercury and Psyche*, 1593-97. Etching, 27.5 × 34.2 cm. Rijksmuseum, Amsterdam.

world he can comprehend but instead struggling to keep his balance in a world with which he was fundamentally entangled.

In taking a step back from Bruegel's self-insertion, Hoefnagel treats as distant not the natural world but his own recent artistic past. Significant in this regard is an etching that Hoefnagel later published at Rudolf II's court—based on another vista that Bruegel had drawn in Italy—where once again the figures of an artist and a pupil are absorbed in sketching on a foreground cliff (fig. 67).[96] They survey the river valley from above, their backs turned to us, while the Latin phrase appended by Hoefnagel at the base of the print declares, "The virtue of art and ingenuity endures without end."[97] As in Bruegel's *Tiburtine View*, the figures turned away emphasize the mental activity involved in an artist's creation of a landscape, defying those who would denounce the genre as mere imitation of what is seen. But even as the inscription promises fame to those who apply both their art and their ingenuity to the study of nature, Hoefnagel insists on historizing the encounter between artist and landscape. By inserting the gods Mercury and Minerva as embodiments of inspiring *genius*, who hover in the sky above Bruegel's composition, Hoefnagel maintains that all individuals' relation to their creative faculty is fundamentally dependent on a higher power. It mattered in light of his own recent experience to show that truth lay beyond the picture, that what he and Ortelius observed together—and what Hogenberg translated into print—was still incomplete. It was the *virtue* of art and ingenuity that endured without end. Everything else was just illusion.

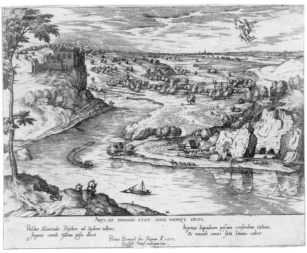

FIG. 67

There is no evidence that Bruegel was a humanist in the sense that Ortelius and Hoefnagel were, no evidence that he engaged with the concerns of natural philosophy as they so assiduously did.[98] But there is no question that both Ortelius and Hoefnagel fashioned Bruegel after their own image in retrospect. In an oft-cited epitaph written shortly after Bruegel's death, Ortelius praised the artist's works as natural and wholly without artifice. "I would not say that he was the best of painters," Ortelius writes, "but nature among painters. And so I judge him worthy of being imitated by all."[99] Hoefnagel, with his view of Tivoli, shows us what Ortelius meant, and Braun affirms it, celebrating the former in the preface to book 3 as "an excellent painter whom the teaching of nature, not of artifice, endowed with rare talents."[100] Hoefnagel was never declared a second Bruegel the way that Bruegel himself was named a second Bosch.[101] He did not simply imitate Bruegel's works, nor would Ortelius have encouraged him to do so. Rather, Hoefnagel saw Bruegel's view and raised the stakes on his own. He recognized the unguarded pursuit of inspiration in Nature's realm as admirable, but no longer enough. Hoefnagel's own travels were born of necessity and fraught with an ever-present concern for the future.

Monuments of Friendship

A monument of friendship eternalizes an intimate bond. So, at least, is its aim. The phrase "a monument of friendship" (*amicitiae monumentum*) achieved currency in the sixteenth century within a new kind of manuscript, one that provided the foundation on which such remembrances could be built. A friendship album, or *album amicorum*, comprises a collection of inscriptions and images dedicated to an individual by a select community of others.[1] Designed to be easily held and shared from friend to friend, these albums were also meant to be shielded—in their scale and proximity—from the scrutinizing public eye. In an era of print and ever-expanding knowledge circulation, *alba amicorum* harnessed the physicality of the manuscript book toward a form of intellectual exchange carried out in intimacy, by hand, and against the force of time.[2]

No aspect of material culture in the sixteenth-century Netherlands impacted Hoefnagel's artistic practice more than did the genre of the friendship album. His sustained engagement with the processes of album making and inscribing informed every facet of his works explored up until this point—from his use of mottoes and emblems to his approach to documenting his travels. Rooted in the album genre is Hoefnagel's innovation of the independent miniature as gift and communicative vehicle among friends separated by war and exile, and as the object of a transaction separate from yet parallel to those in the commercial realm.[3] Every manuscript that he ever made was in some sense a monument, freighted with the temporal concerns that attend the act of remembrance.

Albums first arose among Reformist circles at universities in Germany sometime around the 1540s and quickly spread to the Netherlands. In these early years, they circulated foremost among students and professors, their format rooted in educational practice.[4] Indeed, the *album amicorum* emerged in part from the practice of keeping commonplace manuscripts, in which an individual gradually compiled a florilegium of choice excerpts from diverse literary sources, organizing them around particular themes so as to produce a memory aid and self-designed reference work.[5] *Alba amicorum* likewise coalesced over years and decades, but it was the communal nature of their making that made the genre both distinct in form and broad in appeal. By the later sixteenth century, albums were being created by noblemen, merchants, artists, and other members of the educated public, even as

they remained predominantly a northern European phenomenon. Each was the unique possession of one individual, formed by the larger body of individuals with whom its owner chose to share it. And that choice was crucial, for from it resulted a book that constituted one person's place in the world as a series of journeys, encounters, and relationships formed. Belonging neither strictly to the public nor to the private sphere, albums became mediators in the creation of an alternative associative space, one in which the immaterial notions of community and friendship were endowed with tangible form.[6]

The curious status of these manuscript albums in a technological age manifests in the fact that many early examples (including those in Hoefnagel's milieu) were made using existing printed books, with inscriptions added on interleaved pages or in any available marginal space.[7] Appropriating a volume already made and bound was in part, but not exclusively, a practical choice. Emblem books in particular were frequently transformed into albums and provided inspiration for the way monuments of friendship developed in form. Although the use of blank manuscripts or prefabricated templates became just as common in album making, and so allowed for the inclusion of longer entries and more elaborate visual programs, individual dedications often still mirrored the design of emblems on the page.[8] Some entries were dashed off with a few lines and a signature, but just as often they consisted of mottoes (*symbola*) combined with choice quotations, original poems, drawings, or pasted-in images that together embodied the identity of inscribers and emblematized their expression of friendship toward the recipient. Monuments of friendship were even referred to as "tokens" or *tesserae*—the same word that Sambucus used to describe the encoded and combinatory nature of emblems themselves.[9]

Yet what distinguished *alba amicorum* from printed books was the manual labor involved in their making—and role of that labor in their messaging. Alongside the frequent indication of place and date—down to the exact day when a given page was inscribed— each individual's distinctive script and gestural marks attested to that person's physical contact, however brief, with the manuscript itself. Once that contact was cut, the trace of the inscriber's presence was to remain alive in the hands of the owner and every successive viewer of the album. For monuments of friendship to endure beyond the ephemeral moment of exchange—even after the individuals who inscribed them had moved on or passed away—depended on their reactivation not just through the acts of reading and viewing but also by touch and the turning of pages.[10] Albums existed always in the imperfect tense, their bonds of friendship renewed with every opening.

Of course, friendship was a diverse concept in the early modern period, and not strictly used in reference to intimate ties.[11] Many *alba amicorum* served as instruments for political networking and, in such cases, were far less impervious to the pressures and hierarchies of public life writ large.[12] Nonetheless, the albums produced within Hoefnagel's milieu were all carefully circumscribed in terms of their intended public and deeply invested in the classical ideals of *amicitia*.[13] His close friend Emanuel van Meteren—a fellow Netherlandish merchant, cousin to Ortelius, and the first great historian of the revolt— speaks to how those ideals shaped the discourse surrounding the genre in the context of the late sixteenth-century Low Countries.[14] In the octave of a Dutch sonnet that opens van Meteren's own album, he declares to his friends:

You lovers of virtue, art, and the blessed life,

I invite and beseech you here to make with your hand

Some fine device, which from your good faculty (*verstant*)

And artful ingenuity (*ingien*), a true witness may give,

So that the same for eternity here below,

Like a permanent seal to this fine volume (*bandt*)

of our great unity and abundant love,

Will be inscribed in this book as also in our hearts.[15]

Van Meteren conceives monuments of friendship as reflections of their creators' innate capacity for learning and invention; their dedications are therefore premised on a common investment in virtue, the arts, and the moral path. The album that contains them bears witness to interactions of friendship and scholarship: a chronicle of the personal and intellectual sphere akin to van Meteren's published account of the revolt's public and political history.[16] In referring to each monument as a seal (*seghel merck*) of unity and love, van Meteren alludes to the parallel genre of letter writing through which learned exchange had long been signed, sealed, and delivered.[17] Finally, his choice of the word *bandt* (which refers both to the book as physical volume and to an emotional bond) figures the manuscript as testament to what the heart knows and feels. To borrow Miguel Tamen's words, friendship albums were "interpretable objects" that achieved their full resonance only within the society of the individuals who had formed them.[18]

Hence van Meteren's emphasis on the friendship album's perpetuity, and on its making as a form of preservation. The Netherlandish albums discussed below all reflect how their owners negotiated the shifting political circumstances of their times—circumstances that made refuge in friendship all the more necessary. The creation of *alba amicorum* in Hoefnagel's circle emerged as an act of resistance to the external forces of iconoclasm, inquisition, and spiritual disunity of which the ongoing revolt was a constant reminder. Books, like works of art, were under threat from all sides—proscribed by Catholic inquisitors, engulfed in the flames of Calvinist iconoclasts, and torn from the shelves of Antwerp's bookshops and homes by the Duke of Alba's soldiers.[19] This violence against the worlds of knowledge making and community that books embodied was in no small part what Hoefnagel and his colleagues sought to redress through the albums they made, kept, and shared.

IN TROUBLED TIMES

Van Meteren's album was itself a book with an embattled history. His first friendship album had been confiscated by the Spanish Inquisition when he was imprisoned in Antwerp on 2 May 1575, under suspicion of dealings with William of Orange. The volume's value to the inquisitors was as a document of his network and movements. Paradoxically, however, it was through the bonds represented in the album that van Meteren's release was ensured. Hoefnagel, Abraham Ortelius, and Johannes Radermacher, who were all among his close friends, argued successfully on his behalf that his business in the city had no ties to the rebels.[20] But his *album amicorum* was still gone for good—a casualty van Meteren experienced as symbolic of the war's assault on his person and community. Van Meteren had long

served as trade consul to the Netherlandish merchants in London, and it was there that he returned upon his liberation and began to build his now-surviving album, from which the sonnet above derives.[21] On the hand-drawn frontispiece to the new volume, dated prominently to 1575 and framed by a cartouche strung with ripe fruits, van Meteren proclaims himself still a merchant of Antwerp (*mercatoris Antverpiani*), whose friendships and ties to his homeland could never truly be taken from him (fig. 68):

> When in this year the Spanish snatched away (among other things) the friendship album of this Antwerp-born man, in which the elegies of his friends—most learned men—were contained, he himself cared for the making of this other album, in place of the one that was lost.[22]

The Inquisition had long been a force in the Habsburg Netherlands, with numerous printed books already banned in the wake of the Reformation. Yet the hunting down of manuscripts, letters, and works of art had reached extremes following Philip II's ascent to the throne. A 1561 letter that Ortelius received from Lisbon, written by the Netherlandish trader Joannes Vryfpenninck, begins by warning that inquisitors were on the lookout for any images that might be deemed scandalous or heretical, just as much as they were for books, and he counsels Ortelius that "he should always keep this to heart" when sending him works for sale.[23] Switching from Latin to Dutch (presumably to avoid prying Spanish eyes), Vryfpennick then advises Ortelius: "The best thing would be that you put all works on paper of the same format together in a binding in the manner of a book, and cut down the edges on the top and sides, so that they might pass here as books— on which they exact no duties."[24]

FIG. 68

Although Vryfpennick shows a businessman's concern for evading taxes, he also speaks to the ironic status of the book in an inquisitional age. Even when subject to prohibition, the bound volume had the capacity to serve as cover. This tension manifests both in the loss of van Meteren's first *album amicorum* and in his immediate decision to begin making a new one. The manuscript book was not safe from the forces at work in the public sphere, but it was—if not always in practice—at least in conception an entity capable of sheltering personal exchanges from the censure of the outside world.

The inscriptions in van Meteren's album made by his liberators speak to the oppositional mentality that informed the way albums functioned in the midst of the revolt. Hoefnagel's contribution, dating to 6 December 1575 and composed in Antwerp, is structured in response to the recent hardships that his friend had faced (fig. 69).[25] At the summit of the verso, two verses in Dutch set up the theme of the opening as a whole: "The flesh must perish before it can inherit life through Christ, just as a seed must first fall in order to bear fruit."[26] The body text at center, written in capital letters, bequeaths to van Meteren "a symbol of eternity depicted by his own hand, with nature as teacher (*natura magistra*),

formed in itself as an eternal monument of enduring friendship."[27] Echoing the emphasis on permanence in van Meteren's own poem to his friends, Hoefnagel portrays his natural talent as that which guides both his hand and his heart. Finally, in italic script below, Hoefnagel breaks the seal on the album's enclosed world and acknowledges its making "in troubled times" (*temporibus erumnosis*). Through this unmistakable allusion to the revolt, Hoefnagel expresses not only sympathy for van Meteren's plight but also the pressing need for maintaining the bonds that monuments of friendship affirmed.

 Hoefnagel expands on this rumination through a watercolor drawing on parchment just opposite: the "symbol of eternity" to which his dedication refers. Both the motto *spes altera vitae* ("another hope for life") and the accompanying image derive from Claude Paradin's emblem book *Heroic Devices*, but, as ever, Hoefnagel has outdone his model (fig. 70).[28] In a palette of brown hues, tired stalks of wheat bend over a plot of uprooted earth, which supports only a few weeds and an overturned skull. Like the figure of death in the corner of his 1571 allegorical miniature and the figuration of the title to his *Patience* album, the cycle of nature reveals that troubles in the earthly realm are only transitory (see fig. 16, fig. 25). The fading sheaves promise regeneration through their scattered seeds, even in the face of death and carnage—a promise affirmed by the lines below from St. Paul's First Epistle to the Corinthians: "That sown in corruption is raised in incorruption; that sown in weakness is raised in strength; that sown in a natural body is raised in a spiritual one."[29] This island of earth embodies the condition that van Meteren and Hoefnagel shared; no longer rooted securely in their homeland, their friendship must rejuvenate wherever they are and

FIG. 69. Joris Hoefnagel, Dedication in the *album amicorum* of Emanuel van Meteren, 1575. Bodleian Library, Oxford.

FIG. 70. "Spes altera vita," from Claude Paradin, *Heroica symbola*, 1563. Bijzondere Collecties, Amsterdam, OTM: OK 63-5326.

FIG. 69

FIG. 70

wherever they carry their albums with them. In the act of making and the preservation of community, both men found hope for a second life.

Equally poignant is the dedication that precedes Hoefnagel's own, this one penned by Ortelius (fig. 71).[30] The recto of the opening constitutes a fairly standard monument of friendship dating to March 1576: "a token by his own hand" (*tesseram sua manu*) that represents both "the likeness of his body and the image of his mind" (*corporis effigiem et animi sui imaginem*). Ortelius has pasted an engraved portrait of himself just above, juxtaposing his likeness with the thoughts expressed through his words on the page. Yet the tenor changes on the opposite verso, which includes an addition that Ortelius made in April 1577, after he had escaped the Spanish Fury and arrived in London. "I added my symbol here," he writes, "after Antwerp was plundered by the barbarous Spaniards, and I had fled."[31] That Ortelius would inscribe van Meteren's volume on two different occasions is less usual and speaks not only to the closeness between these two men but also to how album inscriptions—as records of personal history and friendship—still reflected goings-on in the larger political sphere.

Above this second inscription is the additional symbol of which Ortelius speaks: a snake coiled around a pile of books, with a world globe superimposed over its head.[32] The surrounding inscription in Greek, μωρια παρα τω θεω ("foolishness in the eyes of God"), recalls two additional passages from Corinthians, in which St. Paul writes that God, even in foolishness, is wiser than all human wisdom.[33] On one level, Ortelius is certainly expressing humble acknowledgment of the same. Yet the combination of image and motto might also be interpreted in light of the "barbarous Spaniards" evoked in the inscription below and the

FIG. 71

other print pasted at the bottom of the page: an emblem of the globe combined with one of Ortelius's personal mottoes, "I scorn and adorn, by mind, by hand."[34] A sinister serpent posing as head of the world, tangling its tail around a pile of tomes, is a fitting visualization of Philip II's inquisitional measures. There is foolishness and barbarity in an earthly ruler who purports to know where true wisdom lies, and who impedes intellectual pursuit through cruel juridical measures. In antithesis to the posture of the serpent at the top of the page, Ortelius takes the position of a scholar who both disdains the ephemerality of human affairs and strives—through his innate creative capacity—to honor the greater world of God's creation. However many books the Inquisition might confiscate, neither Ortelius nor van Meteren would desist in their endeavor to achieve truer knowledge of that world, nor would they lose sight of nature's renewing power that Hoefnagel so beautifully visualized.

A few folios later, Radermacher—the last of the friends involved in van Meteren's release from prison—echoes these sentiments in his own "testimony of venerable friendship" (*testimonium veteris amicitiae*) dedicated in London on 14 June 1576 (fig. 72). At the summit of the recto, Radermacher's symbol of a celestial orb turning on a wheel figures God as the guiding *artifex* of worldly fortune, a message affirmed by his surrounding device (*bonis in bonum*) and the two biblical passages cited below.[35] On the opposite verso, he also inscribed a segment of George Buchanan's paraphrase of Psalm 102—a salient choice in light of van Meteren's recent brush with the authorities. As Buchanan recounted in his autobiography, he began composing his metrical renditions of the Psalms while himself imprisoned by the Lisbon Inquisition in the early 1550s.[36] Radermacher underlines one passage in particular, addressed to God as the constant force amidst the metamorphoses of

FIG. 72. Johannes Radermacher, Dedication in the *album amicorum* of Emanuel van Meteren, 1576. Bodleian Library, Oxford.

FIG. 72

FIG. 73. Alvarus Nonius, Dedication in the *album amicorum* of Abraham Ortelius, 1576. Pembroke College Library, Cambridge.

human life: "Thus the cunning engine of the world goes and turns round, and changes its form at Your command."[37] Van Meteren's recent misfortune would resolve itself through faith, as God brings only good to the good who follow him.

Even these few dedications to van Meteren reveal how the friendship album served as a space where communal history could be preserved and ingenuity fostered despite the threats posed by the ongoing war. They also exemplify the irenic nature of spiritual expression found in so many albums produced in the context of the revolt, expression that served to bridge mounting confessional divides by promoting unity and common ground. Hoefnagel, Ortelius, and Radermacher all articulate their faith in God's wisdom in a manner that is universal rather than exclusionary.[38] Toleration was an essential means to keep them together, defending against the external machinations of war. But it was also a means to a greater end, allowing for exchanges that fostered further learning and invention.

And nowhere is this goal more in evidence than in Ortelius's surviving *album amicorum*, the best-known example of the genre from the sixteenth century, and one as exceptional as its keeper.[39] Rich in both poetry and pictures—and wide-reaching in its network of participants—it is also remarkable for its self-reflexivity about the nature and purpose of *alba amicorum* themselves. One cannot imagine a more succinct representation of the album as eternal archive than the drawing penned by Ortelius's colleague Alvarus Nonius in 1576 (fig. 73).[40] Within a grotesque cartouche shaded in blue ink, glossed by the surrounding phrase "a monument more lasting than bronze" (*monumentum aere perennius*), a

FIG. 73

disembodied hand emerges from outside the frame and displays a closed manu-script volume, bound in leather and sealed with metal clasps.[41] As the image of an album within an album, the drawing embodies the rhetoric of every indi-vidual monument of friendship contained within it—not an open book but one sealed for eternity to all except the honored few.

Indeed, through Ortelius's well-preserved correspondence, we also learn just how se-riously this honor was taken and the importance invested in crafting a dedication signifi-cant to both maker and recipient.[42] When Alexander Grapheus received Ortelius's volume in the mail, he was both eager and anxious about adding a dedication alongside "so many elegant symbols of learned men."[43] Fearing that he might end up "honking like a goose among swans," he tells Ortelius to cut his pages from the album if he deemed them un-worthy.[44] Likewise, the great English historian William Camden hesitates at the invitation to join such "ingenious" company, describing his inscription as "neither subtly invented nor artfully depicted."[45] Still Camden hopes that his friend will understand: "You know how heavy the climate we endure—we exiles of the world— and I candidly but sorrowfully confess that my hand has no ability at all."[46] Self-deprecation is here a rhetorical means of complimenting Ortelius, but one not without sincerity. Camden speaks to the struggle of making and inventing in times of upheaval, which in turn invested albums with greater meaning. Friendship and its expression, particularly in trou-bled times, were not meant to be easy.

The comments of Grapheus and Camden help to con-textualize the singular nature of Hoefnagel's own dedication to Ortelius, which is preserved among the album's early pages (fig. 74).[47] Dated to 1 September 1574 and inscribed in Antwerp, it survives today only as a fragment. Ortelius's nephew Jacob Coels, who acquired the album upon his uncle's death, made an index at the back affirming that Hoefnagel's contribution once comprised a full opening, of which only the verso is now extant.[48] It makes sense to envision a layout similar to his dedication to van Meteren. In fact, the Dutch inscription at the top of the extant verso is the same as the text Hoefnagel inscribed at the summit of the latter, which may suggest that he employed the emblem of *spes altera vita* here as well.[49]

FIG. 74. Joris Hoefnagel, Dedication in the *album amicorum* of Abraham Ortelius, 1574. Pembroke College Library, Cambridge.

FIG. 74

At the center of the surviving page, Hoefnagel's bestows on Ortelius his "monument of love, made by his own hand (with nature as his teacher)."[50] As with his homage to van Meteren, Hoefnagel's use of Roman capitals evokes an ancient inscription on stone— a reference further punctuated by the concluding phrase *amico bene merenti posuit* ("he placed it well for a worthy friend"), which was a standard epigraphic formula in the context of funerary epitaphs.[51] Of course, Hoefnagel had no intention of sending Ortelius to an early grave. The rhetoric of permanence and afterlife associated with memorials is what Hoefnagel seeks to harness, and in doing so to juxtapose two different notions of *genius*: on

the one hand, as source of inspiration; on the other, as fleeting spirit hovering on the boundary between life and death.[52]

Likewise, the very first dedication in Ortelius's volume is an ode written four years later by Daniel Rogers: a relation of the cartographer and mutual friend of Hoefnagel (on whom more in a moment). Dedicated "to the *genius* of Abraham Ortelius" and "placed willingly for a worthy [friend]," Rogers declares that however "mortal" his poem, its testament of "immortal love" will endure without end—just as Ortelius's spirit will live on even after he is gone.[53] In the ode itself, Rogers evokes the other meaning of *genius* when he writes, "For Nature, Love, and Minerva bind the two of us, Abraham, by a triple bond, and we stand conjoined by the ties of family, genius, and ingenuity (*generis, genii, ingeniique*)."[54]

A remarkable poem in French that constitutes the final segment of Hoefnagel's monument to Ortelius may have inspired these words from Rogers, who could have read them before adding his own dedication. Hoefnagel expounds in his verses on the relation between following Nature and the guidance of friendship, much as in his opening sonnet to Radermacher from the *Patience* album:

> If God is the father of Nature
> and if love is Nature's mother,
> and if she is mistress of knowledge
> and also of art, who is my Ortelius?
> What do I owe you, a good heart perhaps?
> The true heart of a friend, not of a flatterer,
> so as to follow God and Nature,
> and to show pure affection
> (having nothing else), I thus employ
> the art with which Nature enriched me.
> Nature alone, the only nursemaid
> of the good spirit, abhorrent of vice.[55]

The question of what Hoefnagel "owes" Ortelius echoes the concerns of Grapheus and Camden even as it renders them obsolete. Hoefnagel makes clear that he disdains flattery. He expresses humility not just toward Ortelius but also toward the heavenly and natural powers that rule them both. Love, knowledge, and art all have a higher origin, and Hoefnagel can only offer the gifts derived from them: pure affection and the natural talent that guides his pen. He has nothing else. The precepts of *sola natura* instruct that by nurturing the good spirit of friendship, both friends honor the lineage of their bond, which derives from Nature and ultimately from God.

The album also reflects how the affection between Ortelius and Hoefnagel endured over the following decades. At least seventeen years after Hoefnagel's dedication, his engraved 1592 portrait was pasted on the recto just preceding his dedication, likely at the hand of Ortelius himself (see fig. 10).[56] The print, through which Sadeler had memorialized his friendship with the artist, was perfectly suited to the album context; indeed, one wonders whether it was not produced in part with this purpose in mind. Its small scale (just over 14 by 8 centimeters) accommodated it well to an *album amicorum* page, as Ortelius's

own volume (which measures 16 by 11 centimeters) was of a typical size. Hoefnagel may have enclosed the image in a letter and sent it to Ortelius, a practice for which there is ample evidence.[57]

When a printed image enters a manuscript album, its activation of the space differs from that of an inscription or drawing on the page. Recall that Ortelius had inserted his engraved portrait in the album of van Meteren in order to show "the likeness of his body" alongside "the image of his mind." Yet Hoefnagel's portrait does not just put a face to the name, any more than the printed collections of *icones* that emerged in the sixteenth century were about the straightforward portrayal of personages they represent.[58] In the Netherlandish context, no one could forget Erasmus's seminal line "A better image will his writings show," which appears on his portrait medal and adorns his 1526 engraved likeness by Albrecht Dürer (see fig. 4).[59] The reproducible portrait pasted within a manuscript book—alongside the handwritten word—toes the boundary between the private and public realms, and begs the question of which medium or space would prove the most enduring.[60]

In Hoefnagel's case, it was less his features than his transformation at a distance—through war, emigration, and court service—that Sadeler's portrait brought to bear in Ortelius's volume. The public disclosure of Hoefnagel's body in the trappings of courtly life contrasts with the personal rumination inscribed directly onto the page. The temporal distance between print and poem exposes the instability of Hoefnagel's outward identity. At the same time, the reproduced image sent from abroad arrives in the album to reaffirm the intimate proximity professed by the poem alongside which it was pasted, and to reinforce the permanence that the volume as a whole was meant to provide. Ortelius knew Hoefnagel back when, and that made all the difference.

We have already seen, through the views published in Braun and Hogenberg's *Civitates*, that Hoefnagel produced more monuments of friendship for Ortelius than for anyone else. But the significance of those widely circulated engravings is nuanced by comparison to their album counterparts. The performance of enduring friendship in print carried the rhetoric of the *album amicorum* out into the open, transforming it from intimate exchange into a vehicle for taking a stance both within and against the public sphere. On the road, Hoefnagel and Ortelius defied the divisive threats of war, declaring their bond sealed through travel, shared experience, and the persistent study of the natural world.

The most profound statement in this regard is another view from the Italian series: a representation of the harbor of Baiae just west of Naples, enclosed in a cornucopian frame spilling out fruits, gourds, and sheaves of wheat from its horns (fig. 75).[61] Two cupids in the upper corners direct their arrows toward the *locus amoenus* depicted at center, which the banderole above celebrates as more pleasing than anywhere else.[62] The "delights of the world" and "the beauty of luxurious nature" meet in the fertile arbors and slopes of her well-plowed hills, which echo the striated curves of the surrounding cornucopias themselves.[63] Below on a wineskin strung through a scrollwork frame, Hoefnagel dedicates to Ortelius a "monument of love" for all to see:

> When I was thinking to which of my friends I could best convey these diversions
> of my *ingenium*, and honorable fruits of my peaceful leisure, you alone came to
> mind—you first, you last, my Ortelius. When sweet Naples once embraced and

kissed us both, you were standing beside me seeing all these miraculous things—you, my companion eyewitness.[64]

Hoefnagel suggests that the abundance pictured here amounts to the bounties reaped through friendship itself.[65] The medium of the printed book allows him to convey this monument to Ortelius, to preserve the memory of a fruitful encounter in nature's realm that had taken place far from the pressures and obligations of court or civic life. Hoefnagel signs the dedication from Munich in 1580, emphasizing that the messenger god, whom he names "our Mercury," will send it with Minerva's blessing. Yet all this warmth and recollection of travel was familiar to Ortelius already, and the true intended recipients of the message are the readers and viewers of the *Civitates* at large. Hoefnagel offers the print as an eternal reminder that the *genius* of friendship would find places to flourish no matter the vagaries of the times, no matter the hardships and the arduous journeys. The barbarous Spaniards be damned.

CHAINS OF LOVE

Among the many words invented and used to describe albums in the sixteenth century, one stands out in particular for its paradoxical meaning. Depending on the etymological route one takes, *philophilacium* might translate either as "treasury" or a "prison" of love.[66] It is a term that emphasizes, on the one hand, the function of the album as a collection and proto-museum of cherished materials. On the other, it expresses the hope that the chains of friendship would remain ever bound. This doubled-sided concept is essential to understanding not only the *alba amicorum* that Hoefnagel inscribed but also the one that he created himself.

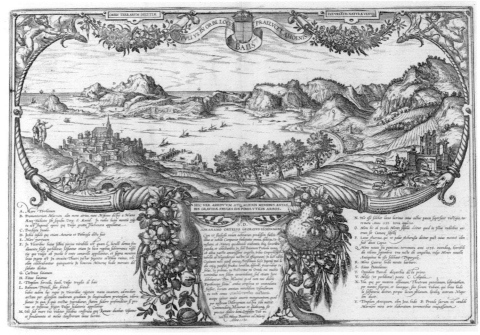

FIG. 75

Hoefnagel's *philophilacium* is lost today, but even the few traces of its content suggest that it was an exceptional example of the genre. Two dedications from its folios survive in manuscripts compiled by others, copied down so that they might be kept in mind even after the album itself had been carried onward by its owner. This was a ubiquitous practice in letter writing throughout the early modern period, and its extension to the "monuments" created for *alba amicorum* indicates the equivalent worth given to preserving their records of exchange. At the same time, an anxiety underlies this impulse to duplicate, one that van Meteren's confiscated album bears out. That which made these manuscripts precious was also their vulnerability: there was only one of them.

The first source for Hoefnagel's lost album comes from Daniel Rogers, whose ode to Ortelius mentioned above is addressed to his *philophilacium*, and three of whose poems Hoefnagel borrowed for inclusion on his map of Antwerp in the *Civitates* (see fig. 48). Rogers was born in Wittenberg to Protestant parents who had emigrated from Antwerp and then moved to England midcentury. There, at age fifteen, he witnessed his father, John Rogers, burned at the stake—a memory that would linger with him even after he became a key diplomat at the court of Queen Elizabeth I.[67] He returned to the southern Netherlands in 1575 as part of an embassy to negotiate the Anglo-Dutch alliance with William of Orange and was again in the region between mid-1576 and early 1578.[68] This is the period when he likely inscribed his long dedication in Hoefnagel's album, characteristic of his penchant for writing effusive and erudite Latin verse.[69] Rogers's neatly kept manuscript of his own poems includes several album dedications that he seems to have considered important literary works, even independent of their personal significance.[70] In a metareflection on the *album amicorum* as a genre in which he so often participated, Rogers writes to Hoefnagel:

> What end will there be to your love?
> What limit or measure, Hoefnagel, will you set to obtaining new friends
> who are to be held equal to you in esteem?
> Already manifold inscriptions are held in your album,
> as are friends represented by their pictures,
> friends united in a faithful bond,
> friends from various places of birth,
> whose names I have seen in your album.[71]

Rogers tells us something that comes as no surprise: Hoefnagel's album was a multimedia compendium comprising images as well as texts, and specifically several portraits.[72] But his description is not just a form of praise but also the prelude to a larger point. Rogers evokes the album's material nature by way of emphasizing its complex process of making. On the one hand, the volume serves to affirm the "faithful bond" among its participants, and represents Hoefnagel's travels and experiences through the diverse origins of the individuals who had already inscribed it. On the other hand, it confronts its owner with a dilemma: just how widely should the manuscript be shared? In the subsequent verses, Rogers goes on to evoke advice from the *Nicomachean Ethics*: "That Aristotle of yours, that illustrious master of every kind of art, thought it best to have few friends."[73] Not only does Rogers perceive Hoefnagel's artistic and scholarly pursuits as allied with those of the great

natural philosopher; he also emphasizes that however much love Hoefnagel receives, he should be sure that he can reciprocate in kind.

The second recorded inscription from Hoefnagel's album surfaces in a private manuscript rather looser in form, and compiled by his friend Johannes Radermacher.[74] Radermacher's folio-sized manuscript—too unwieldy to be passed between hands—is not an *album amicorum* but rather a kindred storehouse of correspondence, dedications, and poems written to and by close colleagues. The volume attests to the cultivated interest in arts and letters that buttressed his friendship with Hoefnagel, and shows Radermacher's efforts to maintain a connection with friends from whom war and emigration had distanced him.

The particular entry from Hoefnagel's album that Radermacher chose to transcribe provides a further window into the nature and content of the lost volume. It also introduces us to another of their mutual colleagues: Johannes Vivianus, who is among the contemporaries most frequently represented in Radermacher's manuscript. Vivianus was a poet, merchant, and antiquarian who hailed from Valenciennes but came to Antwerp to earn his livelihood in 1571, where he fostered a friendship with Ortelius and several members of his circle.[75] He remained during Antwerp's period of Calvinist rule, and occupied a lucrative position in the city government, but fled for Aachen in 1585 when the region again fell under Catholic control.[76] During these later years in Germany, he and Radermacher became such good friends that the latter went so far as to declare Vivianus his "alter ego," testifying as much to their shared scholarly interests as to a bond solidified by their shared experience of war.[77]

Vivianus's dedication to Hoefnagel itself requires a bit of context. It relates to another anecdote handed down by Karel van Mander, describing Hoefnagel's visit to Rome with Ortelius in early 1578. Reportedly, the cardinal Alessandro Farnese had asked to see Hoefnagel's works; upon viewing the same portrait miniatures so recently displayed to Albrecht V, he too offered the artist a position at his court.[78] The cardinal was eager to find a replacement for the great Croatian miniaturist Giulio Clovio, who had just died in January, and who—like Hoefnagel—possessed skills in the art of illumination that were rare at the time. Hoefnagel could not accept the job owing to his standing commitment in Munich, but he memorialized his encounter with Clovio's legacy by acquiring a self-portrait miniature by his fellow artist. Radermacher tells us as much in a few explanatory lines at the top of his own manuscript page:

> On a picture of Giulio Clovio il Macedone, wrought by his own hand, extant in the friendship album (*philophilacio*) of Joris Hoefnagel, on which Johannes Vivianus wrote the verses that follow.[79]

A complex chain of connections is immediately established here, initiated by Hoefnagel himself. His pasting of Clovio's miniature to his original album page was both a means to enshrine it as a physical object for safekeeping and to transform it into a souvenir of an encounter that never actually happened.[80] We might even consider a prehistory to this memorial in the well-known exchanges in miniature painting that took place between Clovio and Bruegel (over two decades earlier) on the latter's own sojourn in Italy.[81] Significantly, Radermacher also includes an inscription that Hoefnagel penned to

accompany the portrait: "To the immortal shade of Giulio Clovio il Macedone: Joris Hoefnagel, imitator of his genius (*genii*), set this in place of a monument."[82] The date of Clovio's death follows on the next line.[83]

Thereafter comes the poem written in homage by Vivianus, the first stanza of which is spoken as if by Hoefnagel in the first person. Even as he laments that death has snatched his fellow artist away, Hoefnagel declares through Vivianus's mouth, "I see you [Clovio] alive in pictures, and following my teacher *genius*, with you in the lead, I ever honor your footsteps (*vestigia*)."[84] Clovio's works not only manifest his enduring presence but also allow for the transfer of spirited *genius* from one body to the next. Vivianus's second stanza affirms that Clovio bequeathed his art to Hoefnagel in passing, and that swift-footed Mercury blessed the exchange between living artist and immortal shade.[85]

A surviving self-portrait miniature by Clovio now in Vienna, which shows him at age thirty accompanied by a loyal dog, may well be the likeness that Hoefnagel originally pasted into his volume (fig. 76).[86] Its gold lettering is inscribed in what appears to be Hoefnagel's handwriting: "Giulio Clovio, portrayer of his own likeness in his 30th year of life," and dated to 1528. The miniature measures just seven centimeters in diameter—making it an easy fit onto a page of a friendship album. The miniature is now treated as an independent work and preserved in a later sixteenth-century wooden frame; Hoefnagel may have taken it out of his album to sell or gift at a later point.[87] It remained for a long time among the treasures of the Ambras Castle in Innsbruck, once home to Archduke Ferdinand II of Tirol, for whom Hoefnagel worked while still living in Munich.[88]

Hoefnagel's documented practice of excerpting folios from the *Four Elements* speaks to his agency in the afterlife of Clovio's miniature.[89] So too does a book of hours now in Brussels, originally commissioned by the nobleman Philip of Cleves in the late fifteenth century, but which later came into Hoefnagel's hands.[90] He augmented the manuscript with occasional verses and marginal illuminations of flowers, fruits, spices, and insects that defy the bounds of the Ghent-Bruges borders painted by its original Netherlandish illuminator.[91] One opening shows a fly smashed on the parchment, as if punished for vexing a prior reader (fig. 77).[92] Having lost its right forelimb in the battle, the insect has crawled to the opposite side of the binding to breathe out its last breath in peace.

The fly is not the only thing that stuck to these pages. A handful of works on paper by other artists were pasted onto folios throughout the manuscript, including fragments of drawings by two Netherlanders of the previous generation: Hugo van der Goes and Hieronymus Bosch. Now blank spaces alone indicate where these two works once were placed, as they were subsequently removed and sold. There is little reason to doubt that Hoefnagel added these drawings himself, and it is pleasing to speculate that he chose to place Bosch's drawing opposite a fittingly Boschian subject: a miniature of St. Christopher surrounded by hybrid monsters and warring wild men (fig. 78).[93] It may also have been

FIG. 76. Giulio Clovio, *Self-Portrait*, 1528(?). Watercolor on vellum. Kunsthistorisches Museum, Kunstkammer, Vienna.

FIG. 77. Joris Hoefnagel, Marginal illuminations in the *Hours of Philip of Cleves (use of Rome)*, before 1600. Watercolor on vellum. Royal Library of Belgium, Brussels.

FIG. 78. Joris Hoefnagel, Marginal notations in the *Hours of Philip of Cleves (use of Rome)*, before 1600. Royal Library of Belgium, Brussels.

FIG. 76

Hoefnagel who noted the price received for Bosch's drawing in the margin below where it once stood on the page (970 sols), which would accord with his fastidious practice as a collector and dealer.[94] As with his friendship album, Hoefnagel seems to have used this precious manuscript as a space in which to safeguard other precious works, which here represent not just his personal history but the history of art in his native land.[95]

That Hoefnagel's *philophilacium* encompassed expressions of love not only for his friends but also for cherished founders of Netherlandish artistic tradition was hardly typical of the *album amicorum* genre as a whole. However, the epitaph to Bruegel already mentioned, inscribed by Ortelius in his own album after the artist's death, modeled this approach to constructing a friendship in absentia (fig. 79).[96] The three different colors of ink

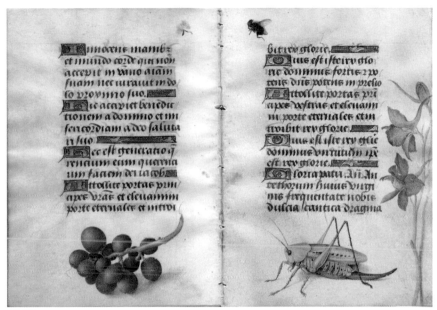

FIG. 77

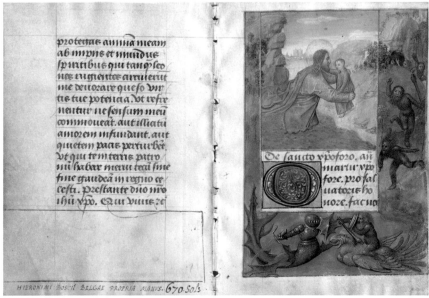

FIG. 78

and distinct segments of text suggest that Ortelius kept expanding his ruminations on the great Antwerp artist over time until they spilled over from verso to the margins of the opposite recto. Similarly, a folio of Ortelius's album devoted to the recently deceased Netherlandish artist and antiquarian Lambert Lombard includes both a pasted-in portrait print and a slip of paper with Lombard's own signature—a means to make him present even beyond the grave.[97]

It is not insignificant that Hoefnagel and Ortelius were preserving these vestiges of the recent art-historical past at a moment when the history of Netherlandish art was just starting to be written down. Dominicus Lampsonius's seminal 1572 treatise on the Netherlandish painters had been published just a few years earlier, following on the heels of the numerous contemporary accounts describing the altarpieces and sculptures smashed in the Iconoclastic Fury.[98] But Hoefnagel and Ortelius were reconstructing history in a manner both more prospective and more hands-on. They were putting the pieces back together again—scraps of drawings, traces of writing, and records of poems—in order to reestablish the ground on which art and culture might flourish anew.

PAPER, PARCHMENT, AND SUPPORT

For the Ghent rhetorician, poet, and artist Lucas de Heere, "harm teaches you" was anything but a dispassionate motto.[99] In November 1568, de Heere was banished from the Netherlands because of his Calvinist faith and fled to England, where he was active for nearly a decade in the circles of Netherlandish émigrés like Radermacher and members of

FIG. 79. Abraham Ortelius, Epitaph to Pieter Bruegel the Elder, in the *album amicorum* of Abraham Ortelius. Pembroke College Library, Cambridge.

FIG. 79

FIG. 80. Lucas de Heere, *Damna Docent*, 1576. Brown and blue ink on paper, 32.9 × 44.2 cm. Rijksmuseum, Amsterdam.

the English court.[100] De Heere's adoption of the personal motto *schade leer u* in Dutch, *damna docent* in Latin, reflected his fraught experience during the early years of the revolt and the embrace of that experience as definitive to his identity. The Dutch phrase is even an anagram of de Heere's last name. If all of this sounds much akin to Hoefnagel's own *dum extendar* motto, it should come as no surprise that these two men were intimate friends.[101]

In August 1576, de Heere made a large independent drawing for Hoefnagel that untethered the friendship monument from the space of the book (fig. 80).[102] The gift would have reached Hoefnagel's hands just a few months before the devastation of the Spanish Fury that November, its message prescient of harms to come. Sent from London, the drawing carries a dedication, its form by now familiar, inscribed on a stone at the base of the composition: "Lucas de Heere of Ghent painted this for the most famous painter and poet Joris Hoefnagel, in testimony of true and perpetual friendship."[103]

At its simplest, de Heere's gift embodies his personal motto through the figure of the siren infamous from Homer's *Odyssey*, a work that the Netherlandish scholar Dirck Volckertsz. Coornhert had recently rendered accessible through his 1561 Dutch translation.[104] De Heere used the creature as his standard *symbolum* across several albums of friends over the years, including those of van Meteren, Vivianus, and Ortelius (fig. 81).[105] His process of thinking through variations on the device manifests most strongly in the last.

FIG. 80

Two different colors of pen and wash indicate that de Heere went back to make the drawing more gruesome, emphasizing the harm that comes from the siren's treacherous allure. As a final touch, he inserted the head of a man (penned in the same ink as the inscription) looking desperately heavenward as he drowns in the wreck of his misguided vessel. "Sin may be a pretty face," de Heere tells Ortelius, "but just look at her tail; it wields such great destruction."[106]

FIG. 81. Lucas de Heere, Dedication in the *album amicorum* of Abraham Ortelius, Pembroke College Library, Cambridge.

None of these album dedications, however, equal the complexity and scale of de Heere's drawing for Hoefnagel. Executed in muted brown and blue pen, it shows evidence of folding along its horizontal and vertical axes. Perhaps de Heere made these folds to fit the drawing inside the original letter within which he sent it. At center a Janus-faced Jezebel—classical beauty on one side and grotesque monster on the other—strums her deadly instrument as two men flail and scream in the waters around her. Her serene visage, curling locks, and delicate pearl earring are belied by the gargoyle opposite, who expectorates from his engorged lips as if to manifest the vileness of the siren's song. Erasmus, in his 1525 treatise on the tongue (*Lingua*) had already commented on the double-sided nature of speech as both salutary and deadly: "Janus masks are laughed at in popular comedies because they show one face in front and another very different one behind, but speech is the face of the soul."[107]

FIG. 81

In the far left of de Heere's drawing, the remains of a ship's mast, broken on the nearby rocks, bends in near-perfect parallel to the body of the desperate man clinging to her tail. A second, younger man lifts his hands imploringly to the sky while his shield disappears on the waves behind him. The shield floating away is at once a symbol of the man's loss of defenses and a subtle allusion to de Heere and Hoefnagel's shared profession: the Dutch word for shield (*schild*) is also at the root of the word *schilder*, for painter.

Farther in the distance, another ship follows course toward a second siren lying in wait. A torture wheel on the far right, weighted by the carrion remains of its last victim, rhymes in its circular form not only with the abandoned shield floating on the waves but also with the crow's nests atop the masts of the ship itself. The drawing begs the question whether the men in the ship are yet aware of the danger toward which they are sailing. There is no indication of Odysseus tied to the vessel's mast, and although the Dutch sonnet inscribed above evokes the hero's long peregrinations in exile from his home, the ship itself appears to be a Spanish galleon: the specter of a real rather than a mythological enemy. Indeed, it seems that Odysseus's narrative resonated with both de Heere and Hoefnagel as individuals cast abroad by war.[108] The positioning of the text within a classicizing frame, broken and overgrown with weeds, might suggest at once the venerable voice of Homer and the perpetual cycle of destruction across time, from antiquity to the present:

FIG. 82. "Levitas secura,"
from Johannes Sambucus,
Emblemata, 1564. Woodcut.
Bijzondere Collecties,
Amsterdam, O 74-124.

This strange creature of which Homer spoke already,

Half woman, half fish, delectable in appearance,

Pulls and ensnares with her pleasant playing,

Man and ship that steer into her shoals.

Odysseus's men, who lacked nothing in wisdom,

Sailed quickly by without injury or reproach.

He who follows the path of the flesh, although it seems pleasing,

Goes wrong in the end: since God takes vengeance upon him.

But he who avoids the bad, and follows closely after virtue,

Enjoys the rewards of the right sort of happiness and rejoices,

Even if he suffers blows along the way:

Thus he comes to know the servitude of sins,

The ways they inflict deadly wounds on body and soul,

That harm teaches you proves to be the case over time.[109]

Odysseus steered clear of the siren's clutches, but de Heere concludes on a less certain note. Even he who pursues virtue, so the verses suggest, will encounter perils along the way. The two paths outlined in the poem, one resulting in God's vengeance, the other in hard-won spiritual reward, may well be represented by the two flailing men in the foreground of the drawing. A woodcut published in Sambucus's 1564 emblematic treatise, for which de Heere designed several illustrations, elucidates their significance (fig. 82).[110] Accompanying the image is a verse that explains: "The one man—a flatterer, lying and inconstant—avoids harm the world over, as long as a light breeze drives him onward, but ready dangers devour those whose constant faith and tested morals expose them to envy."[111] The bearded sycophant is being buoyed to shore, while the soldier weighed down by his faith and morals is about to drown. In de Heere's drawing, the old man clinging to the siren's tail, willing to save himself even if it means latching on to a two-faced monster, contrasts with the younger man's uplifted arms, his body turned away as he puts his faith in God alone.

De Heere returned to this motif the following year in his design for William of Orange's 1577 triumphal entry into Ghent, at the moment when he himself returned to the Low Countries.[112] According to the published account, the prince entered the city accompanied on one side by personifications, Merciful God, Labor, Bravery, Love of Country, and Freedom, and flanked on the opposing side by Violence, Death, and Theft—the latter three in the guise of Spanish soldiers. The leader of this opposing camp was Treachery, described by de Heere as having "a beautiful face on the front and an ugly one behind. Beneath her was a woman named Inquisition, who was thin and ugly and dressed like a Spanish

FIG. 82

Papist, and it seemed that she wanted to advance and push this woman [i.e., Treachery] forward."[113] The ultimate progression of the entry shows William conquering the Spanish enemy through his brave and pious deeds.

De Heere's drawing for Hoefnagel translates the events of the political sphere into a realm of private concern. It conveys a message about how both men found in their literary and artistic pursuits a means to endure and evade the snares of the times. De Heere's two-faced siren is at once a personification of Spanish treachery and the antithesis of the kind of genuine exchange that the drawing itself embodies. Faced with violence in their homeland and forced like Odysseus to wander on distant shores, de Heere and Hoefnagel find solace in the arduous yet worthwhile path of true friendship. De Heere combats the siren's aural and visual snares—the cacophonous mingling of her song and the screams of her victims—with the measured lyric of his own sonnet, his patient draftsmanship, and the sincerity of his gift itself.

Hoefnagel mirrored de Heere's approach to transforming monuments of friendship into independent works of art, but he did so with a more insistent concern for material afterlife. De Heere's drawing, after all, is on an unwieldy sheet of paper too large when unfolded to fit in any standard-sized album. Cognizant of the inherent fragilities of his medium, Hoefnagel experimented with a method of pasting his own miniatures to thin pieces of wood to better ensure their preservation.[114] This practice again reveals the concerns of Hoefnagel as art dealer and collector of old master works. But it also shows him as antiquarian invested in both preserving the past and securing the legacy of his works for the future.

Ortelius was the recipient of one among Hoefnagel's "freestanding" monuments of friendship: a small miniature pasted to a wood panel and perfectly suited to be held between two hands (fig. 83).[115] The composition centers on an owl resting atop the globe of the world, flanked on either side by olive branches: tokens of Minerva's peace-giving wisdom. "The only enemy of art is ignorance," declares the inscription above.[116] In its right talon, the owl grasps the caduceus of the messenger god Mercury, its form echoing the branches below and implying the Hermathenic union of Athena's and Mercury's endeavors. The caduceus is fashioned from a paintbrush: Hoefnagel's own instrument of communication and means to engage, like Mercury himself, in an act of transmission that could bridge the physical distance between the artist and his friend back in Antwerp. The span of the owl's left talon traces like a compass the expanse that separates them, hundreds of miles on the European continent scaled down to mere millimeters on the page. Within the microcosm of the painting, Hoefnagel encompasses the macrocosm of the natural world and the human effort to understand it. The facing butterflies in the foreground echo the symmetry of two friend's names in the bottom corners of the sheet and frame the field of scattered instruments, paintbrushes, and shells filled with pigment that lies beyond. No matter how far apart, or how fleeting their perch, the pursuit of art and knowledge brings these friends together. In the words of the dedication, "Joris Hoefnagel gave this monument of friendship to Abraham Ortelius, guided by *genius*."[117]

Hoefnagel's miniature is built upon the tension between life and death, the ephemeral and the eternal. A flimsy piece of parchment pasted to a hard wooden surface. A composition peaceful on first glance, but full of implied movement and instability. An owl

balanced on a sphere that is itself balanced precariously on a heavy book; insects poised momentarily, creeping and crawling on blooms and ledges; flowers insistently cut at their stems and doomed to fade. The two butterflies in particular, which might be taken as figurations of Hoefnagel and Ortelius themselves, are creatures whose larval stage is long but whose adult lives are brief. Turned toward one another on the page, they recall the words of Cicero: "In the face of a true friend a person sees, as it were, an image of himself, and what is more difficult to conceive, through his friend he enjoys a second life after his own is finished. Such is the respect, the loving remembrance, and the regret of friends that follow us to the grave."[118]

Together with this monument of friendship, Hoefnagel also sent Ortelius a second miniature, no longer extant: a flower still life or "flowerpot" (*blompotteken*) that he describes at length in the letter announcing his gift:

> I am sending you a piece by my hand that I hope will not displease you, and also the little flowerpot that I made in your honor a while ago, which came into my hands again. Because Lord Oykens asked me to make him another one that is fresher, and since the one that I dedicated to you is for you alone and nobody else, I send and present it once again, adorned with many insertions and restored and refreshed. It became yellowed because its ebony frame was oiled and the oil was absorbed into the parchment. You should have another frame made for it from a non-oily wood; otherwise it will be entirely spoiled. I put no price on the new piece. Rather than money, I would prefer in return to have something from our arts and speculation that would serve my study. Likewise, for this little flowerpot, I desire nothing except art for art.[119]

Hoefnagel affirms that his miniatures were created in honor of specific friends (one for Oykens and another for Ortelius). He suggests that they could truly belong to nobody except their intended recipient. In describing one painted flowerpot as "fresher" (*verscher*) than another—and in explaining that he has "refreshed" (*ververst*) an old work with new additions—he extends to his miniature a quality by which flowers themselves are often described. At the same time, he speaks to the material experiment and trials involved in his efforts to preserve these delicate parchment works in frames that would sustain rather than damage them. And finally, there is Hoefnagel's emphasis on what he desires from Ortelius in return. Playing upon the language of his own mercantile origins, Hoefnagel asks for some reciprocal token of their shared "arts and speculation" (*consten ende speculatie*), referring both to their creative and to their scholarly pursuits, while also hinting that he would be grateful for an actual work in exchange. The word *speculatie* in Dutch, as in English, can refer to the contemplation of ideas and commercial transactions alike. Hoefnagel thus deliberately evokes the realm of public consumption only to set his gift apart from it.[120] His miniature monument traversed physical distance to refresh and restore his love for Ortelius, a love on which he could put no price. In such a circumstance, he would accept nothing except art for art.

The remainder of the letter expounds on this notion of exchange, and on the etymological roots of "speculation" itself, which at its core means simply the faculty of sight.[121]

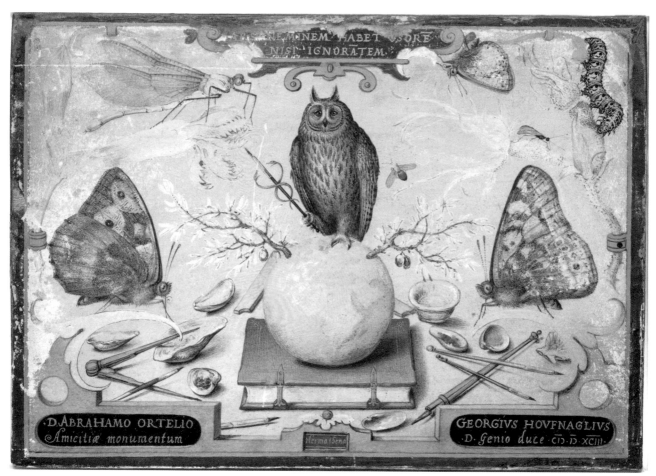

FIG. 83

FIG. 83. Joris Hoefnagel, *Monument of Friendship for Abraham Ortelius*, 1593. Watercolor and gouache on vellum, heightened with gold, mounted on panel, 11.8 × 16.5 cm. Plantin Moretus Museum, Antwerp.

FIG. 84. Joris Hoefnagel, *Monument of Friendship for Johannes Radermacher*, 1589. Watercolor and gouache on vellum, heightened with gold, mounted on panel, 11.8 × 16.3 cm. Zeeuws Museum, Middelburg.

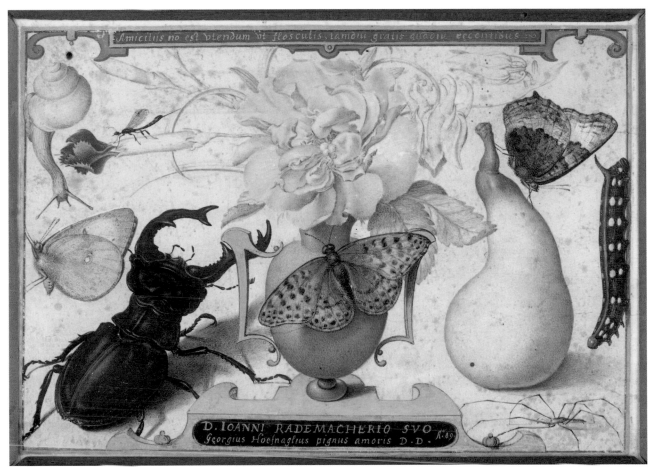

FIG. 84

Hoefnagel mentions to Ortelius (perhaps again by a way of a hint) that he is "continuing with the gathering of designs in his 'art book' (*constbouck*), having obtained already some 300 masters' hands all good and preeminent" but still hoping to obtain others.[122] He also notes that the fifth book of the *Civitates* was in the process of being produced, through which he would "communicate much" from his own travel albums, including beautifully engraved views of Seville and Naples.[123] Hoefnagel's collecting of old master drawings, in what must have been another of his personal albums, arose from the same impetus as these other projects. The histories of art, civilization, and friendship were enlivened in the present by being seen, and through vigilant safekeeping from the flames and blows of the ignorant. What Hoefnagel sealed in a book or secured on a wooden support would also be inscribed, as van Meteren had declared, forever in the heart.

In the absence of the lost flowerpot for Ortelius, another monument of friendship that Hoefnagel sent to Radermacher in 1589 reveals nature's realm as an analogue for the microworlds created through *consten en speculatie* (fig. 84).[124] The work is in itself a testament to Hoefnagel's enduring friendship with Radermacher, for whom the *Patience* album was the beginning of a lifelong exchange of art and ideas. At the time of its making, Hoefnagel was settled in distant Munich, and it is uncertain whether he and Radermacher ever met again before his death in 1600.

Like the allegory for Ortelius, Radermacher's miniature is preserved on the original panel to which Hoefnagel pasted it. The dark spot in the upper left corner is a hole left by a worm that burrowed through the wood—an unintended moment of real nature breaking through its painted illusion. Sometime later (probably in the late seventeenth or early eighteenth century), the small work was further enshrined in a double-sided frame devised specifically for it; a sliding door opens to reveal the miniature, while the back cover lifts to reveal a portrait print of Radermacher himself.[125] Even in its afterlife, Hoefnagel's miniature never hung on a wall. The knob on the back of the frame would have allowed the viewer to prop it on a table or, holding it with one hand, to slide open the front door with the other and contemplate the work up close.[126]

The crowded composition centers on a pink rose, which contrasts in its softness with the vibrant blue vase on which a fritillary has come to rest. Carnations and columbines radiate from behind its open petals, leading the eye first to the magnificent pear and then to the slinking snail making its way down the left edge of the painted frame. The snail's body is an inverted analogue to the pear in both its shape and its coloring, just as the two butterflies depicted in profile—a clouded yellow and a small tortoiseshell—mirror each other across the horizontal page. Yet the pictorial field is so shallow that the creatures and objects set back into space seem to abut those perching on the illusory frame. These points of contact close the distance between the viewer and Hoefnagel's depicted subjects. The gesture of the miniature is one of opening up rather than receding away, a gesture articulated most forcefully by the frontal rose and the open-winged fritillary at its center. Hoefnagel further heightens the invitation to touch by enhancing the butterfly wings with gum arabic and gilding, which give them a luminous sheen and tantalizing dimensionality. In what Bernhard Siegert has called a "medial operation," Hoefnagel breaks down the boundaries between the real and the illusory by insisting on the ground of the picture itself.[127]

Parchment and wood support become implicated in the representation, the tactility of the miniature as object asserting the physical presence of its subjects in the visible realm.

And so we might suspend disbelief and marvel at the lively depiction of the other insects here: the ichneumon wasp alighted on a budding carnation, the creeping caterpillar of a spurge hawk moth, and the stretch spider just below. We might nod in recognition at the stag beetle (*Scarabeus*) lurking in the bottom left, who saunters into this strange new pictorial world from a folio in *Ignis* adapted in turn from one of Albrecht Dürer's famous nature studies (Pl. 26).[128] In contemporary emblem books, the stag beetle was described as a filthy creature who died upon catching a whiff of a sweet-smelling rose, but if Hoefnagel's scarab awaits a similar fate, no signs within the miniature portend it.[129] The rose, wasp, and spider also linger in the wings of the *Four Elements*—each its own study that might at any moment enter a conversation, a friendship monument, or another manuscript folio (Pl. 31).[130] The cut bloom in *Ignis*, alone in its oval and strung through a plug in the frame, is glossed by the warning that one "should not seek again a rose that is past its prime."[131] Yet as Hoefnagel shows us, his representations of flowers and insects were something to which he could always return, refreshing them each time with renewed life.

The benevolent unfolding of the composition, with its many tactile encounters both depicted and implied, echoes the dedication that Hoefnagel inscribed to Radermacher along the lower border: "Joris Hoefnagel gave this gift as a pledge of love to his friend Johannes Radermacher."[132] He also makes clear through the inscription at the miniature's summit just what this pledge should be understood to comprise. It does not reside in any one specimen of plant or insect, each of which would perish after a short life. Instead, it is constituted by their unified preservation through the painting. "Friends," he writes, "should not be treated like flowers, beloved only so long as they are new."[133]

This poignant phrase of Hoefnagel's invention, like his nature studies themselves, is preserved in the *Four Elements* on an opening that discloses its full range of meaning (Pl. 38). The same drooping columbine in Radermacher's miniature here grows from the surface of the page, surrounded by insects that all seem to inhabit different spatial worlds—their angles and shadows at fundamental odds with the bloom at center. "A flower is only ash," reads the title above the image, and a line from the Psalms atop the opposite verso affirms that we are formed by God from dust, grow like flowers in the field, and return whence we came.[134] So when we come again to the lines from Radermacher's monument, inscribed at the bottom of the verso, we do so with the knowledge that friendship is something as rejuvenating as the divine love from which it springs. Perhaps this opening in the *Ignis* volume was Hoefnagel's way of preserving his gift to Radermacher for himself, just as Rogers and Radermacher had preserved dedications to Hoefnagel after the albums that contained them had left their hands.

Either way, it seems that one monument was not enough to express the bond that Hoefnagel felt with his old Antwerp friend. An allegorical painting that he made for Radermacher that same year, surely delivered along with the miniature, depicts at its center a goddess cradling in her lap a very recognizable monument of friendship (fig. 85).[135] Crowned like Flora and seated beside musical instruments and manuscripts of song, she grasps one end of a staff also held by a male figure who leans on a plow and wears a crown of laurel.

If these two figures seem to embody the origins of the arts in the fertility of nature, their counterparts on the right—a robed female pointing toward the heavens and a virtuous youth attired like a Roman soldier—connect the love nurtured in the human realm to that of God's eternal flame burning on the altar between them.[136] The entire world of the picture, as if brought to life by Hoefnagel's picture inside it, asserts that neither war, exile, nor the ravages of time will ever overcome the amicable arts that Nature and God together inspire. Both painting and miniature remained together for generations in the collection of the Radermacher family, for whom its dedication would have resonated still: "Take heed, onlooker, lest you think this is a vain simulacrum of love. The love between Joris Hoefnagel and Johannes Radermacher is not feigned but has its origin and end in the mutual solace of absence."[137]

FIG. 85. Joris Hoefnagel, *Allegory of the Friendship between the Artist and Johannes Radermacher*, 1590. Oil on panel, 22.5 × 34.5 cm. Museum Boijmans van Beuningen, Rotterdam.

FIG. 85

PLATES

Joris Hoefnagel, the *Four Elements*, 1570s–1600. Watercolor and gouache, with oval border in gold, on vellum, 14.3 × 18.4 cm (approximate). National Gallery of Art, Washington, DC, Gift of Mrs. Lessing J. Rosenwald.

Quam magnifica sunt opera tua Domine ? omnia
In sapientia fecisti, Impleta est terra possessione tua *ps. 103.*

Tristantur rapto parto lætantur Sonore
Corda Elephantum, studijs obnoxia nostris.
Vsque adeo Ingenium mite est Elephantibus, alter
Fraterno alterius damno vt succurrat amore.
Omnibus est spatium longum, longissima vitæ
Tempora, viginti bis dicunt Viuere Lustra

4

Et Barrus barrit: cervi glocitant et onagri:
At taurus mugit: et celer hinnit equus.

ELEPHANTVS INDICVS NON CVRAT CVLICES

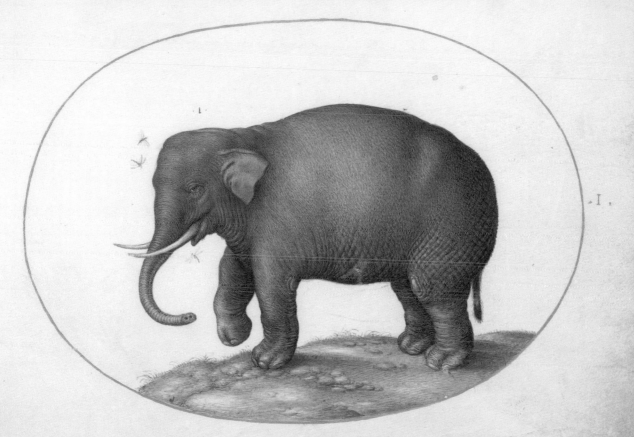

.I.

Omnis caro sicut foenum Veterascet: et sicut FOLIVM
fructificans In arbore viridi. Ecc.es 14.

Subdola, saeua, rapax, Inuentrix mille malorum
Corpore quot pili, totidem sunt pectore fraudes.

Dum lynces orcando fremunt: Vrsus ferus vncat:
Ast Lupus ipse vlulat: frendet agrestis aper.

Quo non protrahitur pellis robusta Leonis
Est vulpis Iungenda: facit solertia vires.

CAVDA DE VVLPE TESTATVR.

XXVII.

ANNOSA VVLPES HAVD CAPITVR LAQVEO.

Gangetis Sapido celebratur Simia gustu.

Infelix animal quod se virtute, dolisue
Æquiparare cupit mortalibus. His dedit vnis
Ingenium velox, diuino semine natis
Maximus ille opifex qui nutu temperat orbem.
Et quantum superi præstant mortalibus ipsi,
Tantum mortales præstant animalibus istis.

Sicut TERRA profert GERMEN suum: Sic Dominus Deus
Germinabit Justitiam, et Laudem corā vniuersis gentibus.
Jsaias. 61.

PLATE 3
Terra, Folio XXIX

Inter aues turdus, si quis me Judice certet,
Inter quadrupedes, gloria prima lepus.

Lepusculus plebs Jnualida collocat Jn petra
Cubile suum. pro: 28.

PLATE 4
Terra, Folio XXXXVII

TVTE LEPVS ES ET PVLPAMENTVM QVAERIS

XXXXVII.

LEPVS DORMIT.

Insidias cum forte sui presentit Ecsinus
 Mox sua se spinis clausus In arma globat:
Innotuit virtute sua se quisq̃ tueri
 Qui contra sortis se mala mille studet — A: Steckelius San.

Corporibus rigidis mira est prudentia parvis,
Vndiq̃ diripiunt fructus Hÿemique reponunt.
Pomorum super Si cumulos se sæpe volutant,
Inde domum redeunt onerati tergora pomis.

Spargite humum folijs, Inducite fontibus vmbras
Pastores: maudat fieri sibi talia, Christus.

PLATE 5
Terra, Folio XXXXVIII

Multa sagax Vulpes, vnum tamen Sirtns Echinus
Nouit, qua mundi parte flet aura Vaga.

EX SCABRO IN LEVĒ NV̄QV̄A VERTETVR ECHINVS.

VIS NVLLA SED ERROR

XXXXVIII.

ARS VARIA VVLPI, AST VNA ECHINO MAXIMA.

Priusquam MONTES fierent. et crearetur terra , et orbis:
A seculo et vsq3 in seculum. tu es DEVS ps: 89

TERRA mota est : Etenim, Cœli distillauerunt a facie
Domini DEI sinai. ps. 67 /

PLATE 6
Terra, Folio LI

Necdum Montes graui mole constiterant, ante Colles
Ego SApientia parturiebar: Adhuc TERRAM non fecerat.
Et flumina, et cardines orbis terræ. pro. v.

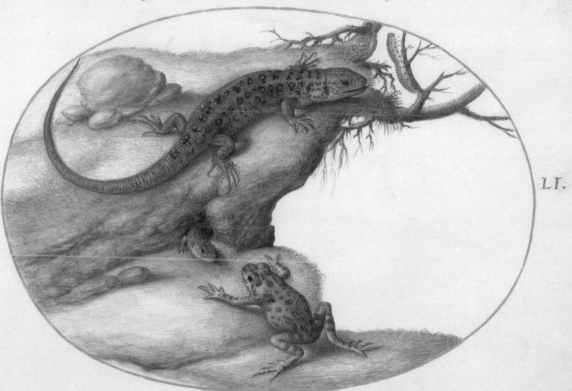

LI.

Qui fecit mirabilia magna solus: Quoniam
in æternum misericordia eius ps. 135.

Dominus regnauit: Exultet TERRA: letentur
INSVLÆ multæ ps. 96.

PLATE 7
Terra, Folio LIII

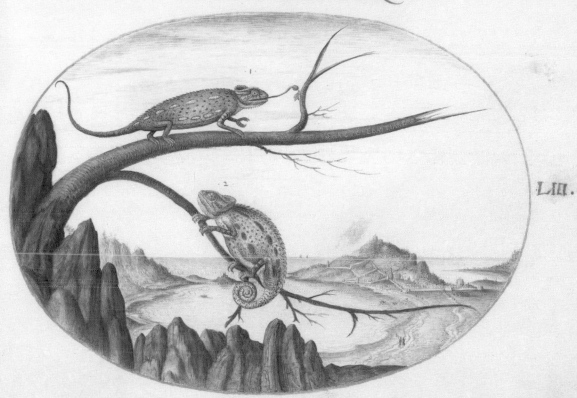

Id quoq; quod ventis animal nutritur et aura,
Protinus assimilat tetigit quoscunque colores.

CHAMALEONTE MVTABILIOR.

LIII.

Quis, nisi vidisset, pisces habitare sub vndis,
Sub limo ranas, salamandras vivere In Igne,
Aëra CHAMELEONTA, et pasci rore cicadas.
Crederet.

Qui facit magna, et Jucōpreſensibilia, et
mirabilia, quorum non est numerus. Job. 9.

Ecce Venenoſus, serpendo ſibilat Anguis.
Garrula Limoſis Rana coaxat aquis.

PLATE 8
Terra, Folio LIV

NIHILI COAXATIO IN ACTIONE CÕSISTIT VIRTVS .

LIV.

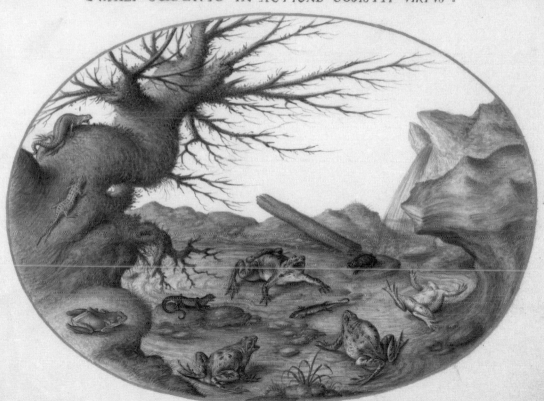

Cupiens æquare bibendo
Rana bouem, rupta numᵍ̃ bibit amplius alủo.

Terrigena, Herbigrada, domiporta et saguine cassa,
sub pedibus Veneris CHous quam pinxit Apelles.

Jubilate Deo omnis TERRA: servite
Domino In Latitia .ff=100.

PLATE 9
Terra, Folio LXI

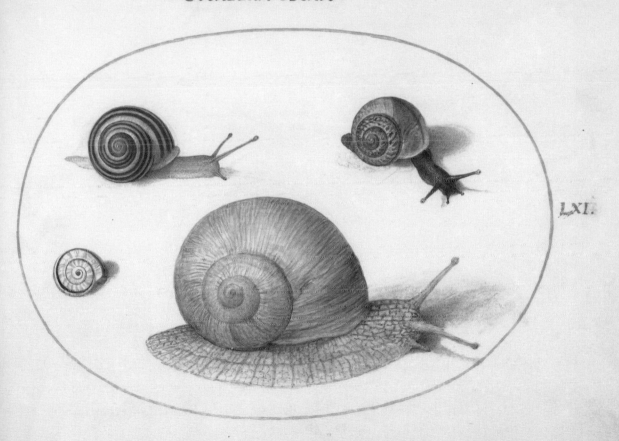

COCHLEAM PEGASO.

LXI.

Ne erigas oculos tuos ad opes, quas non potes habere: quia
faciunt sibi pennas quasi Aquilae, et volabunt In Coelum.

Tentanda Via est, qua me quoq; possum
Tollere Sumo, Via g virum volitare p ora.

PLATE 10
Aier, Folio II

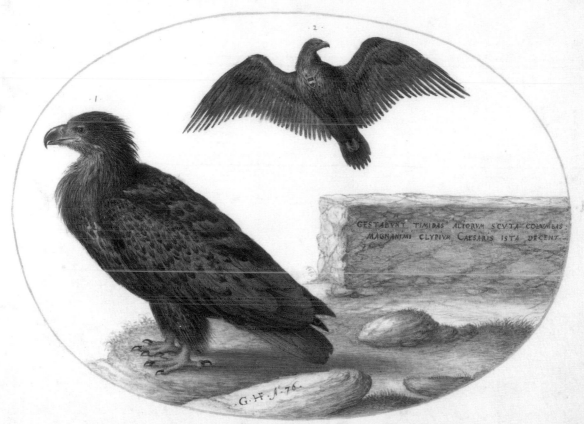

AQVILA IN NVBIBVS.

GESTABVNT TIMIDAS ALIORVM SCVTA COLVMBIS.
MAGNANIMI CLYPIVM CAESARIS ISTA DECENT.

·G·H·ʃ·76·

AQVILA NON CAPTAT MVSCAS.

Super montes volucres Cœli habitabunt: de
medio petrarum dabunt voces ps: 103.

Laudate Dominum de COELIS: Laudate
eum in excelsis. ps. 148.

PLATE 11
Aier, Folio XX

PRVDENTIS IMITARE CHARADRIVM.

Non auis vtiliter viscatis effugit alis:
Non bene de laxis cassibus exit Aper.

Date gloriam Deo super Israel: Magnificentia eiᵒ
Et virtus eius In Nubibus. ps. 67.

PLATE 12
Aier, Folio XXVIII

Bubulat horrendum ferali carmine bubo,
Humano generi tristia fata ferens.

Pallas quas Condidit arces
Ipsa colat, nobis placeant ante oĩa Syluæ.

PLATE 13
Aier, Folio LIV

Non mare non tellus, non aër tutus, vbigz
Hostis adest: prodestg parum non esse nocentem.

Noctua vt in tumulis, super vtq cadauera Bubo,
Talis apud Sopsoclem, nostra puella sedet.

Ignauus bubo, dirum mortalibus omen.

PLATE 14
Aier, Folio LV

MVLTAE NOCTVAE SVB TEGVLIS LATITANT.

LV.

NOCTVA VOLAT.

Et vlulant Vlulæ, lugubri voce canentes:
Inq paludiferis, Buteo bubit agnis.

PLATE 15
Aier, Folio LVI

VLVLAS ATHENAS .

LVI.

Tu confirmasti In virtute tua Mare: Contribulasti
Capita DRACONVM In aquis p/ 76:

Omne solum forti patria est Vt piscibus æquor:
Vt volucri nitido, quicquid In orbe patet.

LII.

POLYPI MENS.

Loquere terræ, et respondebit tibi:
Et enarrabunt pisces maris. Job 12.

Sicut aqua profunda, sic consilium In Corde Viri:
Sed homo sapiens exhauriet illud. pro: 20.

PLATE 17
Aqua, Folio XXVIII

MAGIS MVTVS QVAM PISCIS.

XXVIII.

Benedicite Domino omnia opera eius
In omni Loco Dominationes ei? ps 102.

Nonne dominus fecit sanctos enarrare oia mirabilia sua
quæ cōfirmauit dominus deus ōmpotens stabilin In gloria sua
Eccus 42.

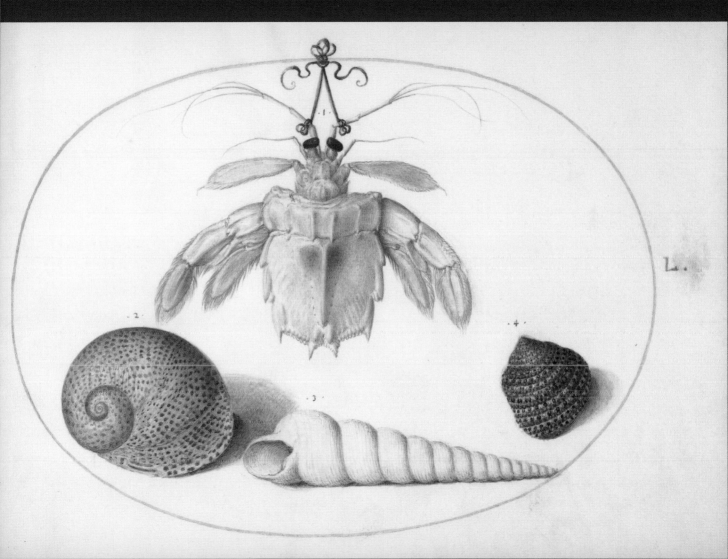

Foris albo Vtitur pallio, Intus autem
totus est purpureus.

In purpura, atq auro Implicatur sciurtus.

PVRPVRA IVXTA PVRPVRÃ DIIVDICANDA.

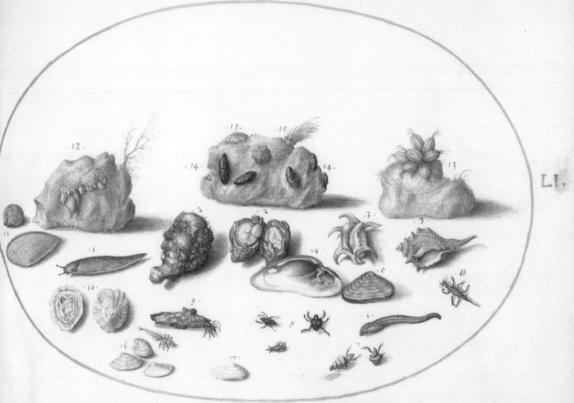

Sanguine de nostro Tinctas Jngrate Lacertas
Jnduis, et non est Soc satis, esca sumus.

3

Hic nigra succus Loliginis, hoc est
Ærugo mera.

Et nigrum mineo, portans in corpore virus
Loligo.

PLATE 20
Aqua, Folio LII

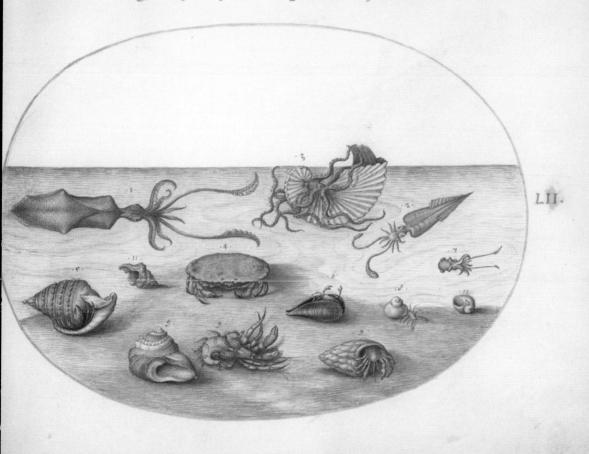

Tuq̃ comes ratium, tractiq̃ per æquora sulci:
Qui semper spumas sequeris Pompile nitentes.

Quis satiabitur videns gloriam eius? Ecc 42.

Nunc quoq̃ CORALIIS eadem natura remansit,
Duriciem tacto capiant ut ab aëre: quodque
Vimen In æquore erat, fiat super æthera saxum.

PLATE 21
Aqua, Folio LIII

Sepia tarda fugæ, tenui cùm forte sub vnda
Deprensa est, Jamiamqȝ manus timet illa rapaces:
Insiciens æquor nigrum vomit illa cruorem,
Auertitȝ vices, oculos frustrata seqüentes.
· 6 ·

LIII.

At contra Scopulis cuinali corpore segnis
Polÿpus hæret, et Sac eludit re tia frande:
Et sub lege loci sumit mutatqȝ colorem,
semper ei similis, quem contigit.
· 4 ·

.1.
Iste licet digitos testudine pungat acuta :
Cortice deposito, mollis Echinus erit.

Vine tibi tecumqʒ Sabita nec grandia tentes;
Effugit Immodicas, paruula puppis AQVAS

LIV.

Pronaq̈ cum spectent Animalia cętera terram:
Os Homini sublime dedit, Cælumq̈ tueri
Jußit, et erectos ad Sydera tollere Vultus.

PETRVS GONSALVS Alumnus REGIS GALLORVM
Ex Insulis Canariæ ortus: ⁓

Me Teneriffa tulit : villos sed Corpore toto
Sparsit opus mirum naturæ : Gallia, mater
Altera, me puerum nutriuit adusque Virilem
Ætatem : docuitque feros deponere mores,
Ingenuasq̈ artes, Linguamq̈ue sonare Latinam.
Contigit et forma præstanti munere Diuum,
Coniunx, et Thalami charißima pignora nostri.
Cernere naturæ licet hinc tibi munera : nati
Quod referunt alij matrem formaq̈ Colore,
Ast alij patrem Vestiti crine seqüuntur.⟶

Conparuit Monachÿ boiorum. Aº 1582. ―

Sed prior hęc Hominis cüra est, cognoscere terram
Et quæ nunc miranda tulit Natura, notare.

PLATE 23
Ignis, Folio I

Omni miraculo quod fit per Hominem maius miraculum est HOMO
Visibilium omnium maximus est Mundus, Inuisibilium DEVS
Sed mundum esse cōspicimus, Deum esse Credimus.

I

HOMO natus de MVLIERE, breui viuens Tempore
Repletur multis miserys. Job. 14.

Ex ore Infantium, et lactantiū pfecisti laudem.
propter Inimicos tuos .psal.8:

Domine quid est HOMO quod Innotuisti ei? aut filius
hominis quia reputas eum? HOMO vanitati similis
factus est, dies eius sicut umbra pretereunt .ps: 143.

PLATE 24
Ignis, Folio II

LAVDATE PVERI DOMINVM.

LAVDATE NOMEN DOMINI.

Confodit me vulnere super vulnus: Irruit In me
quasi GIGAS. Iob 16

Ad subitas Tracum Volucres, nubemq̃ Sonoram,
PYGMEVS parvis currit bellator In armis:
Mox Impar hosti, raptusq̃ per Aëra curvis
Vnguibus, a sæva fertur fine.

PLATE 25
Ignis, Folio III

Deum time, et mandata eius obserua, Soc enim est ōnis HOMO. Ecc 12.

IIII

Non est dignus nomine hominis: qui vel vnum diem
totum velit eße In voluptate. cic.

Cornibus armatus generat se Cantharus ipsum
Christus Somo sumet, solus origo fuit. A: s.

PLATE 26
Ignis, Folio V

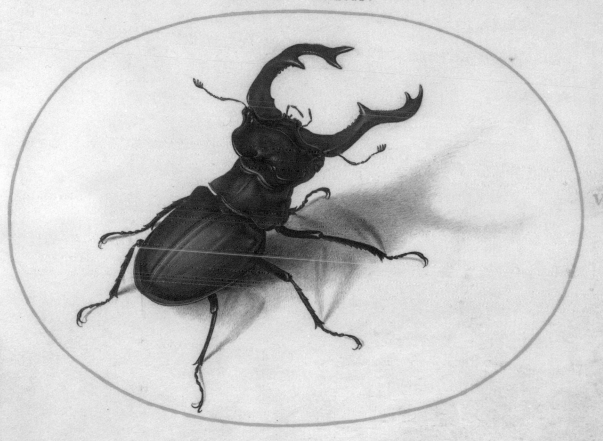

SCARABEI VMBRA.

Posuit oculum suum deus super corda hominum ostendere
illis magnalia operum suorum: vt nome sanctificionis
collandet: et gloriari In mirabilibus ei9 Eccus vj.

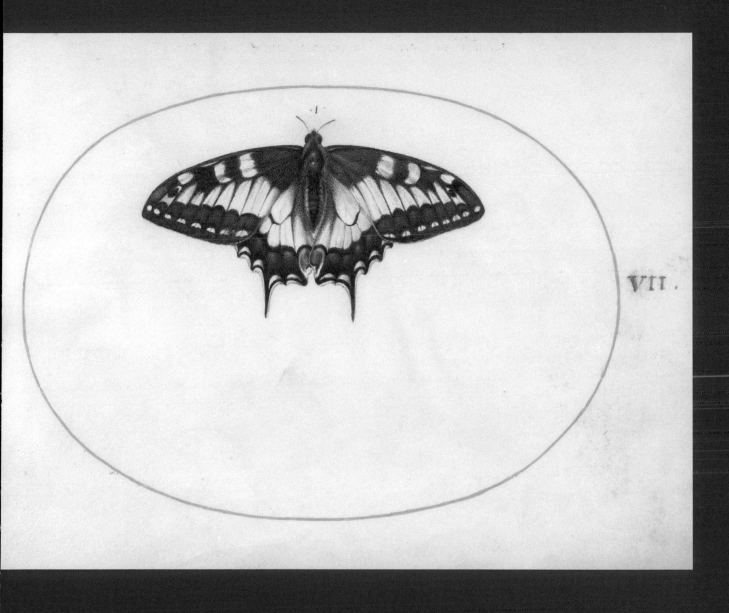

VII.

Suauis dominus Vniuersis: et miserationes eius
Super omnia opera eius ps. 144.

PLATE 28
Ignis, Folio XI

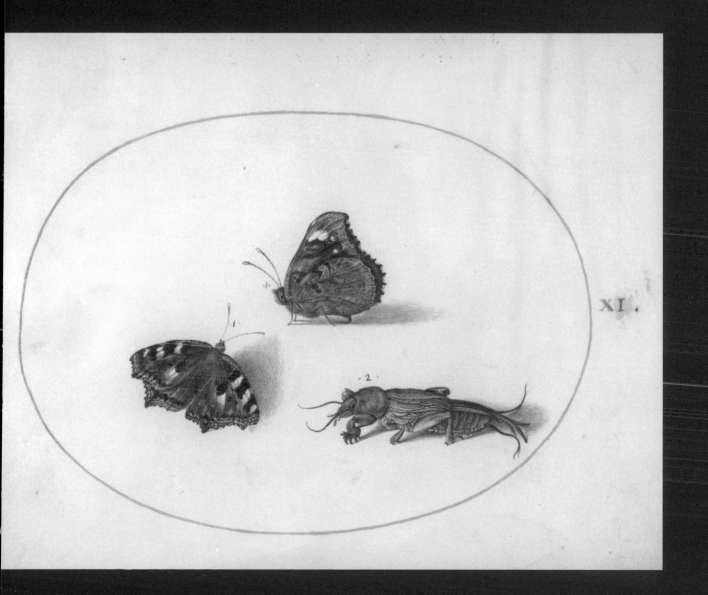

XI.

Confiteantur tibi domine omnia opera tua
et sancti tui benedicant tibi. ps. 144.

PLATE 29
Ignis, Folio XII

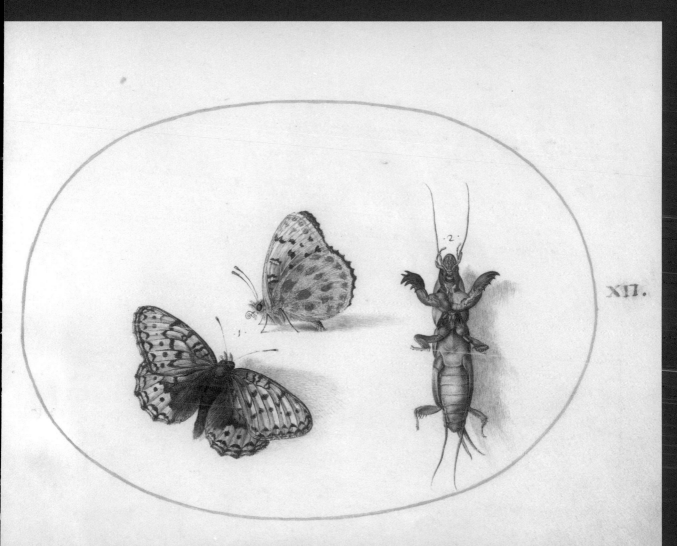

Ne Sumamis rationibus divina opera Curiosius excutiam?
Sed ex operibus manuducti admiremur artificem —

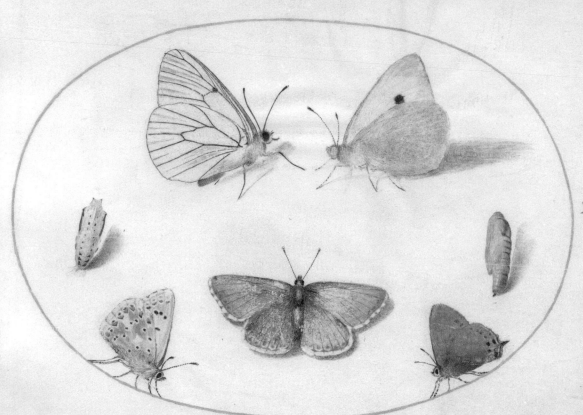

XVI.

Quam modo nascentem rutilus cospexit Eous.
Hanc rediens sero Vespere Vidit anum.

 Nulla est ita prouida tellus,
Vt non triste ferat quid: non ita perfidus vllus,
Vt non quid pariat mortalibus Vtile, campus.
Cernis vt vrtica, et spinis palimris acutis,
Purpureaȝ ROSÆ surgant, violisȝ propinqui. —

Mirabar Celerem fugitiua Ætate rapinam.
Et dum nascuntur consenuisse Rosas.

PLATE 31
Ignis, Folio XXIV

ROSÃ QVAE PRAETERIERIT, NE QVAERAS ITERVM.

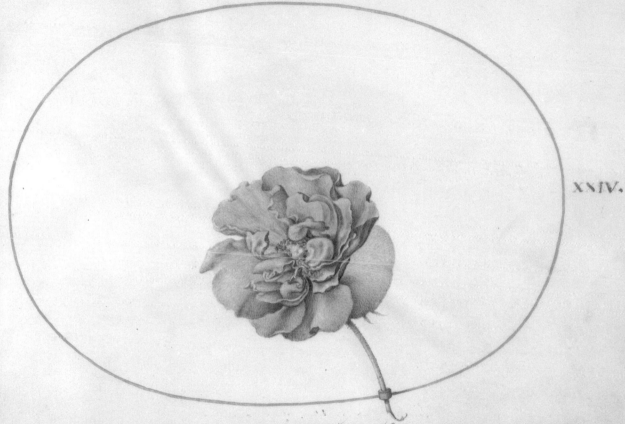

XXIV.

Ambigeres raperetne Rosis Aurora ruborem.
An daret, et flores tingeret orta dies.

Dicite Deo quam Terribilia sunt opera tua domine.
In multitudine Virtutis tuæ mentientur tibi
Inimici tui .ps.65.

PLATE 32
Ignis, Folio XXXV

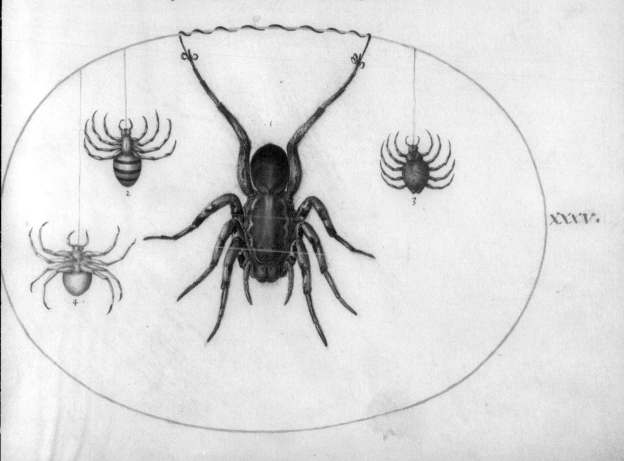

Dabo prodigia In Cælo et In terra: sanguinem et
Ignem, et Vaporem fumi. Joel: 2:

PLATE 33
Ignis, Folio XXXXIV

PRIVS LOCVSTA BOVEM.

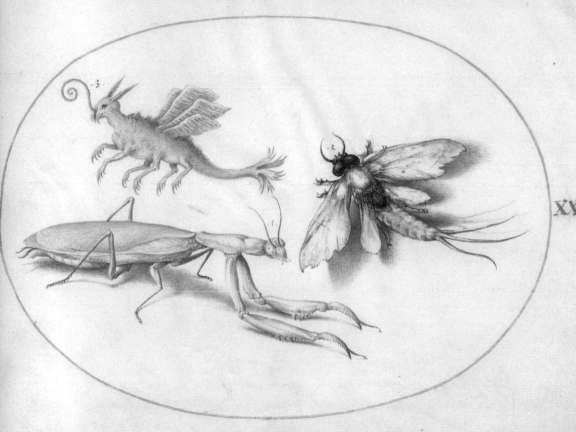

XXXXIV.

Dixit et venit locusta, et brucus, cuius
non erat numerus ps: 104: —

PLATE 34
Ignis, Folio L

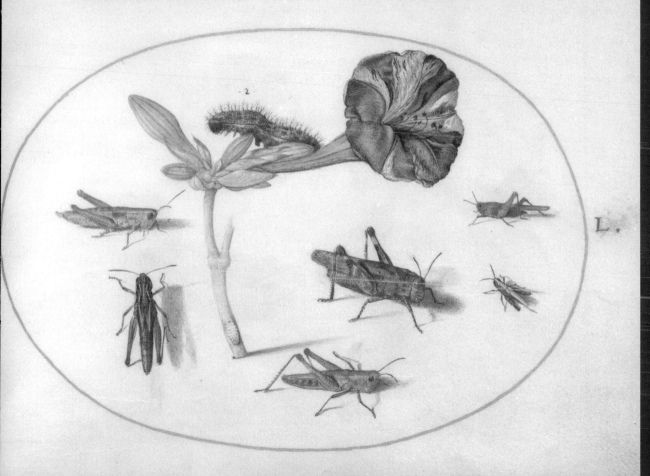

Benedicite Dño oīa opera ejus: In omni loco dominationes
ejus: Benedic anima mea Domino. pſ: 102. ㄴ

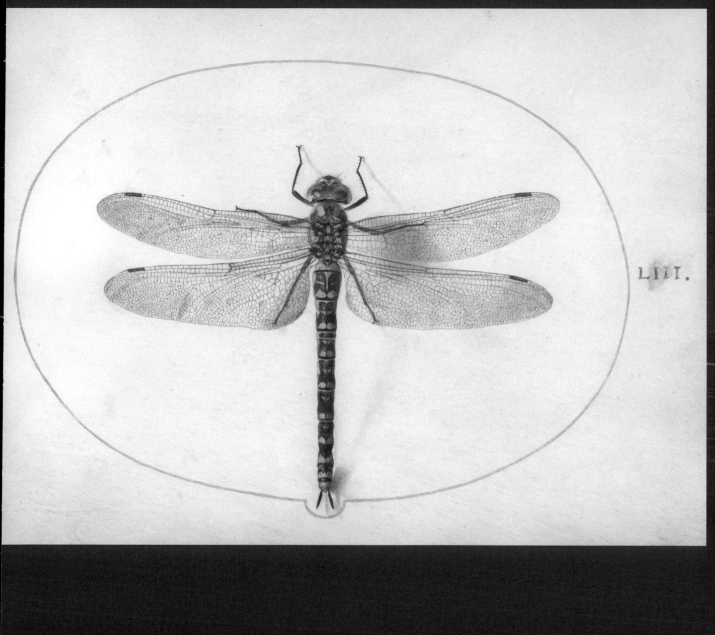

LIII.

Quis adiuuit spiritum dominj? aut quis Consiliarj?
eius fuit, et ostendit Illj. Isa 40..

PLATE 36
Ignis, Folio LIV

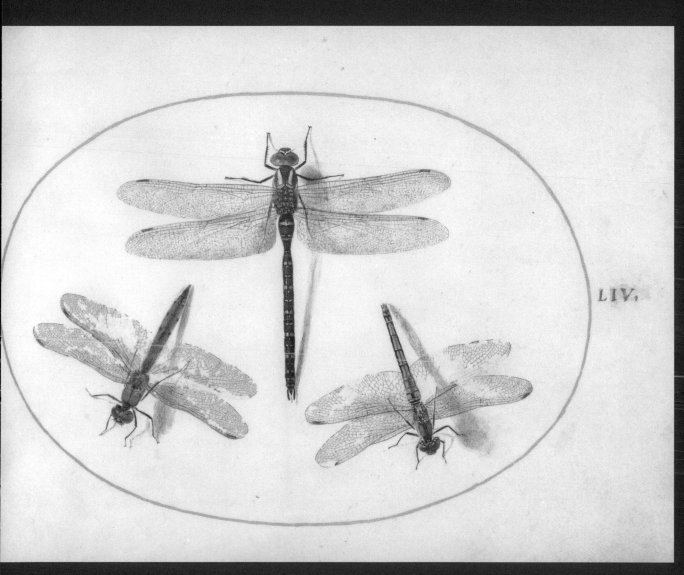

LIV.

Quid Imbecillius homine, quem morsus musculam necat?

PLATE 37
Ignis, Folio LX

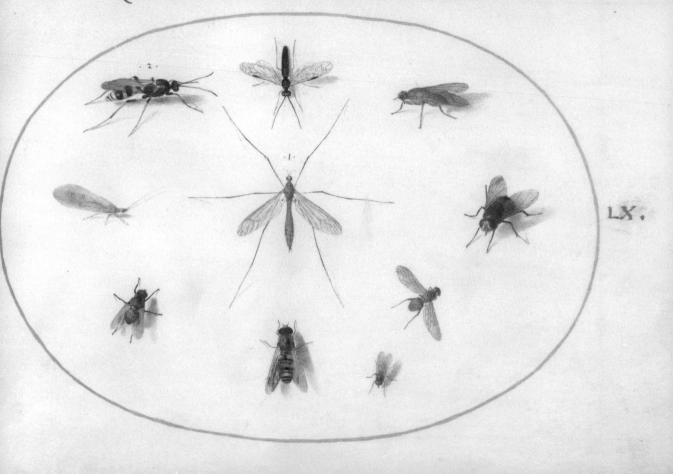

QVOD INVOCATVS CAENITARE AMO MVSCA SV̄.

LX.

Ipse cognouit figmentum nostrum : recordatus est
quoniam puluis sumus : Homo sicut foenum dies ei?
tanquam flos agri sic efflorebit . ps:102.

Amicitijs non est vtendum vt flosculis
tamdiu gratis quamdiu recentibus .

PLATE 38
Ignis, Folio LXII

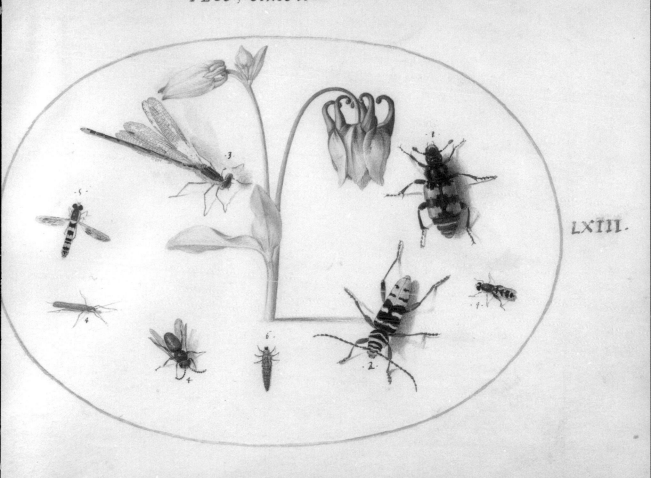

Non Laudes Virum In specie sua: Neq spernas hominem In
visu suo. Breuis In Volatilibus est Apis: et Initium
dulcoris habet fructus eius. Eccl: 11. mm

Dum puer alueolo furatur mella Cupido,
 Furanti digitum cuspide fixit Apis.
Sic etiam nobis breuis et peritura voluptas,
 Quam petimus tristi mixta dolore nocet.

In apes ne Iruas, ne malum feras. m
Illis ira modum supra est lethaqᵤe venenum
Morsibus Inspirant, et spicula Caeca relinquunt
Affixa venis, animasq In vulnere ponunt.

PLATE 39
Ignis, Folio LXIX

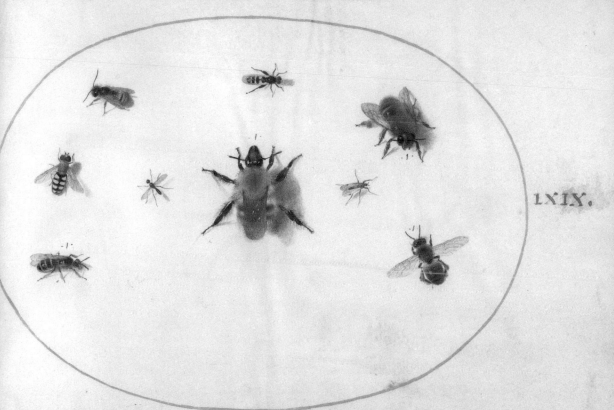

Ingentes animos angusto In pectore versant.

VBI MEL IBI FEL.

LXIX.

VBI VBER IBI TVBER.

Omnibus vna quies operum labor omnibus vnus.

NATURE'S UNMASTERABLE ELEMENTS

Animal Ingenuity

Images raise questions far better than they give answers. Their role in the early modern pursuit of knowledge (*scientia*) consequently fell within the first order of operation.[1] As one among the tools of the arts (*artes*), they were understood to serve on the path to further inquiry. For the sixteenth-century antiquarian and natural philosopher alike, images were instruments to harness alongside wide reading in textual sources and the investigation of the world as perceivable through the senses.[2] Of course, an image that successfully provokes thought does so, in no small part, by virtue of the skill and invention put into it.[3] But Hoefnagel—for all his virtuosity as an artist—was not one to mistake the means for the end.

In 1573, precisely around the time that Hoefnagel began the creation of his *Four Elements*, Ortelius wrote in the preface to his treatise on ancient coins, "We see that for serious investigators of Mother Nature, it is not enough unless they also have the animals themselves represented in figures (*figuris*) before their eyes."[4] Ortelius was drawing a comparison between illustrations of natural specimens and those of Roman coins in his own publication. These likenesses of gods reproduced in print, and derived from the numismatic record, offered compelling insight into the culture and spirituality of the pagan past (fig. 86). Nonetheless, as Ortelius makes clear in the rest of the preface, images augmented but did not supplant written scholarship; they were one additional piece of equipment to be employed in historical inquiry.[5]

Hoefnagel's miniatures of animals, insects, and plants were likewise crucial to his investigations, and themselves reflect a vast body of learning achieved through research and observational study. But his immediate aim was neither to master an encyclopedic knowledge of nature nor to demonstrate his representational mastery of nature's forms. *Natura magistra*, the motto that defined his earliest creative pursuits, has already proven to express the opposite view. Nature was not something that he mastered. She was the mistress of him. As he wrote in Ortelius's friendship album, Nature was the giver of all knowledge and all arts that served in the quest to achieve them.[6] She was the source of *ingenium*, and the *Four Elements* is the most prolonged exercise in ingenious invention that Hoefnagel ever undertook—a ruminative, imaginative, and manually arduous exploration of a world that he did

not hope to ever comprehend in full. The neatness of each ruled opening, gilded oval, and numerated page—every meticulously painted miniature and line of inscribed text—all index the decades over which Hoefnagel applied mind and hand to the question of what Nature had yet to teach him.

Hoefnagel's *Four Elements* makes sense only when considered in light of the material and humanistic practices that defined his Antwerp years. The emblematic mode of organizing thought and ideas; the pursuit of nature through firsthand encounters with foreign sites and topographies; and the treatment of the manuscript album as a space for collection, preservation, and exchange among friends—all fundamentally shaped the creation of these volumes. As the *Four Elements* took form over the course of Hoefnagel's later period abroad, it nonetheless remained a work driven by the concerns that also undergirded *Patience* and his lost albums of travel and friendship. Despite the project's long-standing association with treatises of natural history—and Hoefnagel's indisputable debt to their content—this protoscientific category of knowledge production was one to which he never intended his volumes to belong.

Here it is worth going back to the historiography for a moment. In a 1927 article, the Vienna School art historian Ernst Kris influentially wrote that Hoefnagel's oeuvre was defined by a "scientific naturalism" that led to his production not of "artworks" (*Kunstwerke*) but of "images" (*Bilder*).[7] With this distinction, Kris meant to separate Hoefnagel's representational goals from the larger course of naturalism in the history of art. He was defining Hoefnagel's works as oriented toward knowledge production—what more recent scholarship might describe as "epistemic images."[8] By this account, the illustrations produced and published by early modern naturalists would appear to be the closest analogue to those found in Hoefnagel's manuscripts like the *Four Elements*. For Kris, such illustrations were a different kind of cultural and historical project altogether: a by-product rather than an essential step in the developments that spanned from Jan van Eyck to seventeenth-century still-life painting. He therefore deemed Hoefnagel

FIG. 86

an eccentric whose intellectual concerns led him to operate outside the artistic tradition that he had inherited.

In the case of the *Four Elements*, it is clear that Kris's strict divide between *Kunstwerke* and *Bilder* does not hold. Hoefnagel drew extensively on models ranging from tromp l'oeil manuscript borders to Albrecht Dürer's nature studies and the illustrations in Conrad Gesner's *History of Animals*. In essence, all subsequent scholarship has been concerned with demonstrating that the *Four Elements* does in fact belong as much to the history of art as to the history of early modern "science," and that Hoefnagel's works are far less empirical than Kris would have had us believe. Yet within early modern visual practice at large, there is nothing especially interesting or unusual in the fact that Hoefnagel drew on existing sources perceived to have a certain authority, authenticity, or appeal.[9] Lost in this discussion of models is Kris's true insight, which I wish to resurrect: his recognition of the singularity of Hoefnagel's impulses as artist and thinker. If Kris's terminology was misleading, his struggle to understand the tension between Hoefnagel's aesthetic and his intellectual aims

(and the psychological motivations behind them) cuts to the heart of why the *Four Elements* has proven so challenging to categorize.

Hoefnagel drew extensively on the systematic account of the animal world offered up in Gesner's multivolume *History of Animals*. Gesner had achieved something unprecedented in combining a rich program of woodcut illustrations with various strands of classical, adagial, Aesopic, and emblematic wisdom. Ortelius praised the naturalist as an avid compiler of knowledge whose approach "promised much" for his own endeavors.[10] William Ashworth, inspired by Michel Foucault, foundationally characterized Gesner's treatise as an "emblematic natural history" in its privileging of association and similitude between the human and animal worlds.[11] Underlying Gesner's scholarship was the conviction that assembling such a wide range of information, and sharing it with a wide public, would result in the unlocking of nature's manifold secrets for humankind.

This is the first reason why the *Four Elements* should be recognized as distinct in intent, however indebted it may be to Gesner in substance. Hoefnagel's choice of the manuscript medium meant that his volumes were accessible to only a limited few and that he—unlike Gesner, Ulisse Aldrovandi, or other contemporary naturalists—did not collect and codify knowledge with the ultimate goal of contributing to networks of learning beyond his immediate circle. Even to speak of an intended "audience" for the *Four Elements* is misleading given how little we know of their reception. More productive is to consider Hoefnagel's friends as interlocutors in the development of the volumes, contributing thoughts and material to a project that they understood to belong to their creator alone. If anything, the *Four Elements* should be compared not to a natural history treatise but to the private "museums" of images, objects, letters, and other bits of information that encyclopedists like Gesner and Aldrovandi collected via their own research and collegial networks, and which included far more than they ever managed to organize and put into print.[12] Both Gesner and Aldrovandi understood the collecting and cataloguing of natural knowledge as a valuable endeavor in itself, and one essential to their pursuit of invention.[13]

Hoefnagel too seems to have valued his volumes as a source and stimulus for his inventive process. Notably, animals and inscriptions recorded in the *Four Elements* appear in many of Hoefnagel's other works. While one might posit that he kept a now-lost model book of studies, the simpler solution is to surmise that the surviving manuscripts of the *Four Elements* themselves served him as both model books and commonplace books over the course of his travels and courtly appointments.[14] The rare combination that Hoefnagel possessed of artistic skill and humanistic training is certainly one way to explain the volumes' hybridity as compendia of word and image. His learned orientation toward the manuscript book as a site of memory, an inner space of collected thoughts and images, also distinguishes Hoefnagel's volumes from what one might take at a glance to be their counterparts: the seventeenth-century animal books like those made by Rudolf II's physician Anselmus de Boodt, which were instead directed outward at a courtly audience.[15]

Second, the personal nature of Hoefnagel's enterprise meant that what he endeavored to convey on any given folio of the *Four Elements* was not a complete digest of knowledge about a given species. Rather, he represents in each case a series of questions both finite and infinite, or *quaestiones* (to borrow a term of classical rhetoric), some of which are resolved and others acknowledged as inherently unanswerable.[16] Hoefnagel posed these

questions to himself through a combination and interrelation of word and image. As with his visual material, his florilegia of texts stem from a wide range of sources including biblical passages, ancient and contemporary authors, and emblems. Many of these he found through their citation in Gesner's treatise as well.

Yet the manner in which Hoefnagel arranged his inscriptions and miniatures on the page—and his complex and varied pictorial compositions themselves—suggest associations that the format of Gesner's dense commentaries and simple woodcuts did not allow. To open a volume of the *Four Elements* is to reactivate a space of thought still in process, in which even the most complete opening does not present a closed case. From a material standpoint, it seems not only that the volumes are unfinished but that Hoefnagel never considered the project terminable. There are empty ovals in all four volumes, some of which have text but no miniature, which already suggests that he did not necessarily give primacy to image over word (Pl. 25).[17] Many more folios are ruled for text but include no quotations—their blank spaces conveying the silence that comes with acknowledging what still remains unknown.

The most recurrent *quaestio* that Hoefnagel posed across the volumes is in many ways antithetical to that which drove Gesner's anthropocentric project: if God bestowed on every animal species its own ingenuity, then what claim does humankind have to being exceptional? This question, as Hoefnagel framed it, reflected his uncertainty about the direction in which humanity itself was headed. His study of the animal and insect kingdoms emerged from the friction between his experience of war and his interest in the arena of inquiry that natural history had opened up. As with the views that he designed for Braun and Hogenberg's *Civitates*, Hoefnagel's *Four Elements* depended on the notion that his ability to understand the natural world was limited, but that it was the endeavor and not the outcome that mattered. In exploring the innate capacity for adaptation and survival among other creatures—from the largest to the most microscopic—Hoefnagel took up a philosophical stance premised not on mastery but on humility. He found solace in the relative smallness of the human conflicts that loomed around him when compared to the complexities of an infinitely diverse cosmos.

THEORY VERSUS PRACTICE

The titles that Hoefnagel gave to his manuscripts are both evocative and misleading. The ancient cosmogenic theory of the four elements traces back to the Greek physician and philosopher Empedocles, whom Aristotle himself cites as its originator.[18] Empedocles described a world composed of earth, air, fire, and water, in which those forces combined and recombined in various permutations to form all living creatures, including humankind. Via Aristotle and Hippocratic medicine, particularly Galen's writing on elemental theory, this notion provided a basis for a wide range of subsequent ancient and Renaissance thought on the natural world.[19] But when appropriated to inform the organization of objects within the *kunstkammers* and *wunderkammers* of Hoefnagel's later sixteenth century, the theory found a specific purchase.[20] The popularity of the four elements as a theme for serial artworks in this context paralleled the frequent representation of the four seasons. Both were means to encapsulate the dynamic cycles in the universe at large and to complement the organized bodies of learning that their patrons desired their cabinets to represent.

Arcimboldo's series of composite heads based on these two themes, first produced for the Habsburg emperor Maximilian II in 1566 but frequently copied thereafter, are archetypal of this phenomenon (fig. 87).[21] Arcimboldo's ludic paintings figure the animal, plant, and mineral worlds as collected—and literally contained—by human form and ingenious artifice.

FIG. 87. Giuseppe Arcimboldo, *Earth*, 1570. Oil on panel, 70.2 × 48.7 cm. Private collection.

But Hoefnagel did not commence his *Four Elements* under courtly patronage. It seems worth asking whether he even began with the elemental categories in mind or only fitted his work to this schema during his later tenure abroad—at either the Bavarian or the Rudolphine court. Doing so under the influence of his new surrounds makes a certain degree of sense. In any case, the evidence of rearranging and excerpting within the manuscripts frustrates any attempt to ascertain how coherent their organization was from the outset. And once again, we do not know at what point the volumes were bound. Either way, proceeding on the assumption that the elements provided the structural premise for the work does not prove especially satisfying. Compared with Arcimboldo's paintings, Hoefnagel's *Four Elements* evince far less concern with placing nature's species within a system that is either compositionally or conceptually consistent, or with the achievement of comprehensive knowledge that motivated collectors like his later patrons Albrecht V and Rudolf II.[22]

FIG. 87

Hoefnagel makes almost no explicit reference to the relation between the species that are his subjects and the titular headings under which they are arranged. In practice, he seems to have been guided instead by his own peculiar artistic and scholarly interests, which must have shifted and changed over the long course of the project's making. These interests also inflected the individual volumes differently. *Terra* and *Aier* (with seventy and seventy-one folios, respectively) are the most similar to one another in their emblematic mode of pairing image with extensive inscriptions, in their groupings of species that relate to those found in Gesner's treatise, and in the analogies they suggest between the human and nonhuman worlds. These miniatures are diverse and strange in their scenography and in the interspecies encounters that they stage. The earliest dated folios also appear within the latter two volumes, which may indicate that quadrupeds and birds were his starting point. They are, in any case, the focus of the present chapter, and the logical place to begin.

Aqua weighs in as the least ample volume, with only fifty-eight folios. It is the most repetitive in compositional approach and significantly less loquacious. By and large, the manuscript contains underwater medleys of fish and crustaceans in which it was seemingly a struggle to find opportunities for pictorial variation or clever textual commentary. The titular motto above one folio reads, "More mute than a fish," as if Hoefnagel were justifying his subjects' relative lack of expression (Pl. 17).[23] My next chapter deals with the more curious and original folios in the manuscript, which parallel themes that arise within *Terra* and *Aier* as well as those already manifest in his views for the *Civitates*.

It follows that *Ignis*, the most expansive and exceptional of the *Four Elements* manuscripts, is here treated last. With eighty folios in all, *Ignis* reflects Hoefnagel's sustained fascination with representing the insect specimens that populate it. Unlike the case of the

FIG. 88. Hans Verhagen den Stommen. *Indian Elephant*, third quarter of sixteenth century. Gouache on paper, 26 × 37.5 cm. Kupferstichkabinett der Staatlichen Museen, Berlin.

fishes in *Aqua*, the inventive possibilities posed by these creatures were seemingly limitless. The vast majority of the insects are studied from life—another quality that distinguishes this manuscript from the others—and yet they are situated within miniatures that are the most silent (in their minimal inclusion of text) and the most complex in their play between reality and illusion. The unique visual tactics employed in this volume index Hoefnagel's most far-reaching and unresolved questions about the natural world.

Before I turn to address these discontinuous approaches in further detail, it is worth making a final point about the project's nominal theme. When Hoefnagel alludes to the realms of earth, air, fire, and water in his accompanying inscriptions (which he does only rarely), it is almost always through the lens of scripture—and far more as a passing gesture than as a programmatic statement. Folio I of *Terra* is a good example (Pl. 1). The placement of the miniature on the recto first draws the eye to Hoefnagel's embodiment of an adage from Erasmus: "The Indian elephant is scarcely troubled by gnats."[24] The largest earth-

FIG. 88

bound quadruped of the animal kingdom lazily bats his trunk and kicks his front leg in response to the three pests buzzing around his head. His rough skin is immune to their threats, as the high-minded are unperturbed by minor scrapes or injuries, according to Erasmus's gloss.

The image derives from a watercolor by the Antwerp artist Hans Verhagen, whose animal studies were among the first of their kind produced within Hoefnagel's milieu and served as one of his many bodies of reference material (fig. 88).[25] The Latin names for Verhagen's pictured animals are inscribed on these sheets in Hoefnagel's hand-writing (*elephas*), which affirms his close engagement with them.[26] Verhagen's elephant may be the celebrated creature that traveled northward by ship from Lisbon and was processed through Antwerp in 1563: a gift from the king of Portugal destined for the same Maximilian II who owned Arcimboldo's *Four Elements* and *Four Seasons*.[27] Hoefnagel followed Verhagen closely in his representation of the animal's body, but his addition of the gnats and the playful wink in the elephant's eye are crucial in connecting his miniature to the titular motto above.

Only at the top of the opposite verso does Hoefnagel zoom out to the realm embodied by the volume as a whole, and he does so through an inscription that connects back to the image only obliquely. There a quotation from the Psalms declares: "How great are thy works, O Lord? Thou hast made all things in wisdom: the earth (*terra*) is filled with thy riches."[28] This is earth not as an element but as a synonym for the world of divine creation in all its diversity, which the scalar distinction between elephant and gnat might be taken to demonstrate. This theme is picked up by the inscription at the bottom of the page from the anonymous late-antique *Song of Philomela*: an alliterative elegy to the nightingale that contrasts the bird's melodic song with the less elegant sounds made by other members of the avian and mammalian kingdoms.[29] Although the verses were employed in the Middle Ages

as a comment on *garrulitas*—or the dangers of idle and unguarded speech—Hoefnagel disencumbered them from any moralizing message.[30] The phrase *barrus barrit* ("the elephant roars") sounds out the creature's voice as distinct from any other. Hoefnagel's frequent quotation from this poem elsewhere across *Terra* and *Aier* demonstrates his desire to show that the riches of God's creation manifest as much through sight as through aurality.

In a different color of ink, a final inscription in the middle of the verso attests to the gradual accumulation process through which Hoefnagel's volumes were formed.[31] These verses are excerpted in part from Natale Conti's poem "On the Hunt," first published independently in 1551 but then reissued in 1581 together with the Italian humanist's better-known *Mythologies*.[32] Hoefnagel must have discovered this poem later in the process of working on the *Four Elements*, as his borrowings from Conti primarily appear dispersed across the *Terra* volume within the same middle space that they occupy on Folio I.[33] Hoefnagel seldom filled in this space at all, and only when he had used up the other quadrants, as keeping it empty served to protect the miniature opposite from reverse blotting when the manuscript was closed.

The reason for Hoefnagel's particular interest in Conti's poem, and for his addition of its verses here, was the dynamics it explores between humankind's attempts to wield dominion over the natural world and the ingenuity demonstrated by animals in eluding our clutches. The "gentle ingenuity" (*ingenium mite*) of the elephant is praised on the grounds of the animal's eagerness to come to the help of his wounded companions. "The delicate hearts of the elephants are saddened by booty plundered and made happy by the honor of our affections," reads the opening line, in which "booty" presumably refers to the poaching of the animal's tusks. The sagacious and peace-loving creature might be hunted down or paraded as a prize through various courts and cities of Europe, but to him,

FIG. 89

we are just like the gnats buzzing around his head—a nuisance. Two lines that Hoefnagel added after Conti's verses explain that the life span of these imposing animals could be as long as two hundred years.[34] The elephant winks and waits patiently to outlive us all, trusting—as we should too—in the divine wisdom bestowed in equal measure across the natural world.

The perspective that Hoefnagel offers here proves even more peculiar in comparison to Arcimboldo's depiction of *Earth* from the series mentioned above. In the latter painting, the elephant's head is scaled down and subsumed into the face of a man formed from dozens of other four-legged creatures—its ear his ear, its eyes vacant, and its precious tusks defining the curve of his jaw. The creature is only one among the wonders of nature that humankind can capture and hold within its grasp. But in Hoefnagel's miniature, even as the elephant stands within the bounds of the frame, he also stands apart, cognizant of the innate capacities that God gave him. To honor the ingenuity of animals, so Hoefnagel implies, is to honor the workings of a universe as mysterious as it is beyond our control.

According to a central tenet of Empedocles's original theory, humankind's perception of the natural world was shaped by the combinatory and conflicting movements of the elements themselves. The cycles of nature were something we existed within and thus could never wholly view from the outside. The Stoics took a similar outlook with their concept of *sympatheia*, referring thereby to a common sympathy that bound all living souls not only to one another but also to the elemental forces of the cosmos.[35] Hoefnagel's own practice of investigating nature's creatures was guided far more by this kind of sympathetic approach than by any concern for classification. The volumes of the *Four Elements* may present on first glance as manuscript counterparts to Arcimboldo's serial paintings, but they are instead something far more unusual: a compendium of visual and textual introspections on natural philosophy, inflected by the journeys and experiences of the individual who made them.

MIMETIC OBSCURITY

It might be objected at this point that the format of the openings in the *Four Elements* still suggests a concern for keeping to a coherent structure—one that is emblematic by design, and which aligns the volumes with cabinets of art and naturalia more closely than I have allowed. Contemporary emblem books were increasingly conceived as virtual collections, ordered and arranged not unlike the objects in a *kunstkammer*, and there is no doubt that Hoefnagel's relational positioning of text and miniature across his folios was inspired by their example.[36] But Hoefnagel's approach to the emblematic mode in the *Four Elements* is far more akin to his use of it within his *Patience* album or to the way that it informed the *alba amicorum* that he inscribed: as an open-ended platform for personal reflection. Through his extensive readings in Erasmus, Hoefnagel had internalized the view that the human endeavor to circumscribe the natural world could quickly turn from the pursuit of wisdom to idle folly. From the history of Netherlandish art, he had also learned that images—long before they were recruited in the service of knowledge production—were means to expose folly's well-laid traps.

For Erasmus's contemporary Hieronymus Bosch, one creature above all others embodied the limits of human perception when confronted with the mysterious workings of nature.[37] That creature was the owl, and its capacity to see through the dark realms that our vision cannot penetrate surfaces in many of Bosch's works, including his remarkable drawing *The Field Has Eyes, the Forest Has Ears* (fig. 89).[38] The bird at its center imparts an uncanny message: as we endeavor to observe and understand the natural world, nature is always already looking back at us. A line inscribed at the top of the page reads, "It is indeed the mark of a miserable *ingenium* to always use what has been invented and never feel compelled to invent."[39] The owl knows well how to employ his own natural talent, but the question that hangs heavy in the air is whether his viewers can do the same with theirs.

A series of openings in Hoefnagel's *Aier* builds on Bosch's precedent.[40] On Folio LIV, Hoefnagel twice depicts a mighty eagle owl—the high-flying master of the strigine kingdom—ensnaring a rabbit atop a cliff in the background and then resting in the foreground plane (Pl. 13). But however menacing his stance, it is nothing compared to the shock of the subsequent Folio LV (Pl. 14). Three different species of night owls stare out from the page, each numbered and identifiable by the meticulous depiction of their physical attributes. Two little owls lurk in the upper left, pictured from both front and back.

A tawny owl with gleaming eyes peers out from the far right. But the short-eared owl below upstages them all with its fully spread wings and crisscrossing talons. The bird is shown in the act of mantling, a stance taken when an owl wishes to cover its captured prey from the sight of other greedy predators—and yet its talons are mysteriously empty. Turning to the next and final folio in the series, we are somewhat calmed by a group of captive long-eared owls and barn owls within the confines of a man-made platform (Pl. 15). Here the barn owl holds a mouse in its clutches: a presumed gift from its keeper that suggests domestication rather than unbridled conquest.

But the night owls of Folio LV are too arresting to be so easily forgotten. Poised between the poles of wild nature and human civilization represented by the two surrounding miniatures, they leave us wondering where we stand in relation to them. The absence of prey in the talons of the short-eared owl, despite the defensive stance it adopts, distinguishes its action from that of the other nearby captors of rabbit and mouse. It serves to signal something within the image that only the most discerning viewer will recognize. In the staring contest between the human and animal worlds that Hoefnagel has constructed, he—like Bosch before him—asks whether we are up to the task.

To meet that challenge, we might turn to the texts that Hoefnagel collected to accompany Folio LV. The two inscriptions surrounding the miniature on the recto both draw on the propitious associations between the owl and the goddess Minerva, which Hoefnagel took up in several of his independent miniatures.[41] The text above declares, "Many night owls hide under the rooftops," an enigma that Hoefnagel found in Gesner.[42] The phrase refers not only to the night owl's penchant for haunting the crevices of human dwellings but also to the coins of ancient Athens, which pictured Minerva's owl on their reverse: an embodiment of how concealed wisdom leads to profit. The text below the image, "The night owl flies," is derived from Erasmus, who likewise traces its origins to Athenian tradition and explains that the flying owl heralds a victory achieved through negotiation rather than physical force.[43] Hegel's seminal line, "The owl of Minerva spreads its wings only with the falling of the dusk," is descended from this adage and expressed his view that philosophical revelation always came late, that only when the actualities of history had matured did the ideals of philosophy acquire real substance.[44]

The owl takes on a still more sinister cast with the two inscriptions on the opposite verso. The text above, taken from one of Alciato's emblems (and quoted in Gesner), was allegedly written to lampoon the aging tragedian Sophocles for taking a young lover: "As the night owl perches on tombs, and the eagle owl on corpses, so my girl sits with Sophocles."[45] The second text, borrowed from Ovid's account of the abduction of Proserpina to Pluto's dark underworld, declares the owl "a fearful omen to mankind" and likewise associates the bird with the realms of death.[46] For the reader perusing the manuscript leaves in sequence, both quotations recall the foreboding message of the inscription above the eagle owl on the preceding folio, from the *Zodiac of Life* by the Neapolitan poet Palingenius: "Neither sea nor land nor air is safe wherever an enemy is present; it does little good to not be harmful."[47] Altogether, the commentary that Hoefnagel has assembled from these diverse sources presents the owl as a paradoxical bird: both sentient and sinister, wise and wounding.

Yet there is still one more inscription to be found, hidden within the image just to the right of the tawny owl's talons. Painted in gold like the oval that frames the miniature itself,

the letters that make up the phrase *in nocte consilium* ("counsel in the nighttime") are visible only when light catches them from a certain angle—an effect lost in reproduction (fig. 90). This is the Latin version of the saying "to sleep on it" still in common parlance today, and the vernacular use of which Erasmus already cites "among his uneducated fellow countrymen" (*ab idiotis nostratibus*).[48] Hoefnagel's point with this metacommentary, following Erasmus, is that all of us—educated or not—face the same limitations when confronted with that which we do not immediately comprehend. The night owls model the perspicacity and understanding that we can only hope to achieve through sustained patience and contemplation. Even then, we might have to wait for dusk to fall.

It should be observed, in the first instance, that the texts assembled on Folio LV much more closely resemble a selection of commonplaces than they do the inscriptions generally contained within emblem books. They are all topical in the sense that they take the owl as their subject, but none clearly serves an explicative function that guides the reader/viewer from representation to intended meaning. That some are inscribed in capital letters does not immediately indicate their role as titular mottoes, nor does Hoefnagel keep to a consistent structural pattern across his volumes that would allow for certain texts, given their placement, to be understood as functioning in the roles of subscript or commentary.

Hoefnagel's visual references within the miniature are similarly elusive. Comparison of Hoefnagel's tawny owl to the woodcut in Gesner's *History of Animals* reveals a close affinity in the pose of the two birds and in their placement on a conspicuously broken branch (fig. 91).[49] However, not only does Hoefnagel convey more detail about the owl's habits and habitat (information that Gesner instead provides in his text); he also surpasses his model through firsthand knowledge of the bird. Correcting the crude talons shown in Gesner's image, Hoefnagel has carefully observed the owl's distinctive grasp of its perch with two toes in front and the other two twisted behind: a dexterity that also serves the creature

FIG. 90

FIG. 91

when clutching its prey. And needless to say, Hoefnagel's media of watercolor and gouache allowed him to capture not only the variegated colors of the bird's feathers but also the haunting gleam of its all-seeing eyes—details that Gesner's woodcut could not convey in black and white.

FIG. 92. Joris Hoefnagel, *Missale Romanum (fol. 637v),* 1581–90. Österreichische Nationalbibliothek, Vienna.

Yet nowhere in the accompanying text does Hoefnagel tout his owls as observed *naer het leven* or signal his contributions as new and improved. There are neither deictic references to particular aspects of the image nor explanations of the birds' visible traits. This is true across the *Four Elements* as a whole. That individual species (like the night owls) are often numbered within a given miniature seems to promise such information without actually fulfilling it—as if Hoefnagel adopted an encyclopedic format only to deny its functionality.

A simple solution might be to posit that Hoefnagel made a pendant key for the *Four Elements*, which provided the natural-historical information not otherwise present in the extant volumes.[50] No such key either survives or is attested, but it is not inconceivable that Rudolf II requested for one to be made when the manuscripts entered his possession. Manuals were produced on occasion to accompany works destined for princely collections, particularly in the case of objects like scientific instruments that required specialized knowledge to understand.[51] Hoefnagel himself created one such manual to accompany the Roman Missal that he illuminated while in Munich (c. 1591–90) for the archduke Ferdinand II of Tirol.[52] The missal was later acquired by Rudolf II, in whose inventory it is listed along with "an exposition of the hieroglyphics (*hieroglyphici*)" constituting the work's decoration.[53]

The missal's final illuminated folio, among the Masses for the Dead, anticipates the kind of reception that this lost "exposition" suggests. At the base of the page, Hoefnagel refers to himself as a *hieroglyphicus* on a tomb slab that prefigures his own (fig. 92).[54] A long-eared owl, perched on the shovel used to dig his grave, evokes the Alciatan emblem he had cited already on Folio LV of *Aier*, while the beginning of a line from Ovid's *Tristia* inscribed on the shovel's blade suggests his fame will live on through his patron's appreciation of the work itself: "I will not be yours, earth, though I die today—so whether I have earned this fame through favor or a

FIG. 92

poem, I rightly give thanks to you, kind reader."[55] As with all his evocations of Ovid's exilic poetry, Hoefnagel's own sufferings as an émigré—the troubled past from which court offered refuge—reverberate in the background.[56] In this sense too Hoefnagel here proves a skillful hieroglypher, encoding his own life history in language that flattered the hand that fed him.

The popularity of hieroglyphics at the courts where Hoefnagel worked was spurred by the rediscovery of Horapollo's treatise on the subject in the early sixteenth century, and a flurry of scholarship that resulted from it.[57] But the more fundamental appeal of these symbols was that they were perceived to be a closed system. Despite the aura of their ancient

origins, their meanings were considered decodable and communicable so long as one had a guide to interpreting them.[58] As such, they served as an ideal hermeneutic for the realms of the *kunstkammer* and *wunderkammer* alike. Never mind that Egyptian hieroglyphs remained largely misunderstood in the period.[59] Hoefnagel's awareness that his patrons at court desired works that would affirm their mastery of universal knowledge was doubtless what spurred him to adopt the epithet of hieroglypher in this context.[60] How much bearing this approach had on the *Four Elements* is another matter. Comparison to the Roman Missal only puts the differences between Hoefnagel's commissioned works and the ones he made for himself into starker relief.

If treated as part of his working process, Hoefnagel's numbering practice within the *Four Elements* makes a certain amount of sense on its own and suggests that an accompanying key—if one ever existed—was not planned from the beginning.[61] Sometimes a numeral above or alongside one of Hoefnagel's textual excerpts does refer back to a represented animal or plant in the miniature that it accompanies, however inconsistently.[62] For instance, Folio XX of *Aier* shows five numbered birds situated at the edge of a body of water, though only the one labeled "2" receives textual commentary (Pl. 11). "It is prudent to imitate the *charadrius*," reads Hoefnagel's adaption of an adage discussed by both Erasmus and Gesner.[63] According to ancient legend, this bird had healing powers that vendors exploited for profit, hiding it from the view of afflicted customers until their sale was complete, as the very sight of the creature instantly effected a cure. To imitate the *charadrius*, according to Erasmus, was to cleverly disguise that which was useful.

De Charadrio. A. Lib. III. 245

FIG. 93

Although Hoefnagel doubtless knew Gesner's entry on the bird, his image of the *charadrius* is not indebted to the latter's woodcut (fig. 93).[64] In fact, it offers a far superior depiction of a Eurasian stone curlew (*Burhinus oedicnemus*) than its printed counterpart, which reflects observation from life as clearly as do Hoefnagel's impressively observed owls. When the later seventeenth-century ornithologist Francis Willoughby coined the curlew's name in the English language, he affirmed its identification with the *charadrius* of Gesner.[65] In short, Hoefnagel got it right, but nothing indicates that getting it right was his endgame. This composition of five species in profile, and in close formal relation to one another on the page, begs the question of their potential affinity—a question that underlies Hoefnagel's choice to arrange them together. But in his own endeavor of making these manuscripts, Hoefnagel had no compulsion to present a definitive classification or explanatory key. He was not, in the first instance, asserting findings for a publication or a patron; instead he was engaging in a gradual process of finding things out for himself—at most sharing his thoughts with a few close friends as he did so.

The mimetic obscurity of the *Four Elements* is an index of this process, and the most telling marker of Hoefnagel's eccentricity.[66] Renaissance artistic and poetic theory generally held up mimetic naturalism as an intrinsic moral good, which offered a mirror of the

world not only as it is but as God revealed that it should be.[67] By holding up a mirror to nature, scholars and artists sought to better understand how we should relate to the divine intentions underlying its creation. This was the aim of a naturalist like Gesner, and many of Hoefnagel's artistic contemporaries engaged in producing images in the vein of natural history. Unlike them, Hoefnagel eschewed confidence in the belief that mimesis would lead to moral or spiritual clarity. Instead, the keys that seem to unlock Hoefnagel's miniatures only point back to his underlying doubts. Would any amount of sleep ever really be enough?

WHAT THE HEDGEHOG KNOWS

As Hoefnagel's circumstances changed over the years that he produced the *Four Elements*, the project transformed with him. Although the progressive development of the volumes is difficult to trace beyond the few miniatures that Hoefnagel dated, a few folios from the project—on the basis of their content—can be situated within his time at the Munich court. These folios suggest that even as Hoefnagel took on the role of hieroglypher, and produced ever more skillful and allusive pictures, he still kept his sights on following the wisdom of Nature's example in the face of uncertain times.

A series of small mammals represented in *Terra* explore the virtue of defending oneself against enemies without resorting to force: an irenic position evident already in Hoefnagel's earliest works, and in his *Patience* album especially. A loose recto labeled Folio LIIII, which once belonged to the series, is surmounted by an inscription that justifies Hoefnagel's attention to the diminutive subjects on display (fig. 94).[68] "Industrious nature has brought forth nothing so small that it does not prevail in ingenuity (*ingenio*) or any strength (*viribus*)," read the verses again taken from Conti's poem "On the Hunt," which

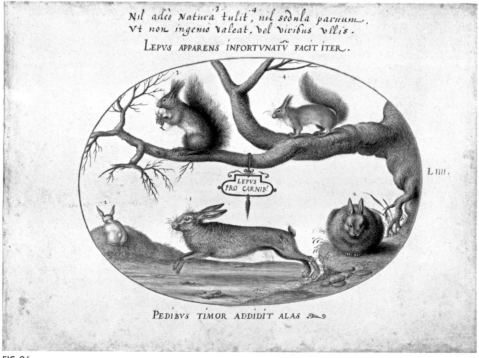

FIG. 94

FIG. 94. Joris Hoefnagel, *Squirrels and Hares (Folio LIIII)*, 1570s-1600. Watercolor and gouache, with oval border in gold, on vellum, 14.4 × 19.5 cm. Staatliche Museen, Kupferstichkabinett, Berlin.

FIG. 95. Detail of Fig. 94.

gloss the two Eurasian squirrels, the rabbits, and the fleeing hare caught in the still frame of the composition.[69] While suspended in mirror symmetry for the moment, even the animals not already in motion seem poised for ready escape; each faces away or against the turning of the page. The tree branch that defines the horizontal and vertical axes of the pictorial space also connects the numbers "3" and "4" above Conti's lines to the two numbered squirrels below—their ingenuity already implied by their watchful eyes and pricked ears.

Hidden on the branch beneath the ruddy squirrel is a gilded inscription that comments on the very act of hiding (fig. 95).[70] "She lies concealed" (*Latet abdita*) reads the phrase that Hoefnagel borrowed from the *Metamorphoses*, where Ovid's account of Rome's second king, Numa Pompilius, concludes with his wife, Egeria, retreating to a secluded forest to mourn his death. As with the maxim "to sleep on it" embedded within Folio LV of *Aier*, Hoefnagel has thickened the plot rather than giving away the ending. In the context of the miniature, it is the squirrel's ability to scale trees and remain hidden from predators that constitutes its particular nature-given virtue. This is a form of strength dependent not on physical might but on single-minded survival. Likewise, Hoefnagel glosses the hare scurrying through the picture's lower register with an adage from Erasmus ("the hare for meat") and a line from Virgil's *Aeneid* ("fear added wings to his feet").[71] The animal's swift flight shows his awareness of the hunter who seeks him out as game. "A hare appearing makes your journey ill-fated," reads the other Erasmian adage inscribed in red just above the ovular frame.[72] It is the human pursuant, and not his animal counterpart, who appears to be out of luck.

But the miniature also conceals something more in its juxtaposition of the running hare and the frontal rabbit resting in the lower right—even in the careful attention to the modulations of fluff that delineate the squirrels' bushy tails. Two watercolors by Hans Verhagen were again Hoefnagel's superficial source for the poses of the creatures on

FIG. 95

display.[73] Yet latent here is an evocation of the most celebrated depiction of a hare in sixteenth-century art: the obsessively copied 1502 watercolor by Albrecht Dürer, whose nature studies (and their progeny) Hoefnagel first encountered in Munich and again at the court of Rudolf II (fig. 96).[74] Placing Folio LIIII back in context leaves no doubt as to the intended reference. It would have been closely proximate to Hoefnagel's own direct rendition of Dürer's hare on what is now Folio XXXXVII of the *Terra* volume (Pl. 4). In the latter, by juxtaposing the real creature alongside a fantastical horned rabbit known as the jackalope, Hoefnagel poses a question at once intriguing and disingenuous: Which is more wondrous, the art of Dürer or a curiosity of divine creation?

Hoefnagel knew that Dürer's hare would not lie hidden for long, that it stood out within the *Four Elements* in a way that his other visual models did not. The hare was more than just another "figure" of the kind that Ortelius described as useful to the investigation of the natural world. Already in his own lifetime, Dürer was the northern European artist more associated with virtuosic invention than any other.[75] Hoefnagel's allusions to Dürer's art—and erudite demonstrations of ingenuity across his oeuvre—would seem to position him as a conscious rival to this legacy.

His friend Johannes Vivianus certainly suggested as much in dedicating to Hoefnagel a poem on Dürer's *ingenium*. Like Vivianus's verses on the self-portrait miniature of Giulio Clovio, this poem survives today only as copied down in Johannes Radermacher's personal manuscript and may well date to around the same time. Indeed, it too may have originally been penned for Hoefnagel's lost *album amicorum*. Although misattributed to Hoefnagel

FIG. 96. Albrecht Dürer, *Hare*, 1502. Watercolor and gouache, 25 × 22.5 cm. Albertina, Vienna.

FIG. 96

in past scholarship, the poem is recorded among a sequence of encomiastic verses that Vivianus wrote on various subjects, ranging from a portrait of Gerard Mercator to the Antwerp stock exchange.[76] So too the poem's title, "On Albrecht Dürer, in esteem of Joris Hoefnagel" (*In Albertum Durerum in gratiam Georgii Hoefnagel*), makes clear that Hoefnagel was the recipient rather than the author, and that Vivianus intended to praise the latter by aligning him with Dürer's paradigm:

> To the ingenuity of Dürer, who never exerted himself in vain,
> (Whom nobody has equaled in graphic art, and few in coloring).
> Not satisfied by the arts of peace, he likewise perfected
> The preparation and waging of war, and so cultivated both sides
> Of Minerva such that on his head, he bore a double crown.
> A German, he taught the Germans how to conduct war, and an art
> once undisciplined and scattered, he replaced with fixed principles,
> That he might lay out its precepts in beautiful order.
> You might think that you were watching Euclid as Socratic teacher
> In a great assembly, with [those of] Megara admiring his mathematical learning
> In discussing how far a line extends from a single point.
> Indeed Dürer is said to have given certain counsel to his homeland
> On uncertain matters. [This he did] that the Nuremberg people might possess,
> In a single citizen, brilliant signs of praise equal to all those bestowed on others.[77]

The poem's second line could be taken to suggest that while Dürer remained unequaled in graphic skill, there was still room for a Netherlandish miniaturist to come along who might surpass him in painting. But the crux of Vivianus's encomium is that Dürer was a thinker as much as an artist, someone whose treatises on geometry and military fortification, and whose insights into civil affairs, contributed to the betterment of culture as a whole.[78] In representing the German artist as an epitome of learning, Vivianus seems to realize that Hoefnagel—the friend whom he esteemed—was after more than the mere demonstration of painterly virtuosity. He recognizes in Hoefnagel and Dürer alike the phenomenon by which Erwin Panofsky once sought to define the Renaissance period as a whole: both embody a moment when the barriers that had long separated scholar and practitioner finally came down.[79]

Recent scholarship has more often linked Hoefnagel to a phenomenon of a very different kind: the "Dürer Renaissance"—a term coined to describe the avid (though not always erudite) production of posthumous copies of and riffs on the artist's works.[80] The courts that employed Hoefnagel were central to this development, though the collecting of Dürer's works was far more widespread; in Antwerp, for instance, Ortelius had already compiled an impressive collection of the artist's prints.[81] Among the contemporaries considered most exemplary of the "renaissance" in question was an artist whom Hoefnagel knew personally: the Nuremberg-born Hans Hoffmann, who was likewise lured to Munich and then to Rudolf II's court in Prague.[82] Hoffmann's numerous renditions after Dürer's nature studies, based on direct knowledge of the originals, are at once repetitive and quirky.[83] He had a particular obsession

with Dürer's hare, which he sometimes inserted into elaborate forest settings and, at other times, evoked by aping its restive stillness in his portrayal of other little beasts (fig. 97).[84]

FIG. 97. Hans Hoffmann, *A Hare in the Forest*, c. 1585. Oil on panel, 62.2 × 78.4 cm. J. Paul Getty Museum, Los Angeles.

Hoffmann's performance of these re-productions was compelled as much by the widespread veneration of his predecessor as by the pressures of supply and demand. Dürer's watercolors were far more scarce than his prints, and they consequently soared in esteem among sixteenth-century collectors and connoisseurs. Although Hoffmann sometimes forged Dürer's initials on his own works, just as often he signed his own monogram or dated them to their later sixteenth-century moment.[85] In every case, their appeal stemmed from the slippage between original and replica that they staged, and in their enactment of an exchange between two artists: one dead and one living. If not a Dürer, the next best thing was a clever approximation.

Yet the "Dürer Renaissance" is in many ways a misnomer for what it describes. A renaissance, as Boris Groys has written, effects a reinvention of the old with a drive toward the production of the new.[86] This is not what Hoffmann was up to. Rather, his works perpetuate an existing cultural tradition without reconceiving or moving beyond its norms. For the opposite reason, it is equally misrepresentative to say that Hoefnagel brought about a renascence of Dürer's art. Hoefnagel innovated by evoking past tradition only as something to move beyond, appealing instead to Nature herself as an extracultural source and stimulus for invention. As with Bruegel, Hoefnagel no doubt admired the *ingenium* of Dürer, yet he was not inter-

FIG. 97

ested in the emulation game that Hoffmann played so well. Instead, he found in Dürer an alibi for pursuing the directives of his own natural talent. Dürer was only human after all, and even the most virtuosic artist could never outmaneuver the ingenuity of Nature herself.

But there is also another reason why Hoefnagel did not concede to following along, why for him—to evoke Gombrich's classic formulation—making preceded matching.[87] Amidst the cultural and political upheavals of the later sixteenth century, Dürer's ideal pursuit of "fixed principles" in both art and war looked increasingly like a thing of the past. By the time of his appointment in Munich, Hoefnagel no longer had the luxury of contributing to the glory of his hometown, and "the arts of peace" were quite enough to hope for without cultivating the bellicose side of Minerva's crown. Hoefnagel's interest in the way that creatures cleverly hide from their predators and elude capture was as much about showing the diverse intelligences within the animal kingdom as it was about asking what lessons they might offer in the present. For an individual who had fled his troubled homeland, and who himself had to contrive new means to survive, those lessons mattered far more than perpetuating another artist's afterlife. Dürer's hare, which began as a nature study and became in Hoffmann's hands an archetype of his art, was for Hoefnagel a prompt to ask again why we study nature in the first place.

The opening in *Terra* immediately following the hare and jackalope (Folio XXXXVIII) addresses this question through a game of iteration (Pl. 5). The watermelon, guinea pig, central hedgehog, and his curled-up counterpart all echo the shape of the ovular frame that

surrounds them. But only one of these forms is as ingeniously and artificially contrived as Hoefnagel's composition itself: the body of the hedgehog in hiding, whom Hoefnagel singles out through the inscription plaque dangling from a ribbon above him: "No strength is anything but an error" (*vis nulla sed error*). Like a round of musical chairs, every time the eye circles through the picture, it lands again on the creature turned in on itself.

Vis nulla sed error may be a phrase of Hoefnagel's own invention, though it borrows a rhetorical formula that Cicero used more than once, and perhaps never more forcefully than in a passage cited by Lipsius in his controversial and widely read *Politics* (1589): "No strength of command will be lasting if it can be held only by the pressure of fear."[88] Lipsius's quotation from Cicero, which follows his chapter condemning the concealed forces of conspiracy and treachery, is employed to demonstrate that taxation, censorship, and execution—the instruments of rule by fear—are ineffective in securing a stable government.[89] The Duke of Alba had proved that to be true in the recent history of the Low Countries, though Lipsius never points the finger directly. Hoefnagel's Folio XXXXVIII is not in any sense a political allegory, but, like Lipsius's theoretical writing, it takes up an issue that had unquestionable bearing on the contemporary context. Indeed, Hoefnagel's portrayal of the cunning fox—the hedgehog's proverbial counterpart—in an earlier folio of the *Terra* volume shows that he was not above taking sides (Pl. 2). The miniature on Folio XXVII, surmounted by the adage "A fox is given away by his tail," mocks the creature by way of counterpoint. The baboon showing off his buttocks on the tree above and the legendary gulon (labeled "4") just below—a creature known for shitting constantly as he eats—are also given away by their behinds.[90] The fox may be clever enough to entrap the hen that lies dead before him, but he is still a consummate ass, and, as with the heretic with whom he was associated in medieval tradition, his plots will always be found out.[91]

The fox serves as antithesis to the hedgehog on Folio XXXXVIII as well, even if the connection is "visible" only through the adjacent texts that Hoefnagel provided. At the summit of the page, the first inscription reads, "The wise fox has discerned many things, the rough hedgehog just one· on which side of the world the vagrant wind blows."[92] This may be Hoefnagel's own variant on a familiar adage cited by Erasmus, and here conveniently inscribed at the bottom of the folio: "The fox knows many things, but the hedgehog one big thing."[93] In the comparison between the two forms of ingenuity evoked in the proverb, the wiles of the fox prove superior in quantity but not in efficacy. Erasmus cites several fables revealing that animals who employ diverse schemes are still often caught by hunters, while the hedgehog (like the squirrel and the hare) sticks to its guns and fends off the dogs every time. The gilded inscription in all capitals just above the miniature, "The rough hedgehog will never be made smooth," is in turn a quip from a comedy by Aristophanes on how hard it was for the Greeks to embrace peace and leave war behind.[94] We are all of us constrained by our own natures, but there is conflict enough in the world already that pursuing unnecessary battles has little virtue to recommend it. Hoefnagel, who took the hedgehog's view on history, insists that the error of relying on force could lead only to tragic ends.[95]

Finally, on the verso opposite Folio XXXXVIII, Hoefnagel left a clue that links his opening to the Munich court: this time through a textual rather than a visual reference. The lines inscribed in the upper register of the folio were written, as Hoefnagel indicates, by his Munich friend Anselmus Stockelius, to whom he granted a privilege that neither Ortelius

nor any of his other friends enjoyed: of composing original material for his volumes. It is clear not only that Stockelius was allowed to contemplate the manuscripts intimately but that he entered into conversation with Hoefnagel on the page:

> When the hedgehog perceives snares devised by the mighty,
> He soon curls himself up, closed within the defenses of his spines.
> Whoever wraps himself in his own virtue (*involuit virtute sua*)
> Applies himself to guarding against a thousand evils of fortune.[96]

Stockelius's penultimate line alludes to a poignant phrase from Horace's *Odes*. "I wrap myself in my virtue," says the poet when faced with the fickleness of fortune, declaring that one must attend to oneself before all else.[97] By no coincidence, this is also the final concealed inscription within Hoefnagel's adjacent image, painted faintly in gold letters (*mea me in virtute involvo*) on the branch just below the central hedgehog's feet. Stockelius combines the notion of self-defense with the pursuit of a virtuous life, showing thereby an understanding of the concerns that Hoefnagel was contemplating as he himself, guided by Nature, struggled to persevere against the blows of fortune.[98]

It does not seem too fanciful to imagine Hoefnagel and Stockelius hunting down sources together in the library of the Munich court, from which we know Hoefnagel borrowed books for use in his work on the Roman Missal.[99] And they certainly could have drawn on their well-stocked memories to riff upon the classical associations evoked by Hoefnagel's depicted worlds. His early years in Antwerp had taught Hoefnagel to forge friendship through scholarship, and it must have been a boon to find a like mind in his new surrounds. Perhaps he and Stockelius even discussed together the much-read commentary on Horapollo's *Hieroglyphics* by Piero Valeriano (1556), in which they would have found the curled-up hedgehog pictured as an emblem beside the same quotation from Horace, and praised for its *ingenium* in avoiding dangers.[100] But in the privacy of their exchanges, away from the watchful eye of their patrons, no further exposition was required. And there was no need for anyone to hide.

SOUND AND SILENCE

In an age of religious conflict, the prudence of keeping silent was no less crucial than keeping out of sight. Hoefnagel's condemned heretic in *Patience* already expressed as much through his evocation of the refrain "Mouth closed, purse closed" (see fig. 45). Far better to choose silence than to have it forced upon you. But silence is also an act of communication, one that gives voice to inner constancy, and which offers a means to rise above the relentless clamors of those consumed with worldly affairs.[101] Here too, Hoefnagel found that nature's creatures provided exemplars both virtuous and admonitory.

Toward the close of the *Terra* volume, Hoefnagel turns from mammals to reptiles, wavering between reference to the baser associations often ascribed to these beasts and his persistent concern to understand the purpose behind all God's creations. Two folios in particular stand out within this sequence for the density of their allusions. The first is set against the familiar harbor of San Sebastián off the west coast of Spain, which had figured already in some of Hoefnagel's earliest works (Pl. 7).[102] The site is identified by name in

gilded letters on the broken tree occupied by a female chameleon, who is nabbing a fly with her tongue. Her male companion (distinguished by his size and curved abdomen) weighs down the branch below her. Both take the place of St. Sebastian's martyred body as pictured in Hoefnagel's corresponding view from the *Civitates*—the jagged twigs of the branches in the *Terra* miniature almost echoing the arrows puncturing the saint's corpse (see fig. 44). Meanwhile, two tiny human figures walking along the beach guide the eye toward the town in the distance. They recall the depiction of Hoefnagel and Ortelius as eyewitness observers in so many views from the *Civitates*—and yet how small such investigations now appear compared to the creatures hovering in the foreground.

The chameleon's interpretation in the Renaissance was as shifty as the creature's coloring. The adage in red ink above the miniature, "More mutable than a chameleon" (*chamaleonte mutabilior*), is taken by Erasmus to refer to a person of inconstant character.[103] Numerous sixteenth-century emblem books accordingly figure the chameleon as a flatterer who (in Alciato's words) "feeds on the winds of popular approval and gulps down all with open mouth."[104] Yet Hoefnagel finds ingenuity and even divinity in the animal's adaptability, which overrides these negative readings—in a way that recalls Pico della Mirandola's famous positive characterization of humankind as chameleon in nature.[105] The lines from Ovid's *Metamorphoses* at the summit of the page compare the miraculous renewal of the phoenix with the chameleon "who feeds on the winds and air, and immediately adopts the colors of whatever it touches."[106] On the adjacent verso, two excerpts from the Psalms evoke God as the sole creator of wonders, who gives the earth and its many islands to rejoice.[107] All these passages support the quotation at the bottom of the recto from Palingenius's *Zodiac of Life*: "Who would believe it unless they had seen the fish living under the seas, frogs beneath the mud, salamanders in fire, the chameleons in air, and the cicadas feeding on the dew?"[108] In short, the chameleon is a marvelous example of divine creation to be admired rather than scorned.

Hoefnagel's citation here and elsewhere of Palingenius, whose other early modern admirers included the likes of Giordano Bruno and Shakespeare, bears noting in itself.[109] The *Zodiac of Life*, a didactic poem first published in the 1530s, achieved infamy on the papal index within two decades of Palingenius's death for its unorthodox melding of ancient and Christian learning, not to mention its condemnation of the Catholic clergy. By the later sixteenth century, the book had in turn earned a significant following among Protestant readers, particularly in England through Barnabe Googe's oft-printed translation.[110] The *Zodiac* is Platonic in construct with notes of Lucretian cosmology; through the latter, it traces back in part both to Empedocles's physical theory of the universe and to his poetic model.[111] Indeed, Hoefnagel seems to have found appeal precisely in Palingenius's attempt to grapple with the relation between the visible world and the celestial sphere, to acknowledge rather than attempt to contain the infinite. This is one of those cases when we cannot but wonder about the substance of Hoefnagel's learned exchanges with his many Protestant friends, however close to the chest he played his cards.

In his original poem, Palingenius employs the rhetorical question quoted by Hoefnagel to assert that gods and saints alike have no need of nourishment. Because they reside in the heavens above, so he writes, such bodily concerns are moot. Indeed, the diverse means of subsistence observable among nature's creatures affirm that heaven itself

exists—no matter how far beyond our grasp it remains.[112] Hoefnagel's chameleons, who thrive between the firmament and the lowly shores of human civilization, are thus neither turncoats nor flatterers but animals closer to the realm of the blessed than we are. And for this reason, they may have insight we lack. If the specter of the martyred St. Sebastian lingers in Hoefnagel's miniature, it is as a reminder that the chameleon modeled the safer path: camouflaging one's inner faith rather than exposing oneself to the dangers that come with open confession.

FIG. 98. "Jupiter and the Frogs," from Marcus Gheeraerts the Elder, *De warachtige fabulen der dieren*, 1567. Bijzondere Collecties, Amsterdam, O 80-876.

The chameleons set the stage for the subsequent Folio LIV in *Terra*, which turns from the heights of heaven to the slime of the earth (Pl. 8). This noisy gathering of frogs was originally followed within the volume by the now-loose miniature in Berlin: a representation of Hoefnagel's enemies in ranine guise (see fig. 7). The uninviting tree on the left side of the composition casts sufficient dread over the scene even before one discovers the overturned frog flailing on the right. The mouth of the source feeding the murky pool eerily mirrors in shape the gaping mouths of the creatures themselves. Whereas the chameleon wields its tongue with precision, the frogs bellow away as the earth reverberates with their noxious sound.

FIG. 98

Hoefnagel's composition on this folio is unusual in its derivation from a recognizable source: the Dutch emblem book of Aesopic fables financed and illustrated in 1567 by Marcus Gheeraerts, with accompanying verses by the rhetorician Eduard de Dene.[113] Hoefnagel and Gheeraerts themselves moved in parallel circles, and it is not unlikely that they were acquainted.[114] In 1568—the same year as Hoefnagel—Gheeraerts fled to England to escape execution under Alba's rule, having come under fire for producing images that satirized the corruption of the Catholic Church.[115] He made a temporary career at the English court, where his son Gheeraerts the Younger would remain to become a prominent portraitist of the Elizabethan age. But the elder Gheeraerts, among the first members of the Calvinist congregation in his native Bruges, returned to the Low Countries in 1577 and seems to have produced at least one propaganda print in the service of the rebels.[116] In this respect, his career more closely parallels that of his friend Lucas de Heere, whose poem "To the Reader and Viewer" tellingly appears among the work's prefatory materials. De Heere suggests in his opening lines that the emblems of Gheeraerts and de Dene are revealing of humankind's place in the divine plan: "Come you mortal creature, created after God's image, and learn from the animals how it stands with the world."[117]

This invitation is hardly as universal as it seems, since several emblematized fables in the 1567 edition conceive the world through the lens of the religious stance that de Heere and Gheeraerts shared. The fable "Jupiter and the Frogs," which inspired Hoefnagel's Folio

FIG. 99. Marcus Gheeraerts the Elder, *Allegory of Iconoclasm*, c. 1560-70. Etching, 43.5 × 31.5 cm. British Museum, London.

LIV, is one such case (fig. 98).[118] The story goes that when the frogs cried out to the heavens for a king, Jupiter threw down a log into their marsh and watched them scatter in fright. But soon, their fear having subsided, the frogs emerged from hiding and began to pay homage to their new ruler. Unsurprisingly, they found it inanimate and unresponsive. So jumping atop the log, they scorned their "new king" and began to croak yet again. This second time, Jupiter sent down a stork who—in de Dene's words—"stormed" (*bestoormde*) and devoured them one by one.[119]

Gheeraerts's illustration shows every stage of the story, collapsing the narrative into a single scene with Jupiter wielding the log in the sky, the frogs perched on the same log below, and the stork on the right enacting the god's justice. The message of de Dene's accompanying text is that one should honor and trust in the higher powers that be. But given

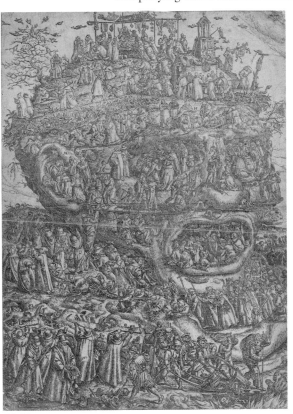

FIG. 99

that this emblem was published in the Netherlands just one year after the Iconoclastic Fury, it is hard not to see the log as embodying the emptiness of a false idol and the stork's attack as punishment for the frogs' heresy.[120] To Gheeraerts, after all, is attributed a contemporary etching that is one of the most grotesque visual embodiments of Catholic corruption produced in the sixteenth century: a monstrous head populated by a frenzy of indulgences, shrines, and votive gifts, while a group of Protestant iconoclasts (*beeldenstormers*) is shown calmly cleaning up the mess of misguided material devotion in the foreground (fig. 99).[121]

Hoefnagel's own miniature includes neither god nor stork but only the log fallen on the opposite bank of the marsh: the inanimate block of wood that the frogs have already rejected—and for all the wrong reasons. The emphasis lies on their ignorant croaking as a condemnable speech act: the very antithesis of productive discourse or well-placed prayers.[122] The phrase above the miniature combines two maxims borrowed, respectively, from Plautus and Cicero. All this "croaking over nothing" (*nihili coaxatio*) goes nowhere, Hoefnagel suggests, as "virtue consists in action" (*in actione consistit virtus*).[123] Not only is it what you do that really matters, but taking the wrong form of action—choosing idle words or misplaced devotions over measured thoughts and deeds—has even worse consequences. Another quotation from Palingenius at the bottom of the folio in *Terra* refers to a second fable from Aesop, which describes how "a frog, desiring to match an ox in a drinking contest, so utterly burst his own belly that he never drank again."[124] Paired in Palingenius's poem with the mythic falls of Icarus and Phaeton, the story exemplifies the failure to embrace prudence when faced with God's unmeasurable magnificence. Two lines from Googe's contemporary English translation suggest the path for mortals to follow: "Take good advise from harmes and hurts to flie, and gather things that may geve ayde, and live here quietlie."[125]

Palingenius's words sum up the approach that Hoefnagel espoused over his years of work on the *Four Elements*—from the onset of the revolt to his long tenure in exile. He sought guidance in what he gathered from and about the natural world, and found quietude in pursuing his inquiries through the silent medium of painting. The elements that God set in motion remained unmasterable, yet the virtue of making consisted in striving after knowledge of their workings all the same. To learn from the animals how it stands with the world meant weighing the lessons of nature's creatures in balance when shaping one's own life course, remembering always the consequences of flying too high or clamoring too loudly. In *Terra* and *Aier*, Hoefnagel keeps to this middle path, sticking close to the ground in the parallels he draws among animals, birds, and the human condition. But the fallen idol in the frogs' marshy pool—lifeless even before it hit the ground—also raised a threat that Hoefnagel, as a witness to the recent havoc let loose on his homeland, could not ignore. At a moment when images could as readily provoke thought as violent dissent, the purpose behind God's creations demanded scrutiny in the highest and the lowest corners of the visible realm, and a pushing to the limit of humankind's perceptive faculty. As a student of natural philosophy, Hoefnagel knew his bounds. As an artist, he bore witness that nature's forge held mysteries too powerful to leave unexplored—however unresolved his explorations might remain.

Fossil Forms

That fossils are specimens of petrified time was once anything but self-evident.[1] In the sixteenth century, petrification evoked more than the static remains of prehistoric animals and plants; it resonated as a metamorphic process that was always and still underway. Under the rubric of "fossil" fell corals, shells, starfish, sharks' teeth, and exoskeletons etched in stone, all of which were perceived as objects of continued liveliness and latent potentiality in the hands of early modern artists and scholars. The mutability of their forms and the generative forces they embodied meant that fossils occupied the interstitial space between nature and artifice.[2] Fossils were not just another manifestation of nature's power; they were objects that made visible the very traces of God's animating hand.

The emergence of modern paleontology was a long and gradual one, slowed by debates that raged throughout the seventeenth century (and well beyond) over the origins of fossils and their relation to biblical history.[3] The central question was whether God had created fossils ex novo or whether they were instead the result of catastrophic geological events like Noah's Flood. The discovery of fossils seemingly derived from creatures that no longer existed on earth led eventually to hypotheses about the extinction of ancient species. Only as the notion of a divinely controlled universe waned did the scientific investigation of fossils—and more precise distinctions between mineral and animal—fully come into being.

Hoefnagel participated in the nascent decades of fossil study when their status as miraculous artifices of nature was still of primary interest. The most intriguing folios from his *Aqua* volume address this question in ways both parallel to and distinct from developments in contemporary natural history. Gesner's foundational treatise *On the Nature of Fossils* (1565)—the first on the subject to include a significant program of illustrations—stresses the wondrous work of the supreme *artifex* in shaping nature's forms, and the attendant need for visual representation as a means to understand them.[4] Alongside his firsthand study of fossil specimens, Gesner drew inspiration from Pliny the Elder and his frequent comparisons between the works of nature and those of the visual arts.[5] Regarding stones in which "likenesses and images" appear, Gesner writes that "Mother Nature herself expressed in these things as much variety as in painting," thereby linking nature's art to the artful

enterprises of humankind (fig. 100).[6] Gesner goes on to acknowledge that painting is the province of admirable human endeavor, but that figures impressed on stones reveal—more truly than hieroglyphic ciphers—a kind of divine majesty surpassing that of any work made by mortal hands.[7] All the more reason, he explains, why an illustrated text is fundamental to comprehending fossils in all their manifold complexity.

For Gesner, the overarching goal was to classify fossils as a distinct category of natural objects and to inform their organization in collector's cabinets, such as the one depicted in the pendant study bound with his own treatise (fig. 101).[8] This "chest of fossil objects" belonging to the Dresden naturalist Johannes Kentman, as the accompanying key makes clear, organized various kinds of stones both by their material—flint, marble, and silver—and by formal qualities suggesting their facture through the morphing of waters, sands, and animal remains.[9] Kentman dedicated his published catalogue to Gesner, and the two men exchanged knowledge of mineral specimens as they prepared their respective treatises. The lines of verse appended to Kentman's cabinet, written by the Protestant antiquarian Georg Fabricius, mirror Gesner's own assertion that the study of nature offers a direct path to comprehending God's creative power:

> Whatever the earth has buried in its lap, and its sprung depths,
> Such are the treasures of the world that this small chest holds.
> Great is the glory in inquiring after the silent powers of nature,
> Greater still, through this display, is to come to know God himself.[10]

As with his investigations into the creatures of earth and air, Hoefnagel's own approach to fossils stopped far short of certitude about God's knowability. Amidst the wartime climate in Hoefnagel's Antwerp, these specimens were as much objects of playful inquiry as they were analogues for the unfathomable metamorphoses unfolding around them. For Hoefnagel and his Netherlandish colleagues, a nagging question undergirded their interest in the natural world: how to make sense of the divine agency behind the forces inciting

FIG. 100. Various fossils, from Conrad Gesner, *De rerum fossilium, lapidum et gemmarum maxime*, 1565. Woodcut. Universiteitsbibliotheek, Leiden.

FIG. 101. "Chest of Fossil Objects," from Johannes Kentman, *Nomenclaturae rerum fossilium*, 1565. Woodcut. Universiteitsbibliotheek, Leiden.

FIG. 100

FIG. 101

troubles in their native land. The ambiguity of fossil forms—their categorical in-betweenness and prodigious nature—offered this group of scholars and artists a salient problem on which to dwell.

THE MIND OF THE POLYP

Among the nature studies circulating in Antwerp when Hoefnagel began work on the *Four Elements* was an album of watercolors attributed in part to the artist Lambert Lombard.[11] The surviving album, which comprises careful studies of animal and insect specimens, bears a dedication to Emperor Charles V on its title page dated to the year 1542, but watermarks indicate that the work was augmented after Lombard died in 1566. That these additions arose within Hoefnagel's close circle seems likely, not least given the folio honoring the deceased artist in Ortelius's friendship album.[12] Whether the *Lombard Album* was complete by the time Hoefnagel laid eyes upon it, or whether his own animal and insect studies helped to inform the images within it, is less important than the evident dialogue between the two projects, and the ways that it reveals again the singularity of Hoefnagel's approach to representing the natural world.

One folio from the album in question constitutes a kind of thought experiment on the nature of fossil forms (fig. 102).[13] The carefully ordered composition pairs living creatures with their skeletal and fossil remains. In the upper quadrant, a hermit crab lies unclothed above its protective abode, while three snails travel across the page in counterpart to the

petrified shell in the upper left corner. This portion of the image recalls a folio toward the end of Hoefnagel's *Terra* volume, in which a small fossilized shell resides within the oval frame alongside three snails of varying color (Pl. 9).[14] The inscription above the latter miniature compares the snail to the winged horse Pegasus and evokes the fitting motto *festina lente*, "to make haste slowly." But it is not just the added text that distinguishes Hoefnagel's folio from its counterpart. The texture and slinkiness of the snails' slow-moving bodies—even the lightness of the shadows they cast—also show him the greater master of his medium, irrespective of his likely dependence on the *Lombard Album* as a source.

But the snails are not the most curious aspect of the *Lombard Album* folio, nor the one that most piqued Hoefnagel's interest. As the eye moves down the page, the morphological resemblances become stranger still. A prickly shell pursues a dialogue with a facing animal skull. A conch beneath them opens its lips as if to emit echoes of the seas on which it has tossed.

Cara Coles

FIG. 102

And below the last is a specimen that truly eludes categorization, and around which the entire image has been designed. The creature seems in the process of metamorphosing between animate and inanimate form: part mammal, part coral, part driftwood. It confronts the viewer with a watchful eye, all the more uncanny in juxtaposition with the vacated shells and empty socket of the animal skull nearby. The creature's pinkish tendrils suggest a potential liveliness akin to that of the hermit crab above, yet its seemingly hard outer surface shares more affinity with the shells that also frame it. The curt inscription in Spanish at the base of the sheet identifies its subject only as "snails," but the image itself is an open question, a provocation for further inquiry.

Hoefnagel took up the challenge of this curious specimen on the third folio of his *Aqua* volume, where he situates the creature in a very different kind of space (Pl. 16). Submerged in the sea rather than isolated on a blank page, the creature casts quiet ripples on the water's surface. A hirsute walrus floats above, whose exaggerated tusks and prominent male member affirm his bestial nature. Trailing behind are two open-mouthed fish, both labeled with the same number, who seem to share the walrus's appetitive instincts. At bottom center, an octopus boasts a display of nine tentacles: an anomaly that cannot be readily explained away by ignorance on Hoefnagel's part, particularly as eight-legged counterparts appear elsewhere in the *Aqua* volume (Pl. 21). Perhaps Hoefnagel had heard tell of a monstrous specimen and decided to include it here as a curiosity. Or perhaps the nine legs are based on a misinterpretation of the Latin text above, taken from Erasmus's *Adages* (*bis septem* means "twice seven" or fourteen, but may have been construed instead as "2 + 7"). Erasmus glossed the adage itself, "A polyp crushed with fourteen blows," as referring to the fisherman's practice of pounding a captured octopus in order to render it edible fare; by extension, he writes, an individual gains wisdom through the blows of misfortune.[15]

The polyp's embodiment of knowledge wrought by harsh experience finds expression in the Latin text below: *polypi mens* or "the mind of the polyp." This second adage derived from Erasmus's compendium sheds light in turn on Hoefnagel's understanding of the fossil-creature in the lower left.[16] Erasmus explains that ancient writers such as Pliny and Lucian described the polyp as an animal that changed color when absconding from enemies, camouflaging himself among rocks so as to hide in plain sight.[17] The adage thus "advises us to suit ourselves to every contingency of life, acting the part of Proteus, and changing ourselves into any form as the situation demands."[18] Not only does Erasmus evoke the demigod Proteus and his capacity for natural transformation; he also summons up Odysseus's ability to apply his adaptable wits in a pinch.[19] The mutable mind of Hoefnagel's polyp contrasts with the more simpleminded walrus and fish depicted adjacently on the page. At the same time, the combination of image and text suggests that the protean specimen, which in the *Lombard Album* was poised on the threshold between animate being and fossilized remains, in Hoefnagel's hands has instead become a cephalopod practiced in the arts of concealment, capable of ingeniously mimicking the process of petrification. Whereas the fossil's mutability depends upon the force of time, the polyp metamorphoses in the moment and by virtue of his own cognitive faculties.

Hoefnagel's recasting of the creature from the *Lombard Album* was a revisionist taxonomic move, one that he could have made through his wide reading and without empirical knowledge of the cephalopod genus.[20] Here as elsewhere, he sought to understand nature's

FIG. 103. "Duer Godts ghenade ben ic ghevaen," from Marcus van Vaernewijck, *Van die beroerlicke tijden in die Nederlanden*, 1566-68. Gent Universiteitsbibliotheek, Ghent.

protean forms as much with a naturalist's eye as with an emblematist's intent. One way to interpret the folio is as a collection of creatures of indeterminate category: the nine-legged octopus, the walrus that was thought to reside both on land and in the sea, and of course the polyp itself.[21] Yet as with his adaptation of emblematic structure in the *Patience* album, the valence of the folio may also extend from the universal problem of nature's anomalies to the personal lessons that might be derived from them. Indeed, the question of how to adapt himself to difficult circumstance not only echoes the message of Hoefnagel's *dum extendar* motto but also parallels his representation of animals like the chameleon in *Terra* (Pl. 7).[22]

On the accompanying verso, Hoefnagel gathered two quotations that resonate with the metamorphoses in his own life as an émigré. The lines above, "Thou by thy strength didst make the sea firm; thou didst crush the heads of the dragons in the waters," derive from the Psalms and from a larger passage in which God is beseeched to defend the afflicted peoples of Zion against their enemies.[23] The verses below are taken from Ovid's *Fasti*, describing the flight of the Arcadians to Latium and written on the verge of the poet's own exile to the Black Sea: "Every land is to the brave their country, as to fish the sea, as to the bird whatever place stands open in the void world."[24] The Arcadians, who fled to Italy prior to the Trojan War, faced a plight parallel to that of the Israelites. Both examples give added freight to Erasmus's message on the need to adapt oneself against misfortune. In the face of exile, the protean polyp modeled an artful ingenuity as a means to evade impending threats. Hoefnagel's own variegated pigments were his medium of expressing what could not be voiced aloud, of camouflaging in plain sight his response to the war unfolding in his native land. Like the fish of the sea, Hoefnagel had weathered the blows and bravely adapted to circumstance.

FIG. 103

Any doubts as to the plausibility of linking the polyp to the events of the revolt evaporate in light of a passage by the contemporary Ghent chronicler Marcus van Vaernewijck.[25] Van Vaernewijck's diary entry from late November 1566 recounts a Holland fisherman's capture of an octopus that was sold in Amsterdam as a curiosity, resold for a higher price, taken to nearby Utrecht, and likely destined to travel farther southward to Antwerp.[26] Van Vaernewijck describes how the eight legs of the monster were covered "in white suction cups, very much like the white cups of the Beggars (*geuzen*)."[27] The word *geuzen* refers to the adopted name of the Netherlandish rebels who had taken up arms against Spanish dominion, and who carried beggars' cups at their sides to represent their plea for peace.[28] To emphasize the point, van Vaernewijck even includes a rare drawing in his chronicle portraying another octopus found off the coast of Holland that same year, the likeness of which he reports had been circulated in the form of a print; the image shows the creature's tentacles upturned so as to display the suction cups in question (fig. 103). The inscription above in both Dutch and French declares, "By the grace of God I was caught;

one can understand great wonder through me."[29] The parallel between the octopus's cups and those of the Beggars was taken to mean that God was on their side and would send help to their shores.[30] Although van Vaernewijck voices skepticism regarding this interpretation, he acknowledges that because God "made all things by his divine will in order to show us his wrath," there was much to learn from the monsters of the deep.[31]

The difference between the Beggars' interpretation of the octopus and Hoefnagel's treatment of the polyp is as telling as their common subject. Within the political sphere, the captured creature was a fixed and portentous omen signaling that help was on the way. Hoefnagel's personal ruminations instead led him to consider the mutability of the polyp's mind as a model through which Nature revealed—but did not dictate—a course of action that an individual could choose to adopt. The world offered up many mysteries in the form of fossils and subaqueous dwellers—all of them prodigious manifestations of divine creation. Yet it was still up to humankind to shape its own path. Investigating nature, as Hoefnagel understood it, did not lead to knowing God in full. But it did suggest means to navigate the straits of troubled times.

A DROP IN THE BUCKET

A striking series of images among the last folios of *Aqua* moves from the study of the individual objects of nature to the probing of their origins. The series opens with a miniature of a fanciful crab tied by a ribbon to the oval frame. As a specimen in a collector's cabinet, it might have shared space with the three shells casting drop shadows below (Pl. 18). Hoefnagel stays with this mode of display on the subsequent Folio LI but zooms out to show a microcosmic diversity of slugs, insects, mollusks, barnacles, and bits of rock that seem to have been exhumed from the shore (Pl. 19). The labeling is meticulous—a full seventeen different specimens in all—some bearing the same number but shown from different angles. The accompanying texts dwell on the marine gastropod numbered "3," from which the ancients derived the Tyrian purple used to dye their robes. Below the image the lines from Martial's *Epigrams*, which are spoken from the perspective of the gastropods themselves, declare man an ingrate for coloring cloaks with their blood and then eating them in turn.[32] The specimens labeled "2" appear to be enlarged representations of the creature itself, extracted from its shell and cut open to reveal its purplish core.

However, Hoefnagel's glosses on this folio do not account for the spectrum of strange things on display, which—unlike those on the preceding page—present far less as static curiosities than as creatures with their own agency. The goose barnacles labeled "13" in the upper right of the composition were thought to have been born from the ocean's spume, transforming first from fungus to shell, and then opening to emit the feathery beginnings of the fowl that would emerge fully formed from their interior.[33] Hoefnagel likewise depicts the goose barnacles in *Aier*, as if to demonstrate their simultaneous belonging to the categories of air and sea; there he shows the barnacles attached to a log and strands of driftwood on the shore, where they are juxtaposed with a living goose standing in proud profile (Pl. 12). One barnacle, just left and above the head of the fowl, is opened to showcase the filaments that grow within it. The goose barnacle confounds classification—aqueous and avian, living creature and fixed shell—in a manner consonant with the tensions of Folio LI from *Aqua*.

Hoefnagel's carefully arranged objects on the page likely reflect his knowledge of the shells and stones that were being collected and exchanged in his contemporary circle, as the correspondence of Ortelius affirms. The latter's cabinet was formed—like many scholarly collections of the period—through the circulation of specimens transmitted across Europe, often accompanied by written debates over their origins and nature. In 1579, Ortelius received a compound rock as a gift from the jurist Johannes Gevaerts, described by the latter in his accompanying letter:

> As I know you to be most studious of all miracles (*miraculorum*) of nature, I send you this stone in which you will be able to observe nature's wondrous cunning (*solertiam*), since indeed, even beyond the pebbles echoing within it, you will see the various and diverse shards of shells, slugs, snails, and mussels, which have been transformed by some wonderful metamorphosis (*metamorphosi*) into stones.[34]

The language that Gevaerts employs in this passage animates the stone as the product of nature's metamorphic processes, at once miraculous and demonstrative of the ingenious craft at play in specimens of this kind. The echoes of shells and insects within the stone evince yet again that nature eludes the boundary between animal and mineral, animate and inanimate. This may reflect in turn Hoefnagel's intentions on Folio LI, namely, to show how these various entities—stone, insect, shell—interacted before they cohered through nature's playful artifice.

Ortelius offers his own ruminations on fossil forms in a later 1589 exchange with his nephew Jacob Coels. The latter had fled with his Protestant family to England in 1563 to escape religious persecution in the Netherlands, and there became a prominent member of the London circle of naturalists.[35] Aware of an ongoing dialogue on the origin of fossils between Coels and the English historian-adventurer Richard Hakluyt, Ortelius proves more interested in posing questions than in hazarding answers:

> I am pleased by the discourse you are pursuing on fossilized shells. You desire to know what I think about them. I would say that I am of divided mind and willingly confess that I am more perplexed than knowledgeable about anything on this matter. If the shells were once alive, I would ask why they are more readily found in mountains rather than valleys? I would inquire as to why it would not be the creature that hardens into stone rather than the shell itself. But your friend [Hakluyt] will say that the shells were empty before either the place or land that preserved them hardened into stone. That may be the case. But then why does the bivalve itself not petrify as well? Does it then follow that sands do not always remain sands but were turned into stone? Perhaps one might say that they are no longer turned but were turned, doubtless before the Flood. I am more of the mind to agree (though I do not believe it firmly) with the judgment of those who think that these forms were created thus by ludic Nature from the start, without any metamorphosis.[36]

Spanning from mollusks to sand to stone, Ortelius's considerations also shift from the biblical Flood to natural transformation as explanations for the sites where fossilized shells are found. But as his evocation of "ludic Nature" suggests, he tended toward understanding fossils as deliberate and playful artifices and rejecting the notion that they were formed by gradual metamorphosis. Still, in the next line of his letter, Ortelius defers conclusion by pointing his nephew to another source: "Have you ever read the *Niloscopium* of our friend Becanus? If you delight in matters and questions of this kind, you would by chance read it not without enjoyment."[37] Ortelius is referring to Johannes Goropius Becanus's influential 1569 publication *The Origins of Antwerp*, which includes a chapter on the evolutions of the natural world and the origins of fossil specimens, alongside a chapter on the ancient history of giants.[38] Becanus emphasizes that fossils are the products of miraculous transformations in nature well exceeding the art forms contrived by the human hand; he also cites fossil finds in Antwerp as evidence of the region's antiquity.[39]

Taking his cue from Becanus, Ortelius proceeds in the denouement of his letter to appeal to a specific example. He refers to a specimen from his collection that was likely an ammonite: an extinct mollusk species known only through its fossil remains. He implies that Coels had also studied this curiosity firsthand. "I have seen here in Antwerp a snail rolled in a coil that was dug up from our soil," Ortelius writes, "which in its magnitude you have seen to be my largest specimen. You know its diameter to be equal in measure to a human foot. For this reason, here I would admit metamorphosis. For who will persuade me that so large a creature once lived? Neither men nor letters."[40] In the absence of any theory of extinction, Ortelius can only understand the fossilized ammonite as an entity that was once something other than what it is now.

Ortelius's openness to this nascent paleontological debate parallels the next three folios that follow in the series from Hoefnagel's *Aqua* volume. Progressing from the still-life format of Folio L and Folio LI, Hoefnagel shifts to landscape compositions showing interactions between the sea and sandy coasts where fossils of marine specimens were often discovered. On Folio LII, we encounter several squid, an imposing nautilus, and a cluster of hermit crabs on the shore that are in various states of emerging from their shells (Pl. 20). On the subsequent Folio LIII, two more squid and an appropriately eight-legged octopus float above a beach populated by shells, starfish, sea cucumbers, and corals (Pl. 21). Both of these folios are glossed with lines from the pseudo-Ovidian poem *On Fishing*, describing the arts by which sea creatures entrap their prey and conceal themselves from attack.[41] The pairing of cephalopods with shell-dwellers recalls the implicit debate in which Hoefnagel engaged concerning the ambiguous specimen from the *Lombard Album*. Particularly on Folio LIII, the overlap between the curling legs of the octopus, the branches of coral, and the arms of the starfish implies again that Hoefnagel is exploring not so much taxonomic distinctions as the relational resemblances between living creatures and hardened specimens discovered on land—much as did Ortelius in his query to Coels on the origin of fossils.

The series, as now preserved in *Aqua*, further extends these relations to the ways nature interacts with the course of human fate. In a rare instance within the *Four Elements* volumes at large, Hoefnagel includes on Folio LIV a sign of human presence: a tiny ship sailing just past the rocky cliff in the distant background (Pl. 22). The vessel appears off a shore inhabited only by echinoderms, arranged both on land and floating on the water beyond as if they were sea

FIG. 104. "Secreta revelat,"
from Joachim Camerarius,
*Symbolorum et emblematum
(IV)*, 1654. Royal Library of the
Netherlands, The Hague, 488
D 36.

monsters far larger and more menacing than the ship itself. Again, Hoefnagel titles the folio with an adage from Erasmus: "A sea urchin is rough all over"—a phrase used to describe individuals who are intractable in any negotiation or quarrel.[42] The opposite verso includes another quotation from Martial's *Epigrams* on the "bristly armor" of the urchin's outer shell, emphasizing that the creature's defenses are only surface deep.[43] Still, Hoefnagel expresses the futility of trying to face off against such well-armed combatants when he quotes the pseudo-Ovidian line in the lower left: "Live for yourself and reside with yourself, and do not try great things. The small ship flees unruly waters.[44]

Lucas de Heere had already conveyed a similar message in his drawing of the siren for Hoefnagel, in which steering clear of treacherous shoals was as essential to an individual's spiritual journey as to the continued pursuit of art (see fig. 80). Yet Hoefnagel's compositional inspiration more immediately derived from an emblematic tradition that goes back to Alciato, one that his friend—the German naturalist Joachim Camerarius the Younger—

FIG. 104

likewise employed as a strategy for representing a diversity of sea creatures.[45] In Camerarius's emblematic natural history, the fourth and final volume (published only posthumously in 1604) includes several such compositions glossed with messages about the dangers that lurk for those seeking to follow the course of true faith (fig. 104).[46] A letter that Hoefnagel wrote to Camerarius around 1589, dating to his time in Munich, intriguingly reports:

> I am returning your book of animals, which I used as much as my service allowed me—but not as much as I wanted—and I thank you infinitely for the long patience that you have had with me. I will not leave off recognizing this benefit by keeping my promise at such a time when I get a little repose from the service of my two patrons, our duke [Wilhelm V] and the archduke Ferdinand. I remain and profess myself obligated to you to serve you and yours, wherever I am able, with my weak strength.[47]

The "book of animals" for which Hoefnagel expresses such gratitude was perhaps a manuscript collection of Camerarius's own preparatory material, given that the first volume of the latter's emblems was not published until 1594.[48] Not only does the exchange suggest that artist and naturalist collaborated in their study of nature; assuming that Hoefnagel followed up on his promise to reciprocate in kind, his shoreline compositions from the *Four Elements* may in turn have inspired those later published in Camerarius's 1604 volume. Hoefnagel's repeated emphasis on the cumbersome obligations of court service also frames his exchanges with Camerarius as part of his own learned pursuits during the rare stolen moment of leisure. Although Hoefnagel does not specify how he used the book that was lent to him, his language ("as much as my service allowed me") may well indicate a distinction between the *Four Elements* as a personal project and the commissioned works like the Roman Missal for the archduke Ferdinand, which he was still busy completing at this time. Regardless, Camerarius emerges here—alongside Anselmus Stockelius—as a key friend and interlocutor during Hoefnagel's tenure at the Munich court.

But it was still his fond memory of Ortelius, and his reminiscence of their travels together, with which Hoefnagel chose to conclude this series of openings from *Aqua*. This

sequence once extended beyond the five folios discussed above to include at least two others, which are now preserved as loose sheets in Paris and Berlin, respectively. They shift format yet again from imagined shores to site-specific backdrops that Hoefnagel sourced from his drawings for the *Civitates*.[49] The first, in Paris, now somewhat yellowed and faded, echoes Hoefnagel's composition of Naples and Mount Vesuvius, which was published in book 5 of the atlas (fig. 105).[50] Whereas the foreground of the scene in the atlas is populated by human figures, in the miniature they are replaced by shells of uncannily large size.

These shells might be taken for treasures that Hoefnagel had himself collected on the shores of Naples, with the landscape as an index of their provenance. Yet the bay, which Braun describes as "well known to contain the work of delightful nature all in a single place," was hardly an incidental backdrop against which to display such finds.[51] Braun's account of Vesuvius includes a lengthy excursus on the subterranean fires and fumes emitted from its core. Braun also cites extensively from the description of the volcano by the ancient geographer Strabo, whose treatise was an important locus classicus for the debate over why fossilized shells are found in mountainous and inland locales.[52]

In the Paris sheet, the transmutations of shells from sea to shore—each various and variegated on the outside while concealing the possibility of inner life—make them miniature analogues for the wonders of the mountains beyond. Recall that in their exchange on the nature of petrified forms, Ortelius had asked his nephew Coels why shells were more readily found on mountains than in valleys. Hoefnagel's miniature likewise implies a curiosity about geological processes and the heights to which the sea once rose, and may even reflect discussions with Ortelius on the subject. The specimens depicted are more than the fruits of a leisurely gathering of shells along the coastline; they manifest the landscape's history of metamorphosis and potentiality for future change. We have already seen that Hoefnagel ascribed personal significance to the sulfurous crater at the nearby Forum Vulcani, aligning its internal energies with his own inventive capacity (see fig. 12). The shells in the foreground of the Neapolitan vista likewise activate the locale as a realm of discovery, akin to the way Pietro Bembo and other earlier Italian humanists engaged volcanic sites as platforms for rumination and self-expression.[53]

And what Hoefnagel discovered in those igneous mountains was the limit to his own adventures in pursuit of knowledge. The two inscriptions surrounding the miniature both pose questions to which the image itself responds. In the passage above, Hoefnagel quotes from the book of Isaiah: "Who hath measured the waters in the hollow of his hand, and weighed the heavens with his palm? Who hath poised with three fingers the bulk of the earth, and weighed the mountains in scales, and the hills in a balance?"[54] The answer is God, who is present in every visible manifestation of the elemental cosmos from the largest mountain to the smallest mollusk. In the passage below, a personified pine tree is more accusatory: "You ignoramus, why make me into a vessel to wander the waves? Do you not heed the sign?"[55] Here the shells become the "sign" of God's expansiveness, a chastisement to any mortal who thinks that traveling farther, or ascending higher, will lead any closer to the truth.

These questions finally culminate in the Berlin sheet labeled Folio LVIII, which depicts the by now familiar town of Cádiz in the distance (fig. 106). The shells, again taking the place of human subjects, are anything but static specimens in a conchologist's cabinet.

FIG. 105. Joris Hoefnagel, *Shells and View of Naples and Mount Vesuvius (Folio LVII)*, 1570s–1600. Watercolor and gouache, with oval border in gold, on vellum, 14.5 × 18.6 cm. Musée du Louvre, Paris.

FIG. 106. Joris Hoefnagel, *Shells and View of Cádiz (Folio LVIII)*, 1570s–1600. Watercolor and gouache, with oval border in gold, on vellum, 14.4 × 19.5 cm. Kupferstichkabinett, Staatliche Museum, Berlin, KdZ 4818.

NEAPOLIS MONS VESVVIVS

LVII

Pinis ego ventis facilis superabilis auror
Stulte quid vndnagam me facis ergo ratem?
An non augurium metuis? cum persequitur me
Jn terra, Boream qui fugiam in pelago?

FIG. 105

I nunc et ventis animam committe, Dolato
Confisus ligno, digitis a morte remotus
Quattuor, ac Septem, si sit latißima Tæda.

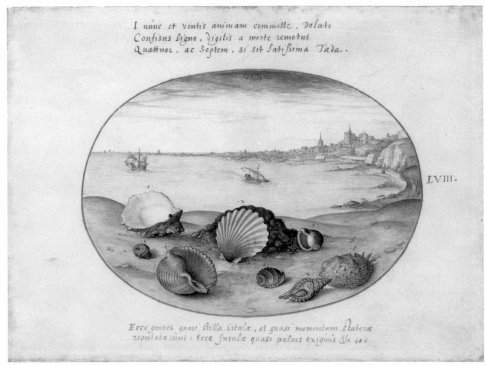

GADA

LVIII.

Ecce gentes quasi stilla situlæ, et quasi momentum stateræ
reputatæ sunt: Ecce insulæ quasi pulvis exiguus Isa 40.

FIG. 106

Not only do they dwarf the galleon and trireme sailing through the harbor; they also up-stage the diminutive figures of two men engaged in conversation and walking along the shore, who recall the figures of Hoefnagel and Ortelius within the vistas of the *Civitates*. Whereas the conversation between the two men eludes our ears, the shells themselves are animated, even anthropomorphic. The overturned bivalve labeled "8" almost seems to display a face in three-quarter view, with an eye peeking out at the viewer beneath a prominent brow. Hoefnagel has borrowed the verses above the image from Juvenal's *Satire* on friend-ship, lines that advise their addressee to "go now and commit [his] spirit to the winds," en-trusting his future to a flimsy vessel rather than the false security of stable land.[56] The lines below, from the same chapter of Isaiah, extend this message outward from the human to the divine realm: "Behold, the nations are as a drop of a bucket and are counted as the smallest grain of a balance. Behold, the islands are as a little dust."[57] Friendship may offer one form of refuge in a perilous world, but all humankind is nothing compared to the power of God, to whom we are no different from a mere shell tossed by the sea.

Given how closely Hoefnagel was reading Isaiah across these last two miniatures, it seems logical to think that he was reflecting on the biblical chapter as a whole. It is a pow-erful passage, one that progresses from acknowledgment of God's magnificent presence in the world to disdain for the failed human attempts to circumscribe him:

> To whom then have you likened God? Or what image will you make for him?
> Hath the workman cast a graven statue? Or hath the goldsmith formed it with
> gold, or the silversmith with plates of silver? He hath chosen strong wood, and
> that will not rot: the skilful workman seeketh how he may set up an idol that may
> not be moved.[58]

Yet what idiocy, the prophet goes on to say, to think that any idol created by human hands could have meaning or power in a world of divine creation. Human artifice could never begin to match the powers of the Creator, who founded the earth and stretched open the heavens. How frivolous that crab strung to the frame of Folio L now seems compared to the larger history of divine nature and human folly that Hoefnagel constructed in its wake. Acknowledging himself a mere drop in the bucket was always the starting point for Hoefnagel's understanding of nature, no matter how ardently he sought to understand the art of the birds in the air or the fossils formed in the sea. Nature was his only teacher, whom he followed no matter where the current took him, always in quiet admiration of that which he could never hope to equal.

NOT MADE BY HUMAN HANDS

Hoefnagel's friend Lucas de Heere may have left behind no explicit comment on either the Iconoclastic Fury or its impact on the future of art in the Low Countries, but his late writ-ings suggest that even the study of nature in Hoefnagel's context was inflected by this looming concern.[59] As a coda to the latter's own investigations into the strange world of fossil forms, de Heere gives voice to questions implicit in the folios from *Aqua* discussed above. To what extent did God sanction the making of images? And to what extent were the works of nature themselves works of art?

As an art theorist, painter, and Calvinist, de Heere was in a position to reflect on the recent events of the revolt from multiple sides. Karel van Mander recounts that de Heere had salvaged panels from the house of the Antwerp artist Frans Floris (who was de Heere's teacher), keeping them in his workshop "where they were protected from the iconoclasm and daily served us in our learning process."[60] Yet when de Heere returned from his exile in England, he joined ranks with William of Orange and his Calvinist government, and is documented to have participated in the "soft" iconoclasm of 1578, when Catholic institutions were quietly stripped of many remaining treasures.[61] His collaborations during these later years with Marnix van Sint-Aldegonde, whose virulent treatise on the 1566 Iconoclastic Fury defended its actions as the direct will of God, might lead one to wonder just where de Heere stood in this debate.[62] Indeed, de Heere's translation into Dutch of an anti-Catholic treatise by the Hugenot theologian Philippe du Plessis-Mornay, published in Antwerp in 1580, includes ample disdain for the Catholic cult of images—a view from which the translator himself shows no sign of dissension.[63]

De Heere's best-known writings are his early poetry, particularly his verses on Jan van Eyck's *Ghent Altarpiece* and his invective debating the relative merits of classical and local style in Antwerp's artistic circles.[64] But his last years of authorial production resulted in a remarkable and long-neglected treatise on the subject of portents titled *The Forest of Wonder*.[65] Published only posthumously as a chapter in the Dutch translation of Pierre Boaistuau's *The Wondrous Book of Treasures*, this text provides the clearest window into his understanding of image making in the wake of iconoclasm.[66] It also gives insight into the distinction between his outward religiopolitical stance and the more fundamental convictions that he likely shared with friends such as Hoefnagel and Ortelius. For Marnix, the physical materiality of images had the potential to incite condemnable idolatrous responses, irrespective of their subject matter.[67] For de Heere, the material stuff of the natural world was an argument to the contrary.

When de Heere penned *The Forest of Wonder* is uncertain, but it was likely only a few years prior to his death in 1584. Any doubt that might be cast on de Heere's authorship of the treatise is readily belied by the strong spiritual bent and localized knowledge of the southern Netherlands attested in the work itself, as well as by the interest in natural phenomena evident in de Heere's other writings.[68] In his *Description of the British Islands*—a history of ancient England that he completed around 1575—de Heere refers not only to the goose barnacle and to the bones of giants but also to wondrous fossils "transformed into stone" that were found in the region.[69] Van Mander even reports presenting his former master with the gift of "a large molar or back tooth, a real one, five pounds in weight" discovered between two towns in West Flanders, which suggests that de Heere may have kept his own collection of curious specimens.[70] But de Heere's early refrain dedicated to the *Violeren*—a guild of Antwerp rhetoricians to which many artists belonged—is the most salient to understanding his later treatise. Proclaiming the art of painting a divine gift to humankind, de Heere cites as evidence images that reveal themselves in fossilized stones: the artful formations of God's own hand.[71]

The short sections of de Heere's *The Forest of Wonder* variously describe weather portents and celestial signs like comets, making reference to recent storms heralding favor for the Protestant cause. He muses on the subject of giants and human curiosities, recalling the

interests of Becanus's earlier treatise *The Origins of Antwerp*. In another passage, he espouses the anthropocentric view that God endowed animals and insects with virtues so that they might serve as models to humankind—much as he suggested in his dedicatory poem on Gheeraerts's fables.[72] The most inventive chapter of the treatise, however, concerns nature's figurative properties:

> "On the Wondrous Flowers and Stones that Contain Figures of Men and Beasts"
>
> It seems that the Lord God wanted to show himself doubly and doubly wondrous in all his works. I am speaking of such figures that nature has expressly and willfully painted in stones, just as a painter makes a figure in a painting. One finds written (as already mentioned) that King Pyrrhus (who waged war against the Romans) had an agate stone in which the nine muses with their Apollo were engraved in a manner lifelike and natural. Over thirty years ago, I myself (who am writing this) saw in the house of Cardinal Granvelle various stones in which nature had painted the forms of men and beasts. Abraham Ortelius tells from the writings of Dabranus that there was recently found in Moravia a figure of a man who grew naturally from myrrh. Which either means that nature portrayed his likeness, or the one thing was transformed into the other. And it is openly known that stone creatures such as snakes, snails, and others have been found, so natural and indeed from the life (*naer het leven*) that they lack nothing except movement. In Antwerp, I saw such a snake changed into stone, or else one that always was made of stone and was not made by human hands (as all who understand art easily could judge). Therefore those who hold that the arts of painting and sculpture in themselves are to blame would seem to condemn that which God himself (who can do nothing but good) created.[73]

It is no surprise to find a consummate art theorist like de Heere sourcing Pliny on the famed agate stone of Pyrrhus.[74] Nor is it remarkable to find him quoting from his friend Ortelius on the man of myrrh, or citing his firsthand viewing of other fossils in Antwerp—like those we know to have been in Ortelius's collection.[75] The reference to the various stones in the house of Antoine Perrenot de Granvelle shows that de Heere was interested in fossils already in the early 1560s; de Heere can only be referring to Granvelle's former palace in Brussels, which the cardinal was forced to abandon by 1564 when he was condemned for his allegiance to Catholic Spain.[76]

In short, it is not de Heere's sources but the argument derived from them that proves exceptional. He suggests that the morphological resemblance between fossils and living organisms—their resistance to easy categorizing as either animate or inanimate, imitations of nature or nature itself—endowed these natural specimens with their portentous significance and allied them with the arts of both painting and sculpture. On the one hand, he uses the phrase *naer het leven* to describe the mimetic nature of fossilized stones that show the traces of snakes and snails.[77] On the other hand, he refers to the fossilized snake, presumably an ammonite, that he saw in Antwerp as "not made by human hands" (*van gheen menschen handen*). This is a clear evocation of *acheiropoieta*, a term often used in reference to Catholic icons and to describe an image as the miraculous work of God alone. While

de Heere's association between fossil forms and image making has precedents in earlier writings (from Gesner's treatise mentioned above to those of Girolamo Cardano and Leon Battista Alberti), the Netherlandish author has taken the concept to its logical extreme.[78]

De Heere may have been untroubled by iconoclasm as a political act in the context of the revolt's religious controversies. But however great his disdain for Catholic image worship, he was no enemy to art itself. The conclusion of his chapter from *The Forest of Wonder* shows him deriving from the natural realm—and from fossils in particular—a justification for the making of images through the evidence of nature's own artifice. If God painted and sculpted with his own hand, then the work of an artist imitating his creations could not be anything but divinely sanctioned. While Hoefnagel and de Heere may have taken different paths in response to the war in their homeland, they found common ground in viewing the natural world as the site where spiritual understanding should be sought before all else. Neither made any significant contribution to the scientific categorizing of fossils or the emergent paleontological discourse that would blossom in subsequent decades. Instead what they saw in the mollusks, polyps, ammonites, and echinoderms of the sea was a protean world akin to their own—a world in which the drawing, coloring, and shaping of forms were not the misguided enterprises of the idolater but the endeavors of Nature's most ardent followers.

The Insect as *Artifex*

Insects make their own worlds. They crawl the earth, swarm the air, and flit through water with uncanny agility. Like fossils, they resist belonging in any one category or elemental realm. Aristotle, and Pliny after him, rendered insects stranger still by describing the overwhelming diversity of their forms and propagating the theory of their spontaneous generation. But together, they also established the dominant topos of early modern discourse on the subject: that Nature most truly manifests her artifice in the minutest of things.[1] Even the Dutch philosopher Spinoza, who is said to have diverted himself by inciting battles to the death between spiders and flies, still devoted study to "the different parts of the smallest insects" through a microscope.[2] Finding consequence in the seemingly inconsequential was the paradoxical endeavor that would lead, however gradually, to entomology's foundation as a distinct field of inquiry.

The advent of microscopy in the seventeenth century offered a powerful tool for advancing the understanding of insect bodies, but those bodies in themselves also already compelled a different way of seeing.[3] To valorize the microscope as the invention that changed everything falsely privileges scientific advance over the more fundamental point: to study such tiny creatures, with or without a lens, required patient attention and an almost devotional practice. The illustrations in Robert Hooke's 1665 *Micrographia*—and in the works of his Dutch counterpart and fellow microscopist Jan Swammerdam—are justly renowned for representing the anatomy and reproductive processes of insects as never before.[4] But Hooke and Swammerdam also employed images as more than mere vehicles for presenting empirical discoveries; they were also a means to unlock the Book of Nature and to elevate previously overlooked realms of divine creation.[5] The same impulse motivated the very first publications devoted to insects exclusively: Ulisse Aldrovandi's 1602 *On Insect Animals* and Thomas Moffett's 1634 *Theater of Insects*.[6] Although both projects were initiated during Hoefnagel's lifetime, the latter was closer to his scholarly ambit and significant in a larger sense: its history shows just how hard it was to get such a project off the ground. Insects were the final frontier in sixteenth-century natural history, and they came last for a reason.

In the 1570s, when the English physician Thomas Penny began to compile what became the *Theater of Insects*, he drew on a palimpsest of material. He began with notes

acquired from his elder colleague Edward Wotton and from the posthumous estate of Conrad Gesner; the latter had succumbed to the plague before realizing his own volume dedicated to the insect kingdom.[7] Penny also pursued observations of his own, corresponding with contemporaries like Hoefnagel's friend Ortelius to ask for aid in hunting down rarer specimens.[8] Thomas Moffett took up the project only after Penny died in 1588. The names of Penny, Gesner, and Wotton all grace the cover of the volume that Moffett is said to have "perfected" and illustrated "with images done from life."[9] Indeed, a letter that Moffett wrote to Carolus Clusius from London in 1590 singles out the visual as significant to his process of transforming Penny's manuscript into publishable form. Although Penny "had taken up describing the history of insects day and night," with both Clusius and Camerarius the Younger as confidants, his manuscript was left in shambles upon his death. "That whole work," Moffett declares, "I have set in order, corrected, completed, and together with images, have so obtained all things insect-related at great expense."[10]

Moffett's claim is less impressive than it sounds. The images to which he refers are often schematic and rarely convey the vivacity of their subjects. Many he cribbed from Aldrovandi and others, albeit with characteristic enterprise.[11] Following Pliny, Moffett chided the human tendency to gawk at giant beasts like the elephant and crocodile and to deem those like the worm or flea "common and exceedingly insignificant."[12] Yet the challenge of uncovering the virtues modeled by insects, the complex artifice behind their diverse forms, confounded Moffett's desire to "set in order" a creaturely kingdom that made his own efforts look insignificant by comparison. No matter how much he praised God's minuscule creations in words, his pursuit of encyclopedic quantity detracted from the recreation of their wonder on the visual page.

For all these reasons, the remarkable qualities of Hoefnagel's own insect volume cannot be overemphasized. *Ignis* excels so many of the works that came after it—in both artistry and observational accuracy—precisely because Hoefnagel did not take order as his goal. But this point is not immediately evident. Unlike the other manuscripts of the *Four Elements*, the studies in *Ignis* garnered a wide and varied reception that to some extent obscures the volume's true nature. Hoefnagel's son Jacob, whose efforts in large part ensured this afterlife, was closest to his father's original aims. In the 1592 series *Archetypes and Studies* that Jacob engraved after his father's miniatures, insects predominate over all other natural subjects. They are arrayed in endless variety rather than strict classification, capitalizing on the tension that we will encounter in *Ignis* itself between the insect kingdom's playful and uncanny dimensions (see fig. 112).[13] The prints not only disseminate Hoefnagel's firsthand observations and replicate his pictorial strategies for enlivening insects on the page; they also present their specimens as both products of and prompts for invention. As such, Jacob's series quickly became a sourcebook for subsequent artists, and their archetypes resurface everywhere from watercolor copies to still-life paintings to subsequent engraved series.[14] They even appear as incised decoration on costly nautilus shell cups that enact the representation of nature upon nature itself.[15]

Yet artists were not alone in drawing on Hoefnagel's precedent, nor were the inventive qualities of his studies always responsible for their appeal. His models resurface too in later works of natural history, both as authoritative illustrations and as evidence for the lineage of insect study in the Netherlands.[16] An early and sensitive example is Outger Cluyt's

On the Hemerobion: a study of the mayfly published in 1634 and dedicated to Nicolaes Tulp—the same Amsterdam surgeon whom Rembrandt had immortalized in his *Anatomy Lesson* just two years earlier.[17] In the preface, Cluyt refers to an observation already found in Pliny's *Natural History*: "The river bug seen on the Black Sea at midsummer does not live beyond one day, owing to which it is called the *hemerobion*."[18] This quotation prefigures Cluyt's reference to Hoefnagel in the body text. An image of the insect, derived from Hoefnagel's works (*quem opera Houfnaglii possideo*), is illustrated just above a description of the artist engaged in fieldwork on his native shores (fig. 107):

> Hoefnagel, a most diligent investigator of nature, also seriously pondered this
> *hemerobion*. Indeed, he observed with admiration how swarms of mayflies
> expended their vigor as they glided along the bank of the river in Mechelen.[19]

Perhaps Jacob Hoefnagel, who spent his last years in Amsterdam, conveyed this account to Cluyt and provided him with the attendant visual model.[20] Or perhaps Cluyt constructed the anecdote in the interests of the present, like so many anecdotes told about artists past. He champions Hoefnagel for reviving Pliny's model, for having brought the study of insect specimens from antiquity to the early modern Low Countries, and for justifying his own continued inquiries. The real relevance of Cluyt's story lies in the truth of its fiction.

Situating *Ignis* in relation to the history of insect study and representation is crucial at the outset, by way of acknowledging Hoefnagel's most important and original contribution to early modern art and knowledge. But like the *Four Elements* as a whole, this volume was never intended in the first instance for public consumption—let alone designed to attain the status that it subsequently achieved. Hoefnagel's study of insects was the natural conclusion of the patient pursuits that had defined even his earliest years: a chance to overcome the struggles of the present and to direct his creative spirit toward a higher goal. Hoefnagel's manuscript shares little in its concerns with the works of the naturalists that he knew or those of the microscopists who came after him. Information is ancillary to representation on nearly every illuminated folio. The world of insects, glimpsed obliquely through Hoefnagel's artifice, is both an ode to the divine *genius* that surpasses human understanding and his ultimate argument against an anthropocentric view of the cosmos.

SPECIMEN ILLOGIC

Hoefnagel's *Ignis* diverges in both appearance and constitution from the rest of the *Four Elements*. Landscape settings disappear, and the isolation of subjects on the blank page (which occurs only occasionally in the other volumes) becomes the prevailing compositional mode. This approach reinforces the impression that the miniatures are the products of firsthand observation—an impression borne out in almost every case. The history of insect study outlined above suggests a practical reason why *Ignis* differs, in this particular respect, from the other volumes. The dearth of existing source material, compared to what Hoefnagel possessed for creatures like mammals and birds, compelled a reliance on his own eyes—and to remarkable result.

And so the question follows: How invested was Hoefnagel in his miniatures as *ad vivum* productions? The notable diminishment of inscriptions throughout *Ignis*—when

FIG. 107. Mayfly, from Outger Cluyt, *De hemerobio*, 1634. Woodcut. Bijzondere Collecties, Amsterdam, OTM: O 62-6381.

again compared to the other volumes—complicates the illusion of empiricism within the miniatures themselves. Janice Neri has argued that artists like Hoefnagel positioned themselves as "gatekeepers" to the newly discovered world of insects, decontextualizing specimens from their habitats and reducing ancillary commentary in order to focus the viewer's attention and inquiry: a process she terms "specimen logic."[21] This concept may have relevance to later representations of insects. In Hoefnagel's case, however, it proves more anachronistic than accurate.

The folios in *Ignis* occupied by only a single insect are the most straightforward place to begin, though they are in themselves far from simple. A sequence of butterflies and moths early in the volume includes a folio depicting a lone swallowtail, superfluously labeled "1" and positioned spread-winged in the upper half of the ovular frame (Pl. 27). The insect's body neither casts a shadow nor quite aligns, on close inspection, along the oval's vertical axis. Because a living butterfly would almost never land in perfect symmetry within such a contrived form, one might take this subtle decentering as a marker that nature is here privileged over the conventions of art. Yet the intricacy of the swallowtail's depiction—the way that Hoefnagel has so meticulously captured the coloring of its wings and the texture of its body—cannot but invite admiration for the artifice underlying the picture's making.

FIG. 107

On the verso opposite, a line adapted from Ecclesiasticus anticipates this quandary but does not resolve it: "[God] set his eye upon their hearts to shew them the greatness of his works, such that they might praise the name which he hath sanctified and glory in his wondrous acts (*mirabilibus*)."[22] Elsewhere in *Ignis* and along similar lines, Hoefnagel cites excerpts from the Psalms to praise nature's smallest creatures as paradoxical *mirabilia*.[23] Celebrating insects as unlikely expressions of God's magnificence was a trope in medieval spiritual writing, which surfaces everywhere from St. Augustine's encomium on the "happy worm" to Islamic manuscripts on the wonders of creation.[24] The point was to ascend from admiring the minutiae of the visible realm to contemplating the higher sphere of the invisible beyond. The placement of scattered insects and flowers in the margins of late medieval devotional manuscripts depended on the same rhetoric—a rhetoric that Hoefnagel's repositioning of his subjects at center stage might seem to overturn. At the same time, and despite initial appearances, his miniature worlds do not quite allow for insects like the swallowtail to transmute from "wonders" into objects of curiosity.[25] Objectivity of representation does not present itself as the primary aim.

Likewise, the reduction of text across *Ignis* is crucial to understanding the boundary between the known and the unknowable as Hoefnagel eccentrically conceived it. The limits that he encountered to his own practice of commonplacing were nowhere greater than in this volume, given the scarcity of references to insects in the emblematic, adagial, and natural-historical sources on which he was accustomed to rely. But when pertinent glosses were available, Hoefnagel did fill in the blanks, and amply so. The folios in *Ignis* of bees and ants—two insects with a particularly rich literary tradition—are as replete with inscriptions

as are their counterparts in *Aier* or *Terra* (Pl. 39). These denser openings not only upend the assumption that Hoefnagel reduced surrounding information for either aesthetic or "epistemic" reasons; they also endow the sparseness of the folios occupied by the swallowtail and its companion *mirabilia* with greater significance. There are, as *Ignis* shows us, countless creatures from which God's lessons have yet to be derived and for which visual representation is only a starting point. By preserving a quiet awe for the enigmas of divine creation, Hoefnagel would seem to resist the disenchantment that his own detailed studies and close-up compositions imply.

One of the most stunning examples of this resistance surfaces much later in the volume: a single dragonfly spread out across Folio LIII and oriented as if resting on the surface of the page (Pl. 35). A faint shadow, most visible at the end of its tail and beneath its front legs, grounds the creature in Hoefnagel's invented pictorial world. Yet the illusion soon crumbles. Although the recto of the opening is devoid of text, Hoefnagel has built a commentary into the frame surrounding the insect itself. The little dip at the bottom of the oval, which seems so placed in order to accommodate the dragonfly's very long tail, would have been unnecessary had Hoefnagel moved the creature's body up a half centimeter. In this act of manipulation, artifice bends to nature rather than the other way around.

Within the entirety of the *Four Elements*, the dragonfly's frame is the only one that breaks the mold, and it begs consideration of the motif itself. The oval is a shape created with a compass through the conjoining of two carefully intersecting circles, and one that immediately suggests the macrocosm to which both we and these microcosmic insects belong. Contemporary maps representing the Eastern and Western Hemispheres also took an ovular form—at once schematizing the entire globe and picturing something impossible to ever observe in reality. To one such map that opens his famous atlas, Abraham Ortelius appended a telling quotation from Cicero: "What greatness seems there in human affairs to him who discerns the eternity and vastness of the whole world?"[26] Although Hoefnagel probably used a pattern to create the hundreds of frames throughout the *Four Elements* (rather than making each one anew), the discrepancy on Folio LIII suggests him thinking through its form about his own small place in the cosmos.

We can see this train of thought unfold on the subsequent Folio LIV, where Hoefnagel further qualifies his artistry in deference to its source. Another upright dragonfly shares space with two that seem distinct from their counterpart only in the color of their abdomens. But closer scrutiny reveals the difference: while their bodies are painted in watercolor and gouache, their wings are real (Pl. 36). The addition is more evident now than it once would have been, as pieces of the insect wings have flaked off over time and exposed their materiality as far more fragile than paint. This application of collected materials onto the manuscript page recalls how Hoefnagel glued additional scraps of information to his drawing of Cádiz for the *Civitates*, or how he seems to have used Philip of Cleves's original book of hours as a scrapbook for preserving old master works (see fig. 56, fig. 78). Yet continuity in practice hardly accounts for the full implications of this mixed-media folio.

As often observed, Hoefnagel's pasted wings presage those in the eerie still lifes of the seventeenth-century painters Otto Marseus van Schrieck and Elias van den Broeck.[27] The latter was infamously condemned as a cheat for applying insect wings to his canvases rather than expending the effort to imitate them with his brush.[28] If the aim—despite such

FIG. 108. Albrecht Dürer, *Stag Beetle*, 1505. Watercolor and gouache, 14.1 × 11.4 cm. J. Paul Getty Museum, Los Angeles.

critique—was to stage a competition between art and nature, Hoefnagel concedes defeat. Inspecting the wings of Hoefnagel's dragonflies up close reveals that even his finely painted lines are no match for the complex geometries of the specimens themselves. So perhaps he sought less to affirm an oppositional binary than to explore the productive friction that the juxtaposition invites. In the overlap between the real wings and the illusionistic shadows rendered beneath them, Hoefnagel expresses the inextricable relation between the hand of God and the hand of the artist: one a creator of substance, the other a tracer of fleeting impressions.

This relation is also implicit in the rare instance when Hoefnagel did have another artist's model on which to draw. By far the best-known folio in *Ignis* is his adaptation of Dürer's stag beetle (Folio V), which, like his refiguring of the latter's hare, is not a "renaissance" but a deliberate misdirection (Pl. 26).[29] This may seem counterintuitive, given how closely Hoefnagel followed the outlines of Dürer's original, or whatever copy of that original he had on hand (fig. 108).[30] He quotes the latter as unmistakably as he refers to Bruegel's landscape of Tivoli in the *Civitates*, thus ensuring that the first step in our understanding of the miniature is a recognition of its source (see fig. 63). Only thereafter do we start to realize what Hoefnagel has altered, and how significant those alterations are.

FIG. 108

A striking feature of Dürer's watercolor are the gaps left at the joints of the beetle's body. Perhaps these served to emphasize that an insect is a creature (by its very name) with a body composed of segmented parts. Nonetheless, Hoefnagel not only connected the joints but also demonstrated independent knowledge of the insect by depicting it spread-winged on another folio from *Ignis*, which now survives as a loose sheet.[31] Subtle shifts in the position and length of the scarab's antennae and wings also reveal his commitment to study from nature, rather than reliance on Dürer alone.

Yet Hoefnagel's most radical revision has nothing to do with a naturalist's concern for accuracy. It hinges yet again on the shadow that his beetle casts, which is far more complex in its shading and also longer—immediately indicating a different light source, place, and time.[32] Within the shadow, we encounter again the ghost of the scarab's spindly legs, heavy abdomen, and magnificent mandibles. But we also encounter an insistence on the insect's illusionistic presence and the artifice of its re-presentation. The scratchy brushstrokes that constitute the shadow give us to observe all the other minuscule marks that describe the sheen on the scarab's body, which likewise index the physical labor of Hoefnagel's hand. The shadow hovers somewhere between the natural and the artificial, disorienting rather than grounding us in the physical world.

Erasmus writes that the adage *scarabei umbra*, or "the shadow of the stag beetle," is used in reference to an instance of unwarranted angst.[33] When the insect flies at nightfall, it makes a buzzing noise that often frightens a person caught unawares. That fright is without cause, so Erasmus explains, as the scarab does no harm to humankind. But the phrase "the shadow of the stag beetle," which Hoefnagel inscribed above his miniature, becomes at once a direct descriptor and a directive to observe the artificiality of the picture as a whole. We are no longer taken by surprise because we have seen this creature before in an image that

preceded Hoefnagel's own. His miniature presents not as evidence of something that exists but as the likeness of something we already know but still cannot understand. His friend Anselmus Stockelius, who was given the privilege of perusing the folios of *Ignis*, confirms that message unequivocally. Through the lines that he composed in response, and which Hoefnagel included on the opposite verso, Stockelius draws a parallel between the creature's ancient associations and the paradox of Christ's dual nature: "Armed with horns, the stag beetle generates itself. Christ as a man originated himself alone."[34] The scarab may not be a threat, but its origins are as miraculous as the son of God's mortal presence in the world.

Although Hoefnagel's stag beetle is the first insect to appear within the *Ignis* volume as presently constituted, this sequence is not original. The Roman numeral after the "V" beside it has been scratched out and repainted. Another surviving loose sheet labeled Folio VI—and without alteration to its numbering—depicts a magnificent elephant beetle (*Megasoma elephas*) that likely preceded the scarab by two openings (fig. 109).[35] The elephant beetle's central place in the inaugural print of Jacob's *Archetypes and Studies* may also reflect the prior organization of his father's manuscript.[36] In any case, Hoefnagel's observations led him to associate these two insects to a degree that modern science later affirmed: both beetles are classified today as members of the family *Scarabaeidae*.

Folio VI speaks to many key aspects of *Ignis* overall, including the practical circumstances and collaborative exchanges that underlay its making. Hoefnagel's elephant beetle resurfaces prominently within Moffett's later *Theater of Insects*, accompanied by a description of its source (fig. 110). Moffett reports that Camerarius the Younger "had sent to Penny

FIG. 109

an image [*iconem*] of this insect from the Duke of Saxony's sanctuary of natural things," together with an explanatory letter and verses commenting on the creature's spontaneous generation.[37] Moffett's descriptions may rely on the notes that Thomas Penny had gathered or on Camerarius's own recollections. In turn, we might speculate that the *icon* in question was either by or after Hoefnagel's hand, given the stated provenance of the specimen at the Munich court and the artist's documented friendship with Camerarius himself.[38]

Hoefnagel's knowledge of the elephant beetle, a creature found only in the Americas, indeed likely transpired through court channels. Otherwise, and almost exclusively, he depicted insects within *Ignis* that are indigenous rather than "exotic" to Europe, and which he might have encountered just by snooping around in his own proverbial backyard. The scarab, for instance, is native to both England and the Continent, and is reported to have been quite common at the time.[39] Other more modest collections assembled by Hoefnagel's friends may also have been a source. An astonishing tarantula strung on Folio XXXV seems identifiable with a specimen that was in Ortelius's possession (Pl. 32). The cartographer described it in a 1586 letter to his nephew Jacob Coels, who had written on behalf of Penny and his ongoing endeavors. Although Ortelius greets the latter's project with enthusiasm, he professes to have few specimens of interest save one:

FIG. 110

I have a *phalangium*, called a tarantula by the Italians—that perhaps [Penny] has not seen—which was sent to me from Naples. It is a kind of spider. It should be observed in this genus of insect that it has four eyes on its head, which I would scarcely have believed from the report of others unless I had seen it with my own eyes. I have the utmost praise for Penny's stated intention. The subject is indeed praiseworthy, and to my knowledge, it has been attempted by no one else as yet.[40]

It is uncertain when Ortelius acquired his tarantula, but one can well imagine him showing Hoefnagel the creature firsthand back in Antwerp, or at least sending him a similar description. Hoefnagel not only delineates the four red eyes on the spider's brow but also strings it to the frame as if to signal its status as a now-lifeless collectible—distinct from the surrounding three spiders gleefully dangling beside it.

Comparing Hoefnagel's depiction of the tarantula to that of the elephant beetle further reveals a certain hierarchy of wonder implicit in his approach. The monstrous predator of the spider kingdom can be captured and suspended. Not so with the beetle. Hoefnagel's cropping of the creature's left back leg brings our consciousness back to the artificiality of the frame. By moving the insect just slightly to the left, Hoefnagel could have avoided the crop altogether. Even the shadow trailing behind it supports our suspicion that this creature is not subjugated to the realm of art but is instead acting of its own volition. By the time we have turned to the next folio, we can readily imagine that the beetle will have

traversed the length of the oval and disappeared behind its opposite side. The quotation from the Psalms inscribed above affirms what the image already shows: "The fear of the Lord is the beginning of wisdom."[41] No creature embodying such a formidable power could ever be tamed by human artifice.

If we return again to Moffett, Hoefnagel's evocation of the divine is put into greater relief. After explaining whence the image of the elephant beetle derived, he goes on to associate the insect with the phoenix: that legendary bird said to rise again from the ashes, and to be fueled by the heat of the sun.[42] Moffett explains that the beetle, like the phoenix, has the ability to die and subsequently revive "from its own corruption"—a notion that again evokes Christ's mortal death and divine resurrection.[43] The insect's spontaneous rebirth becomes a marker of its magnificence, no matter the fright we may feel in watching it slouch across the page to be reborn.

The metamorphic properties associated with insects help at last to elucidate the conundrum of their association with the igneous element in Hoefnagel's volume—a choice that no ancient or contemporary source readily justifies.[44] As discussed above, the importance to Hoefnagel of the titular theme is open to doubt, and Gaston Bachelard's ruminations on the element suggest good reason for not spilling too much ink over the question.[45] Fire, so Bachelard writes, is "a privileged phenomenon that can explain anything," and the sole element "to which there can be so definitely attributed the opposing values of good and evil."[46] From the perspective of media theory, John Peters suggests that fire exposes "our radically precarious dependence on nature"—at once a tool of art and civilization and an uncontrollable agent of destruction and creation alike.[47] Hoefnagel's own understanding of fire as medium is best explicated with reference to the sites of Solfatara, Vesuvius, Alhama, and Antequera that he depicted in the *Civitates*. We have seen not only his fascination with the subterranean fires that he understood to animate those locales, but also their professed link to the origins of his natural talent and the constant reforging of his identity. Fire, like the best of artists, always signs its works *faciebat* because its acts of making and self-making are never truly finished. So too Hoefnagel's illustrations repeatedly suggest that the insect was the sole and ceaseless *artifex* of its own existence.

Excepting the title page of Hoefnagel's manuscript, only one inscription within *Ignis* refers to the unruly substance directly, and the reference is not unremarkable. A quotation from the book of Joel on the subject of portents appears on the verso opposite a miniature that depicts a strange congregation comprising a mayfly, a praying mantis, and a fantastical locust. God's heavenly voice declares through Joel, "I will shew wonders in heaven and in earth, blood and fire and vapour of smoke" (Pl. 33).[48] The ephemeral, the spiritual, and the terrifying imaginary embodied by the three creatures on the page attest to the variously wondrous and vengeful nature of divine power, which is as mutable in the moment as the flames of a fire or the lives of insects themselves. "Sooner will a locust give birth to a cow," reads the adage that serves as the miniature's title, and which Erasmus took as referring to something considered impossible.[49] But if God expended his efforts on a creature like the mayfly, which lives only one day—or on an insect as otherworldly as the praying mantis— then human imagination is unequipped to delimit what is actually possible. Perhaps, more than anything, this is what the making of *Ignis* led Hoefnagel to ponder.

ASYMMETRY AND THE RULE OF LAW

More common than the single-specimen approach are folios in *Ignis* that depict entire communities of insects in miniature. These compositions transform Hoefnagel's oval frames even more insistently into spaces of play.[50] He employs geometrical arrangements both as artificial designs (the products of his own imagination) and as a means to again expose the uncontainable nature of his subjects. In nearly every instance, Hoefnagel upsets the appearance of order by including some creature who is stubbornly out of place. On Folio LX, where eight insects encircling the central mosquito would have made for perfect reflective symmetry, there is instead that ninth fly in the lower right corner who refused to stick to the program (Pl. 37).[51] Flies, of course, were the ultimate tromp l'oeil interlopers, always landing on panels, parchments, frames, and windowsills and disrupting even the great Gian Lorenzo Bernini—according to his filial biographer—so as to remind him that even the tiniest creature is still more lifelike than a mute image.[52]

This kind of play does important work, not least given that Hoefnagel likely made the majority of his studies by working from dead specimens. Their subsequent reenlivenment through paint demonstrates Hoefnagel's ability to transform observation into representation—and to mimic the transformative properties and movements of his uncanny subjects. His reanimating strategies also unfold in the sequencing of the manuscript's pages. On Folio XI, two butterflies—a red admiral and small tortoiseshell—are paired with a mole cricket who appears not only alive but aware of the viewer's presence, turning its head as if to look out at us (Pl. 28). The composition sets us up for a double take on the subsequent Folio XII (Pl. 29). Two new butterflies that both appear to be dark green fritillaries (*Argynnis aglaja*) occupy positions that correspond to those of their immediate precursors. Yet the same mole cricket now lies vertically and overturned, sprawling inert on the parchment.

The cricket exposes the interventions of Hoefnagel's hand—his own flipping and manipulating of specimens as he worked. At the same time, it simulates that experience for whoever peruses the manuscript. So too, on Folio XII, the repetition of the dark green fritillary from two different angles is signaled by the disagreement in the shadows that they cast. The open-winged butterfly, like the cricket, rests on the surface of the page, while its counterpart in profile is positioned as if in a realm of receding depth. Here the artificiality of Hoefnagel's compositions is at once playful and purposeful, exposing the exercises of his *fantasia* and his observational inquiries in turn.

Only on the rare occasion did Hoefnagel provide his insects with any form of scenography, and even then he never allows the scenes to resolve as such. Folio L shows a vibrant petunia growing up from the surface of the page, and against which two insects have already mounted an attack (Pl. 34). Of the six grasshoppers that surround the central flower within the oval, only half of them cast shadows in accordance with the shadow cast by the petunia's stem, while the other half stand in defiance and claim their own spatial worlds instead. The flower's ephemerality, attested by the inscription above ("The very day that it opens, it passes away"), is intensified by the insects who embody the devouring of time, and who anticipate their destructive counterparts in the flower still lifes of the seventeenth century.[53] The triumphant caterpillar digging its spiky feet into the flesh of a still-unopened bloom threatens to topple the very structure that Hoefnagel has so artfully built.

A similar conceit governs one of the most unusual folios from *Ignis*: another loose sheet now in Berlin (fig. 111).[54] The oval is intersected by a rare sign of human civilization: the hint of a wooden door or window jamb to either side of the composition, which frames the intricate web at center and the grassy mound below. Two cross spiders (*Araneus diadematus*) appear to be the artificers of this microworld. One encamps on the plot of earth below while the other occupies the web's middle point, where all the radial lines of its warp converge. The signature cruciform marking on the latter's back, which is even more prominent than that on its counterpart, punctuates the horizontal and vertical axes of the surrounding matrix. Hoefnagel shows himself a keen and informed observer in his depiction of the spiral web, a characteristic feature of orb weavers like the cross spider and other members of the family *Araneidae*. He even distinguishes between the two protagonists by depicting the lower spider with a more rotund body characteristic of gravid females, and the upper spider with the longer legs that individuate male members of the species.

The miniature takes up a familiar topos: spiders are hunters, and webs are their snares. A meek housefly in the upper right, which fell victim to the trap, has been enshrouded in silk and saved for later meal. Directly opposite is the spiders' main antagonist, a European hornet (*Vespa crabro*) that has pushed through the web's threads and left a gaping hole in its wake. For dramatic effect, Hoefnagel has chosen a species that dwarfs the adjacent spider in magnitude; European hornets can exceed three centimeters in length. The hornet's wide wingspan, fuzzy thorax, and the sheen of light on its abdomen all assert its liveliness in contrast to the vanquished fly. If we follow the logic of the image, the creature has thrust itself through the picture and is dangerously encroaching on our space as viewers.

FIG. 111. Joris Hoefnagel, *Spiders and Hornet (Folio XXXXVII)*, 1570s–1600. Watercolor and gouache, with oval border in gold, on vellum, 14.4 × 19.5 cm. Kupferstichkabinett, Staatliche Museum, Berlin, KdZ 4818.

FIG. 111

To heighten the play of scale—and our sense of the instable boundary between the real and illusory worlds—Hoefnagel has positioned a diminutive bee in the lower right that safely avoids the web by crawling along the interior edge of the frame. Escaping a spider's clutches is a matter not just of size and strength, but also of ingenuity.

The adjacent texts that Hoefnagel selected echo the implied narrative of the scene. "Lawless law" (*Lex exlex*) is a common sixteenth-century aphorism that derives from the ancient Athenian Solon. According to his biographer Diogenes Laertius, Solon had "compared laws to spiders' webs, which stand firm when any light and yielding object falls upon them, while a larger thing breaks through them and makes off."[55] This acknowledgment that laws are biased toward the mighty and lay low the weak directly parallels Hoefnagel's juxtaposition of the free-flying hornet to the captured fly. Several sixteenth-century emblem books picture the larger insect's victory over the spider in precisely these terms.[56]

The inscription at the bottom of the page derives from Erasmus's adages: "You weave spiders' webs; you are more anxious over something trifling."[57] As Erasmus explains, a spider's web appears carefully wrought, even formidable. Yet like the belabored argument of a grumbling scholar, it is spun from nothing more than the excretions of its creator's entrails.[58] Such a web is easily broken by a powerful antagonist or eluded by a cunning one. To marvel at the intricacy of the silken threads, and Hoefnagel's ability to paint them, is to be taken in by a construct that is weak by nature and dependent only on its own authority. So too the laws that human civilization constructs for itself are never as just or effective as they purport to be. In this light, the seemingly indomitable spider at the center of the web may be the closest that Hoefnagel ever gets in *Ignis* to the kind of worldly allusions that appear interspersed across the rest of the *Four Elements*. The cross on its back—which might be taken as a blazon of the struggle that incited the revolt itself—becomes a false sign of might, proven as flimsy in an instant as the web that the spider so assuredly spun for itself. Another beautiful opening that shows an elegant dance between butterflies and the pupae from which they sprang might be taken as a précis of Hoefnagel's answer to navigating a lawless human realm (Pl. 30). "Should I investigate divine works with greater attentiveness, by means of human reason? But no. Guided by those works, let us admire the artifice alone."[59]

And this is precisely what Hoefnagel does in the miniature that opens the entire *Ignis* volume—its subject not insects but a remarkable human being (Pl. 23). A poem on the verso composed by Hoefnagel himself, and dated to Munich in the year 1582, reads:

> Tenerife bore me, but a miraculous work of nature strewed my whole body with hairs; France, my other mother, nurtured me from a boy up to a virile age, and taught me to cast aside uncivilized manners, to embrace the natural arts, and to speak the Latin tongue. A wife of surpassing beauty befell me by a gift of God, and from our marriage bed came the most beloved children. Here you may discern the munificence of nature: those born to us resemble their mother in form and coloring, yet likewise take after their father, as they too are cloaked in hair.[60]

The ostensible speaker of these words is the famous hirsute man Petrus Gonsalus, so named in the title above.[61] From the accompanying miniature, Gonsalus looks out rather dispassionately at us, as his wife rests her hand on his shoulder and directs her stoic gaze

into the distance. The whiskers of a root jutting from the rocky ground before them echo the rough hairs that cover Gonsalus's visage, reinforcing the point that the works of nature extend from the humble roots of plants to the most extraordinary of human beings. At the same time, the root disrupts our sense of scale within the ovular frame, such that Gonsalus and his wife appear almost diminished in size, dwarfed by the earthy mound that engulfs their lower bodies. Their daughter, represented with her younger brother in the miniature on the next folio, is far more imposing (Pl. 24). Her body pushes against the edges of the frame as she stands assertively at full length with a prominent cross at her chest. "Praise the children of the Lord," "praise the name of the Lord," read the inscriptions from the Psalms above and below them.[62] Whereas Gonsalus was born on the fringes of the civilized world in the Canary Islands, brought to Europe as a curiosity, and acculturated at the court of France, his children were born of a European mother and brought up in the customs of Christian culture from an early age. Yet the rhetoric that drives Hoefnagel's complex of text and image turns on the larger tension between nature and civilization, between that which God cultivates in the visible realm of his creation and the learning cultivated through the human arts. The munificent and miraculous capacity of nature emerges—both with Gonsalus and with the insects that follow after him within the volume—as a supraconfessional power uniting all creatures more strongly than could any organized religion or national boundary.

At the summit of the verso opposite Gonsalus and his wife, Hoefnagel cites the source most central to his identity as an artist, poet, and thinker, and the one with which this book began. Hoefnagel inscribed on this verso lines from the opening chapter of Ovid's *Metamorphoses* on the history of creation: "While other animals look downward at the ground, he [the maker of the world] gave human beings an upturned aspect, commanding them to look toward the skies, and, upright, to raise their face to the stars."[63] That Hoefnagel would attach these verses to the image of the hirsute Gonsalus is telling of the way he approached the act of representing nature again and again across the folios of the *Four Elements*. He, like Gonsalus, had been compelled to leave his homeland, to navigate the shifts of fortune, and to suffer injustice in the name of rule and authority. So it was not with a sense of dispassionate mastery over his subjects but rather with a sense of entanglement in their worlds that he applied his natural talent and pursued his arduous inquiries. In an age of war and discord far distant from the moment of creation, the tiny creatures on the ground beneath his feet, and those swarming in the ether around him, offered more hope than any lingering faith in human exceptionalism. Hoefnagel's *Ignis* volume powerfully presages how the field of entomology and the illusionistic tactics of still-life painting would develop in the seventeenth century. But in its making, Hoefnagel was looking forward as much as he was reflecting back to that moment when he first sprang as if from the dead, with his spirit full of fantasies, and found in art his own capacity for regeneration.[64]

The Font of Everything

The man who finds his homeland sweet is still a tender beginner;
he to whom every soil is as his native one is already strong;
but he is perfect to whom the entire world is as a foreign land.
— *Hugh of Saint-Victor*, Didascalicon[1]

In 1952, the literary critic Erich Auerbach quoted Hugh of Saint-Victor's lines at the conclusion of his essay "The Philology of World Literature."[2] The essay itself is a rumination on how humanist scholarship might continue in the wake of the cultural demise that attended the two world wars. Auerbach was a German-born Jew who was stripped by the Nuremberg Laws of his teaching post at Marburg in 1935, fled to Istanbul, and eventually emigrated to the United States. He read the *Didascalicon* through the lens of his own experience of exile, deriving therefrom a call for an embrace of the world in the present, beyond arbitrary borders, and in acknowledgment of humanity's common ground. "Our philological home is the earth," Auerbach writes; "it can no longer be the nation."[3] Implicit in his plea is a longing for the ideals of the Republic of Letters, which Hoefnagel and his colleagues had realized, almost four centuries earlier, were always already under threat. To exist simultaneously as a citizen of the world and a foreigner within it was a viewpoint that Hoefnagel himself had come to embrace, and under conditions that Auerbach would have recognized as akin to his own.

Among the engravings in Jacob Hoefnagel's *Archetypes and Studies* is an image archetypal not just of his father's nature studies but of the latter's philosophical stance (fig. 112).[4] A butterfly perches atop a crab amidst a field of flowers variously strewn across the page, clipped to the surrounding frame, and sprouting up from the imagined ground below. At once a flat folio surface and a plane that recedes toward a high unseen horizon, the realm of the butterfly is no more fixed than the crustacean on which it has landed. Yet a symmetry, however restive, governs the butterfly's momentary habitat, eliding flat and recessional

space into a perceivable whole. While the verses inscribed at the bottom of the folio gloss the ripened fig in its lower corner, the two lines above are less clearly referential to any one still-life object within the picture.[5] They might be taken as much as a comment on the butterfly as on the instability of the picture itself: "Surest virtue extends the span of life. Every land is to the brave their country, as to fish the sea."[6]

Drawing from both Martial and Ovid, this titular motto expresses a thought in agreement with the worldview that Hugh and Auerbach after him espoused. "A good man extends the span of his life," Martial wrote; "this is to say, he lives twice by being able to delight in his life past."[7] The wisdom and virtue that come with experience teach what the remainder of the line suggests: the only true home of the brave is not the nation but the entire world.[8] Hoefnagel had already employed Ovid's line ("Every land is to the brave their country") in reference to the mutable polyp in his *Aqua* volume, a creature whose powers of adaptation—like those of the butterfly here—modeled a means to endure an existence of perpetual itinerancy and change (Pl. 16).

Exile is a condition that necessarily reconstitutes identity. The first aim of this book has been to take seriously just how fundamental that condition was to the creative and intellectual endeavor of Hoefnagel and his colleagues. Leaving the Netherlands not only forced a reconception of self untethered from any one fixed place or doctrine; it also compelled the embrace of art and letters as an act of defiance against the forces that savaged their homeland. Hoefnagel's own turn to the study of nature was his means to seek understanding beyond the immediate trials of war, to grapple with the larger realm of divine creation and plan. As he wrote to Radermacher already at the close of the *Patience* album, only God knew the purpose for which humankind was made.[9] The same was true, as Hoefnagel came to

FIG. 112. Jacob Hoefnagel after Joris Hoefnagel. *Archetypa studiaque patris (pars 3, no. 8)*, 1592. Engraving, 15.4 × 21.6 cm. Bayerische Staatsbibliothek, Munich.

FIG. 112

realize over his years of work on the *Four Elements*, for every creature who occupied the earth's visible realms. To overcome the turmoil that he had experienced, Hoefnagel looked beyond himself and the city of his youth. He chose to follow the path of virtue and *genius*: moving rather than staying still, not shuffling around like the crab but instead taking flight.

My larger aim has been to disentangle the history of engagement with nature in the art of the early modern Low Countries from the myth of the "golden age" that is still applied—often without scruple—to the era that followed Hoefnagel's own. Johan Huizinga already signaled the incongruity of this phrase with the realities of the Dutch Republic when he declared of his country's most famous century, "If our great age must perforce be given a name, let it be that of wood and steel, pitch and tar, color and ink, pluck and piety, fire and imagination."[10] Hoefnagel's self-conception as a student of art and nature who was constantly laboring to make, to invent, and to seek after knowledge bears out Huizinga's words. It was not the comfort of peace but the continual drive to establish a culture through which peace might be preserved that underlies the period from Hoefnagel's own lifetime through the rise of the short-lived and tenuous republic. The latter, after all, was founded upon the efforts of innumerable individuals who shared the same experiences of war and emigration. Even at the end of the seventeenth century, one has only to think of a figure like Maria Sibylla Merian, who suffered "the long and expensive journey" across the Atlantic to Surinam that she might produce her stunning book on the metamorphoses of insects that she observed there—a project involving not only arduous manual labor but also tremendous imagination.[11] Hoefnagel's nephew Constantijn Huygens—himself one of the great proponents of nature study in the Dutch Republic—already recognized these same qualities in Hoefnagel when he extolled his uncle for the strength of his perseverance. As Huygens writes, "Even when exiled from his homeland, and stripped of all his wealth, he was never ashamed to support his family with money earned abroad, by employing the extraordinary talent bestowed on him by heavenly God."[12]

Huygens's reference to the years that Hoefnagel spent in court service suggests a fitting place to conclude. The last major project of Hoefnagel's career was also the grandest work that Rudolf II ever demanded from him: the illumination of two calligraphic manuscripts created between 1561 and 1562 by the Hungarian scribe Georg Bocskay for Rudolf's grandfather Ferdinand I.[13] Bocskay's demonstrations of virtuosity in script were prized even in their own right within the imperial collection, but Rudolf was keen to claim the works as his own. Across the two volumes, Hoefnagel staged a contest between penmanship and painting that not only fulfilled his patron's desire but also drew on his many years of nature study and engagement at the intersection of word and image.

Of the two manuscripts in question, the one surviving today in Los Angeles is the better known and the apogee of the veristic skill that Hoefnagel had achieved in miniature painting by his late years (fig. 113).[14] Fruits, flowers, and little creatures here mimic the flourishes of text on the page. Amidst playful forms and teasing brushes with symmetry, Hoefnagel abandons truth to nature nowhere more so than in the insects whose bodies and coloring are manipulated for the sake of artificially echoing the lettering of Bocskay's calligraphy, and of melding with the compositions they inhabit.[15] What Hoefnagel had gained through his arduous observational study in *Ignis* became the foundation for inventions unburdened by the weighty questions that consumed his private inquiries.

Yet the other Bocskay volume, now in Vienna, is as heavy with emblematic images as with memories of Hoefnagel's life past. One miniature in particular speaks to the distance that Hoefnagel traveled from Antwerp to Rudolf's court, and reflects back on the hardships of his early years (fig. 114). A condensed excerpt from the Penitential Psalms, inscribed by Bocskay in the upper quadrant of the page, allowed Hoefnagel to occupy the remaining space with a monument in miniature. Antwerp's town hall, represented much as it appears in an illustration from Guicciardini's 1567 *Description of the Low Countries*, is meticulously delineated down to its sculptural decoration and the tiny figures peering out its windows.[16] Below, a diminutive panorama of the city's harbor, seen from the opposite bank of the Scheldt River, sets the grand edifice in context. Between the two profiles is inscribed the phrase "the font that irrigates everything" (*fons irrigans omnia*): a reference to Antwerp that featured among the decorations for the triumphal entry of King Philip II into the city in 1549.[17]

The crowned letter "P" at the summit of the page is a further reference to Philip, and the red-cloaked man processing on horseback before the town hall, surrounded by a crowd of armed troops, may well be the king himself.[18] The heavy money bags hanging in the upper right, which index the commercial success that had once made Antwerp the professed font of the world, seem precariously close to falling down. The Habsburg eagles, situated above the inscription of the city's name, spew forth jets of water onto orbs

FIG. 113. Georg Bocskay and Joris Hoefnagel, *Mira calligraphiae monumenta (fol. 65r)*, 1561–62 and 1591–96. Tempera colors, watercolors, gold and silver, and ink on vellum, 16.6 × 12.4 cm. J. Paul Getty Museum, Los Angeles.

FIG. 114. Georg Bocskay and Joris Hoefnagel, *Schriftmusterbuch (fol. 96r)*, 1571–73, and 1591–94. Watercolor and gouache, heightened in gold and silver, on vellum. Kunsthistorisches Museum, Kunstkammer, Vienna.

FIG. 113

FIG. 114

representing the Western and Eastern Hemispheres: the spheres of global trade over which Philip so ardently sought to exercise control. Beneath them are the arms of Brabant, and the conjoined shield of Antwerp and her Habsburg rulers. Yet the thorny roses growing up from the orbs are symbols of transience, and a second glance at the harbor below reveals two ships firing their cannons in what seems an otherwise peaceful scene. Philip was Rudolf's maternal uncle, but the two were anything but the closest of allies, and the emperor was unlikely to have missed the irony of Hoefnagel's miniature. Antwerp was a font of all things *before* Philip got there, and he became the unquestionable source of her demise. The great public monument that was built to embody the pinnacle of the city's achievements had itself been transformed into a symbol for all that she had lost.

Hoefnagel's evocation of Antwerp's former grandeur is still more poignant when read against the psalm above: the lament of an impoverished man, beseeching God to hear his prayer. "I am become as a sparrow all alone on the housetop," cries the afflicted penitent; "all the day long my enemies reproached me, and they that praised me did swear against me, for I did eat ashes like bread and mingled my drink with weeping, because of thy anger and indignation."[19] It was surely not by chance that Hoefnagel chose to depict his hometown beneath these verses—the city where the flowing Scheldt had been flooded with tears, and from which he and so many others had been forced to flee like lone sparrows to distant rooftops.

Yet Hoefnagel had learned to answer the indignation of God with more than prayers. As Karel van Mander recognized, the pursuit of art was his refuge. It was a means to make and remake his identity in each new circumstance but also to keep sight of the experiences that had forged him most profoundly. For all his years in practice, Hoefnagel never really became a court artist in spirit. This émigré of the revolt would never again subscribe to the view that power or security resided in any one city, ruler, or country. What Hoefnagel became instead was an artist of exile, a wayfarer of the world, who held one conviction firm: that the true font of everything was nature alone.

Notes

A NOTE TO THE READER

1 On the manuscripts' provenance, see Vignau-Wilberg, *Joris and Jacob Hoefnagel*, 98, 103, and further discussion in chapter 1.

INTRODUCTION

1 Vulcanius, VUL 36, fol. 113r: "Inter omnia divinae providentiae potentiaeque documenta, quae certe innumera paucis ab hinc in hoc nostro Belgico emicuerunt, nullum profecto exstat illustrius, Cons[ule] Amplissime, metamorphosi Antverpiana. Quid enim maius dici aut fingi potest quam urbem hanc in qua tyrannis Hispanica perpetissimum tutissimumque sibi domicilium, fixisse videbatur?"

2 For Vulcanius's biography, see Cazes, *Bonaventura Vulcanius*. For Junius and his tenure as Antwerp burgomaster, see Blok and Molhuysen, *Nieuw Nederlandsch biografisch woordenboek*, 5:263–64. Because Vulcanius refers to Junius as burgomaster in the letter, it has been proposed that it dates to c. 1579. Despite Antwerp being under Calvinist rule at the time, Vulcanius was still writing fervently against the Spanish threat. See Meerhoff and Oranje, "Bonaventura Vulcanius," esp. 30–32.

3 Ovid, *Metamorphoses*, 1.5–7: "Ante mare et terras et quod tegit omnia caelum / unus erat toto naturae vultus in orbe / quem dixere chaos." See Vulcanius's marginalia in VUL 36, fols. 16r, 45v, 46v, 104r, 164r, 176r–v, 178r, 198r, 210v, 212r, and 213v. Vulcanius also scribbled Ovid's line elsewhere, including on the verso of an undated note he received from Josias Vinslerus, who had sent him a glass cup as a gift of friendship (VUL 106:1).

4 Ovid, *Metamorphoses*, 1.76–88.

5 Ovid's most immediate source for the association between humankind's upright posture and proximity to the heavenly realm would have been Cicero, *De natura deorum*, 2.56, who in turn looked back to Plato and Aristotle. See discussion in Kraye, "Moral Philosophy," esp. 310–11.

6 I paraphrase here from the French scholar Jean Bodin's influential refutation of the golden age, published in 1566 at the height of the religious wars in France. See Bodin, *Methodus*, 304–11, esp. 310, and Bodin, *Method*, 296–302, esp. 301 (for English translation).

7 See Ortelius, *Epistulae*, 696–97, no. 294 (Jacob Coels to Abraham Ortelius, London, October 1596): "si nullum sit seculum aureum, nisi quale fingit Ovidius, nempe in quo 'ver erat aeternum' et in quo 'flumina iam lactis, iam flumina nectaris ibant', certe extra hunc orbem quaerendum est, et quaerendum tantum," with citations from Ovid, *Metamorphoses*, 1.107, 111. Coels's remarks were prompted by a debate surrounding Ortelius's 1596 treatise *Aurei saeculi imago*, which the exiled poet Johannes Vivianus, in a recent letter to Ortelius, had critiqued for its depiction of war and torture as part of the golden age. For the latter correspondence, see Ortelius, *Epistulae*, 693–94, no. 292 (Johannes Vivinaus to Abraham Ortelius, Aachen, 5 September 1596).

8 For the larger phenomenon of reading signs and portents of nature during the revolt and over the ensuing Eighty Years' War, see Jorink, *Reading the Book of Nature*, esp. 109–79, and Melion, "Prodigies of Nature."

9 Van der Voort, *Een schoon profijtelik boeck*, E8v: "de Egiptsche sprinchanen die tgroen verteiren / Ja dlant çael maken, en blijven noch onversadisch." See also Müller, *Exile Memories*, 38–39.

10 Van Haecht, *De kroniek*, 2:8. On the role of rumor and superstition in the writings of van Haecht and other chroniclers of the revolt, see van Nierop, "And Ye Shall Hear of Wars."

11 For an evocative reflection on the value of pursuing the anomalous case in the writing of history, see Ginzburg, "Our Words, and Theirs," esp. 111–16.

12 "artifice, n." OED Online. December 2016. Oxford University Press.

13 The only major prior study of the *Four Elements* is Hendrix, "Joris Hoefnagel." See also Kaufmann, *Drawings from the Holy Roman Empire*, 154–57, no. 56; Kaufmann, *The School of Prague*, 202–3, no. 9.1; Hand et al., *The Age of Bruegel*, 198–200, no. 73; Rikken, "Dieren verbeeld," passim; and Vignau-Wilberg, *Joris and Jacob Hoefnagel*, 98–130, no. A6.

14 Virgil, *Georgicon*, 4.83, 4.184.

15 Apuleius, *Florida*, 18.11. Hoefnagel seems to have taken the specific variant of the phrase from Erasmus's treatise *Lingua*. See Erasmus, *Opera Omnia*, 4.1:240: "Adeo late patet illa sententia: ubi mel, ibi fel; ubi uber, ibi tuber."

16 See Homer, *Iliad*, 2.84–96; Virgil, *Georgicon*, 4; Seneca, *Ad Lucilium Epistulae Morales*, 84; and Seneca, *De clementia*, 1.19.1–4. Within the vast secondary literature on this topic, see especially Campana, "The Bee and the Sovereign?"; Hassig, *Medieval Bestiaries*, 52–61; Hollingsworth, *Poetics of the Hive*; Polleichtner, "The Bee Simile"; Rentiis, "Der Beitrag der Bienen"; and Woolfson, "The Renaissance of Bees."

17 Within the vast body of literature on the revolt, useful overviews are provided in Israel, *The Dutch Republic*, esp. 74–230; Parker, *The Dutch Revolt*; Groenveld, *De Tachtigjarige Oorlog*; and Groen, *De Tachtigjarige Oorlog*. On the relation between the revolt and the Reformation, see especially Duke, *Reformation and Revolt*; Duke, *Dissident*

Identities; Marnef, *Antwerp*; and Pettegree, "Religion and the Revolt."

18 For the history of religious heterodoxy in the Netherlands prior to the Dutch Revolt, as told through the case study of Antwerp, see Christman, *Pragmatic Toleration*.

19 See van Nierop, "A Beggars' Banquet," and on the history of the inquisition in the Habsburg Netherlands, Duke, *Dissident Identities*, 99–118, and Goosens, *Les inquisitions*.

20 See especially Backhouse, *Beeldenstorm*; Scheerder, *De Beeldenstorm*; Duke, *Reformation and Revolt*, 125–51; Freedberg, "Art and Iconoclasm"; Marnef, *Antwerp*, 88–105; and Arnade, *Beggars, Iconoclasts, and Civic Patriots*, esp. 90–165.

21 For an overview of Alba's career, see Ebben et al., *Alba: General and Servant*, and Janssens, *Don Fernando*.

22 Marnef, *Antwerp*, 109–52.

23 On Alba's statue, see especially Becker, "Hochmut kommt," and on the citadel, Soly, "De bouw." Further discussion in chapter 3.

24 Horst, *De Opstand*, 84–86; Sawyer, "The Tyranny of Alva"; and Spicer, "Medium and Message," esp. 174.

25 On Granvelle, see Durme, *Antoon Perrenot*, and on his connection to the revolt, Janssens, "Cardinal Granvelle."

26 On the execution of Egmont and Horn, see Arnade, *Beggars, Iconoclasts, and Civic Patriots*, 183–89.

27 Geurts, *De Nederlandse Opstand*; Duke, "Dissident Propaganda"; Duke, "Posters, Pamphlets, and Prints"; Harline, *Pamphlets, Printing, and Political Culture*; and Horst, *De Opstand*. See also Swart, "The Black Legend"; Soen, "Más allá de la leyenda negra"; and Greer, Mignolo, and Quilligen, *Rereading the Black Legend*.

28 Geurts, *De Nederlandse Opstand*, vii and passim.

29 See Groenveld et al., *De kogel door de kerk?*, for a rare example of an exhibition that considered the history of the Dutch Revolt and the Eighty Years' War through the lens of material culture.

30 The foundational study of this question is Freedberg, *Iconoclasm and Painting*. See also Freedberg, "The Hidden God," and, most recently, Jonckheere, *Antwerp Art after Iconoclasm*; Jonckheere and Suykerbuyk, *Art after Iconoclasm*; Jonckheere, "The Power of Iconic Memory"; and Leuschner, *Rekonstruktion der Gesellschaft*.

31 See especially Honig, *Painting and the Market*; Moxey, *Pieter Aertsen*; and Filedt Kok, Halsema-Kubes, and Kloek, *Kunst voor de beeldenstorm*.

32 On the history of Protestant, and later Catholic, exile from the Low Countries, see Janssen, *The Dutch Revolt*. For a pan-European exploration of this phenomenon, see Kaplan,

Divided by Faith, and for the struggles that continued even with the emergence of religious toleration in the later Dutch Republic, see Pollmann, *Religious Choice*.

33 A rare acknowledgment of these issues is found in Freedberg, *Iconoclasm and Painting*, 167–94.

34 For the tension between destruction and creation in the history of iconoclasm, see Gamboni, *The Destruction of Art*. See also the recent and compelling discussion in Jonckheere, *Antwerp Art after Iconoclasm*, and Jonckheere, "Images of Stone"—both focused primarily on the transformation of large-scale painting in response to the image debates of the sixteenth-century Netherlands.

35 For the multiple publics that developed in the early modern period, and a nuancing of Jürgen Habermas's notion of the public sphere, see Wilson and Yachnin, *Making Publics*, and Helgerson, *Forms of Nationhood*. For an important parallel study on manuscript production and preservation in the aftermath of the Reformation in Germany, see Lundin, *Paper Memory*.

36 On the private sphere as a space for multiconfessionalism in the Low Countries, see Spohnholz, "Confessional Coexistence," 68–72.

37 For an excellent overview, with additional literature, see Findlen, "Natural History." For the important case study of Carolus Clusius, see Egmond, "Observing Nature," and Egmond, *The World*.

38 See Kusukawa, *Picturing the Book of Nature*, and Ogilvie, *The Science of Describing*.

39 Jorink, *Reading the Book of Nature*; Blair, *The Theater of Nature*; Harrison; "The 'Book of Nature'"; Santmire and Cobb, "The World of Nature," 116–23; Lohr, "Metaphysics and Natural Philosophy"; and Berns, *The Bible and Natural Philosophy*. See also Serjeantson, "Francis Bacon," for a welcome revisionist approach to understanding the "Book of Nature" in the early modern period.

40 Ashworth, "Natural History," and Ashworth, "Emblematic Natural History." On the continued importance of classical and medieval traditions of knowledge to early modern natural philosophy, see also Grafton and Siraisi, *Natural Particulars*.

41 Pico della Mirandola, *Oration*. See also Greene, "The Flexibility of the Self."

42 See Gouwens, "What Posthumanism Isn't," esp. 45–47.

43 L'Obel, *Plantarum*, 3: "Non possum . . . huiusce communis patriae nostrae calamitates piis lachrymis vobiscum serio non deplorare, quae detestando atque exercabili hoc bello civili tam misere atque hostiliter hinc inde dilaceratur, ut non tantum urbes, et firmissimas munitiones funditus dirutas spectemus,

multaque hominum millia aquis, ferro, fame, et incendio extincta, sed etiam mutuis populationibus agricolas passim profligari, exterminari, et Musarum Pieridumque chorum, qui in amoenissima huiusce provinciae viridaria, relicta Graecia et tantum poëtis antiquis decantato Helicone, sua sponte a multis iam annis commigraverat, fere hinc infestissimis armis disturbari."

44 Ibid.: "Est enim tota haec Galliae-Belgicae nobilissima et antiquissima provincia . . . tanquam celeberrimum totius Europeae emporium, in quod quicquid usquam terrarum est eximium aut expetendum, cumulate terra marique advehitur, omnesque Europae, Asiae, atque Africae thesauri congesti sunt; praeclaris ingeniis, in omni genere artium ac scientiarum excellentibus, fertilissima."

45 Ibid.: "quamvis is caeli tractus Septentrionalis enutriendis innumeris plantis minus sit idoneus, ob frigorum saevitiam et longas hyemes, et continuas durabilesque ei incumbentes caeli tempestates, atque iniurias; tamen ea est incolarum industria, sedulitas ac pertinax in tutandis a praedictis incommodis tenerioribus plantis diligentia, ut nulla stirps toto orbe invenire possit, quac non improbo labore et indefessa opera clarissimorum heroum et virorum illustrium, nullis impensis parcentium, novis hic artibus educetur, alaturque egregie: unde non immerito in excolenda re herbaria, antiquissimo studio, summisque viris dignissimo, primam laudem Belgis obtulerim."

46 So wrote the great English philosopher John Dee to his friend Abraham Ortelius on 16 January 1577. See Ortelius, *Epistulae*, 157–60, no. 67, esp. 159: "Doleo vero ex animo, vestrae Reipublicae statum . . . quibus, cum placidissimis Musis res est: et quorum in manibus egregia artium nobilissimarum, et vitae humanae utilissimarum, habentur monimenta, consulo, ut sibi suisque asylum aliquod, ad tempus, disquirant tutum et tranquillum, donec Martis vesana deferbuerit rabies."

47 On the formation of "imagined communities" among Netherlandish exiles during this period, see Müller, *Exile Memories*, esp. 27–58. For analysis of the primary pockets of sixteenth-century émigrés from the Low Countries, see Schilling, *Niederländische Exulanten*, and also Janssens, "'Verjaagd uit Nederland.'"

48 On dissimulation as an essential strategy of the early modern period, and a means of navigating intolerance, see Snyder, *Dissimulation*, esp. 5–10, 33–42.

49 On the rhetoric of exile, see Ferguson, "Saint Augustine's Region of Unlikeness," esp. 69–70.

50 Sprengius, *Metamorphoses Ovidii*, 5r–v: "In hoc poëmate, tanquam uno quodam fasciculo

continentur: adeo, ut totius vitae humanae illustre quasi speculum videatur, e quo memorabilia, cum benevolentiae, tum irae divinae exempla, et insuper etiam gubernationis Dei mutationis rerum humanarum, levitatis fortunae, et totius mortalius conditionis, perspicuae quaedam imagines elucent." See also Moss, *Latin Commentaries*, 138–40 and passim, for Sprengius's summary commentary on the poem and the larger popularity of this genre in the later sixteenth century. For a case study of Ovid's late Renaissance reception, see Kilgour, *Milton and the Metamorphosis*.

51 Giamatti, *Exile and Change*; Skulsky, *Metamorphosis*; Gaertner, *Writing Exile*; and Claassen, *Displaced Persons*. For a rare discussion of Ovid's exilic poetry as inspiration for later sixteenth-century Netherlandish art, see Papenbrock, *Landschaften des Exils*, 94–98.

52 Williams, *Banished Voices*; Lyne, "Love and Exile"; Burrow, "Re-embodying Ovid."

53 Ovid, *Tristia*, 1.1.119–20: "his mando dicas, inter mutata referri / fortunae vultum corpora posse meae."

54 Ibid., 4.10.125–32.

55 Van Mander, *The Lives*, 1:308–9, 262v. For further discussion of this anecdote, see Vanhaelen, *The Wake of Iconoclasm*, 27–33.

56 On Hoefnagel's biography, see also Vignau-Wilberg, *Joris and Jacob Hoefnagel*, 13–52.

57 See Coornaert, "Anvers et le commerce Parisien," 10–11, and Schlugleit, "Alphabetische naamlijst," 33. For Hoefnagel's family genealogy, see Jorissen, "De genealogie van Hoefnagle."

58 See Bevers, *Das Rathuis*.

59 On Hoefnagel's education, see Monballieu, "Joris Hoefnagel." On his travel drawings, see chapter 3. On the popularity of these two French cities among Netherlandish students in this period, see Verhoeven, *Europe within Reach*, 67–70.

60 Van Mander, *The Lives*, 1:310–11, fol. 263r: "altijt onledigh, soo met versen, Carmina, oft yet anders te maken, waer in hy oock seer geestich was, en soo dapper in zijn Latijn, dat hy een Latijns Boeck voor hebbende, t'selve soo heel ras in Nederlandtsch las, als oft Nederlandts geweest hadde." For discussion of the Renaissance artist-poet, see Parker, *Bronzino*, and, most recently, Cole and Gamberini, "Vincenzo Danti's Deceits." The topic remains unexplored in the context of the Netherlands.

61 See chapter 2.

62 Van Mander, *The Lives*, 1:308–9, fol. 262v. See further discussion in chapter 3.

63 On Bol, see especially Franz, "Beiträge," and Hautekeete, "New Insights."

64 See Hendrix, "Joris Hoefnagel," esp. 40–65; Dreyer, "Zeichnungen"; Rikken, "Abraham Ortelius"; Rikken, "Dieren verbeeld," 25–48, and further discussion in chapter 5.

65 Van Mander, *The Lives*, 1:308–9, fol. 262v: "Eyndelinghe t'Antwerp woonende, verloor al wat hy in zijn Coopmanschap hadde: want hy met den Vader t'samen handelde in Juweelen, en hadde voor veel duysenden verborghen in eenen put, met wetenschap van een dienst-maeght en zijn Vrouw, door welcke de Spaensche Soldaten dit al in hun roovighe handen cregen, in den roof, die men noemt de Spaensche furie." On the Spanish Fury, see Génard, *La furie espagnole*; Wegg, *The Decline of Antwerp*, 189–206; and Israel, *The Dutch Republic*, 185. For a powerful contemporary account of the Spanish Fury by one of Hoefnagel's friends, see Ortelius, *Epistulae*, 145–53, no. 64 (Geeraert Janssen to Jacob Coels, Antwerp, 14 November 1576), esp. 152: "Hier is menighen benauden mensche binnen Antwerpen, syn nu arm geworden."

66 Vignau-Wilberg, *Joris and Jacob Hoefnagel*, 100–101, speculates that it would have been nearly impossible for Hoefnagel to carry loose folios safely, but his fastidious concern for preserving works on paper, especially when transport was involved, is documented in a number of cases. See chapter 4.

67 Van Mander, *The Lives*, 1:308–9, 262v: "een stucxken met beestgens en boomkens, van verlichterije, op pergamijn."

68 See chapter 1 for further discussion of this episode, and of the miniature that Albrecht is actually documented to have purchased from Hoefnagel (fig. 17).

69 On Hoefnagel's tenure in Munich, see especially Vignau-Wilberg, "Joris Hoefnagels Tätigkeit." For art patronage and collecting at the Munich court, see Kaliardos, *The Munich Kunstkammer*.

70 See discussion in chapter 5.

71 See the essential study by Vignau-Wilberg, "Qualche deseigni."

72 On Rudolf's religious stance, see Evans, *Rudolf II*, 84–115.

73 Two excellent starting points for literature on Rudolf II's court and court artists are Fučíková et al., *Prag um 1600*, and Fučíková, *Rudolf II and Prague*.

74 See the epilogue to this book.

75 See Vignau-Wilberg, *Archetypa*, 20–26; Vignau-Wilberg, "Neues zu Jacob Hoefnagel," and especially Vignau-Wilberg, *Joris and Jacob Hoefnagel*, 461–513.

76 For the inventory, see Bauer, Haupt, and Neuman, "Die Kunstkammer," which does list several of Hoefnagel's other works.

77 Van Mander, *The Lives*, 1:310–11, fol. 263r: "Noch maeckte Hoefnaghel voor den Keyser Rhodolphus vier Boecken, een van alle viervoetighe Dieren, den anderen van de cruypende, den derden, van de vliegende, en den vierden, van de swemmende oft Visschen, en hadder voor in specien duysent gouden Croonen."

78 Hendrix, "Joris Hoefnagel," 15, 39–41, and passim.

79 On this point, see further discussion in chapter 1.

80 As suggested by Vignau-Wilberg, *Joris and Jacob Hoefnagel*, 35, if artist and biographer ever met, it could have been in Munich on the latter's journey home from Italy in 1577. Although there is no documentation to support this supposition, it would account for the greater specificity of van Mander's account of Hoefnagel's earlier years. While we know that the Rudolphine court artist Bartholomeus Spranger met van Mander on a visit to the Netherlands in 1602 (van Mander, *The Lives*, 1:354–55, fol. 274r), we can only speculate about what Spranger told him regarding Hoefnagel's works for Rudolf. On this point, see also Taylor, "Karel van Mander," 146–48.

81 See Hendrix, "Joris Hoefnagel," 132–214; Rikken, "Dieren verbeeld," 111–44; and Haupt and Staudinger, *Le Bestiaire*.

82 As pointed out in Kaufmann, "Christian IV and Europe," 21, even documents from a few decades after Hoefnagel's death already propagated his association with the Rudolfine court as a marker of his identity and skill. See Heiberg, *Christian IV and Europe*, 133, no. 467 (Jacob Mores to Prince Christian V, 12 August 1637), and Kongsted, "Archivalische Quellen," 38, for an excerpt from a letter that describes an album of fifty-six works by the "best masters," including works by the "imperial miniaturist" Joris Hoefnagel ("Das Kunstbuch enthielt 56 Stücke von den berühmtesten Meistern, so u.a. Stücke von dem kaiserlichen Miniaturmaler Georgius Hoffnagel").

83 See the excellent study by Reitz, *Discordia concors*, and also Konečný, "Migration, Entfremdung, Aemulatio." A rare precursor to Reitz's arguments is Mout, *Bohemen en de Nederlanden*.

84 Van Mander, *The Lives*, 1:306–9, fols. 262r–v: "Een beter ghewente bevind' ick by ons Nederlanders, als wel by ander volcken in gebruyck te wesen, dat de Ouders of sy schoon machtigh van rijckdom zijn, hun kinderen veel tijts vroegh oft in hun jeught laten leeren eenige Const of Ambacht, het welck besonder in tijt van krijgh en vervluchten wonder wel te pas can comen: want wy oock bevinden dat de quade avontuer oft ongeluck van dese Weerelt minder macht heeft over de Const als over den rijckdom en dat de Const, die men in zijn jeught heeft gheleert dickwils den uytersten plicht-ancker in den noot, en een troostlijcke toelucht wort om d'ellendighe schipbreuck van de perssende armoede voor

te comen. Dit heeft wel bevonden warach-
tich te wesen den seer geestigen Jooris
Hoefnaghel van Antwerpen."

85 See Jacoby, "*Salus generis humani.*"

86 For an overview of the relations among
Stoicism, its diverse reception in the
Renaissance, and the history of Lipsius's
Neo-Stoicism, see Kraye, "Moral Philos-
ophy," 360–74, and Kraye, "The Revival
of Hellenistic Philosophies," 99–102. See
further discussion of Lipsius's philosophy in
chapter 2.

87 Verwey, "The Family of Love"; Hamilton,
The Family of Love; Mout, *Bohemen en de
Nederlanden*, 99–117, and Mout, "Political
and Religious Ideas."

88 Blouw, "Plantin's betrekkingen," 121n2;
Marnef, *Antwerp*, 209–10. See especially
Landtsheer, "Benito Arias Montano," 60–61,
and Pérez, "New Documents," 258–59, both
writing against Rekers, *Benito Arias Montano*.

89 On Lipsius's Catholic devotion, see Bass,
"Justus Lipsius."

90 Lipsius made this comment to Ortelius
when referring to the dangers of openly
professing one's faith, and praised Ortelius's
judgment in this matter: "You, together with
a few others, conduct yourself modestly and
prudently amidst all this commotion of the
times" ("Tu cum paucis in omni hoc motu
temporum te modeste et prudenter"). The
irony is that Lipsius penned these lines just
as he was about to declare himself a Catho-
lic. See Ortelius, *Epistulae*, 492–93, no. 205
(Justus Lipsius to Abraham Ortelius, Liège,
3 December 1591).

CHAPTER 1: HOEFNAGEL'S SHOES

1 Dennis, "Scattered Knives," 168–69, and
Mann, *European Arms and Armour*, 2:426–28.

2 Smith, "*Als ich can.*" Van Eyck's motto is a
perfect demonstration of the self-referential
wit and name-play characteristic of the
genre; if the vowel of *ich* is spoken as long
rather than short, the "I" becomes "Eyck"
himself.

3 See Rosenthal, "Plus Ultra, Non Plus Ultra,"
and Rosenthal, "The Invention."

4 The development of the Italian *imprese*,
together with attendant literature on the
subject by Paolo Giovio and others, was
especially important to this scholarly tradi-
tion. For a survey of this literature and its
focus on the interrelation of text and image,
see Caldwell, "The Paragone." For the
northern European context, see especially
Russell, *Emblematic Structures*, and Silcox,
"*Ornament of the Civill Life.*"

5 Erasmus's use of the motto grew out of his
interest in both the adage and the aphorism,
and his contribution to the latter genres in
turn impacted the motto's larger develop-

ment in and beyond the Netherlands. See
Wesseling, "Devices, Proverbs, Emblems."
For Erasmus's edition of the aphorisms of
Cato, see Cato and Erasmus, *Catonis disticha.*

6 See Panofsky, "Erasmus and the Visual Arts,"
215–16, and on Erasmus's self-presentation
in general, van der Coelen et al., *Images of
Erasmus*, 57–72.

7 Wind, "Aenigma Termini"; Panofsky,
"Erasmus and the Visual Arts," 215–16;
McConica, "The Riddle of 'Terminus'"; and
Rowlands, "Terminus."

8 Erasmus, *Collected Works*, 14:240–45,
no. 2018 (to Alfonso de Valdés, Basel, 1
August 1528). The letter was printed already
in 1528 and later reprinted among the
Apologiae in his posthumous *Opera Omnia*,
for which see Erasmus, *Opus epistolarum*,
7:430–32, no. 2018.

9 Wind, "Aenigma Termini."

10 Illustrated here is the exemplar of the medal
that was in Erasmus's own possession, and
which he bequeathed on his death to his
friend Bonifacius Amerbach (now in the
Historisches Museum, Basel, inv. 1916.288).
See Matzke, "Weltgeschichte in der Hand,"
170–72, no. 7, and Pollard, *Renaissance Med-
als*, no. 767, both with prior literature.

11 Translation from Erasmus, *Collected Works*,
14:240–45, no. 2018; Erasmus, *Opus epis-
tolarum*, 7:431, lines 34–36: "in huiusmodi
symbolis captari etiam obscuritatis aliquid
quod coniecturas intuentium exerceat"; and
ibid., 7:432, lines 69–72: "hoc arrisit . . .
quod geminam haberet gratiam: alteram ex
allusione ad priscam ac celebrem historiam,
alteram ex obscuritate quae symbolis est
peculiaris."

12 Schapiro, "The Still Life," and Derrida, *The
Truth in Painting*, 255–382.

13 See Heidegger, "The Origin of the Work of
Art," esp. 32–36.

14 Listed in Hendrix, "Joris Hoefnagel," 6–8.

15 A letter from 1751 offering the *Four Ele-
ments* for sale to Elector Carl Theodor in
Mannheim refers to the albums containing
315 miniatures, which is over 30 more than
they now contain, and which affirms that
some of the folios were removed well after
Hoefnagel's death. For the text of the letter,
see Wegner, *Kurfürst Carl Theodor*, 13. See
also Vignau-Wilberg, *Joris and Jacob Hoefna-
gel*, 103, and Vignau-Wilberg, "Nederlandse
tekeningen," 247–48.

16 A particularly good example is the loose
sheet from the *Aqua* volume in Klassik
Stiftung, Weimar, inv. no. KK 123, labeled
Folio IIII, in which the upper portion of the
parchment folio shows clear smudges of the
opposing text in reverse.

17 Staatliche Museen, Kupferstichkabinett,
Berlin, inv. no. KdZ 4809; Vignau-Wilberg,
In Europa zu Hause, 257, no. D33; and

Vignau-Wilberg, *Joris and Jacob Hoefnagel*,
114, no. A6l.

18 "Nec sum adeo deformis, nuper me in
littore vidi / Cum placidum ventis staret
mare, non ego quenquam / Iudice te met-
uam, si nunquam fallit imago." Hoefnagel
adapted Virgil's original (*Eclogae*, 2.25–27) by
changing "Daphnin" in line 26 to the more
universal "quenquam."

19 Staatliche Museen, Kupferstichkabinett,
Berlin, inv. no. KdZ 4819; Vignau-Wilberg,
In Europa zu Hause, 258, no. D34, and
Vignau-Wilberg, *Joris and Jacob Hoefnagel*,
118, no. A6n.

20 Erasmus, *Adagia*, 3.1.76: "Minus de istis
laboro quam de ranis palustribus." Hoefna-
gel's adaptation also reappears in his later
works, on which see Vignau-Schuurman, *Die
emblematischen Elemente*, 1:175.

21 "Tam de invidis laboro quam de ranis
palustribus."

22 Musée du Louvre, Paris, inv. no. RF 38985.

23 This is among the figures that Hoefnagel
derived from the animal studies of his
Antwerp contemporary Hans Verhagen. The
model by Verhagen is now in the Staatliche
Museen, Kupferstichkabinett, Berlin, inv.
no. KdZ 26226. See Dreyer, "Zeichnungen,"
142–43, no. 14 and passim, for Hoefnagel's
use of Verhagen's studies. Further discussion
in chapter 5.

24 Inscribed "G[eorgius] H[oefnaglius] f[ecit],
a[nn]o [15]76."

25 Calvete de Estrella, *El felicissimo viaje*, 207v:
"Inter aves quanto maior Iovis ales habetur, /
tanto tu cunctis Carole principibus. / Hinc
aquilam tua iure ferunt insignia passim, /
haec sceptri culmen possidet alta tui."

26 Ibid. (from Philip's entry into the town of
Mons): "Gestabunt timidas aliorum scuta
columba; / magnanimi clypeum Caesaris ista
decent." The coat of arms of Holy Roman
Emperor Frederick III (1415–93), great-
grandfather of Charles, was composed of the
double eagle with the red-and-white striped
arms of Austria at its center.

27 For the text of the Pacification of Ghent, see
Kossman and Mellink, *Texts concerning the
Revolt*, 126–32, no. 23 (in English transla-
tion), and https://dutchrevolt.leiden.edu
/dutch/bronnen/Pages/1576_11_08_ned
.aspx (for the original). See also Baelde,
"The Pacification of Ghent," and Swart,
William of Orange, 103–14, the latter with
reference to how Habsburg politics inter-
sected with the events of the revolt in this
year. Note that Vignau-Wilberg, *Joris and
Jacob Hoefnagel*, 101, 109, instead interprets
the ascending eagle as "a reserved exaltation
of Emperor Rudolf II and his accession to
the throne that same year." But she fails to
identify the source for the inscription at
center, and incorrectly assumes that it is a

reference to Rudolf. See also Hendrix, "Joris Hoefnagel," 96–97, who first raised the question of the folio's possible connection to patronage, but who more measuredly dismissed the possibility of Rudolf as its referent. For one among several examples of how Hoefnagel *did* employ the eagle in direct relation to Rudolf as patron, compare Vignau-Schuurman, *Die emblematischen Elemente*, 1:148–49, and fig. 55 (*Schriftmusterbuch*, Kunsthistorisches Museum, Vienna, inv. no. 975, fol. 86r). As one would expect, the eagle in the Vienna miniature is flanked by direct reference to the emperor's name and deeds.

28 Erasmus, *Opera Omnia*, 2.2:342 (1.9.20): "allusio ad spes huius principatus inanes."

29 "Saepe Iovis telo quercus adusta viret." From Ovid, *Tristia*, 4.9.9–16 (translation adapted from A. L. Wheeler). See also *Tristia*, 4.8.45–52, in which Ovid comments further on the might of Jupiter's thunderbolts and the subjugation of humankind to divine will.

30 Equally telling is the miniature's titular motto ("far from Jove and his lightning bolt") which is glossed by Erasmus as a warning to avoid the reach and punishments of tyrannical rulers. See Erasmus, *Adagia*, 1.3.96. The inscription below the miniature derives from Juvenal, *Saturae*, 14.81–83, and also describes the eagle as a ruthless hunter who serves at Jove's bidding.

31 Shortly after his arrival in Munich, Sadeler produced a series of prints after Maarten de Vos depicting paradisiacal landscapes inflected by the interest in natural history that also fueled Hoefnagel's work in these years. See Herrin, "Pioneers of the Printed Paradise." For Sadeler's comment on his "voluntary exile" from the Netherlands, see Mout, "Political and Religious Ideas," 2.

32 Kunsthalle Bremen, Bremen, inv. no. 1262; Vignau-Wilberg, *In Europa zu Hause*, 36–38, no. A5. Sadeler's motto at the summit of the portrait drawing declares that "art is content merely to be shown" (*ars est contenta doceri*), an adaptation of a popular line from the Roman astrologer Manilius, which calls for the impartment of knowledge without oratorical embellishment (Manilius, *Astronomica*, 3.39). In the Dutch inscription below, Sadeler writes that "one can have no greater delight than to wander in the court of virtue, and can find no better desire than in the company of friends" ("Men can gehebben geen meerder vreught / dan wandelen inden hof der deught, / oock canmen geen meerder lust gevinden, / dan inder tgeselschap vande vrinden").

33 Wither, *A Collection of Emblemes*, 1.17, taken from Rollenhagen, *Nucleus emblematum*, no. 17. See also Scheller, "Joris Hoefnagel."

34 Menestrier, *Devises des princes*, 94, no. 10: "pour une personne resoluë de souffrir, pour-vû qu'elle pût s'avancer."

35 Braun and Hogenberg, *Civitates*, 3:no. 58. See chapter 3 for further discussion.

36 See Strabo, *Geographica*, 5.4.6, as cited by Hoefnagel himself in the upper left inscription within his view of the site itself. See also Weddigen, "Italienreise als Tugendweg," 118–20.

37 National Gallery of Art, Washington, DC, inv. no. 1974.21.1; Staatliche Museen, Kupferstichkabinett, Berlin, inv. no. KdZ 3991. See also Vignau-Wilberg, *In Europa zu Hause*, 252–54, no. D31, and Vignau-Wilberg, *Joris and Jacob Hoefnagel*, 293–95, no. F-e13.

38 Braun and Hogenberg, *Civitates*, 3:no. 58: "Quanquam vero gravis atque teter sit, ad fluxiones tamen et rheumata vehementer confert. Aqua quoque sulphurariae fossae, nervos emollit, visum acuit, lachrymas et vomitum comprimit, stomachi doloribus auxiliatur, foecunditatem sterilibus conciliat, febres cum frigore pellit, et infecta scabie membra purgat."

39 Ibid.: "Lapides e monte Sulphurariam cingente coquunt in fornacibus, eductosque coacervant, dein aquam certis ex puteis, qui hic sunt, spacio dierum aliquot infundunt, et adeo macerant, ut in cineres dissolvantur."

40 See Vignau-Schuurman, *Die emblematischen Elemente*, 1:257, and, more recently, Konečný, "Joris Hoefnagel's 'Emblematic' Signature."

41 See Haverkamp-Begemann, *Fifteenth- to Eighteenth-Century European Drawings*, 222; Brink and Hornbostel, *Pegasus und die Künste*, 205–6, no. IV.19; and Rijks, "Defenders of the Image."

42 Koninklijk Museum voor Schone Kunsten, Antwerp, inv. no. 816.

43 For an excellent recent study of this concept, see Degler, *Parergon*.

44 See Göttler, "Vulcan's Forge," on the conception of the forge as the origin site of artistic invention, especially for artists active in early modern Antwerp.

45 Hoefnagel also elsewhere evokes this association between the igneous element and his signature. In a miniature from a prayer book he illuminated for Laureins van den Haute in 1581 (Bijloke Museum, Ghent, inv. no. 3546, fol. 20v), the Christian martyr St. Laurence stands on an unkindled basket of charcoal and logs from which dangles a bellows inscribed with Hoefnagel's initials. On this prayer book, see Vignau-Wilberg, *In Europa zu Hause*, 200–201, no. D2, and Vignau-Wilberg, *Joris and Jacob Hoefnagel*, 63–65, no. A1, with additional literature.

46 "Mirabilium sulphureorum montiu[m] apud Puteolos (ca[m]pos flegreos Plinius, vulcani forum Strabo, vulgo nunc solphatariam vocant Neapolitani) genuina accuratissimaque ad vivum depicta representatio."

47 See Summers, *The Judgment of Sense*, 99–101; Kemp, "From 'Mimesis' to 'Fantasia'"; Klein, "Genius, Ingenium, Imagination"; Lewis, "Francis Bacon"; and, for historiography and further literature, Emison, *Creating the 'Divine' Artist*, 321–48, and Moritz, *Ars imitatur naturam*. A representative early example of the term's attachment to the figure of the artist is the portrait medal of the early sixteenth-century Venetian painter Giovanni Bellini, with the motto *virtutis e[t] ingenii* and the Athenian owl of wisdom on its reverse. See Woods-Marsden, *Renaissance Self-Portraiture*, 100–101. For further discussion of *ingenium* in the context of artistic creation and works of art themselves, see Kemp, "The 'Super-Artist'"; Christian, "Poetry and 'Spirited' Ancient Sculpture"; and Bass, "Hieronymus Bosch."

48 On the latter usage, see Vérin, *La gloire des ingenieurs*.

49 Plantin, *Thesaurus Theutonicae*, entry for "verstant datmen van natueren heeft."

50 Currently in a private collection. See also Vignau-Wilberg, *Joris and Jacob Hoefnagel*, 146–48, no. C1.

51 See Meganck, *Erudite Eyes*, 105–6, for identification of these costumes, based on Hoefnagel's contributions to Braun and Hogenberg's *Civitates*.

52 "Quid non mortalia pectora cogis / auri sacra fames et honoru[m] dira cupido?" Adapted from Virgil, *Aeneid*, 3.57 and 6.721.

53 See Grapperhaus, *Alva*, and Israel, *The Dutch Republic*, 166–68.

54 For dismissal of this likeness as a self-portrait, and a tenuous suggestion that it represents Emanuel van Meteren, see Vignau-Wilberg, *Joris and Jacob Hoefnagel*, 148.

55 Unfortunately, Hoefnagel's signature and motto at bottom center are now so badly abraded as to be almost illegible to the naked eye, but technical study has confirmed their presence, and most of the miniature's inscriptions are also transcribed by a nineteenth-century hand on the reverse of the sheet. See http://www.sothebys.com/en/auctions/ecatalogue/2015/old-master-british-drawings-l15040/lot.11.html.

56 Cicero, *De oratore*, 2.36. As mentioned in Meganck, *Erudite Eyes*, 103.

57 Ovid, *Remedia amoris*, 359–98.

58 Ibid., 389–92: "Rumpere, Livor edax: magnum iam nomen habemus / Maius erit, tantum quo pede coepit eat / Sed nimium properas: vivam modo, plura dolebis; / Et capiunt animi carmina multa mei."

59 Koninklijk Bibliotheek, Brussels, inv. no. SI 23045. See Vignau-Wilberg, *In Europa zu Hause*, 250–51, no. D30; Vignau-Wilberg,

Joris and Jacob Hoefnagel, 149–51, no. C2; and especially Bracke, *Joris Hoefnagel*.

60 For the frequent parallel made between Spanish tyranny in the Netherlands and in the "New World" during the Eighty Years' War, see Schmidt, *Innocence Abroad*, esp. 111–22.

61 On Hoefnagel's knowledge of the Spanish slave trade as evinced by this miniature, see Fracchia, "The Urban Slave," 197–99.

62 Kaufmann, *The Mastery of Nature*, 96–98.

63 See especially Kraye, "Moral Philosophy," 360–74, and further discussion in the introduction to this book.

64 As Eduard Chmelarz already wrote of the *natura magistra* motto in his foundational 1896 article: "Dieser Satz . . . kennzeichnet uns seinen Entwicklungsgang vom Dilettantismus durch Naturstudium zur vollendeten Künstlerschaft." See Chmelarz, "Georg und Jakob Hoefnagel," 276–78.

65 The common use of *faciebat* in the signatures of Renaissance artists was a practice revived from antiquity, following Pliny's characterization of the imperfect as a gesture of modesty and an expression that even the greatest artwork could always be improved. See Pliny the Elder, *Naturalis historia*, 1.26–27. For an interpretation of *faciebat* in spiritual terms, which parallels Hoefnagel's usage here, see Lavin, "Divine Grace."

66 See Vignau-Wilburg, "Joris Hoefnagels Tätigkeit," esp. 107–12.

67 Occo's letter is transcribed in ibid., 159, no. A-3 (original in Munich, Bayerisches Hauptstaatsarchiv, Kurbayern, Äußeres Archiv 4854, fol. 218r): "Id si impetrare poterit a Serenissima Celsitudine Tua vicissim monstrabit picturas stupendas, quales non puto me vidisse usque, praesertim Hispalis . . . delineationem tam artificiosam ut visum propemodum subterfugiat." For the inventory reference from 1598 to "Die Statt Sivilia in Hispania von Miniatur subtil aufgemahlt," see ibid., 112n41 and 160, no. C-1.

68 Speaking to the copious complexity and diversity of coins, Occo professes to Albrecht, "I have brought as much as possible together in this book of mine—I mean to say, all things that seemed to me most rare and which never before (as far as I know) have been *seen, perceived, and understood* either by me or by others" (emphasis mine). See Occo, *Imperatorum Romanorum numismata*, 4r: "quamplurima ex illis libello huic meo inserui; ea inquam omnia, quae et rarissima mihi videbantur, et numquam antehac vel a me vel ab aliis, quod sciam, visa, perspecta et cognita."

69 For an important study of Wilhelm's patronage, see Maxwell, *The Court Art*, esp. 31–33 on Trausnitz.

70 Braun and Hogenberg, *Civitates*, 3:no. 45: "qui exoticis generosissimarum arborum fructibus, herbis etiam peregrinis, plantis ac floribus ex Italia, Hispania, Gallia allatis areolis labyrinthis, operibus topiariis, florum ac fructuum varietate nitentibus, mira industria distinctus conspicitur."

71 Ibid.: "Quinetiam artificiosissimis statuarum et picturarum figuris magna cum voluptate passim exornatus hic hortus cernitur."

72 Erasmus, *The Collected Works*, 39:171–243, and Erasmus, *Opera Omnia*, 1.3:231–66.

73 Braun and Hogenberg, *Civitates*, 3:no. 45: "Huius demum urbis descriptionem nobis communicavit Georgius Hoefnagell, marcator Antwerpianus, qui ad pacis, non ad belli artes natus, rumores belgicos fugiens, perlustrata Italia, pacifico Principi Alberto Bavariae Duci, sese in clientelam dedit, arti miniatoriae, qua illum mirifice sola dotavit natura, pacifice dans operam."

74 See chapter 3.

75 Staatliche Museen, Kupferstichkabinett, Berlin, inv. no. KdZ 4804. Vignau-Wilberg, *Joris and Jacob Hoefnagel*, 151–53, no. C3.

76 For the history of music at the Bavarian court, see Fisher, *Music, Piety, and Propaganda*.

77 Sellink, *Bruegel*, 181, no. 118, and especially Ilsink, *Bosch en Bruegel*, 148–54. For further discussion of Hoefnagel's engagement with Bruegel, see chapters 2 and 3 of this book.

78 See Silver, *Peasant Scenes*, 23–24, with reference to additional literature.

79 Bol, *Icones quorundam animalium quadrupedium nativam formam referentes*. The Royal Library, Copenhagen, Denmark, inv. no. Gl. kgl. saml. 3471 I, 8°, fols. 67–68. Dreyer, "Zeichnungen," 129n46, incorrectly states that Hoefnagel also copied Bruegel's monkeys in the *Terra* volume of the *Four Elements*.

80 On the Hermathena, see especially Irmscher, "*Hermathena*"; Kaufmann, "The Eloquent Artist," 123–30; Müller and Kaschek, "'Diese gottheiten'"; and Reitz, *Discordia concors*, 379–404. For an overview of Hoefnagel's other representations of this motif, see Vignau-Schuurman, *Die emblematischen Elemente*, 1:190–200, and below.

81 "Georgius Houfnaglius Antverp[iensis] qui picturam delicatiorem genio duce amplexus, eo promovit summis ut princip[ibus] placeat Alberto et Guilielmo Boiaricis, Ferdinando Austriaco, ipsi imp[eratori] Rudolpho August[o]. Joann[es] Sadelerus amicus amico et posteritati."

82 For the use of *genio duce* in Hoefnagel's independent miniatures made for friends, see chapter 4. Hoefnagel also employed the phrase to sign the final page of the *Schriftmusterbuch* that he illuminated for Rudolf (Kunsthistorisches Museum, Vienna,

inv. no. 975, fol. 118r). For an illustration of this folio, see Vignau-Schuurman, *Die emblematischen Elemente*, fig. 71.

83 Zilsel, *Die Entstehung*; Nitzsche, *The Genius Figure*; Murray, *Genius*; Klein, "Genius, Ingenium, Imagination"; Pfisterer, *Donatello*, 111–71.

84 Horace, *Epistulae*, 2.2.187–89.

85 See Bass, "The *Transi* Tomb," and chapter 4.

86 For an attempt at a semantic history of these two words, see Vallini, "*Genius/ingenium*." On artistic *genius*, see Panofsky, *Idea*, 67–68 and passim; Panofsky, "Artist, Scientist, Genius," 172–75; Kemp, "The 'Super-Artist'"; van den Doel, *Ficino*, esp. 193–204; and the foundational study of Kris and Kurz, *Legend, Myth, and Magic*, esp. 58–59.

87 Pico della Mirandola, "On Imitation," 22–23: "genium propensionemque naturae eorum quisque sequebatur." Erasmus, *The Collected Works*, 26:passim; Erasmus *Opera Omnia*, 1.2:581–710.

88 Goclenius, *Lexicon philosophicum*, 614: "Nam genius est ab antique Geno, quod est gigno. Dicitur Genius, quod nascatur nobiscum, ut in prima significatione dicitur, quod genitos nos suscipiat, et tueatur . . . Sic dicimus, Genius meus ab hoc abhorret, id est, natura mea."

89 To complicate matters further, variants of the phrase *ingenio duce* seem to predate the expression *genio duce* in Renaissance writing. Already in a 1391 letter, the Italian humanist Coluccio Salutati wrote that in his youthful studies and reading, he had followed only "the guidance of God's hand and the *ingenium* that [God] gave [him]" (*Dei digito et ingenio, quod michi dederat, duce*), addressing the dual role of divine aid and natural talent in his scholarly formation. See Salutati, *Epistolario*, 2:279, no. 8 (to Bernardo di Moglio). See also Witt, *Hercules*, 54.

90 See Serebrennikov, "Imitating Nature," 234–35. For the impact of Lomazzo's writings on notions of *genius* and *ingenium* on art in northern Europe more broadly, see also Marr, "Pregnant Wit."

91 Lomazzo, *Scritti*, 250: "chi conosce il suo genio è quello segue, facilmente aggiunge al colmo dell'eccellenza, la quella parte dove egli è inclinato." Translation from Lomazzo, *Idea*, 51, in which see also 25–27, and 206n4 for further analysis of Lomazzo's choice of words.

92 Huygens, "Fragment eener autobiographie," 35: "Huius doctrinae quis eventus fuerit, eventus dicat et quae succedentibus annis non infelici vena, genio duce, vario sermone, stilo, argumento lusimus." Huygens's mother was Hoefnagel's sister Susanna, on whom see Smits-Veldt, "Susanna Hoefnagel." For Huygens's comments on Hoefnagel himself, see ibid., 11: "In pictura autem delicatiori

(miniaturam dicimus) suopte genio a pueris acquisitam facultatem habuit inimitabilem." Huygens, who also praises Hoefnagel's contributions to the *Civitates*, may well have been thinking of Braun's description accompanying the view of Landshut (see fig. 19 and discussion above). See also Huygens, *Mijn jeugd*, and Worp, "Constantyn Huygens."

93 The title of the work is as follows: *Archetypa studiaque patris Georgii Hoefnagelii Jacobus f[ilius] genio duce ab ipso scalpta, omnibus philomusis amice d[onat] ac perbenigne communicat. Ann[o] sal[utis] XCII. Aetat[e] XVII.* ("Archetypes and studies of his father Joris Hoefnagel, which Jacob his son—having engraved [them] himself with genius as his guide—gives amicably and conveys kindly to all lovers of the Muses. In the year 1592, at age 17.") As noted in Vignau-Wilberg, *Archetypa*, 20, Jacob was in fact nineteen years old at the time of the work's publication (rather than seventeen as the title page states).

94 The only precedent for the phrase *genio duce* in Latin that I have found within Hoefnagel's circle is an epithalamic poem of 1574 by the German humanist Paul Melissus, seven stanzas of which all end with the same line: "bear fruit, bear children, guided by *genius*!" (*tollite maturam, genio duce, tollite prolem*). In this exuberant call for the newlywed couple to get busy procreating, *genius* refers to the classical notion of a generative spirit in its most literal sense, following from the Latin word's root in the verb *gignere* ("to beget"). Hoefnagel's motto is clearly more metaphorical than this. See Melissus, *Melissi schediasmatum*, 34–36 (from "In nuptias Christophori Andreae Julii et Mariae Mufliac"), and also de Nolhac, *Un poète Rhénan*, for Melissus's connection to humanists in the Low Countries including Ortelius and Lipsius.

95 Swan, *Art, Science, and Witchcraft*, 62–65; van Ommen, *The Exotic World*, 16–17, no. 2; and Chen-Morris, "Imagination," 60–62.

96 A similar rhetoric appears in a 1576 letter from Daniel Rogers to George Buchanan describing Janus Dousa and Philips van Marnix as "ingenio, genio, et genere nobilissimos." See van Dorsten, *Poets, Patrons, and Professors*, 205, appendix 2, no. 22. Rogers was fond of this triple phrase, as he also used it in a poem dedicated to Ortelius. See chapter 4, n54 below.

97 For speculation on this point, see Vignau-Wilberg, "*In minimis maxime*," 234–36.

98 Ortelius, *Epistulae*, 311–12, no. 134 (Anselmus Stockelius to Abraham Ortelius, Bruges, c. 1584), esp. 311: "S[alve] tibi, vir doctissime atque celeberrime, quem ante aliquot annos Monachis, cum, comite Geor-

gio Hueffnaglio amicissimorum meorum intimo, Italiam peteres, conspexi."

99 Braun and Hogenberg, *Civitates*, 4:no. 43: "Effigiavit eam solers Hoefnaglius, unde / urbis adaugescit gloria, nomen, honor." For Stockelius's contributions to the *Four Elements*, see chapter 5 and chapter 7.

100 Stockelius, *Narcissus*, B2r: "Cesses igitur parumper in graviorum rerum tractatione, seriis negociis lassum ingenium laxes, animo indulgeas remissionem, severiora postponas, ocio impertiaris horam, redeas cum genio in gratiam, restituas tibi teipsum . . . ac perlegendo meo poëmati vaces."

101 See Spicer, "Referencing Invention."

CHAPTER 2: THE GOOD HERB PATIENCE

1 The literature on Renaissance emblems is too vast even to summarize. For useful overviews, see Adams and Harper, *The Emblem*, and Daly, *The Emblem*. The latter has more up-to-date bibliography but omits reference to two important studies relevant to my discussion here: Adams, *Webs of Allusion*, and Enenkel and Visser, *Mundus emblematicus*. It should, of course, be noted that there was a strong medieval tradition of dialogue between word and image long before the "invention" of the emblem. For full discussion of these antecedents, see Russell, *Emblematic Structures*.

2 See most recently Rolet and Rolet, *André Alciat*. In my references to Alciato elsewhere in this book, I cite the 1550 Lyons edition: the first to illustrate the full corpus of emblems (211 in total), with the exception of one emblem ("adversus naturam peccantes") deemed by most publishers too obscene to illustrate.

3 For previous exploration of this point, see the excellent article by Visser, "Escaping the Reformation."

4 For background and biography, see Visser, *Joannes Sambucus*; Almási and Kiss, *Humanistes*; Almási, *The Uses of Humanism*, 145–235. For a summary publication time line of emblem books in the sixteenth-century Low Countries, see Landwehr, *Emblem Books*, xli.

5 Wesseling, "Testing Modern Emblem Theory." For the example of Achille Bocchi, another important early emblematist whose work does not fit the *emblema triplex* model, see Rolet, *Les questions symboliques*. On the historiography of these questions in emblem studies, see especially Visser, *Joannes Sambucus*, 215–58, and Graham, "'Emblema multiplex.'" The tripartite theory originated with the scholarship of Albrecht Schöne, most notably with the mammoth compendium Henkel and Schöne, *Emblemata*.

6 Sambucus, *Emblemata*, 3: "Symbola . . . seu

παράσημα ipsae rerum picturae ac imagines dici quasi tesserae verius possunt." Translation adapted from Wesseling, "Testing Modern Emblem Theory," 14.

7 Ibid.: "problematis obscuriora et dilemmatis, aenigmatis apertiora videntur."

8 See chapter 1, n11.

9 For a full facsimile of the manuscript, with commentary and transcriptions of the poems, see van Roosbroeck, *Patientia*. The text is also transcribed in Vignau-Wilberg, *Joris and Jacob Hoefnagel*, 202–23, no. E2. See also Bass, "Patience Grows," for an earlier version of the argument presented in this chapter.

10 See Visser, "Name-Dropping and Networking," and, for a list of the dedicatees in Sambucus's 1564 and 1566 editions, see Landwehr, *Emblem Books*, 589, nos. 590–91.

11 For Sambucus's reliance on artists to produce his woodcuts, see Visser, *Joannes Sambucus*, 227–28, and further discussion in chapter 4.

12 Marnix van Sint-Aldegonde, *De bijenkorf*. For background on Marnix's life and political activities, as well as a summary of past literature, see Duits and van Strien, *Een intellectuele activist*.

13 See Vignau-Schuurman, *Die emblematischen Elemente*, 1:243–45; van Dorsten, *The Radical Arts*, 53; Boon, "*Patientia* dans les gravures," 9–10; Kaufmann, "The Nature of Imitation," 169–70; Kaufmann, *The Mastery of Nature*, 89; Tanis, "Joris Hoefnagel"; Jacoby, "Salus generis humani," 119; and, most recently, Reitz, *Discordia concors*, 327–45.

14 Lipsius, *De constantia*. See also Morford, "The Stoic Garden," and Chen-Morris, "Imagination," esp. 49–59.

15 Saunders, *Justus Lipsius*; Oestreich, *Neostoicism*; Morford, *Stoics and Neostoics*; and Lagrée, "Constancy and Coherence," esp. 152–59.

16 Lipsius, *De constantia*, 11: "At Constantiae vera mater, Patientia et demissio animi est. Quam definio rerum quaecumque homini aliunde accident aut incident voluntariam et sine querela perpessionem."

17 See Forster, *Janus Gruter's English Years*; Bostoen, *Dichterschap en koopmanschap*; van Dorsten, *The Radical Arts*, 26–39, 50–61; Aston, *The King's Bedpost*, 167–99; Prögler, *English Students*, 55–63; and Walker, "Netherlandish Immigrant Painters." For the reattribution of a painting long ascribed to Hoefnagel's English sojourn, and now definitely assigned to his fellow expatriate Marcus Gheeraerts the Elder, see Town, "A Fête at Bermondsey."

18 For Radermacher's biography, see Bostoen, *Bonis in bonum*. See also Radermacher's own autobiographical notes in Ortelius, *Epistulae*, 772–79, no. 330 (Johannes Radermacher to

Jacob Coels, Middelburg, 25 July 1603). On the Dutch Church in England, see Kirk and Kirk, *Returns of Aliens.*

19 See further discussion in chapter 4.

20 See Bostoen, *Kars en bril,* and Joby, *The Dutch Language,* esp. 5, 324–25.

21 Hoefnagel, *Patientia,* 5; Roosbroeck, *Patientia,* 9: "Domino Johanni Radermaecker omnium honestarum liberaliumque artium, ac scientiarum unico fautori, amicoque suo optimo: necessitudinis gratitudinisque ergo, hosce ingenii sui ludos, quibus molestas iniurias, odiosaque tedia, infoelicissimi, ac adversi temporis, in quod (divino volente numine) communi calamitate, ac miseria, ob simultates obortas inter Hispaniarum Regem, Reginamque Angliae, inciderat. Discussit, animumque ab aegritudine, ac maerore, recreavit, levavitque. Dicat, donoque dat, Londini Anno a Christo nato millesimo quinientesimo sexagesimo nono Calendis Maii, Georgius Hoefnaghel, sui observantissimus." Note that this dedication is written by Hoefnagel in the third person, but for greater clarity, I have used the first-person address in my translation.

22 On this rivalry, see Ramsay, *The Queen's Merchants,* 153–73.

23 Hoefnagel, *Patientia,* 5; Roosbroeck, *Patientia,* 9: "Den gheest sijnde beroert, doer tlichaems arresteren / Mistroestich en benaut, doer dapprehencie groot. / Heeft godt den gheest verweckt, wel haest al wijt den noot. / Gheen lijden toch zoe groot, den tijdt die candt mineren. / Ghij als sijn instrument, die quaempt mij visiteren / Vrindelijck inviteren, tot d'edele conste bloot / Die Godt mij heft ghegheven, ick spranck als van die doot. / Des gheest vol fantasijen, en ghinck hem imploijeren. / Den loop present aensiende van wonderlijcke tijden / T'verdrach en patiencia, van nood' aen alle sijden / Sijnd' oock int selve lijden, nam t'selve voer mijn subiect. / Nu dan mijn werck volmaeckt, maer rou, en cleyn van machten / Naer Radermaecker gaet, hij sal u nijet verachten / Want hij heeft vriendtz ghedachten, toendt hem mijn hert ontdeckt."

24 Hoefnagel, *Patientia,* 53; Roosbroeck, *Patientia,* 25, no. 24.

25 For the distinction, and complementary relation, between these methods of creation, see van Mander, *Den Grondt,* 1:98–107, and also Melion, *Shaping the Netherlandish Canon,* 65–66.

26 A foundational source for the Renaissance conception of *fantasia* is Aristotle's *On the Soul,* especially 3.427b–28b. See Aristotle, *Complete Works,* 1:641–92, esp. 680–81. See also Swan, *Art, Science, and Witchcraft,* 14–22; Kanz, *Die Kunst des Capriccio,* 62–69; Kemp, "From 'Mimesis' to 'Fantasia'"; Harvey, *The Inward Wits,* 31–53; Lyons, *Before*

Imagination, 32–60; and Parshall, "Graphic Knowledge."

27 See Plantin, *Thesaurus Theutonicae,* entry for "fantasie/valsche inbeeldinge des sins," which he associates simultaneously with phantasms, visions, and figments of imagination.

28 Hoefnagel, *Patientia,* 7; Roosbroeck, *Patientia,* 20, no. 1. For an overview of sixteenth-century Netherlandish representations of patience, see especially Boon, "*Patientia* dans les gravures," and also Vignau-Wilberg, "Patientia: Humanistsche Überlegungsstrategie."

29 Orenstein and Sellink, *Pieter Bruegel,* 48, no. 20; and Orenstein, *Pieter Bruegel,* 161–62, no. 55.

30 Hollstein, *Dutch and Flemish Etchings, Engravings, and Woodcuts,* 30, no. 18.

31 "Patientia ben ick self in persoone, / Hope vertroest mij, in allen mijn lijden / Hope die doet mij, in droefheyt verblijden / Zij heft mijn hert, al naer t'shemels toone / Ick sitte ten toone, voer jonck en oock voer oudt, / Voer rijck end' arm, dus wilt op mij letten / En op den heere, u hope en troest setten / Salich den mensch, die op hem alleene boudt." Translation adapted in part from Tanis, "Joris Hoefnagel," 13.

32 See Kavaler, *Pieter Bruegel,* 29–56; Limberger, *Sixteenth-Century Antwerp*; Heuer, *The City Rehearsed,* 92–98; and Silver, *Peasant Scenes,* 26–52.

33 Van Mander, *The Lives,* 1:192–95, fols. 233v–34r: "Veel vreemde versieringhen van sinnekens sietmen van zijn drollen in Print: maer hadder noch seer veel net en suyver geteyckent met eenighe schriften by, welcke ten deele al te seer bijtigh oft schimpich wesende, hy in zijn doot-siieckte door zijn Huysvrouwe liet verbranden, door leetwesen, oft vreesende sy daer door in lijden quaem, oft yet te verantwoorden mocht hebben."

34 For a reasoned approach to this issue, see Kavaler, *Pieter Bruegel,* esp. 212–54.

35 The prints of Antwerp architect and designer Hans Vredeman de Vries best embody this ideal. For Vredeman's 1560 series *Scenographiae, sive Perspectivae,* which Hoefnagel would easily have known, see Nalis and Fuhring, *The Van Doetecum Family,* 52–57. See also Soly, "L'urbanisation d'Anvers"; Uppenkamp, "The Influence of Hans Vredeman de Vries," 121–23; and Heuer, *The City Rehearsed,* 68–72.

36 Hoefnagel, *Patientia,* 17; Roosbroeck, *Patientia,* 21, no. 6.

37 "Wij arme lieckens, allendelijck veriaecht / van Nederlant, alhier zijn wij ghaen schuijlen, / naulijcx commen, Godt moet dat zijn gheclaecht / doer oorloghen, wilter weder al vuijlen."

38 Orenstein and Sellink, *Pieter Bruegel,* 33, no. 16; Orenstein, *Pieter Bruegel,* 187, no. 73.

39 Hoefnagel, *Patientia,* 11; Roosbroeck, *Patientia,* 20, no. 3.

40 "Wij cooplieden, sijnder zeer qualijcken aen / Wij doen princen, en landen floreren. / Ons tracteren, doe over al wel gaen. / Ons goedt men compt, nu hier confisqueren / Ransoneren, oock onse persoonen. / Doer orloghe, twist, often sulcken gheschille / Patientie, die heer die salt eens loonen / Godt gaf, Godt nam, tis al tsheeren wille." Translation adapted from Tanis, "Joris Hoefnagel," 18.

41 Kuiper and Leendertz, *Het Geuzenliedboek,* 1:254–55, no. 111, lines 1–8, 17–24: "Wilt met ons druck oorbooren / Ghy menschen cleyn ende groot, / Siet hoe dat nu gaet verlooren / Antwerpen die Stadt minioot, / Die Cooplieden kermen seere, / Sy maken also grooten gheclach / Die neeringhe hadden sy gheerne weere, / Maer my dunckt dat het niet wesen mach . . . Waer hoordemen oyt yemant spreken, / Dat een Stadt alsoo lustich stont, / Daer de Coopmanschap gheheel is ghesweken / En veracht tot inden gront, / Daer elck Minnaer triumpheerde, / Om sijn lief te behaghen siet, / De Coopmanschap die daer floreerde, / Maer nu sitten wy int verdriet." Kuiper suggests that this beggar's song was probably written around 1575 or 1576 just before the Spanish Fury.

42 Hoefnagel, *Patientia,* 29; Roosbroeck, *Patientia,* 22, no. 12.

43 "Partiendo por flandres al mundo dorado / Boto a tal que antes helado."

44 Hoefnagel, *Patientia,* 37; Roosbroeck, *Patientia,* 23, no. 16. For an excellent study of the Spanish perspective on the revolt, see Pérez, *The Dutch Revolt.*

45 Orenstein and Sellink, *Pieter Bruegel,* 99–101, no. 41; Orenstein, *Pieter Bruegel,* 174–76, no. 63.

46 Hoefnagel, *Patientia,* 25; Roosbroeck, *Patientia,* 22, no. 10.

47 Courtauld Institute, London, inv. no. D.1978.PG.11. See Mielke, *Pieter Bruegel,* 61, no. 52, and, on Bruegel's representations of storms at sea, Goedde, *Tempest and Shipwreck,* 64–76.

48 Braun and Hogenberg, *Civitates,* 6:no. 58: "repertum inter studia aytographa Petri Bruegelii pictoris nostri seculi eximii, ab ipsomet delineatum. Communicavit Georgius Hoefnaglius, anno 1617." As Hoefnagel died in 1600, the date of "1617" may simply have been a mistake, or it may have been his son Jacob (a fellow contributor to the atlas) who transmitted the drawing to Braun and Hogenberg from his father's collection. See also Popham, "Georg Hoefnagel," 200, and van Grieken, "'View of the Strait of Messina,'" the latter on a drawing after

Bruegel in Brussels's Royal Library that may be linked to Hoefnagel.

49 Sellink, *Cornelis Cort*, 137–46, nos. 49–52, and Vignau-Wilberg, *Joris and Jacob Hoefnagel*, 443–46, nos. G10a–d. See also Goedde, *Tempest and Shipwreck*, 146–47, and Serebrennikov, "Imitating Nature," 227–28.

50 Hoefnagel also added narrative content to Bruegel's landscapes, transforming them into a *Landscape with Mercury abducting Helen* and a *Landscape with the Fall of Icarus*, respectively. For a 1599 allegorical drawing by Jacob Hoefnagel inspired by his father's addition to Cort's design, see also Gerszi, *The New Ideal*, 158–59, no. 63 and Vignau-Wilberg, *Joris and Jacob Hoefnagel*, 494, no. C1.

51 "Omnia mea mecum porto." See Cicero, *Paradoxa Stoicorum*, 1.8; Seneca, *Epistulae morales*, 9.19; and the adaption of this line in Phaedrus, *Fabulae*, 4.22. See also Alciato, *Emblemata*, 44.

52 Hoefnagel, *Patientia*, 13; Roosbroeck, *Patientia*, 20, no. 4.

53 "Wat moet die arme, ghemeijnte toch lijden. / Alst die Princen, lust orloghe te voeren / Malcanderen zij, nijet en willen mijden / Liever die weerelt, brenght sij setten in roeren." For the larger tradition of images showing lamenting peasants suffering attacks from soldiers and other repercussions of the war with Spain, see the important study by Fishman, *'Boerenverdriet'*.

54 Mielke, *Pieter Bruegel*, 69, no. 67. The engraving of *Summer* was published only in 1570, but Hoefnagel could have seen the drawing before leaving Antwerp.

55 Hoefnagel, *Patientia*, 31; Roosbroeck, *Patientia*, 23, no. 13.

56 "Josne je suis, en fleur de mon aàge, / gaillart, dispost, de bon entendement / maijs tout nest riens, si je n'aij de l'argent / La bourse helas, trop me descouraijge / triste visaijge, elle faict a merueijlle / au coeur douleur, jaij l'experience / prendre me fault, en tout patience / fault dargent cest douler non pareille."

57 Kunsthalle, Hamburg, inv. no. HK-755. See Müller and Kränz, *Verführungskunst*.

58 Braun and Hogenberg, *Civitates*, 1:no. 6.

59 Ibid., "Oppidum hoc porro amplissimo porto nobilitatur, in quo naves a saevientibus undis, et a parum propitiis ventorum flatibus, securam et tutissimam stationem habent, eo quod non industria arteque humana, sed sagacis naturae providentia factus sit. Quamobrem multorum mercatorum Germanorum, potissimum vero Cantabrorum frequentiatione celeberrimum est."

60 Hoefnagel, *Patientia*, 33; Roosbroeck, *Patientia*, 23, no. 14.

61 For a closely contemporary account of the Inquisition in Spain as reported back in Antwerp, see Ortelius, *Epistulae*, 17–19, no. 8 (Abraham Ortelius to Emanuel van Meteren, Antwerp, 3 July 1559).

62 "Spighelt aen mij, al die daer hanteren / Spaensche landen, dit is dinquisitie / Aldus verciert se, het heijlich officie / Zoe wie die tonghe, nijet wel en regeren / Dus zij verneren, en brenghen in verlies / Menich fijn man, ten baet u gheen claghen / Tsanbenitto, moet ghij daeruoer draghen / Mont toe, borse toe, dat is tsweerels deuijs." Translation from Tanis, "Joris Hoefnagel," 16.

63 See especially Roose, *Religieuze poëzie*, and also Kavaler, *Pieter Bruegel*, 226–29. A 1583 edition of Crul's poem is the earliest surviving record of the text, which he wrote sometime before his death pre-1551.

64 See further discussion of this motto in Bostoen, *Bonis in bonum*, 50–51, and in chapter 4.

65 This line, "Godt is diet toch al keert, den goeden al int goed," appears four separate times within the poem. Hoefnagel, *Patientia*, 55–56; Roosbroeck, *Patientia*, 9–10.

66 Hoefnagel, *Patientia*, 55; Roosbroeck, *Patientia*, 9: "Wacht u oock te studeren / In tsweerels heeren boecken."

67 Hoefnagel, *Patientia*, 56; Roosbroeck, *Patientia*, 10: "Woort ghij van godt beproeft, met veel allendicheden / Denckt tis om goede reden, godt weet d'oorsaecke waerom / Den mensch die is gheschapen, doer Godtz verholentheden / Dievers van sinlijckheden, verciert ghelijck een blom / Tis godt die daer versaempt."

68 Hoefnagel, *Patientia*, 3; Roosbroeck, *Patientia*, 8.

69 Pliny the Elder, *Naturalis Historia*, 35.85. See also Erasmus, *Adagia*, 1.6.16.

70 "Doen Schilders en poëten, al wat den gheest verdenckt, / Niemant hem en onstichte, oft zij hier bij ghecreckt. / Niemant en trecx hem aen, dan wel int generale / Van wat staete dat hij sij, conditie, landt, oft tale / Ick en steecke niemant wijt, het woort dicwils beproeft, / T'goet cruyt patientia, Een ijegelijck behoeft."

71 As Horace writes in his *Ars Poetica* (lines 9–10): "Pictoribus atque poetis quidlibet audendi semper fuit aequa potestas." For previous observation and discussion of this salient paraphrase from Horace, see also Kaufmann, "The Nature of Imitation," 172–73, and Kaufmann, *The Mastery of Nature*, 95–96.

72 Fuchs, *New Kreüterbuch*, N5r–O2r, chapter 175 ("Von allerlen Mengelwurtz"), and Dodoens, *Cruijdeboeck*, 594–97, chapter 9 ("Van Lapathum").

73 Dodoens, *Cruydeboeck*, 594.

74 The need for a "cure" to the Spanish threat was a recurrent topic in writing of the period. Hoefnagel's friend Ortelius, for instance, wrote to the physician Johannes Crato von Krafftheim in 1572: "I do not know what Asclepius will finally liberate us from this Spanish suffering, against which we have already labored for so long" ("nescio quis tandem Esculapius nos ab hac lue hispanica, qua iam diu nos laboramus, liberabit"). See de Ram, *Caroli Clusii*, 81.

75 Lipsius, *De constantia*, 11: "una illa radix est, qua altitudo pulcherrimi huius roboris nixa."

76 The notion that patience was a virtue of artists also appears a few years earlier in Lucas de Heere's 1565 "Ode to the *Ghent Altarpiece*," where he employs the word *patientie* to describe Jan van Eyck's painterly diligence. See de Heere, *Den hof en boomgaerd*, 29–32, esp. 31, lines 53–56: "Sijn scherpicheit maect ons zijn patientie vroet, / En zijn memorie groot blijckt in tselfde claerlic / Alzoo oock zin en grooten gheest boven al doet, / In d'inventie, ende ordinancien openbaerlic." See also Melion, *Shaping the Netherlandish Canon*, 139–42.

CHAPTER 3: THE *GENIUS* OF PLACE

1 See Norberg-Schulz, *Genius loci*, 6 and passim.

2 On the distinction between *urbs* and *civitas*, see Kagan, *Urban Images*, esp. 9–10.

3 Münster, *Cosmographiae*, title page: "in quibus, iuxta certioris fidei scriptorum traditionem describuntur, omnium habitabilis orbis partium situs propriaeque dotes; regionum topographicae effigies; terrae ingenia, quibus fit ut tam differentes et varias specie res, et animatas et inanimatas, ferat." On Münster, see especially McLean, *The 'Cosmographia'*, and also Grafton, Shelford, and Siraisi, *New Worlds, Ancient Texts*, 97–111.

4 See Koeman, *Koeman's Atlantes Neerlandici*, 4.1:35–261, with prior literature and details of all editions. See also the facsimiles, with commentary, of Skelton, *Civitates*, and Füssel, *Civitates*. Note that only the original 1572 volume of the atlas bears the title *Civitates orbis terrarum*, though, following common practice, I use "*Civitates*" here as a shorthand for all six volumes. The phrase "urbium praecipium" appears in variant forms across the titles of the other five books.

5 See Ballon and Friedman, "Portraying the City," and Koeman et al., "Commercial Cartography."

6 Less than 5 percent of its overall content was ultimately given over to Asia, Africa, or the Americas. See Skelton, "Introduction," xi.

7 See the biography in Mielke and Luijten, *Remigius and Frans Hogenberg*, xxi–xxviii.

8 See Hogenberg and Hogenberg, *Geschichts-blätter*, esp. 106–30; Mielke and Luijten, *Frans Hogenberg: Broadsheets*, 45–55, nos. B56–B76; and Voges, "Power, Faith, and Pictures."

9 See Braun, *Catholicorum Tremoniensium adversus*, 218v–20v, and Wiepen, *Bartholomäus Braun*, 114–15. Braun's discussion of Antwerp's troubles in this 1605 treatise is blatantly anti-Protestant, yet his productive collaboration with Hogenberg seems in no way to have been compromised by their difference in faith.

10 Braun and Hogenberg, *Civitates*, 5:3r: "ex tanta tantarum urbium eversione et interitu, intelligeremus, omnia, quae in mundo videantur admiranda, fluctuanti, ac instabili mutationi esse obnoxia." I allude here to a term first conceptualized in Nora, *Les lieux de mémoire*. On the particular role of Antwerp in the *Civitates*, see also Arnade, "The City."

11 See especially Meganck, *Erudite Eyes*; van den Broecke, van der Krogt, and Meurer, *Abraham Ortelius*; van den Broecke, *Abraham Ortelius*; and Karrow et al., *Abraham Ortelius*.

12 For the *Theatrum*, see especially Koeman, *Koeman's Atlantes Neerlandici*, 3.A:33–244, including details of various editions; Koeman, *The History*; Karrow, *Mapmakers*; and Meurer, *Fontes*. For Johannes Radermacher's early epistolary account of Ortelius's life and the making of the *Theatrum*, composed for the latter's nephew Jacob Coels, see Ortelius, *Epistulae*, 772–79, no. 330 (Middelburg, 25 July 1603). The first mention of the *Civitates* in Ortelius's correspondence is in a 1571 letter from Braun referring to the atlas as "Master Francis's book of cities" (*M. Francisci de Civitates librum*). "Master Francis" is clearly a reference to Hogenberg, but whether this means the work was initially the engraver's idea is less than clear. See Popham, "Georg Hoefnagel," 185–87n2, who cites in full the original from the British Museum, MS Harley 7011, fol. 167. This letter is not included in Ortelius, *Epistulae*. In his preface to book 1, Braun also singles out Ortelius first among those who aided the project. See Braun and Hogenberg, *Civitates*, 1:E2r: "Ita opus hoc nostrum . . . ornavit et auxit praestantissimus, doctissimusque vir, Dominus Abrahamus Ortelius Anverpianus, hoc nostro tempore insignis cosmographus."

13 Braun and Hogenberg, *Civitates*, 3:a4v–a5v (poem by Lampsonius titled "In Georgii Braunii theatrum, urbium orbis terrarum"), esp. 5v: "Sic duo constituent unum Amphi-theatrum, oculisque / iuncta theatra magis grata duobus erunt." For further discussion and translation of this poem, see Meganck, *Erudite Eyes*, 139–40, 224–26, appendix 2. Although information is scarce regarding sixteenth-century ownership of atlases, it is notable that Philips van Marnix van Sint-Aldegonde's 1599 library inventory included both Ortelius's *Theatrum* and Braun and Hogenberg's *Civitates*, along with Münster's *Cosmographia* and several editions of Ptolemy. See Koemen, *Collections*, 20, and, for the inventory, Marnix van Sint-Aldegonde, *Godsdienstige en kerkelijke geschriften*, 4:123–79, esp. 147–48 ("Catalogus librorum bibliothecae").

14 For a succinct summary of Ptolemy's importance in the Renaissance, see Grafton, Shelford, and Siraisi, *New Worlds, Ancient Texts*, 48–54.

15 For particularly evocative accounts of chorography's importance to the sixteenth-century perception of the world, see Conley, *An Errant Eye*, esp. 1–25, and Michalsky, *Projektion und Imagination*, 114–28. The key Renaissance publication for the revival of chorography was Apian, *Petri Apiani Cosmographia*, including an illustration showing the distinction between geography and chorography (fol. 4r).

16 Braun and Hogenberg, *Civitates*, 3:a3v: "maxime, cum citra metum ullius, vitiosorum morum contagii, hisce in libris peregrinari liceat. Fit namque frequenter ut qui longinqua itinera, incertas et periculosas navigationes, mundi cognoscendi gratia, suscipiunt, earum gentium, quibus cum longa consuetudine vivunt, corruptelis ac vitiis infecti, ad suos revertantur. Sed horum librorum praesidio, totus conspicitur mundus, salutaria virtutum percipiuntur exempla viri, eruditione et virtutibus illustres, cognoscuntur."

17 Hogenberg also collaborated on making engravings for the atlas with his Mechelen colleague Simon Novellanus and others. See Klinkert, *Nassau in het nieuws*, 57–67, esp. 58–59.

18 It is difficult to quantify Hoefnagel's contributions precisely. There are fifty-six signed plates from original drawings by his hand, according to Skelton, "Introduction," xii. However, several of the plates that Hoefnagel designed include multiple views arranged together, and he also redrew and reworked many drawings provided by other artists, signing these in some cases explicitly with the phrases "ex archetypo aliorum delineavit Georgius Houfnaglius" (Braun and Hogenberg, *Civitates*, 5:no. 19), and "effigiavit Lucas a Valckenborgh, communicavit Georgius Houfnaglius" (ibid., 5.52). In the latter case, the verb "communicare" means that Hoefnagel "partook" in the final composition through his revisions to the original that he received from another artist. For good analysis of one such example (involving original drawings by Lucas van Valckenborch), see Hand et al., *The Age of Bruegel*, 201–2, no. 74. For prior studies of Hoefnagel's role in the *Civitates*, see especially Popham, "Georg Hoefnagel"; Nuti, "The Mapped Views"; Robey, "From the City Witnessed"; Füssel, "Natura Sola Magistra," 28–36; and Meganck, *Erudite Eyes*, 92–103.

19 On the subjectivity of early modern maps, see Harley, *The New Nature of Maps*, 45–46, 97–99.

20 I refer to the seminal discussion of the relation between Netherlandish mapping and picturing in Alpers, *The Art of Describing*, 119–68, which has been expanded more recently in Gehring and Weibel, *Mapping Spaces*.

21 On this term and the methodization of travel in the sixteenth century, see Stagl, *A History of Curiosity*, 47–81.

22 Thaumastes had first appeared as a para-doxical character and knowledge-seeker in François Rabelais's *Pantagruel* (see Rabelais, *Oeuvres complètes*, 281–91, chapters 18–20, while Argus Panoptes (better known as Argos) was the many-eyed giant of Greek mythology bewitched and slain by the god Mercury. See Duval, *The Design*, 75–84, esp. 82 on the etymology of the name "Thaumastes" from the Greek word for "marvelous."

23 Grapheus employs the same approach in a poem he sent to Ortelius on 5 April 1579— an encomiastic response to the latter's *Synonymia Geographica* (Antwerp: Christopher Plantin, 1578). For the poem, see Ortelius, *Epistulae*, 194–99, no. 83.

24 On the classical origins of the *genius loci* concept, see Nitzsche, *The Genius Figure*, esp. 7–15.

25 Braun and Hogenberg, *Civitates*, 1:A4r–B1v: "Regifico luxu, Dia Andoverpa, superbo / Luxurians fastu, insigni celeberrima cultu, / Nympha Europaeo longe gratissima coelo . . . Squalida nunc, omni penitus spoliata decore, / En iacet, informi vultu, turpique veterno / Obsita, / scissa comas, referens vix virginis ora, / Indignis lacerata modis: hinc turbidus imis / Flexivagus placidum Scaldis caput occulit undis."

26 On this concept, see Cave, *The Cornucopian Text*, esp. 207.

27 On the persistence of this motif in political history and mythmaking, see Matthes, *The Rape of Lucretia*, and Pipkin, *Rape in the Republic*, esp. 3–7, the latter with a focus on the seventeenth-century Netherlands. See also the sweeping reconsideration of the topos from the premodern period to the present in Dürr, *Obzönität und Gewalt*.

28 See Voet, *The Golden Compasses*, 1:369.

29 See Skelton, "Introduction," x–xi, for further discussion of the various modes of mapping represented in the atlas.

30 Braun and Hogenberg, *Civitates*, 1:E1v: "In quo topographicae urbium oppidorumque descriptiones tam geometrica, quam perspectiva pingendi ratione, cum genuina situs, locorum, moeniorum, publicorum et privatorum aedificiorum observatione, singulari artis industria atque praesidio sunt deliniatae."

31 Ibid., 1:35. For discussion and illustration of Conrad Faber's 1552 map, executed by Hans Grave, see van Putten, "The City Book," 169–72.

32 Braun and Hogenberg, *Civitates*, 1:no. 17.

33 Ibid.: "Tam opulentum et nobile totius Europae emporium, cuius plateae, vix mercium et incolarum et mercatorum stipata quasi agmina capere solebant, nunc rarum mercatorem ostendere, silentio, luctu, et horrore cuncta passim possidentibus."

34 Ibid., 5:no. 27. A letter from Braun to Ortelius reports on Hoefnagel's preparation of this map. See Ortelius, *Epistulae*, 619–21, no. 263 (Cologne, 22 January 1595), and Vignau-Wilberg, *Joris and Jacob Hoefnagel*, 306.

35 See Couvreur, "Galle en Hoefnagels stadsplattegronden," and Lombaerde and Geerts, *Antwerpen verbeeld*, 27–35, and 104, no. 27.

36 Rogers's poems (on the city and her bourse) were originally published in his *De laudibus Antverpiae* (1565), B3r–B4r. Scaliger's poem was first printed in Guicciardini, *Descrittione*, 126. Braun also quotes Scaliger's poem in his lengthy commentary on Antwerp in book 5, which draws extensively from Guicciardini. For another poem Rogers wrote in praise of Frankfurt, see Vignau-Wilberg, "Dichter, Denker, Diplomaten."

37 Van Mander, *The Lives*, fol. 262v: "Doe hy nu hem begaf tot reysen, en Landen te besoecken, maeckte hy een heel groot Boeck, van al wat hy over al seldsaems vondt oft sagh, soo van Landt-bouw, Wijn-perssen, Water-wercken, manieren van leven, Houwlijck, Bruyloften, danssen, feesten, en derghelijcke ontallijcke dinghen: hy was over al doende, hy teyckende alle Steden, en Casteelen nae t'leven, alderley cleedinghen en drachten, ghelijck in een Boeck te sien is, die met ghedruckte Steden uyt comt, daer men siet by die op de schilderachtighste maniere ghedaen zijn, zijnen naam Hoefnagel gheschreven."

38 There has been little effort to consider the original nature of Hoefnagel's travel album, with the notable exception of Nuti, "The Mapped Views," whose article includes evocative reflection on Hoefnagel's process of working from drawing to print. For an overview of travel accounts produced in manuscript within the early modern Netherlands, see Lindeman, Scherf, and Dekker, *Reisverslagen*. See also Dekker,

"Egodocuments in the Netherlands," and Verhoeven, *Europe within Reach*. Perhaps the best comparative example from Hoefnagel's lifetime is the manuscript chronicle of Arnoldus Buchelius: a written description of his travels with color drawings of cities and monuments he encountered along the way. See Buchelius, *Diarium* (with text only) and the online facsimile provided by the Utrecht University Library (inv. no. Hs. 798), where the two-volume chronicle is housed: http://bc.library.uu.nl/nl/oude-dagboeken-vernieuwd.html.

39 Staatliche Museeun, Kupferstichkabinett, Berlin, inv. no. 79D2 and 79D2a. See especially Bartsch and Seiler, *Rom zeichnen* for the complex history of Heemskerck's travel album, which underwent as many changes as Hoefnagel's *Four Elements* over its history. For a facsimile, see Hülsen and Egger, *Die Römischen Skizzenbücher*.

40 The largest number is housed in the Albertina, Vienna. See Benesch, *Die Zeichnungen*, 33–34; Alsteens and Buijs, *Paysages*, 213–20, nos. 58–60; and Vignau-Wilberg, *Joris and Jacob Hoefnagel*, 234–414 (the last with extensive illustrations).

41 Braun and Hogenberg, *Civitates*, 5:no. 10. For other instances in which Hoefnagel depicts himself at work, see his views of Tours (1561), St. Adrian's tunnel in Biscay (1562), Zahara (1564), Verona (c. 1577), and Cumae (c. 1577), in ibid., 5:no. 20, 5:no. 16, 5:no. 12, 3:no. 49, and 3:no. 57.

42 Albertina, Vienna, inv. no. 22406; Benesch, *Die Zeichnungen*, 34, no. 324.

43 Notable examples are the *View of Constantinople* (1555–59) by Danish artist Melchior Lorck, and the German artist Hans Mielich's 1549 woodcut *The Encampment of Charles V at Ingolstadt*, both of which show their makers at work in the foreground. See Mango and Yerasimos, *Melchior Lorich's Panorama*, and Geisberg, *The German Single-Leaf Woodcut*, 3:892–909. See also Frisch, *The Invention of the Eyewitness*.

44 The publication of book 5 of the *Civitates* is generally dated to c. 1596–97, though there is no date provided in the colophon. See Koeman, *Koeman's Atlantes Neerlandici*, 4.1:42.

45 On the myth of Cockaigne, see Pleij, *Dreaming of Cockaigne*.

46 Braun and Hogenberg, *Civitates*, 5:no. 51. See also Vignau-Wilberg, *Joris and Jacob Hoefnagel*, 253–56, no. F-b5, who suggests that Joris may himself have been responsible for the original (and surviving) drawn view.

47 Jacob's views of Bohemia, Hungary, Croatia, and Transylvania seem to have been made on commission from his father and were reworked by the latter prior to publication. See Koeman, *Koeman's Atlantes Neerlandici*,

4.1:39, and the examples in Braun and Hogenberg, *Civitates*, 5:no. 55–57 (each inscribed "communicavit G[eorgius] Houf[naglius] a[nn]o 1595, depict[um] a filio."

48 On Braun's travels or lack thereof, see Popham, "Georg Hoefnagel," 183–84.

49 Braun and Hogenberg, *Civitates*, 2:a5r: "Qui autem patriam suam omissam iniquius tolerat, eum maiorem in modum rogo, ut eius commotus amore, eam ad nos depictam transmittat, et artificiosa Hogenbergii manu, cum honorifica nominis sui mentione celari curabimus."

50 For instance, the numerous maps in the *Civitates* borrowed from Jacob van Deventer and copied by Hogenberg include no mention of his name. See Skelton, "Introduction," xiv, and Füssel, "Natura Sola Magistra," 28.

51 Braun and Hogenberg, *Civitates*, 5:no. 10: "Cabeças . . . urbem quondam magnam fuisse, rudera, et moeniorum vestigia docent; nunc ex agraria, et iis, quae terrae beneficium producit, vitae sibi necessaria curat; tum etiam ex frequenti mercatorum et peregrinantium transitu, qui hanc viam ex Hispali ad Gades et S. Lucam frequentant. Et quia Cabeças, idem quod capita sonat, hinc oppidani hoc vulgari sibi laudi ducunt, *non se haze nada nel conseio del rey sensa cabeças*, quod metonymicos venuste sibi ascribunt."

52 Ibid., 1:no. 2, 5:no. 5, and 5:no. 6 (with two views combined on one page).

53 Van Mander, *The Lives*, 1:308–9, fol. 262v: "Te Calis Malis in Spaengien werden hem van een Nederlandtsch schilder aldaer ghesonden alderley Water-verfkens in een doose besloten, waer mede hy de stadt Calis seer aerdich conterfeytte, en was t'eerste dat hy met verwe ghehandelt hadde."

54 Braun and Hogenberg, *Civitates*, 5:no. 5.

55 Braun's text connects the worship of Hercules Magusanus in Cádiz to the evidence of this cult that was discovered in the Netherlandish province of Zeeland earlier in the sixteenth century. On the origin of interest in this cult among Netherlandish humanists, see Bass, *Jan Gossart*, 66, with additional literature.

56 Braun and Hogenberg, *Civitates*, 5:no. 5: "Ad Gaditanam insulam redimus, cuius eam partem hic accuratius exhibemus, quae a Sacello S. Sebastiani promontorium S. Sebastiani nuncupatur, vulgo, Punta di S. Sebastiano. Et, Fin del mundo, eo, quod isthinc in Indiam usque, mare sit perpetuum, et nulla amplius terra appareat."

57 Braun refers specifically to the columns of Hercules as represented in the program of the 1594 triumphal celebrations in Antwerp for Archduke Albert of Austria, which included a distich asserting that the ancient

hero must yield to Philip's legacy ("Amphi-tryoniade ter magno cede Philippo, tu veteri, ille novo defixit in orbe columnas"). Braun quotes from Joannes Bochius's *Descriptio publicae gratulationis, spectaculorum et ludorum in adventu . . . Ernesto Archiducis Austriae*, published by Plantin in 1595.

58 Braun and Hogenberg, *Civitates*, 5.no. 5: "Novum piscationis genus appictum hic cernitur, quod Gaditanorum industria ita instituit. Magnam maris partem, super impositis saxis ac scopulis, quas obsepiunt et muro claudunt, quo dum pisces magna frequenter copia se recipiunt (recenti quippe argilla et luto delectantur) decrescente mari, recedere nequeunt. Et sic, quod delectabile visu, varii generis pisces, sine hamo et reti, manibus capiuntur."

59 Ibid., 5:no. 6. See also Marzano, *Harvesting the Sea*, 119.

60 The leopard and toucan are labeled, respectively, "canis leporarius ex Indiis Occiden-talibus allatus anno 1565" and "Avis sive pica Peruviana allata anno 1578."

61 The toucan does not appear in the *Aier* volume of the *Four Elements* but only later in the *Mira calligraphiae monumenta*, 327, 329, fol. 132r.

62 Albertina, Vienna, inv. no. 22454; Benesch, *Die Zeichnungen*, 34, no. 338.

63 Braun and Hogenberg, *Civitates*, 5:no. 5: "Quando triremibus, quae quotannis in Indiam, vel ad qualescunque regis usus adornantur remiges desunt, arte et eleganti dexteritate hoc hominum genus conquiri-tur, abiecta sordis, vilisque conditionis, vagabundi ac validi, qui ultroniae, sed tamen annuae servituti seipsos mancipant. Prodit in publicum deputatus ad hoc, quem vocant Alquasil de Corte, in erecto tentorio, ad mensam tapeto decenter stratam residet. In quae tria, quibus inescatur et facile capitur hoc hominum genus, adornata sunt fercula, aurea et argentea pecunia, aleae et lusoriae chartae. Fortunae et liberatis praemium pro-ponitur, quatuor ducati, vel eorum vali Iulii, sive Reales quadraginta quatuor. Accedunt bini et bini, chartas vel aleas, prout placuerit, et inter eos conventum fuerit, eligunt, assidente supradicto Alquasillo ludunt, victor praesenti pecunia et libertate donatur, victus, statim ad triremes et annuam servitutem abducitur. Ita remiges cum lusu acquiruntur et gaudio." On the frequent corruption asso-ciated with those who carried out the post of "alguacil de Corte," see Heras Santos, *La justicia penal*, esp. 160–62.

64 For tensions between imperialism and com-merce in contemporary portraits of Spain, see Silverblatt, "The Black Legend."

65 Braun and Hogenberg, *Civitates*, 5:no. 5: "Hic elegans et venusta Hoffnaglii miniato-ris praestantissimi manus mercandi modum

expressit, quo Hispani cum Hollandiae nau-tis in Gaditana insula haerentibus utuntur, qui ut Hispanicam non callent linguam, ita nec hi Hollandicum. Et tamen merces suas, quibus delectantur Hispani, nullo accedente interprete, ipsis divendunt, elatis digitis mer-cium suarum pretium indicantes, tot enim erigunt digitos, quot realibus mercem suam aestimant."

66 Koninklijk Museum voor Schone Kunsten, Antwerp, inv. no. 64. See Vergara, *Patinir*, 170–75, no. 3.

67 On Patinir's contemplative landscapes, see especially Falkenburg, *Joachim Patinir*, and Falkenberg, "Marginal Motifs." On the "world landscape tradition" in the Nether-lands more generally, see Gibson, *Mirror of the Earth*; Bakker, *Landscape and Religion*, esp. 91–114; and Bartilla, "Die Wildnis."

68 Braun and Hogenberg, *Civitates*, 2:no. 3: "Tam fertilitatem soli, quam altissimas atque praecipites montium rupes, valles atque fontes considerarunt, nihil ab oblectationem hoc loci deest. Quas quidem omnes Dei Optimi Maximi naturaeque dotes, aquarum calidarum uberrimi fontes infinitis prope-modum modis superant. Qui peculiari et secreto naturae miraculo, sponte nullo plane externo Vulcani artificio adhibito, calent."

69 Ibid.: "nati in intimis terrae visceribus rivuli (nempe vaporis a circumstante frigore in aquam condensatione, ut Aristoteles liber I *Meteoribus*, caput 13, docet) per occultas cavernulas, venasque fluitantes, in loca subterraneis ignibus plena, aut sulphureas in venas incidant, a quibus calefactae, naturalem secum calorem deferunt." For the original passage from Aristotle's *Meteorology* to which Braun refers, see Aristotle, *Complete Works*, 1:570–71, and for the various avail-able Renaissance editions and translations of this text, Cranz and Schmitt, *A Bibliography*, 181–83.

70 On the rhetoric of the idol and its fall, see Camille, *The Gothic Idol*.

71 Proverbs 8:25–26.

72 Braun and Hogenberg, *Civitates*, 2:no. 4: "Haec fere omnia praestantissimo viro D. Georgio Hofnagel, iconis depictore sic Flandrico idiomate accepimus."

73 Ibid.: "Antiquera, Hispaniae in regno Granatensi oppidum . . . situ peramoeno; salis foecunditate; lapidum fodinis, et figu-lina commendabile."

74 Ibid., "Visendae et suspiciendae capacitatis vasa fictilia, quorum formam in urbis icone spectator habet, hoc loci conficiunt . . . et cuiuscumque generis, liquores, aquam, vinum, oleum, cappares, olivas, et cetera quorum vel unicum modo, ob incredibilem sui capedinem, integrae familiae domesticae refocillandae, toto anno sufficiet."

75 Ibid.: "Nam in vicinis oppida montibus,

plura sunt loca, salinis, naturae beneficio oportuna, ubi passim incredibili abundan-tia candidi salis grumos conspicias, quod quidem non artificiosi ignis adminiculo, uti in Saxonia et Zelandia, maximis in sumpti-bus, sed solis ardore."

76 Ibid.: "iisdem etiam in montibus fodinae sunt inexhaustae, quibus praestantissimi lapides ad sumptosissimorum operum et aedificiorum ornamenta idonei, eruuntur . . . Mirum autem est, quo naturae miraculo quasi sopitum in se ignem hic lapis retineat. Quod quidem, cum admirari, quam scrutari, atque pernoscere multo sit nobis facilius (differentiae enim naturarum, non Aristotle tantum, sed et ipsa rerum veritate asserente, sunt nobis incognitae) D. Augustini de eiuscemodi lapidibus et calce sententiam adscribere placuit, ex XXI de Civitate Dei lib. cap. 4. In quo, dum venusta narratione, plurima recenset, quorum humano ingenio ratio, non posse dari videtur."

77 Augustine, *De civitate dei*, 21.4.47–64.

78 See further discussion in Jeck, "Miraculum calcis."

79 See Agricola, *De ortu et causis*; Agricola, *De re metallica*, 44, 46, 607; and Martin, *Renaissance Meteorology*, 90–92. See also Eichholz, "Aris-totle's Theory," for discussion of the ancient philosopher's own writings on the subject, and Schmitt, *Aristotle and the Renaissance*, for the classic study of the manifold reception of his writings in the early modern period.

80 See chapter 7.

81 See most recently Besse, "Le voyage," and Meganck, *Erudite Eyes*, 95–100.

82 Virgil, *Aeneid*, 7.1–2.

83 Brain and Hogenberg, *Civitates*, 3:57: "Orte-lius et G[eorgius] Hoefnaglius hunc lacum hodie non esse ἄορνος animadvertentes." Relevant citations appear in the surrounding frame from Virgil, *Aeneid*, 6.42–44, 6.239–42.

84 Braun and Hogenberg, *Civitates*, 3:no. 57: "Lacus Agnianus piscibus carens ranis ac serpentibus scatens . . . Vera deliniatio lacus Aniani, Antrique laetalis, in montem facti non ampli nec longi, sed sensim in arctum desinentis, in quod si animal vivum ingres-sum seu intromissum fuerit, subito moritur. Si tamen repente extractum in subiectum lacum proijciatur, paulatim ad se redit ac reviviscit. In canibus saepe facto periculo" (from the text framing the image to the left and right, respectively).

85 Ibid., 3:no. 53: "Bina huismodi Egiptiaca ex porfido marmore Idola Tiburti conspicua sunt, Ia Febru[ari] 1578."

86 Ibid.: "Flumen Tiverona cuius mirabilem naturam ac quietum (stagni instar) sub ingentibus rupibus exitum Abrahamus Orte-lius ac Georgius Hoefnagle studiose visum eunt." Teverone is the former name of what is now called the Aniene River.

87 Orenstein and Sellink, *Pieter Bruegel*, 119, no. 49, and Orenstein, *Pieter Bruegel*, 124, no. 24. Notably, the *Tiburtine View* is the only engraving among the *Great Landscapes* that depicts a specific place.

88 Orenstein and Sellink, *Pieter Bruegel*, 68–69, no. 31; Orenstein, *Pieter Bruegel*, 140–42, no. 39; Bass and Wyckoff, *Beyond Bosch*, 126–29, no. 11.

89 In contrast to the arguments presented in Serebrennikov, "Imitating Nature," esp. 229–32, and Kaschek, "Bruegel in Prag," 52.

90 Gombrich, *Art and Illusion*, 63–90, esp. 82.

91 On the tradition of monstrous and anthropomorphic faces hidden within Netherlandish landscapes, see Weemans, *Herri met de Bles*, passim, and with additional literature.

92 Van Mander, *The Lives*, 1:190–91, fol. 233r: "In zijn reysen heeft hy veel ghesichten nae t'leven ghecontrefeyt, soo datter gheseyt wort, dat hy in d'Alpes wesende, al die berghen en rotsen had in gheswolghen, en t'huys ghecomen op doecken en Penneelen uytghespoghen hadde, soo eyghentlijck con hy te desen en ander deelen de Natuere nae volghen." For insightful analysis of this passage, see Ribouillault, "Regurgitating Nature."

93 On the figure of artist as "observer" in Bruegel's landscapes, see Müller Hofstede, "Zur Interpretation von Pieter Bruegels Landschaft," esp. 118–25.

94 See Koerner, *Bosch and Bruegel*, 294–95.

95 Descola, *Beyond Nature and Culture*, 57–88. Although not cited by him, Descola's analysis also resonates with that of Heidegger, "The Age of the World Picture."

96 Sellink, *Cornelis Cort*, 137–46, esp. no. 51. See also Serebrennikov, "Imitating Nature," and Ribouillault, "Regurgitating Nature," 8.

97 "Arti et ingenio stat sine morte decus." Adapted from Propertius, *Elegies*, 3.2: "ingenio stat sine morte decus," another variant of which Hoefnagel quotes in a view of the region surrounding Seville (Braun and Hogenberg, *Civitates*, 5:no. 8), in this case taken from the "Elegia ad Maecenatum," for which see Clausen et al., *Appendix Vergiliana* 89, line 38: "vivitur ingenio, caeterae mortis erunt." The last was also used by Adolphus Occo on his portrait medal; Occo's acquaintance with Hoefnagel is discussed in chapter 1. See Houtzager, "Andreas Vesalius."

98 This despite the still-dominant interpretation of Bruegel's landscapes as espousing a Stoic worldview, first proposed by Müller Hofstede, "Zur Interpretation von Pieter Bruegels Landschaft." For an account of the rise of Bruegel as "humanist," see Koerner, *Bosch and Bruegel*, esp. 305–9.

99 Ortelius, *Album amicorum*, 12v: "Congruit nostro Brugelio hoc, cuius picturas ego minime artificiosas, at naturales appellare soleam, neque eum optimum pictorum at naturam pictorum vero dixerim. Dignum itaque iudico, quem omnes imitentur."

100 Braun and Hogenberg, *Civitates*, 3:a3v: (in specific reference to the Italian views) "Haec autem omnia peculiaribus Theatri nostri tabulis, tam graphice, praestantissimi viri Georgii Hofnaglii Antverpiani, opera (quem rarae dotes naturae, non artificis institutio praecellentem edidere pictorem) exhibentur."

101 See the poem accompanying Bruegel's portrait in Lamponsius, *Pictorum*, no. 19: "Quis novus hic Hieronymus orbi Boschius?"

CHAPTER 4: MONUMENTS OF FRIENDSHIP

1 For the most thorough analysis and history of the genre to date, see Schnabel, *Das Stammbuch*. An equally invaluable source catalogue of sixteenth-century *alba amicorum* in libraries and collections worldwide is Klose, *Corpus*. See also Rosenheim, "The *album amicorum*"; Klose, *Stammbücher*; Spadafora, *Habent sua fata libelli*; Schlueter, *The album amicorum*, 8–28; and, for Netherlandish albums in particular, Thomassen et al., *Alba amicorum*; Thomassen et al., *In vriendschap verbonden*; and Heesakkers, *Een network*.

2 I am alluding here to Benjamin, "The Work of Art," specifically his notion of the "uniqueness and permanence" (5) that one perceives through the aura of an artwork that is not mechanically reproduced.

3 On the elision between gifts and commodity exchange, see Heal, *The Power of Gifts*, esp. 6–7, in dialogue with the classic study by Mauss, *The Gift*.

4 See Schnabel, *Das Stammbuch*, esp. 244–74, who usefully corrects the long-standing reliance on an apocryphal statement by the German humanist Philip Melanchthon, which has confused the understanding of the genre's original purpose. Melanchthon's "judgment" on the *album amicorum* entered the literature via Keil and Keil, *Die deutschen Stammbücher*, 9, and Nickson, *Early Autograph Albums*, esp. 9–10.

5 See Lechner, *Renaissance Concepts*; Moss, *Printed Commonplace-Books*; Havens, *Commonplace Books*; and especially Blair, *Too Much to Know*.

6 See especially Wilson, "Social Networking."

7 See Rosenheim, "The *album amicorum*," 253; Musvik, "Word and Image"; and Barker, "Alciato's Emblems." The friendship album of Bonaventura Vulcanius is a representative case (Vulcanius, MS II, 1166), constructed on the foundation of Henri Estienne's 1575 *Parodiae Morales*: a printed commonplace book offering variations (or "parodies") of classical sayings, to which several of the album's contributors respond directly. See, for instance, the dedication to Vulcanius by Henri Estienne himself (fol. 58r), in which he adds a new variant ("res est ingeniosa timor") to those printed on the page opposite (fol. 57v), as well as that of Marnix van Sint-Aldegonde (fol. 29r). See also Cazes, "Démonstrations d'amitié," esp. 37–44, and, on Vulcanius, see the introduction to this book.

8 There were also ready-made album templates produced and sold on the print market, the earliest example of which is Jean de Tournes's *Thesaurus amicorum* (Lyon: apud Ioann. Tornaesium, c. 1558), which consists of blank pages with woodcut borders and medallion portraits of famous personages. Theodor de Bry would produce a similar template in the later sixteenth century, designed again on the format of emblem books, on which see Verhaak, "'Emblemata nobilitati.'"

9 On Sambucus's theory of the emblem, see chapter 2. For the various words (including *tessera*) used to describe monuments of friendship, see the case study of Lipsius's album dedications in Tournoy, "Latin Inscriptions," 569–70.

10 See especially Heller-Roazen, *The Inner Touch*.

11 See Burke, "Humanism and Friendship."

12 Keller, "Painted Friends," and Keller, "Forms of Internationality," esp. 230.

13 See Eden, *The Renaissance Rediscovery*, and Lochman and López, "The Emergence of Discourses."

14 For van Meteren's biography, see Blok and Molhuysen, *Nieuw Nederlandsch biografisch woordenboek*, 7:868–70; Verduyn, *Emanuel van Meteren*; and Brummel, *Twee ballingen*.

15 Van Meteren, MS Douce 68 (21642), unpaginated folio, addressed "tot zijn vrienden": "Ghy liefhebbers der deught, const, end' godsalich leven, / ick nood' end' bidde u hier te maken met u hant / eenighe schoon devijs, die van u goet verstant / ende constich ingien, recht getuych mach gheven, / op dat het zelfde zij voor eeuwich hier beneven / als een vast seghel merck van desen schoonen bandt / onser groote eenicheit ende liefde abundant / in dit bouck, alsoo oock in ons hertten gheschreven." For a full transcription of the poem, see Rogge, "Het album," 163.

16 On van Meteren as historian, see Brummel, *Twee ballingen*, 117–72.

17 For a recent study of early modern letter writing and its impact on art and material culture, see Brisman, *Albrecht Dürer*.

18 Tamen, *Friends*, 3–4, and passim.

19 A particularly vivid account of the loss

of books during the 1566 Iconoclastic Fury, from the cloister of the rich abbey of Ter Duinen outside Bruges, is found in van Vaernewijck, *Van die beroerlicke tijden*, 1.15:75. On the rampaging of Antwerp's booksellers and personal libraries on 16 March 1569, see van Haecht, *De kroniek*, 82. For the books proscribed in the sixteenth century, see Reusch, *Die Indices*.

20 On the story of van Meteren's release from prison, see Verduyn, *Emanuel van Meteren*, 123, 127–28, and Nevison, "Emanuel van Meteren," 132–33. See also Buchanan, "An Unknown Double-Portrait," for a newly discovered manuscript account of this episode.

21 Van Meteren, MS Douce 68 (21642). For an overview of the album, with transcriptions (but no images), see Rogge, "Het album." See also Spadafora, *Habent sua fata libelli*, 45–47. On Hoefnagel and Ortelius's involvement in van Meteren's release, see Verduyn, *Emanuel van Meteren*, 123, 127–28.

22 "Cum Hispani hoc anno Antverpiae inter caetera album amicorum illi eripuissent, in quo doctissimorum hominum amicorum suorum elogia inerant, in locum prioris amissi hoc alterum sibi faciendum curavit."

23 Ortelius, *Epistulae*, 22–24, no. 10 (Joannes Terenumus, alias Vryfpenninck to Abraham Ortelius, Lisbon, 15 June 1561), esp. 23: "cavendum autem erit a picturis aut sculpturis vel imaginibus scandalosis hoc est aut in religiosos (nosti quos velim) aut circa venerem (idque suma cura erit cavendum nam eiusmodi picturae, sculpturae, imaginesque, non minus quam libri ab Inquisitore visitantur, quare hoc tibi semper cordi esse debet)."

24 Ibid., 23: "Het beste waer dat ghy alle die pampieren van ghelycken formaet saemen in een pergameno deet setten in maniere van eenen boeck, ende liet maer slechts die rowicheit af snyden boven ende ter syden, op dat se moegten hier voor boecken passeren, die gheven hier gccncn tol."

25 Van Meteren, MS Douce 68 (21642), fols. 5v–6r. Full transcription in Rogge, "Het album," 166, and brief prior discussion in Bass, "Mimetic Obscurity," 539–41, and Vignau-Wilberg, *Joris and Jacob Hoefnagel*, 223–25, no. E3.

26 Ibid., fol. 5v: "T'vleesch moet hier sterven, eert can beerven, / door Christum t'leven, / ghelyck t'ghesayt, tot eer ment mayt, / oft vrucht siet gheven." Matthew 5:5.

27 Ibid.: "Emanuel Demetrio suo Georgius Hoefnagel (initae cum ipso amicitiae in aeternum duraturae monumentum) aeternitatis symbolum propria depict[um] manu (natura magistra)."

28 Paradin, *Devises heroïques*, 258.

29 1 Corinthians 15:42–44.

30 Van Meteren, MS Douce 68 (21642),

fols. 3v–4r. Full transcription in Rogge, "Het album," 165.

31 Ibid., fol. 3v: "Symbolum hoc meum addidi, cum ex direpta a barbaris Iberis Antverpia, profugeram."

32 The same symbol appears on the reverse of a portrait medal of Ortelius made by Jacques Jonghelinck and dated to 1578. See Smolderen, *Jacques Jonghelinck*, 343.

33 1 Corinthians 1:25; 3:19.

34 "Contemno et orno, mente, manu."

35 Jeremiah 18:6; Romans 8:28. Recall that this same device inspired the poem at the end of Hoefnagel's *Patience* album (see chapter 2).

36 See Aitken, *The Trial*, esp. xxiv, and also Robison, "The Slippery Truth."

37 Van Meteren, MS Douce 68 (21642), 9v: "sic abit et redit / et mutat facies imperio tuo / mundi daedala machina." Derived from Buchanan, *Paraphrasis*, 185. Note that this folio is omitted from the transcription in Rogge, "Het album."

38 This aspect of *alba amicorum* during the revolt has often been linked to the Family of Love, though as discussed in the introduction to this book, that link is tenuous at best. On this point, see also Harris, "The Practice of Community," 307–12.

39 See the facsimile by Puraye, *Album amicorum*, and the excellent online edition available through the University of Cambridge Digital Library: https://cudl.lib.cam.ac.uk/view/MS-LC-00002-00113. Among the numerous studies of the album, see Depuydt, "De brede kring"; Albus, *Paradies und Paradox*, 53–74; Harris, "The Practice of Community"; Harris, "Het *album amicorum*"; Spadafora, *Habent sua fata libelli*, 47–50; Wilson, "Social Networking," 206; and Woodall, "For Love and Money."

40 Ortelius, MS LC.2.113, fol. 89r, with Nonius's written dedication opposite on fol. 88v.

41 The cartouche itself derives from the template of the frames designed by Hans Vredeman de Vries for Ortelius's numismatic treatise *Deorum dearumque capita* (see fig. 86 in this book). These frames form the backbone of Ortelius's friendship album and are personalized by various friends' drawings and dedications.

42 Knowledge of Ortelius's correspondence continues to expand with newly discovered letters beyond those contained in Ortelius, *Epistulae*. See Depuydt, "New Letters," and the ongoing project "Early Modern Letters Online": http://emlo-portal.bodleian.ox.ac.uk/collections/?catalogue=abraham-ortelius.

43 Ortelius, *Epistulae*, 163–65, no. 69 (Alexander Grapheus to Abraham Ortelius, Cologne, 1 June 1577), esp. 164: "autem penitius perlustrato, cum quamplurimis doctissimorum virorum elegantibus symbolis

plane refertum atque illustratum viderem."

44 Ibid., 164: "ut ei albo me inserem, ac subscriberem, vix adduci potui, praesertim, quod anser inter olores streperem." The maxim "a goose among swans" derives from Virgil, *Eclogae*, 9.36. For Grapheus and his dedicatory poem to Braun and Hogenberg's *Civitates*, see chapter 3. Grapheus's two poems survive to this day in Ortelius's album. See Ortelius, MS LC.2.113, fols. 91r–93r.

45 Ortelius, *Epistulae*, 169–71, no. 72 (William Camden to Abraham Ortelius, London, 24 September 1577), esp. 170: "Symbolum etiam adieci, sed non eiusmodi, ut inter tot ingeniosa locum mereatur, utpote nec acumine inventum, nec graphice depictum." Camden's dedication is found in Ortelius, MS LC.2.113, fol. 144v.

46 Ortelius, *Epistulae*, 170: "Sed tu nosti quam crasso caelo nos exules orbis . . . utimur, et ego ingenue, sed dolenter fateor, me manu nihil omnino valere."

47 Ortelius, MS LC.2.113, fol. 7v.

48 Jacob Coels's name and the date of 1598 (the year that Ortelius died) are inscribed on the folio preceding his uncle's own title page. See Ortelius, MS LC.2.113, fol. 1r, and, for Hoefnagel's mention in the index, ibid., fol. 124r.

49 As quoted in n26 above. Hoefnagel returned to the *spes altera vitae* device elsewhere in his later oeuvre, including in the Roman Missal he illuminated for Archduke Ferdinand II (Österreichische Nationalbibliothek, Vienna, cod. 1784, fols. 36r and 638v).

50 Ortelius, MS LC.2.113, fol. 7v: "Amoris monumentum propria / depictum manu (magistra natura) / Abrahamo Ortelius suo Georgius / Hoefnagle Antverpianus, amice / amico b[ene] m[erentibus] p[osuit] / Anverpiae cal[ends] Septemb[ris] 1574."

51 Sandys, *Latin Epigraphy*, 63.

52 See further discussion in chapter 1.

53 Ortelius, MS LC.2.113, fols. 2v–4r, esp. fol. 4r: "Genio Abraham Ortelii . . . hanc oden, si mortale[m], certe immortalis amoris . . . lib[ens] mer[enti] posuit." The folio in Ortelius's album has been cut down, but the missing words from Rogers's dedication can be reconstructed through his own copy of the poem in Rogers, HM 31188, fol. 241r. On the latter manuscript, see below.

54 Ortelius, MS LC.2.113, fol. 4r: "Nam nos (Abrame) triplice foedere, / Natura, Amor, Pallasque ligant duos, / vincloque stamus copulati / et generis, genii, ingeniique."

55 Ibid., fol. 7v: "Si de nature, dieu est le pere, / et si d'amour, nature est mere / si du scavoyu, ell'est maistresse, / aussi des aut; mon Ortel qu'est'ce? / aue je vous doibs? Fors ung bon coeur? Coeur vray d'amis, non de flatteur, pour suivre dieu et la nature? Et pour

monstrer l'affection pure, / (n'ayant aultre), j'emplois aussi / l'art d'ont nature, m'at enrichi. / Nature seulle; seulle nourice. / Des bons esprictz, abhorrantz vice."

56 Jacob Coels lists this folio under Hoefnagel's name in the album's index, indicating that it was there by the time of Ortelius's death.

57 A good example is a letter in which Philips Galle sent his 1582 portrait print, executed by Hendrick Goltzius, to Emanuel van Meteren so that the latter might deliver it to the hands of Jacob Coels. The letter and the portrait (inscribed "Philippus Galle schenckt dit sijnen vrient, Jacob Coels") are both preserved in Leiden University Library, BPL 2766. See also Ortelius, *Epistulae*, 759–60, no. 323 (Philip Galle to Emanuel van Meteren, Antwerp, 7 July 1598).

58 See, most recently, Loh, *Still Lives*, esp. 18–55.

59 For Dürer's portrait of Erasmus, see Schoch, Mende, and Scherbaum, *Albrecht Dürer*, 1:243–46, no. 102.

60 On this point, see also Parshall, "Portrait Prints."

61 Braun and Hogenberg, *Civitates*, 3:no. 56.

62 "Nullus in orbe locus Baiis praelucet amoenis."

63 The inscription plaques along the frame's upper edge read, respectively, "orbis terrarum delitiae" and "luxuriantis naturae venus."

64 "Cogitanti mihi cuinam amicorum potissimum hosce ingenii mei ludos otiique pacifici fructus honestos deferrem, occurrebas tu solus, tu primus, tu postremus mi Orteli . . . tum maxime quod cum nos dulcis Parthenope simul ambos complexa et exosculata fuisset, horum omnium mirabilium visendorum tu mihi comes σύναντόπτης exstiteris."

65 Hoefnagel constructed two other explicit friendship monuments within the *Civitates*, each of them memorializing key moments in his life. The first is an image of the famous "stone" of Poitiers in France, which is inscribed (like a natural friendship album) with the names of Hoefnagel, Ortelius, Braun, and many others. The second is an image of Seville showing a scene of inquisition that Hoefnagel dedicated as "a monument of friendship" to Nicolaeus Malepart, with whom he had traveled in Spain. See Braun and Hogenberg, *Civitates*, 5:no. 18 and 5:no. 7.

66 Schnabel, *Das Stammbuch*, 299, notes several others including *philotheca*, *philothesium*, and *philopinakion*. However, I disagree with his assessment that *philophilacium* was entirely a "self-ironic" term, as this view is based on his sole translation of the word as "a prison of love" (from *phylaca* for "prison" in Latin) to the neglect of equal potential association with the medieval Latin word *gazophylacium*

for "treasury." See "gazophylacium, n." OED Online. March 2017. Oxford University Press. For the extension of the latter word to early modern collections, see also Findlen, "The Museum," esp. 59.

67 For the best biographical details on Rogers, see Slavin, "Daniel Rogers."

68 Bell, *Handlist*, 183–84, nos. LC62 and LC70.

69 See van Dorsten, *Poets, Patrons, and Professors*, 33–67, and also Levy, "Daniel Rogers," on his movements between England and the Low Countries.

70 Rogers, HM 31188. There are also a handful of dedications written to Rogers by his friends, which are also copied down or directly inscribed in this manuscript (fols. 366r–83r). The best discussion of its contents still remains van Dorsten, *Poets, Patrons, and Professors*, passim.

71 Rogers, HM 31188, fols. 323r–43r, esp. fol. 323r: "Quis finis fuerit tuo calori / tandem? Quem statues novis amicis terminum Hoefnageli aut modum parandis? / Iam tuo varii tenentur albo / inscripti ut tabulis suis amici, / certo foedere copulati amici, diversis geniti locis amici, quorum nomina visi caput tuum album."

72 A good comparison is the surviving album of Hoefnagel's contemporary and fellow artist Otto van Veen, which includes several drawings by the latter's hand including portraits as well as allegorical images. See Van Veen, KB, Hs. II 874, and also van den Gheyn, *Album amicorum* (a complete facsimile of the manuscript); Thomassen et al., *Alba amicorum*, 54–55, no. 11; and Spadafora, *Habent sua fata libelli*, 50–54.

73 Rogers, HM 31188, fol. 323v: "Ille Aristoteles tuus, magister / ill[ustri]s ille omnigenae artis: optimum qui / paucos censuit esse habere amicos." See Aristotle, *Complete Works*, 2:1830 (*Nicomachean Ethics*, 8.6.11–14).

74 Radermacher, MS 2465. See Bostoen et al., *Het album J. Rotarii*.

75 See http://www.dbnl.org/tekst/rade004albu01 _01/rade004albu01_01_0134.php. Vivianus and Ortelius also made a celebrated journey together through the Netherlands and France to study local antiquities, as recorded in Ortelius and Vivianus, *Itinerarium*. See also Meganck, *Erudite Eyes*, 49–63.

76 Vivianus's troubles with religion continued abroad in Aachen, as Lipsius reported in a letter to Ortelius from late 1591. See Ortelius, *Epistulae*, 492–93, no. 205 (Justus Lipsius to Abraham Ortelius, Liège, 3 December 1591).

77 Ibid., 494–97, no. 206 (Johannes Radermacher to Abraham Ortelius, Aachen, 12 December 1591), esp. 496: "apud alteram me Johannem Vivianum."

78 Van Mander, *The Lives*, 1:263r: "Hy is

met Ortelius oock ghecomen te Room, by den Cardinael Pharnees, welcken Ortelio vraeghde, wat Hoefnaghel voor een was, so dat den Cardinael werdt laten sien de twee verhaelde Conterfeytselkens van Verlichterije: des den Cardinael hem geern by hem had ghehouden, en wouw hem een duysent gulden Iaer-ghelt gheven. Dan hy veronschuldighe hem, seggende: zijn woordt wech te hebben ghegheven aen den Hertogh von Beyeren, t'welck den Cardinael Const-liefdigh wesende, en in zijn dinghen groot behaghen hebbende, leet was, oft bedroefde, dewijl hy nu most missen den seer uytnemenden Verlichter zijnen Don Iulio da Caravaggio, welcken sy daer sagen zijnen constighen edelen gheest Gode opgheven."

79 Radermacher, MS 2456, fol. 69r: "In picturam Julii Clovii Macedonis prop[ri]a manu elaboratam extantem in Philophilacio Georgii Hoefnagelii, quae sequunt[ur] carmina adscripsit Jo[hannes] Vivian[us]." The use of the phrase *in picturam* followed by a genitive indicating subject was common in sixteenth-century epigrams on works of art, and clearly indicates that the miniature in question was a self-portrait, despite argument to the contrary by Vignau-Wilberg, *Joris and Jacob Hoefnagel*, 17n19.

80 On this notion of the souvenir, see Stewart, *On Longing*, 139–45.

81 The inventory upon Clovio's death lists "un quadretto di miniatura" and "una torre di Babilonia" both painted by Bruegel. See Bertolotti, "Don Giulio Clovio," 267, 274.

82 Radermacher, MS 2456, fol. 69r: "D[iis] m[anibus] / Julio Clovio Macedoni / Georgius Hoefnaglius genii eius imitator l[oco] m[onumenti] p[osuit]." The abbreviation "L.M.P." might alternatively stand for "libens merito posuit," but, given the *album amicorum* context, the reference to a "monumentum" seems more likely.

83 Radermacher seems to have wrongly transcribed Hoefnagel's notation of the date, writing 1577 instead of 1578 ("obit Romae pridie Nonas Januarias anno M.D.LXXVII").

84 Radermacher, MS 2456, fol. 69r: "Te specto tamen in Tabulis, geniumque magistrum / te praeunte sequens, vestigia semper adoro." A full transcription of this poem can be found in Vignau-Wilberg, *Joris and Jacob Hoefnagel*, 16.

85 Ibid.: "Venit ut ingenii laudum perculsus amore / Hoefnaglus Clovii Romana ad culmina, fatum / heu! vitam Clovio rapiebat: quem super ales / cum virga insistens Cyllenius, ora Georgi, / lumina dum claudit Clovio, una contigit: artes Julius ipse suas / legat tibi, ut alter ab illo / que fueras, celebret tandem te fama priorem / dixit: et in tenuem ex oculis evanuit auram."

86 Kunsthistorisches Museum, Kunstkammer, Vienna, inv. no. 5202. See Colding, *Aspects of Miniature Painting*, 78; Seipel, *Kaiser Ferdinand*, 548–49, no. X.38; and Evans, "The Pedigree of the Portrait," 238.

87 Vasari refers to the fact that he knew many private persons owned beautiful portrait miniatures by Clovio in "small boxes" (*scatolette ritratti bellissimi*), but the style of the frame of the Vienna miniature still suggests it was added after Clovio's death. See Vasari, *Le vite*, 7:568–69, and Colding, *Aspects of Miniature Painting*, 78.

88 See Schlosser, "Two Portrait Miniatures."

89 See the discussion of this practice in chapter 1.

90 KB, MS IV 40, Royal Library of Belgium, Brussels. This manuscript is still understudied, and is currently undergoing restoration. See the brief catalogue entry in Liebaers, *Vijftien jaar aanwinsten*, 118–20, no. 93, and Vignau-Wilberg, *Joris and Jacob Hoefnagel*, 92–98, no. A5, both with past literature.

91 On the relation between Hoefnagel's marginal illuminations and Ghent-Bruges borders, and his treatment of the book as collection space (including in the Brussels prayer book), see Thoss, "Georg Hoefnagel"; Kaufmann and Kaufmann, "The Sanctification of Nature"; and Kaufmann, *The Mastery of Nature*, 11–48.

92 KB, MS IV 40, fols. 62v–63r.

93 The drawing of Hugo van der Goes (labeled "Hugonis Vergous depict[um] manus") was originally on fol. 41v. The drawing by Bosch is on fol. 122v. Vignau-Wilberg, *Joris and Jacob Hoefnagel*, 93, asserts that Hoefnagel never owned the manuscript, but we have no evidence either way, and the simplest explanation to account for the added content is to posit that he did. On this point, see also Hendrix, "Joris Hoefnagel," 37–39.

94 There were 20 sols or sous in one French livre, which is not an unexceptional amount for such a small drawing fragment. Again, barring evidence to the contrary, I am working on the assumption that Hoefnagel was the one responsible for both the pasting and sale of these fragments, though the restoration of the manuscripts may shed further light on this question.

95 Similarly, another drawing from Hoefnagel's collection, its whereabouts currently unknown, is ascribed by him to Jan van Eyck, "the splendor of Belgium" ("Belgarum splendor Joannes van Eyck floruit A[nn]o 1430"), and preserved in a frame of his own devising painted with luscious fruits, gourds, birds, insects, and animals. See Popham, "On a Letter," 148–49, fig. 2; Vignau-Wilberg, "Qualche deseigni." Likewise, the Eyckian miniature of *A Fishing Party* (Musée du Louvre, Paris, inv. no. 20674) is inscribed at its summit in a later hand that again appears

to be Hoefnagel's own, and he was likely responsible for mounting it to the wood panel on which it is currently preserved (on this practice, see discussion later in this chapter). The inscription emphasizes the work's importance as a historical document of costume: "veterum Burgundiae ducum conjugumque filiorum filiarumque habitus ac vestitus." See Kemperdick and Lammertse, *The Road to van Eyck*, 282–83, no. 79 (they already suggest Hoefnagel's potential role in restoring parts of the composition).

96 Ortelius, MS LC.2.113, fols. 13v–14r. For a full transcription and translation of the epitaph, see Meganck, *Erudite Eyes*, 223–24, appendix 1.

97 Ortelius, MS LC.2.113, fol. 51r. See also fol. 33r for yet another dedication Ortelius inscribed in his album to Frans Hogenberg.

98 See the 1572 treatise by Dominicus Lampsonius illustrating the portraits of celebrated Netherlandish painters with accompanying poems (Lampsonius, *Pictorum*), as well as van Vaernewijck, *Van die beroerlicke tijden*, and van Haecht, *De kroniek*.

99 For an account of de Heere's rather remarkable life, see Waterschoot, "Leven en betekenis."

100 See ibid., 53–81, and Van Dam, "Lucas d'Heere." For a poem that de Heere wrote for Radermacher in these same years, see de Heere, *Lucas d'Heere*, 160–63.

101 The wartime significance of both de Heere's and Hoefnagel's mottoes was first insightfully pointed out in Yates, *Valois Tapestries*.

102 Rijksmuseum, Amsterdam, inv. no. RP-T-1911-83. See Boon, *Netherlandish Drawings*, 1:111–12, no. 316; Mout et al., *Willem van Oranje*, 31–32, no. A30; Balis, "Het lof van Antwerpen," 119–20; and Albus, *Paradies und Paradox*, 81–85. The date of 1 August 1576 appears on the drawing itself, but an extant loose piece of paper, originally pasted onto the finished page, reveals de Heere's careful revisionary process. The inscription on the loose sheet not only is much tidier, but also revises the work's date of completion to 2 August 1576.

103 "D. Georgio Hoefnagel pictori et poetae clarissimo, in verae et perpetuae amicitiae testimonium hec depinxit Lucas d'Heere Handas. Londoni 2 Augusti 1576."

104 For the relevant passage from book 12 of the *Odyssey*, see Homer, *Deerste twaelf boecken*, 89r–v.

105 Van Meteren, MS Douce 68 (21642), fol. 7r (June 1576); Vivianus, KB, 74 F 19, fol. 55r (April 1580); and Ortelius, MS LC.2.113, fol. 30r (July 1580).

106 Ortelius, MS LC.2.113, fol. 30r: "De sond' is wel van een soet schoon aenrdimi; / maer siet den steert, tot groot verderf sy sterct: / schade leer u daer af thebben verschrdinen, /

en leeft Christo / slevens einde perfect: / als Abraham, door tgheloove verivect."

107 Erasmus, *Opera omnia*, 4.1:336: "Ridentur in comoediis vulgaribus Iani, qui faciem unam ostendunt a fronte, et alteram ferunt longe dissimilem a tergo: ast animi facies est oratio." Translation from Erasmus, *Collected Works*, 29:371.

108 Petrarch, one of the great early Renaissance poets of exile, also compared his plight to that of Odysseus. See Petrarch, *Familiares*, 1.1.145–47, 149–53.

109 "Dit selsaem dier, daer Homerus al spreect, / half vrouw, half visch, in het ghelaet minsame, / trect en loct met sjn spel aenghename / man ende schip dat aen den clippen streect. / Ulisses volckt, twelck geen wijsheit ombreect, / vaert snel voor bij zonder schade ofte blame / die twerck des vleesch volghdt, al schijnet bequame / neemt quaden eyndt: want God sick aen hem wreect. / Maer die het schuwt, en volghdt vast na de deuchdt, / gheniett den loon dat's rechte weeld'en 'vreuchet / al lede hy hier onder-weghe wat strijts: / dus ghy die weett watt is den dienst der sonden, / hoe hy den ziel end' tlichaem gheeft dood'-wonden / schade leer u, wijs te werden in tijts."

110 On de Heere's involvement in Sambucus's project, see Visser, *Joannes Sambucus*, 15–16, 63, 253–56; Waterschoot, "Leven en betekenis," 39; and Waterschoot, "Lucas d'Heere."

111 Sambucus, *Emblemata*, 210: "Fluctibus immensis parva est iactata tabella, / sed levitas tuto littore sistit onus. / Altera difficili premitur dum pondere, cedens / nil undis, fundum mox subitura petit. / Vanus, adulator, mendax, variusque per orbem, / noxia declinat, dum levis aura agitat. / Sed quos relligio constans, moresque probati / invidiae obiiciunt, prompta pericla vorant."

112 De Heere, *Beschryvinghe*. See also Waterschoot, "Leven en betekenis," 85–88. On the connection between William of Orange and de Heere, see also Rahlenbeck, "Quelques notes," 39n1.

113 De Heere, *Beschryvinghe*, A2r: "Verraet hebbende een schoon aensicht vooren en achter een leelick. Onder haer was een vrauwe ghenaemt Inquisitie, magher ende leelic zijnde ghecleedt ghelijc eenen Spaenschen pape ende het scheen datse dese vrauwe wilden advanceren ende voortdrijnghen."

114 In addition to the two examples discussed below, many of Hoefnagel's extant independent miniatures show evidence of this practice. His 1594 *Monument of Friendship for Johannes Muisenbol*, for instance, is no longer pasted down on wood, but wormholes evince that it originally was (Rijksmuseum, Amsterdam, inv. no. RP-T-1895-A-3115). See Boon, *Netherlandish Drawings*, 1:112, no. 318, and Vignau-Wilberg, *Joris and Jacob*

Hoefnagel, 177–78, no. C17. His miniature of Seville from 1573, which is pasted to a particularly thick wooden support, is one of the earliest preserved examples (see fig. 17). For an interesting parallel to Hoefnagel's tactics of preservation, see also Göttler, "Affectionate Gifts."

115 Plantin Moretus Museum, Antwerp, inv. no. A.01.03bis. Vignau-Wilberg, *Joris and Jacob Hoefnagel,* 175–76, no. C16.

116 "Ars neminem habet osore[m] nisi ignora[n]tem."

117 "D[omino] Abrahamo Ortelio amicitiae monumentum Georgio Houfnaglius d[edit], genio duce."

118 Cicero, *De amicitia,* 23.

119 Ortelius, *Epistulae,* 566–67, no. 239 (Joris Hocfnagel to Abraham Ortelius, Frankfurt, 20 September 1593): "Sende ick u . . . een stuxken van mijnder handt, hope tselve en sal u. l. nijet misvallen, ende alsoe mij wederom in handen is commen het blompotteken dat ick u l. over langen tydt hebbe vereert, hebbende mij D. Oijkens begert hem te willen daer voer een ander maken dat verscher is, terwijl het aen u. l. is gededicert ende alsoe nijemant anders en dient, sendet u. l. ende presentert u noch eens, vermeerdert van vele inserta ende over al gerenovert ende ververst . . . het is gheel gewoerden door het ebben lijstken dat geolit is woerden ende soe is dic olie int perkement getrocken . . . ende soe u. l. een ander laer maken datter gheen olie aen en comme ende het schelken van anderen houte sij ongeolit oft sal gansch verderven. Prijs van gelde en wil met u. l. nijet maken voer het nieu stuxken, stellet al in u ende liever ijet van onse consten ende speculatie daervoer dan gelt tot mijn studie dienende; ommers voer het blompotteken en beghere nijet anders dan const tegen conste." The first discussion of this document can be found in Popham, "On a Letter."

120 For the early modern topos of juxtaposing the rewards and riches of friendship with commercial and material property, see Davis, *The Gift,* passim, and Eden, *Friends Hold All Things in Common,* esp. 4.

121 "speculation, n." OED Online. June 2017. Oxford University Press.

122 Ortelius, *Epistulae,* 567: "Ick gae voert in het vergaderen van deseignen in mijnen const-bouck, arriverende wel tot 300 meesters handen al goede ende principale."

123 Ibid.: "Den vijfsten stedebouck woert gemaeckt daer ick vant mijne veel in sal communiceren onder andere Sevillen ende Naplis die schoen gedruckt sijn."

124 Zeeuws Museums, Middelburg, inv. no. M98-072-01. See also Vignau-Wilberg, "Freundschaft," and Vignau-Wilberg, *Joris and Jacob Hoefnagel,* 155–56, no. C5.

125 I am grateful to Huub Baija for consulting with me on the dating of this frame, which is still preserved today in the Zeeuws Museum.

126 A representation of another such sliding frame used to house a miniature painting of naturalia appears in an anonymous Flemish depiction of a collector's cabinet in London's National Gallery (inv. no. NG1287). For the reproduced detail, see Baadj, *Jan van Kessel,* 14–17, fig. 4.

127 See Siegert, *Cultural Techniques,* 164–91, esp. 170–76. See also the excellent discussion in Honig, *Senses of Scale,* 33–77.

128 J. Paul Getty Museum, Los Angeles, inv. no. 83.GC.214. See discussion of Hoefnagel's dialogue with Dürer in chapter 5.

129 See Paradin, *Devises heroiques,* 215 ("turpibus exitium").

130 Hoefnagel, *Ignis,* Folios. XXIV, XXXIII, and XXXVIII.

131 The titular motto derives from Erasmus, *Adagia,* 2.6.40 ("rosam quae praeterierit, ne quaeras iterum"). The text below is from a work by the late Roman poet Ausonius commenting on the rose as a symbol of the ephemerality of life. See "De rosis nascentibus" in Clausen et al., *Appendix Vergiliana,* 177, lines 15–16.

132 "D[omino] Ioanni Rademacherio suo / Georgius Hoefnaglius pignus amoris d[ono] d[edit] a[nn]o [15]89."

133 "Amicitiis no[n] est utendum ut flosculis, tamdiu gratis quamdiu recentibus."

134 Erasmus, *Adagia,* 4.7.12, Psalms 102:14–15.

135 Museum Boijmans Van Beuningen, Rotterdam, inv. no. 1308 (OK).

136 Kaufmann, *The Mastery of Nature,* 94–95, identifies the two figures on the left as representations of Poetry and Painting, while Vignau-Wilberg, *Joris and Jacob Hoefnagel,* 142, sees them more generally as "an allegory of the fine arts." The two figures on the right are more easily identified through the inscription below them: "Honesto et Iucundo legitime natus Amor utile mortalibus allaturus, igni suo Deo sacrato immortale a pietate nutrimentum capit" ("Love legitimately born from virtue and pleasure, profitably conveyed by mortals, feeds God's own sacred fire, made immortal by faith"). See also Bostoen, *Bonis in bonum,* 30–31; Vignau-Wilberg, "Freundschaft," 121–23; and Vignau-Wilberg, *Joris and Jacob Hoefnagel,* 141–43, no. B3, with further literature.

137 "Attende spectator ne vanum putes amoris simulacrum non simulati quae origo quae finis Georgii Houfnaglii Ioanni Rademacheri mutuum absentiae solatium. Anno domino 1589." A letter from 1819 records the miniature and the painting both in the collection of Lambrechtsen van Ritthem, for which see Jorissen, "De genealogie van

Hoefnagle," 267–69, and, for an English translation, Vignau-Wilberg, *Joris and Jacob Hoefnagel,* 143. However, at least as late as 1772, both were still with the Radermachers and are recorded in a manuscript compiled by one of Johannes's descendants as works that should always remain with the eldest descendant of the family. See Radermacher, KW 133 M 42, fols. 73r and 76v.

CHAPTER 5: ANIMAL INGENUITY

1 On the term *scientia,* see Park and Daston, "Introduction."

2 On the close affinity between the study of nature and ancient history in this period, see Grafton, *Commerce with the Classics,* esp. 188–89.

3 The notion of "invention" (*inventio*) itself was understood in ancient and Renaissance rhetoric as an instrument for achieving the poet's or orator's aims, a literal process of "finding out" rather than one of demonstrating what had already been found. For a useful biography of the word, see Langer, "Invention."

4 Ortelius, *Deorum dearumque capita,* A3r ("Candidis spectatoribus"): "Videmus Naturae omniparentis sedulis indagatoribus non satis esse . . . nisi etiam ipsa animalia figuris expressa ante oculos habeant."

5 Ibid., A3v: "Nam uti scientiarum peritum ad quodvis penicillo delineandum minime aptum esse non ignoramus, ita pictoris interdum etiam dexterrimi oculos fugere, quae erudito perspicua sunt, procul dubio novimus. Cum vero mutuas coniungent operas, opera eorum multo absolutiora evadere quis dubitat?"

6 See chapter 4, n55.

7 Kris, "Georg Hoefnagel," 247: "Bei aller Meisterschaft der Darstellung sind diese Blätter gewiß nich als 'Kunstwerke' aufzufassen—vielmehr bilden sie zu Bänden vereinigt ein durchaus systematisches Repertorium und die 'Bilder' sind als wissenschaftliche Illustrationen gemeint." This article is also reprinted with an introduction in Uppenkamp, *Erstarrte Lebendigkeit.*

8 For recent discussions of the "scientific picture" and "epistemic image," see Bredekamp, Dünkel, and Schnieder, *The Technical Image*; Lüthy and Smets, "Words, Lines, Diagrams, Images"; Daston, "Epistemic Images"; and, for a critical overview of this literature, Marr, "Knowing Images." See also Mitchell, *Image Science,* 63, on the question of what an image "knows" as a key concern of visual culture studies.

9 See the essential article by Parshall, "Imago contrafacta."

10 See the dedication "To the Reader" in Ortelius, *Thesaurus geographicus,* 3v.

11 Ashworth, "Natural History," and Ashworth, "Emblematic Natural History," in reference to Foucault, *The Order of Things*.

12 See especially Fischel, *Natur im Bild*; Findlen, *Possessing Nature*; and Kusukawa, "The Sources."

13 See Nelles, "Mind and Memory," and Krämer and Zedelmaier, "Instruments of Invention."

14 The first speculation about a lost model book appears, to my knowledge, in Bergström, "On Georg Hoefnagel's Manner," 182, who does not take account of the *Four Elements*. The idea has been picked up and repeated in Vignau-Wilberg, *Archetypa*, 29, and Vignau-Wilberg, *Joris and Jacob Hoefnagel*, 100. On the longer tradition of artists' model books of animals, see Schmitt, *Der Meister*.

15 See Maselis, Balis, and Marijnissen, *The Albums of Anselmus de Boodt*.

16 See Lausberg, *Handbook*, 39–40, and the foundational discussion in Quintilian, *Institutio oratoria*, esp. 3.5.5–16.

17 There is a total of 279 folios extant within the four manuscripts, of which six are blank. The distribution of blank ovals is as follows: 1 in *Terra*, 2 in *Aier*, 1 in *Aqua*, and 2 in *Ignis*. The numeration in *Terra* is also off, with one folio missing (there is no Folio XXXI).

18 See Aristotle, *Complete Works*, 2:1558; O'Brien, *Empedocles' Cosmic Cycle*; and Richard Parry, "Empedocles," *The Stanford Encyclopedia of Philosophy*: https://plato.stanford.edu/archives/fall2016/entries/empedocles/ (with further literature).

19 Brushing Empedocles aside, Galen strongly asserted that Hippocrates was the originator of the theory of the four elements, a claim that continued to hold sway into the sixteenth century. See Galen, *On the Elements*, and Curtis, "Author, Argument and Exegesis."

20 See Minges, *Das Sammlungswesen*, esp. 37–40, and Kayser, "The Intellectual and the Artisan," esp. 53.

21 See Kaufmann, *Arcimboldo*, esp. 54–61, 96–97, 118–19; Kaufmann, *Mastery of Nature*, 100–128; and Ferino-Pagden, *Arcimboldo*, 147–56, nos. IV.16–IV.22 (including the copies after the original series).

22 See Quiccheberg, *The First Treatise*, and Kaliardos, *The Munich Kunstkammer*.

23 Erasmus, *Adagia*, 1.5.29.

24 Ibid., 1.10.66: "Elephantus Indicus non curat culices."

25 Staatliche Museen, Kupferstichkabinett, Berlin, inv. no. KdZ 26227. On Verhagen, see Dreyer, "Zeichnungen," esp. 143, no. 15 (for the elephant); Rikken, "Abraham Ortelius," 103–5; and Rikken, "Dieren verbeeld," 32–35.

26 Dreyer, "Zeichnungen," 115, 118. It is also thanks to Hoefnagel's inscription of the name "Hans Verhagen der stomme[n] van Antwerpe[n]" on one of the surviving sheets that we know the artist to whom they are attributed.

27 See Jordan-Gschwend, *The Story of Süleyman*, 35–43.

28 Psalms 130:24.

29 *Elegia de Philomela*, lines 53–54: "Et Barrus barrit, Cervi clocitant et Onagri; / Ast Taurus mugit, cum celer hinnit Equus." On this poem, see Bettini, *Voci*, 16–24.

30 See Curschmann, "Imagined Exegesis," 163–66. See also Leach, *Sung Birds*, for the manifold interpretations of birdsong in the Middle Ages.

31 "Tristantur rapto parto laetantur honore / corda Elephantum studiis obnoxia nostris. / Usque adeo Ingenium mite est Elephantibus, alter / fraterno alterius damno ut succurrat amore. / Omnibus est spatium longum, longissima vitae / tempora, viginti bis dicunt vivere lustra."

32 Conti, *De venatione*, 13v–14r (first four lines only). See also Conti, *Mythologiae*.

33 A few quotations from Conti's poem appear in *Aier* (Folio XVIII) and *Aqua* (Folio XXII) as well.

34 See Pliny the Elder, *Naturalis historia*, 8.28 as Hoefnagel's plausible source for the animal's life span.

35 Brouwer, "Stoic Sympathy."

36 See Enenkel, "The Neo-Latin Emblem," and the discussion of Joachim Camerarius the Younger in chapter 6 below.

37 See Ilsink, *Bosch en Bruegel*, 30–89; Vandenbroeck, "Bubo significans"; and Stumpel, "The Foul Fowler," esp. 147–49.

38 Kupferstichkabinett, Berlin, inv. no. KdZ 549. See Ilsink, *Hieronymus Bosch*, 498–505, no. 37r, and Koreny, *Hieronymus Bosch*, 170–75, no. 5r, both with additional literature.

39 "miserrimi quippe e[st] i[n]genii se[m]p[er] uti i[n]ve[n]tis et nu[m]q[uam] i[n]veni[en]dis." This passage is borrowed from Pseudo-Boethius, *De disciplina scolarium*, 5: line 4. See further Vandenbroeck, "Over Jheronimus Bosch."

40 See my previous discussion of these folios from *Aier* in Bass, "Mimetic Obscurity."

41 For the Hermathenic owl in Hoefnagel's other works, see figs. 18, 20, and 83 in this book, as well as fol. 20r in the *Schriftmusterbuch* that Hoefnagel illuminated for Rudolf II (Kunsthistorisches Museum, Vienna, inv. no. 975). See also Zenkert, "The Owl and the Birds," 565–72.

42 Gesner, *Historia animalium*, 3:600, 602: "multae noctuae sub tegulis latitant." Gesner also cites the variation "multae sub tegulis cubant noctuae," which he took from Gregorius, *Libelli duo*, 47–48.

43 Erasmus, *Adagia*, 1.1.76: "noctua volat."

44 Hegel, *Hegel's Philosophy of Right*, 13.

45 Alciato, *Emblemata*, 127: "Noctua ut in tumulis, super utque cadaver bubo, / talis apud Sophoclem, nostra puella sedet." The phrase is also cited by Gesner, *Historia animalium* 3:233.

46 Ovid, *Metamorphoses* 5.551: "Ignavus bubo, dirum mortalibus omen."

47 Palingenius Stellatus, *Zodiacus*, 209 (Virgo, lines 501–2): "Non mare non tellus, non aër tutus, ubique / hostis adest; prodestque parum non esse nocentem."

48 Erasmus, *Adagia*, 2.2.43.

49 Gesner, *Historia animalium*, 3:597.

50 This possibility was first suggested by Kaufmann, *Drawings from the Holy Roman Empire*, 156.

51 See Hauschke, "Scientific Instruments," esp. 52, and Korey, *The Geometry of Power*, 7.

52 See most recently Reitz, *Discordia concors*, 278–327.

53 Bauer, Haupt, and Newman, "Die Kunstkammer," 131, no. 2602: "Expositioni delli hieroglyphici nel ornamento della missale in penna miniata da G. Hufnagel." A privilege that was granted by Rudolf II to Hoefnagel the same year for his series *Salvation of Humankind* also refers not only to the work's "pictures" but also to the "many hieroglyphics with a mystical and moral interpretation." See Voltelini, "Urkunden," clxxi, no. 9677 (Prague, 1 April 1590): "pulchras quasdam imagines, quae praeter elegantiam picturae plerumque hieroglyphicam quandam ac mysticam interpretationem aut moralem habeant." Also cited in Evans, *Rudolf II*, 270. On the latter print series, see Jacoby, "*Salus generis humani*."

54 "Georgius Hoefnaglius Antverpiensis / libri huius exornat: / hieroglyphicus / inventor et factor / genio magistro / principio sine principio / fave[t]e, opus inceptu[m] / ann[o] XXCII. Fine sine fine / iuvantur felic[e] absolvit / ann[o] XC." See also Reitz, *Discordia concors*, 11–13.

55 Ovid, *Tristia*, 4.10.130–32: "protinus ut moriar, non ero, terra, tuus. / Sive favore tuli, sive hanc ego carmine famam, / iure tibi grates, candide lector, ago." The first three words are inscribed on the shovel beneath the owl; the next four appear on a shovel surmounted by a parrot on the opposite side of the folio (not illustrated here).

56 See Ibid., 4.10.111 for Ovid's reference to the "harsh sufferings" (*duris laboribus*) of his banishment to the Black Sea, just before the lines that Hoefnagel quotes.

57 See Horapollo, *The Hieroglyphics*, and, for the most influential commentary published on the treatise in the sixteenth century, Valeriano, *Hieroglyphica*. Arcimboldo was also described as a "learned Egyptian" at Rudolf II's court, on which see Kaufmann, *Mastery of Nature*, 102.

58 As Sir Thomas Browne later put it in his incredulous account of the phenomenon, hieroglyphs were deemed "able to communicate their conceptions unto any that coapprehended the Syntaxis of their Natures." See Browne, *Pseudodoxia*, 305.

59 Curran, *The Egyptian Renaissance*, and Weststeijn, "From Hieroglyphs to Universal Characters."

60 See also Spicer, "Referencing Invention," 415–16.

61 Here I concur with Hendrix, "Joris Hoefnagel," 12–13. Indeed, Hoefnagel seems to have been involved in identifying specimens at Rudolf's court. Two fishes in the latter's 1607–11 inventory are referred to by Latin names that Hoefnagel is said to have supplied ("3 andere meervisch mit fligeln . . . von G. Huefnagel *mugil alatus genant*" and "1 ander klein merschwalbenfischlein . . . von G. Huefnagl *lyra mullus asper*"). See Bauer, Haupt, and Newman, "Die Kunstkammer," 14, nos. 230–31.

62 The practice is most common in *Aier*; it occurs occasionally in *Aqua* and *Terra*, and very infrequently within *Ignis*.

63 Erasmus, *Adagia*, 4.7.88, and Gesner, *Historia animalium*, 3:246.

64 Gesner, *Historia animalium*, 3:245.

65 Willughby and Ray, *The ornithology*, 306.

66 My notion of mimesis is here informed by Benjamin, "Doctrine"; Benjamin, "On the Mimetic Faculty"; and Taussig, *Mimesis and Alterity*.

67 See especially Greene, *The Light in Troy*, and Auerbach, *Mimesis*.

68 Staatliche Museen, Kupferstichkabinett, Berlin, inv. no. KdZ 4817.

69 Conti, *De venatione*, 26v: "Nil adeo natura tulit, nil sedula parvum / ut non ingenio valeat, vel viribus ullis."

70 Ovid, *Metamorphoses*, 15.488.

71 Erasmus, *Adagia*, 2.1.80 ("Lepus pro carnib[us]"), and Virgil, *Aeneid*, 8.224 ("pedibus timor addidit alas").

72 Erasmus, *Adagia*, 2.10.45.

73 Staatliche Museen, Kupferstichkabinett, Berlin, inv. nos. 26218, 26228. See Dreyer, "Zeichnungen," esp. 141, no. 6, and 143, no. 16.

74 Albertina, Vienna, inv. no. 3073, and Koreny, *Albrecht Dürer*, 136–37, no. 43. As suggested by Hendrix, "Joris Hoefnagel," 121, it may be more likely that Hoefnagel saw copies rather than originals in Munich, given that Dürer's watercolors were still in the Imhoff collection in Nuremberg at the time. On the other hand, Dürer's hometown was not far from Munich, and Hoefnagel was hardly unaccustomed to travel. On the Imhoff collection and Rudolf's later purchase of several among Dürer's nature studies, see Bubenik, *Reframing Albrecht Dürer*, 47–49,

with additional literature. It is also important to note that Hoefnagel's 1589 miniature for Radermacher (fig. 84) already includes a rendition of Dürer's stag beetle, which clearly indicates that he had encountered the latter's nature studies, or copies of them, prior to entering Rudolf's service and courtly ambit.

75 See especially Parshall, "Graphic Knowledge."

76 Radermacher, MS 2456, fols. 54r–59r. The misattribution to Hoefnagel derives from Kaufmann, "The Nature of Imitation," and Kaufmann, *The Mastery of Nature*, 79–99, both of which remain the most thorough discussion of the poem.

77 Radermacher, MS 2456, fol. 55r: "Dureri ingenio, qui nil molitur inepte / (quem graphide aequavit nullus, paucique colore) / consummasse artes pacis non sat fuit: idem / aggressus bellique actus, sic Pallada utramque / percolit, ut duplicem referat capite inde coronam. / Germanos bellare docet Germanus, et artem / anormem prius, et diffusam ad certa reducit / principia, ut pulchro praecepta hinc ordine pandat. / Credas Socraticum Euclidem spectare docentem / Consessu in magno, Megara admirante Mathesin / A puncto in tantum tractando assurgere limen. / Saepe idem patriae Dürerus certa dedisse / Consilia in rebus dubiis memoratur. In uno / Norica Gens Cive ut possederit omnia quae sint / singula sat praeclara aliis *insignia* laudum. / vel: *encomia* [the last word is given in the margin as an alternative to *insignia*]." My translation draws on that of Kaufmann, as cited above, and that of Ashcroft, *Albrecht Dürer*, 2:1037–38. Notably, Vivianus was not the only one in Hoefnagel's circle to write in praise of Dürer. Johannes Sambucus wrote a similar poem and sent it to Ortelius in 1564. See Sambucus, *Die Briefe*, 66–67, no. XII.

78 Vivianus clearly refers to Dürer's 1525 *Underweysung der Messung* and to his 1527 *Etliche Underricht, zu Befestigung der Stett, Schlosz und Flecken*, but seems to omit any allusion to the 1528 *Vier Büchern von menschlicher Proportion*.

79 Panofsky, "Artist, Scientist, Genius," esp. 128, 134–36. Albeit differently put, a similar argument about the increasing fluidity in early modernity between theory and practice can be found in Smith, *The Body of the Artisan*.

80 See Goldberg, "Zur Ausprägung"; Koreny, *Albrecht Dürer*, 15–21; Kaufmann, "Hermeneutics"; Bartrum, *Albrecht Dürer*, 266–82; and Bubenik, *Reframing Albrecht Dürer*.

81 On Ortelius's collection of Dürer prints, see Buchanan, "Dürer and Abraham Ortelius," and Meganck, *Erudite Eyes*, 158–63. On the *Kunstbuch* of prints and drawings by Dürer owned by the archduke Ferdinand, who was

again one of Hoefnagel's major patrons, see Parshall, "The Print Collection," esp. 147–48.

82 Hendrix, "Natural History Illustration," esp. 159.

83 Bartrum, *Albrecht Dürer*, 270–74, nos. 224–28.

84 J. Paul Getty Museum, Los Angeles, inv. no. 2001.12. For Hoffmann's hares and attendant studies, see Koreny, *Albrecht Dürer*, 144–57, nos. 47–53, and Koreny and Segal, "Hans Hoffmann."

85 See, for example, Hoffmann's takes on Dürer's *Dead Blue Jay*, as discussed in Kaufmann, *Drawings from the Holy Roman Empire*, 88–89, no. 26, and further analysis in Tschetschik, "Monogramme Albrecht Dürers."

86 Groys, *On the New*.

87 Gombrich, *Art and Illusion*, 116 and passim. See also Wood, "Art History Reviewed VI."

88 Cicero, *De officiis*, 2.25: "Nec vero ulla vis imperii tanta est, quae premente metu possit esse diuturna," and Lipsius, *Politica*, 460–61 (4.11): "Nulla vis imperii tanta est, quae premente metu possit esse diuturna."

89 Lipsius, *Politica*, 447–60 (4.10).

90 Erasmus, *Adagia*, 1.9.35: "cauda de vulpe testator." See also Gesner, *Historia animalium*, 1:623–24, on the gulon as described by Olaus Magnus, and for the illustration on which Hoefnagel based his representation. Gesner's entry on the hyena (1:624–31) follows immediately thereafter in alphabetical order, which likely explains why the hyena (labeled "3") appears in this miniature as well. See Rikken, "Dieren verbeeld," 93–96, 98–99, for more discussion of how Hoefnagel not only adapted Gesner's illustrations but also occasionally followed his alphabetical ordering of the species when composing his miniatures.

91 See Hassig, *Medieval Bestiaries*, 62–71, and Fissel, "Imagining Vermin," 89–92.

92 "Multa sagax vulpes, unum tamen hirtus echinus / novit, qua mundi parte flet aura vaga."

93 Erasmus, *Adagia*, 1.5.18: "Multa novit vulpes, verum echinus unum magnum."

94 Aristophanes, *Peace*, 1086, quoted and translated in Erasmus, *Adagia*, 2.9.59: "Ex scabro in levem nunquam vertetur echinus."

95 See Berlin, *The Hedgehog and the Fox*.

96 "Insidias cum forte strui presenti Echinus. / Mox sua se spinis clausus in arma globat: / involuit virtute sua se quisque tueri / qui contra sortis se mala mille studet. A. Steckelius can[ebat]."

97 Horace, *Carmina*, 3.29.54–55.

98 Another quotation at the bottom of the verso, a line from Virgil's *Eclogues* transformed into a foreshadowing of the Resurrection, suggests that the hedgehog's ability to furl and unfurl embodied nothing less than the true path to salvation. Virgil,

Eclogae, 5.40–41: "Spargite humum foliis, inducite fontibus umbras / pastores: mandate fieri sibi talia, Christus" (with "Christus" in place of Virgil's "Daphnis"). For an important Renaissance commentary on this passage as Christian allegory, see Vives, *In Publii Vergilii Maronis bucolica* (Antwerp: ex officina Joannis Loe., 1543), B8r: "Spargite humum foliis: post Christi autem resurrectionem sequitur rerum universarum innovatio ac reparatio." In the middle space of the verso is also another excerpt from Conti, *De venatione*, 27r: "Corporibus rigidis mira est prudentia parvis, / undique diripiunt fructus hÿemique reponunt. / Pomorum super hi cumulos se saepe volutant, / inde domum redeunt onerati tergora pomis." Conti's discussion of the hedgehog's gathering of food for hibernation in turn depends on Pliny the Elder, *Naturalis historia*, 8.133.

99 Vignau-Wilberg, "Joris Hoefnagels Tätigkeit," 123–24.

100 Valeriano, *Hieroglyphica*, 62v.

101 For discussion of the early modern notion of "silence," see especially Burke, "Notes."

102 On the harbor of San Sebastián, see chapter 2. For Hoefnagel's miniature of spiny-footed lizards from this sequence in *Terra*, see Pl. 6 in this book.

103 Erasmus, *Adagia*, 3.4.1.

104 See Ashworth, "Marcus Gheeraerts," 134–37, and Alciato, *Emblemata*, 61: "Sic et adulator populari vescitur aura / hiansque cuncta devorat." Translation from http://www.emblems.arts.gla.ac.uk/alciato/emblem.php?id=A50a053.

105 Pico della Mirandola, *Oration*, 122–23, line 31.

106 Ovid, *Metamorphoses*, 15.411: "Id quoque quod ventis animal nutritur et aura, / protinus assimulat tetigit quoscumque colores." See also Pliny the Elder, *Naturalis Historia*, 8.51.

107 Psalms 135:4; Psalms 96:1.

108 Palingenius Stellatus, *Zodiacus*, 451 (Aquarius, lines 641–44): "Quis, nisi vidisset, pisces habitare sub undis, / sub limi ranas, salamandras vivere in igne, / aëre chameleonta et pasci rore cicadas, / crederet?"

109 See Haskell, "Poetic Flights"; Garin, *History*, 444–47; and Hankins, *Backgrounds*, passim.

110 See Watson, *The Zodiacus vitae*, 14–19; Beckwith, "Barnabe Googe's *Zodiake of Life*"; and Palingenius Stellatus, *The Zodiake of Life*.

111 See Garani, *Empedocles redivivus*, and Haskell, "Poetic Flights," esp. 98–103.

112 Palingenius Stellatus, *Zodiacus*, 451–53 (Aquarius, lines 644–67).

113 This connection was first observed by Hendrix, "Joris Hoefnagel," 244. On the edition, see Smith, *Het schouwtoneel*, esp. 11–26 and passim, for its long afterlife and reception. See also Geirnaert and Smith, "Tussen fabel en embleem."

114 Gheeraerts inscribed the *alba amicorum* of Emanuel van Meteren, Abraham Ortelius, and Johannes Vivianus, on which see Hodnett, *Marcus Gheeraerts*, 17–19.

115 Schouteet, *Marcus Gerards*, 12–15.

116 I refer to the c. 1577 etching *William of Orange as St. George*, attributed convincingly, in my view, to Gheeraerts. See Hodnett, *Marcus Gheeraerts*, 28–29, pl. 4.

117 De Dene and Gheeraerts, *Warachtige fabulen*, A2r: "Comt ghe menschelick Dier, naer Gods beelde gheschepen /en van de Beesten leerdt, hoett met de weerelt staet."

118 Ibid., 36–37 ("Jupiter ende Puden").

119 Ibid., 37: "Hy zandt den Houaere, dien zy ontfijnghen tamelick / die terstont hemlieden bestoormde zonder beyden yet / Hy verzwalgher diveersche, spaerder een niet."

120 The association of frogs and toads with false faith also surfaces in medieval tradition, including in antiheretical writings. See the example of de Tuy, *De altera vita*, 215 (3.15).

121 See Hodnett, *Marcus Gheeraerts*, 26–27, pl. 2, and Koerner, *The Reformation*, 111–13, fig. 50. This print survives today in only one impression (British Museum, London, inv. no. 1933,1111.3).

122 Two frogs are even pictured in contemporary allegorical prints of *Dialectica*, such as the 1565 engraving by Cornelis Cort after Frans Floris, though instead as a quiet audience to her teachings. See Sellink, *Cornelis Cort*, 2:96, no. 199.

123 See Plautus, *Asinaria*, 1.3, line 203, and Cicero, *De officiis*, 1.19: "Virtutis enim laus omnis in actione consistit." Plautus's phrase reads "nihili coactiost" in the modern emended text (Hurka, *Die Asinaria*, 121) but was frequently printed as Hoefnagel quotes it in early sixteenth-century editions of the play, including that of Gianfrancesco Boccardo (first published in 1506). By the time of Joachim Camerarius the Elder's 1552 edition, the phrase was printed as "nihili coctio est." Hoefnagel nonetheless seems to have been particularly fond of his version, as he paired it again with a frog in KB, MS IV 40, fol. 8ov, and it also appears in his son's *Archetypa* (IV.3). For the latter, see Vignau-Wilberg, *Archetypa*, 180–81.

124 Palingenius Stellatus, *Zodiacus*, 213 (Virgo, lines 579–80): "Cupiens aequare bibendo / Rana bovem, rupta numquam bibit amplius alvo." The fable of the frog and the ox is also in De Dene and Gheeraerts, *Warachtige fabulen*, 32–33.

125 Palingenius Stellatus, *The Zodiake of Life*, 97. Google is close to the original Latin here: "consulere et vitare sciant incommode nec non / commoda congerere et tranquillam ducere vitam." See Palingenius Stellatus, *Zodiacus*, 213 (Virgo, lines 570–71).

CHAPTER 6: FOSSIL FORMS

1 For fossils as "petrified time," see Tassy, *The Message of Fossils*, 31.

2 On this point, see especially Findlen, "Jokes of Nature"; Felfe, "Figurationem im Gestein"; Felfe, "'Acarnan fecit'"; and Felfe, *Naturform und bildnerische Prozesse*, 113–62.

3 In the wealth of literature on the early modern study of fossils, albeit largely focused on the seventeenth century, see Findlen, *Possessing Nature*, 232–37; Laudan, *From Mineralogy to Geology*; Morello, "The Question on the Nature of Fossils"; Poole, *The World Makers*, 115–33; Porter, *The Making of Geology*; Rossi, *The Dark Abyss of Time*, 3–120; and Rudwick, *The Meaning of Fossils*, esp. 1–48. For precedent to these endeavors in classical antiquity, see Mayor, *The First Fossil Hunters*, and, on their extension into nineteenth-century American landscape painting, see Bedell, *The Anatomy of Nature*.

4 On Gesner's groundbreaking approach to scientific illustration, see Kusukawa, *Picturing the Book of Nature*, and Fischel, "Collections, Images and Form." The manuscript of watercolors that Gesner owned of fossils and minerals survives today in the University Library Basel, Ms K I 2. See Leu, Keller, and Weidmann, *Conrad Gessner's Private Library*, 87, no. B13.

5 See Pliny the Elder, *Naturalis historia*, 21.1 (for discussion of how nature surpasses the painter in the myriad colors of her flowers). For the superiority of nature's mineral forms to works of art, see ibid., 37.3 and 37.9. See also Isager, *Pliny*, passim. On Pliny's notion of *mirabilia* in nature, see Healy, *Pliny the Elder*, 63–70.

6 Gesner, *De rerum fossilium*, Aa3: "Hoc vero in libro, (qui rerum fossilium, hoc est, metallorum et lapidum in primis, figuras exhibet) similitudinum et imaginum, quas ipsa genitrix Natura in rebus tam variis veluti pingendo expressit, consideratione oblectatus, ipsos etiam Naturae gradus ac ordines, sequi volui."

7 Ibid., Aa4v: "Pictura certe ars homini propria et liberalis, admiratione simul et oblectatione plerunque spectantes afficere solet; a natura vero rebus impressae imagines ac figurae, ceu revera quaedam hieroglyphicae notae, verius quidem quam illae Aegyptiorum sacrificis celebratae, maiestatis etiam aliquid prae se ferunt." On this passage, see also Kusukawa, *Picturing the Book of Nature*, 175–76, and Rudwick, *The Meaning of Fossils*, 11–12.

8 Kentman, *Nomenclaturae rerum fossilium*, A5v–A6r.

9 Kentman's catalogue appears to be the first of its kind published in print. See Findlen, *Possessing Nature*, 36–37. On Gesner's notion of "form" as a guide for the cataloguing of

fossil specimens, see also Fischel, "Collections, Images and Form," esp. 152–57.

10 Kentman, *Nomenclaturae rerum fossilium*, A5v: "Quicquid terra sinu, venisque recondidit imis, / Thesauros orbis haec brevis arca tegit. / Laus magna est tacitas naturae inquirere vires, / Maior in hoc ipsum munere nosse Deum." For Gesner's friendship with Fabricius, who gifted the naturalist a *Handstein* composed of "fossilia" and a nature cast most likely created by the virtuosic Nuremberg goldsmith Wenzel Jamnitzer, see Kusukawa, *Picturing the Book of Nature*, 171–74; and Kusukawa, "Conrad Gessner."

11 See Rikken, "A Spanish Album of Drawings"; Rikken, "Abraham Ortelius," 100–102; and Rikken, "Dieren verbeeld," 27–30.

12 See chapter 4, n97.

13 Catalogued in Boon, *Netherlandish Drawings*, 1:116, no. 575, where the specimen at the bottom of the page is wrongly identified as dead man's fingers (*Alcyonium digitatum*).

14 Hoefnagel's inscription ("Cochleam Pegaso") is an adaptation of Erasmus, *Adagia*, 1.8.76 ("Testudinem Pegaso comparas"), with the tortoise replaced by a snail.

15 Erasmus, *Adagia*, 2.5.99.

16 Ibid., 1.1.93 ("polypi mentem obtine").

17 Pliny the Elder, *Naturalis historia*, 9.87: "Colorem mutat ad similitudinem loci, et maxime in metu." See also Lucian, *Dialogi marini*, 4.3, and, for comment from sixteenth-century naturalists on the polyp's mutability, see Gesner, *Historiae animalium*, 4:475, and Belon, *De aquatilibus*, 330. See also Detienne and Vernant, *Cunning Intelligence*, 27–43.

18 "Qui nos admonet, uti nos ad omnem vitae rationem accommodemus ac Proteum quendam agentes, prout res postulabit, in quamlibet formam transfiguremus." Translation from Erasmus, *Collected Works*, 31:133–34.

19 Erasmus, *Adagia*, 1.1.93, lines 5–6.

20 The confusion surrounding this specimen is also evident in a slightly later copy after it found in an album of nature studies now in Stuttgart (Landesbibliothek, Hs HB XI, fol. 7), where it is depicted alongside shells and corals and labeled "Meer-hand"—a type of coral known as dead man's fingers (*Alcyonium digitatum*). See Nissen, *Die Zoologische Buchillustration*, 101, Tab. XIII, who wrongly attributes the folio to Hoefnagel himself.

21 On the discussion of the walrus as both land and sea creature, see Gesner, *Historia animalium*, 4:210–12.

22 For a direct comparison between the polyp and the chameleon, see Erasmus, *Adagia*, 1.1.93, lines 68–77.

23 Psalms 73:13 (mislabeled by Hoefnagel as from Psalm 76).

24 Ovid, *Fasti*, 1.493–94: "omne solum forti patria est, ut piscibus aequor, / ut volucri vacuo quicquid in orbe patet."

25 On the fixation on natural portents as signs from God during the revolt, see Jorink, *Reading the Book of Nature*, 124–27.

26 Van Vaernewijck, Ms. 2469. Van Vaernewijck, *Van die beroerlicke tijden*, 4:4, 15–16. See also Van Bruaene, "Revolting Beasts," 32–33, and Egmond and Mason, "Skeletons on Show," 104–10. The same polyp is illustrated in the *Visboek* of Adriaen Coenen, for which see Egmond, *Het visboek*, 121–23, fols. 62v–63r.

27 Van Vaernewijck *Van die beroerlicke tijden*, 4:4, 15: "eenen visscher die in de zee ghevanghen hadde een monster als eenen tamelicken grooten salm, hebbende acht strijnghen elc onder alf vierendeel lanck, ende twee langhe zwammen, commende uut tmidden vanden visch, lanck zijnde elc ontrent vijf vierendeelen, ende al vul witte croeskins, gheheel ghelijck de witte ghues schotelkins."

28 On the history and iconography of the Beggars during the revolt, see especially Arnade, *Beggars, Iconoclasts, and Civic Patriots*, 80–84, and van Nierop, "A Beggars' Banquet." For a firsthand account of the wearing and sale of beggars' bowls in Antwerp in 1566, see van Haecht, *De kroniek*, 1:48–49.

29 Van Vaernewijck, *Van die beroerlicke tijden*, 4:4, 16: "Duer Godts ghenade ben ic ghevaen / Duer mij mach men veel wonders verstaen / La grace de Dieu m'a faict prendre / Par moij peut on grand merveille entendre." Translation from van Bruaene, "Revolting Beasts," 33, fig. 1.5.

30 An interesting contrast to this positive view of the polyp is found in a pamphlet issued by William of Orange on 16 June 1572, in which he describes the Duke of Alba as a "venomous squid . . . hiding under its black ink" and attempting to conceal his cruel deeds from the people of the Netherlands. See Kossman and Mellink, *Texts concerning the Revolt*, 93, no. 14.

31 Van Vaernewijck, *Van die beroerlicke tijden*, 4:4, 16: "De Heere wil alle dijnghen schicken naer zijnen goddelicken wille ende zijn gramschap van ons keeren; want ghemeenlic zulcke monstren ijet sonderlijncx te bedieden hebben."

32 Martial, *Epigrammata*, 13.87. The other texts on the Tyrian purple derive, respectively, from Erasmus, *Adagia*, 2.1.74 (upper right: "Purpura iuxta purpura[m] diiudicanda"); Plutarch, *Regum et imperatorum apophthegmata*, 27.17 (upper left: "Foris albo utitur pallio, intus autem totus est purpureus"); and Joachim Camerarius the Elder, "Gnomae sive sententiae generales senariis versibus comprehensae," in *Opuscula quaedam moralia, ad vitam tam publicam quam privatam recte instituendam utilissima* (Frankfurt: apud haeredes Andreae Wecheli, 1583), 225 (lower left: "In purpura atque auro implicatur servitus").

33 See Freedberg, *The Eye of the Lynx*, 408–10. For a contemporary description of the goose barnacle by Hoefnagel's friend Lucas de Heere, who seems to have believed the legend, see de Heere, *Beschrijving der Britsche eilanden*, 29, lines 931–36. Ortelius was also presumed familiar with the creature by one of his Italian correspondents, Colantonio Stelliola, who wrote him to ask "about the story of the fowls which are produced from marine bivalves." See Ortelius, *Epistulae*, 370–71, no. 157 (Naples, 16 June 1588). Another vivid contemporary account can be found in Harrison, *The Description*, 315 16n2.

34 Ortelius, *Epistulae*, 203–5, no. 86 (Johannes Gevaerts to Abraham Ortelius, Turnhout, 11 July 1579), esp. 205: "(cum omnium naturae miraculorum te studiosissimum sciam) transmitto tibi lapidem hunc in quo miram naturae solertiam animadvertere poteris, siquidem praeter minutos lapillos intus resonantes, videbis varias diversasque concharum, limacum, cochlearum ostrearumque testas, mira quadam metamorphosi in lapides mutatos."

35 See Harkness, "Maps, Spiders, and Tulips," and Harkness, *The Jewel House*, esp. 19–25, 30–31, 40–41.

36 Ortelius, *Epistulae*, 393–95, no. 164 (Abraham Ortelius to Jacob Coels, Antwerp, 15 May 1589), esp. 394: "Placet de conchis lapideis dissertatio inter vos. Ego quid de iis sentiam scire desideras. Dicam me animi dubium esse et haerere potius quam scire aliquid in hoc argumento libens fateor. Si primo conchae fuere vivae, queram quare potius in montibus quam in convallibus reperiantur? Quaeram quare potius bestia in lapidem durescit, quam ipsa concha. Sed conchas vacuas fuisse dicet tuus, priusquam locus aut terra quae has continebat, in saxum induresceret. Sit ita. At quare non ipsa concha quoque lapidescit? Unde quoque constat arenas non semper arenas permanere, sed in lapidem verti? Dicet fortasse, non amplius verti, sed versas, ante diluvium nempe. Magis inclinaret (non credit autem firmiter) animus ad eorum sententiam qui putant has formas a Natura ludente ita ab initio creari, sine ulla metamorphosi."

37 Ibid., 394: "An unquam legisti Becani nostri Niloscopium? Si rebus et quaestionibus huiusmodi oblecteris, forte non sine fructu leges."

38 Becanus, *Origines Antwerpianae*, book 3 ("Niloscopium"), 233–327. On Becanus, see Frederickx and van Hal, *Johannes Goropius Becanus*.

39 Becanus, *Origines Antwerpianae*, book 3

("Niloscopium"), 241: "Naturae sunt haec, non hominum, miracula, et ne miracula quidem, cum videntur perinde, atque cetera, è causis suis apta."

40 Ortelius, *Epistulae*, 394–95: "Vidi hic Antverpiae limacem in gyrum convolutam e terra nostra effossam, ea magnitudine qua vidisti tu maximam meam . . . Scis eius diametrum humani pedis aequare mensuram. Qua ratione hic metamorphosim admittam. Nam tam grandem vixisse, quis mihi persuadebit? Non homines, non litterae."

41 Pseudo-Ovid, *Halieutica*, 131–33, 100–101 (Folio LII, bottom left and top right) and 19–23, 31–34 (Folio LIII, top right and bottom right).

42 Erasmus, *Adagia*, 2.9.59.

43 Martial, *Epigrammata*, 13.86.

44 Labeled as by Ovid in Comenius, *Lexicon atriale*, 473–74: "Vive tibi tecumque habita nec grandia tentes. / Effugit immodicas, parvula puppis aquas." The line has parallels in Ovid, *Tristia*, 3.4.4–5 and in the repeated metaphor of ships and shipwreck throughout his poems of exile.

45 Alciato, *Emblemata*, 102 ("captivus ob gulam"). The emblem, beginning with the midcentury Lyons edition (cited here), is represented by a mouse with its head trapped in an oyster shell on a beach strewn with other shells and rocks, and with a ship in the distance. On Camerarius's background as son of the eminent Reformation scholar by the same name, see Kunkler, *Zwischen Humanismus und Reformation*.

46 Camerarius, *Symbolorum et emblematum*, 54, no. LIII: "Secreta revelat. / Elicit obscuris cancros lux clara cavernis, / Falsa etiam vero sic veniente vides." For more on Camerarius's emblem books, see Papy, "Joachim Camerarius's *Symbolorum et emblematum centuriae*"; Harms and Heß, "Einleitung"; Enenkel, "Camerarius's Quadrupeds"; and Smith, "Joachim Camerarius's Emblem Book."

47 Transcribed and cited in Vignau-Wilberg, "Qualche deseigni," 208 (original in Munich, Bayerisches Staatsbibliotheek, Clm. 10378, fols. 61r–v): "Rimando . . . il libro di *Vostra Signoria* delli animali, dello quale io mi sono servito quanto m'ha concedutto lo mio servitio—non quanto havrei volutto—ringratiandola infinitamente per la longa patienza che con mecho lei ha avuta. Lo qual benefitio io non lassaro de riconoscere conforme la mia promessa a suo tempo et quando mi sara dato un puocho de riposo della servitio de duoi principi, nostro duca et l'Archiduca Ferdinando, restando et confessandomi obligatissimo verso di lei de li suoi per servirli dovunque puotro con le mie debole forze, porgendosi occasione et non . . . per altro effetto." I am grateful to

Carolyn Yerkes and Dario Donetti for their assistance with my translation.

48 A 1587 manuscript of Camerarius's emblems does in fact survive, though it includes only about half of the emblems in the printed volumes, and none of the relevant seascapes. See the facsimile edition in Camerarius, *Symbola et emblemata*.

49 For discussion of the loose sheets from the *Four Elements*, see chapter 1.

50 Musée du Louvre, Paris, inv. no. RF 38987; Braun and Hogenberg, *Civitates* 5:no. 65.

51 Braun and Hogenberg, *Civitates* 5:no. 65: "ut palam sit, uno in loco gaudentis opus est naturae."

52 See Strabo, *Geographica*, 5.4.8 (as cited by Braun) and 1.3.4.

53 See Williams, *Pietro Bembo on Etna*.

54 Isaiah 40:12.

55 Taken from Thomas More's Latin translation of a poem from the Greek Anthology. See More, *Latin Poems*, 34: "Pinus ego ventis facilis superabilis arbor / stulte quid undivagam me facis ergo ratem? / An non augurium metuis? cum persequitur me / In terra, Boream qui fugiam In pelago?"

56 Juvenal, *Saturae*, 12.55–57: "I nunc et ventis animam committe, dolato / Confisus ligno, digitis a morte remotus / Quattuor, ac septem, si sit latissima taeda."

57 Isaiah 40:15.

58 Ibid., 18–20.

59 As noted in Jonckheere, *Antwerp Art after Iconoclasm*, 45–46, and Jonckheere, "Repetition," 7.

60 Van Mander, *The Lives*, 1:224–25, fol. 241v: "want wy dese deuren hadden op onsen winckel tot Lucas de Heere, daer sy voor den storm der beelden waren bewaert, en ons dacghlijcx in onse leeringhe dienden."

61 See Waterschoot, "Leven en betekenis," 89–93, and, for de Heere's participation in the propaganda of William's regime, see chapter 4.

62 Marnix van Sint-Aldegonde, *Godsdienstige en kerkelijke geschriften*, 1:3–34 ("Van de beelden afgheworpen in de Nederlanden in augusto 1566"). See also van Deursen, "Marnix van St. Aldegonde," 25–26; Jonckheere, *Antwerp Art after Iconoclasm*, 41; and Jonckheere, "Images of Stone," 118–22. For de Heere's contacts with Marnix, see Waterschoot, "Leven en betekenis," esp. 76–78.

63 Plessis-Mornay, *Tractaet ofte handelinge van de Kercke*. See also Waterschoot, "Leven en betekenis," 99–100.

64 De Heere, *Den hof en boomgaerd*. On de Heere's ode to the *Ghent Altarpiece* and activities as rhetorician, see Melion, *Shaping the Netherlandish Canon*, 85–86, 129–42, and Ramakers, "Art and Artistry." On de Heere's "invective," see most recently Richardson, *Pieter Bruegel the Elder*, 34–48, and Wouk, *Frans Floris*, 19–21, 367–72, and passim.

65 De Heere, *Het wout van wonder*. The only significant discussion of this work in past scholarship is Chotzen, "De 'Histoires prodigeuses.'" It is also briefly mentioned, with reference to Chotzen, in Waterschoot, "Leven en betekenis," 103.

66 On Boaistuau's treatise and its impact in the Netherlands, see also Jorink, *Reading the Book of Nature*, 353–62.

67 See especially Jonckheere, "Images of Stone," 118–22.

68 See Chotzen, "De 'Histoires prodigeuses,'" esp. 247–54.

69 De Heere, *Beschrijving der Britsche eilanden*, esp. 27, lines 874–77: "Voorts houtmen voor een wonder dijngh datter in verscheiden plaetsen van Engelandt, in d'aerde ghevonden werden seker mosselschelpen ende cruudt, medt wortelen, in steen verandert."

70 Van Mander, *The Lives*, 1:282–83, fol. 256r: "Ick ter liefden hy mijn eerste Meester was, hadde hem ooc gesonden eenen natuerlijcken grooten kies oft kaeck-tandt, welcken vijf ponden swaer was, die was ghevonden tusschen onse dorp Meulebeke en Ingelmunster, in een plaetse die men hiet, het dooder lieden landt, met ander ghebeenten, en harnasch oft ijser wapeninghen, dat welck een wonder ding was te sien."

71 De Heere, *Den hof en boomgaerd*, 108, lines 19–22: "Want daer zijn steenen de welcke tschilderen leeren / Brijnghende met hemlien voort menighe figure, Welcke daer in ghegroyt zijn van der eerster ure, / Ghelijcker op sommighe blaerkins beestkins staen." One could compare de Heere's comment here to Leonardo da Vinci's exhortation that the painter should find inspiration for his inventions in the figures discernable in stones or stains on the wall. See Leonardo, *Leonardo on Painting*, 222, and, for discussion of how such ideas impacted the development of painting on stone supports, see Seifertová, *Malby na kameni*, esp. 101–5.

72 See de Heere, *Het wout van wonder*, 8v–11r, and chapter 5, n117.

73 De Heere, *Het wout van wonder*, 11r–12r: "Het schijnt wel dat God de Heere hem heeft willen dobbel en dobbel wonderbaer vertoonen in alle sijn wercken . . . ick spreke van sulcke figuren die de nature inde steenen expresselick ende willens gheschildert heeft, ghelijck eenen schilder een figuere in een tafereel maect. Men vint geschreven (als voren aengeroert is) dat de Coninc Pirrhus (die tegen de Romeynen crijch voerde) eenen camahusteen hadde, waer in de negen Muse met haren Apollo levendich ende natuerlick in ghegroeyt waren . . . Ick zelve (die dit schrijve) hebbe in des Cardinaels Granvellens huys over xxx. jaren gheleden ghesien verscheyden steenen daer de nature gedaenten van men-

schen ende beesten in gheschildert hadde. Abraham Ortelius vertelt uit het schrijven van Dabranii dat onlancks in Moravia ghevonden is gheweest de figure van eenen mensche van mirrhe natuerlijc ghegroeyt. Ende het sj dat de nature heeft gheconterfeyt oft d'een zake in d'ander verandert. Het is openbaer datter steenen beesten als slanghen, slecken ende andere ghevonden worden soo natuerlick ende wel na tleven datter anders niet aen en ghebreect dan het roeren. Ick hebbe binnen Antwerpen ghesien sulck een slange in steen verandert, oft immers die steen is ende van gheen menschen handen (so alle die hun aen de conste verstaen lichtelick ordeelen connen) gemaect en is. Dacrom die de consten van schilderen ende beeldsnijden in haer selven soude voor quaet houden, souden schijnen te verdoemen tghene dat Godt (die niet dan goet doen en can) selve ghedaen heeft."

74 Pliny the Elder, *Naturalis historia*, 37.3. This stone remained a motif in later Dutch art theory. See, for example, Junius, *The Painting of the Ancients*, 85–86 (book 2, chapter 1.4).

75 Ortelius, *Theatrum*, 104 (Moravia), and Dubravius, *Historia Boiemica*, 29.

76 No inventory of Granvelle's Brussels palace survives, but the later inventory of his Besançon collection shows his strong interest in nature and landscape painting (including his ownership of a flower miniature by Hoefnagel) as well as natural specimens like the antlers displayed in his entrance hall. See Castan, *Monographie du Palais Granvelle*, 14–15, for a French ambassador's comment on the "grandeur prodigieuse" of Granvelle's antler collection and, passim, for the list of paintings in his possession. On Granvelle's palace, collection, and gardens, see also Durme, *Antoon Perrenot*, 239–64; De Jonge, "Le palais Granvelle"; De Jonge, "De tuinen"; and Meganck, *Pieter Bruegel*, 145–48.

77 On the concept of *naer het leven*, see van Mander's canonical discussion, *Den Grondt* 1:98–107; Melion, *Shaping the Netherlandish Canon*, 65–66; and Swan, "*Ad vivum, naer het leven.*"

78 For the link to Cardano's writing, see Becker, "Zur niederländischen Kunstliteratur," 115–17, and, for discussion of Alberti and of Pliny the Elder as locus classicus of this tradition, see Janson, "The Image 'Made by Chance.'"

CHAPTER 7: THE INSECT AS *ARTIFEX*

1 See Aristotle, *Complete Works*, 1:955 (*History of Animals*, 612b, 20–21), and Pliny the Elder, *Naturalis historia*, 11.1. For a wonderful rumination on insects and their significances across time, see also Raffles,

Insectopedia, including his lively discussion of Hoefnagel's *Ignis* (123–40).

2 Colerus, *The Life*, 42. See also Berman, "Spinoza's Spiders."

3 On the impact of the microscope in early modernity, see Ruestow, *The Microscope*, and especially Wilson, *The Invisible World*.

4 On Hooke, see Harwood, "Rhetoric and Graphics"; Neri, *The Insect and the Image*, 105–38; and especially Doherty, "Discovering the 'True Form.'" On Swammerdam, see Jorink, "Beyond the Lines of Apelles," and Jorink, *Reading the Book of Nature*, 219–39 and passim.

5 Toward the end of his life, a crisis of faith led Swammerdam to doubt the devoutness of his enterprise, but even then he never gave up the microscope. See Jorink, "Outside God," and Jorink, "Between Emblematics," 164–65. On Hooke's notion of God as an ingenious creator, see also Bennett, "Instruments and Ingenuity," esp. 76.

6 See Aldrovandi, *De animalibus insectis*; Moffett, *Insectorum*; and the 1658 English translation in Moffett, *Theater*. See also Ogilvie, "Nature's Bible," 7–9, and Bourque, "'There is Nothing.'"

7 Leu, Keller, and Weidmann, *Conrad Gessner's Private Library*, 7.

8 See Ortelius, *Epistulae*, 350–51, no. 152, and further discussion below.

9 Moffett, *Insectorum*, title page: "Olim ab Edoardo Wottono, Conrado Gesnero, Thomaque Pennio inchoatum, tandem Tho[mae] Moufeti Londinatis opera sumptibusque maximis concinnatum, auctum, perfectum, et ad vivum expressis iconibus supra quingentis illustratum."

10 Moffett to Clusius, VUL 101 (April 1590): "Beatum Pennium iam diu nobis ad superos praeiuisse, satis tibi, mihi vero nimis est notum. Quos ille noctes diesque in describenda insectorum historia susceperat, tu ipse et Camerarius partim conscii fuistis. Nemo autem me rectius id dixerit, qui interfui illis non solum quasi arbiter honorarius, sed critica quadam audacia (voluit id enim Pennius) saepe praefui. Ab eius obitu vel potius abitu ex hac miseriarum cavea, totum illud opus, lacerum, indigestum, crudum, literati unguis impatientissimus, disposui, correxi, absolvi, et εντομοχέντρωνας omnes una cum iconibus grandi pecunia comparavi." Cited but partially mistranscribed in Vignau-Wilberg, *Archetypa*, 39. Despite Moffett's claim to completion in this letter, the treatise itself was published only after his death.

11 See Neri, *The Insect and the Image*, 27–73.

12 Moffett, *Insectorum*, a1v: "Si quis aliunde immanem onocratalum, elephantem, crocodilum adducat, nemo non ocyus eo involat, quo rem videat novam et inusitatam, atque

ut inspiciendi copia facta sit, magnitudinem duntaxat, colorem, et quae sub sensus cadunt miratur. Syrones autem, bibiones, formiculas, pulicesque nemo suspicit, quod nulli sint non obvia, mireque tenuia."

13 Vignau-Wilberg, *Archetypa*, passim.

14 See discussion in Bergström, "On Georg Hoefnagel's Manner," 179–86, and Vignau-Wilberg, *Archetypa*, 45–54. For a second engraved series focused solely on Hoefnagel's insects, published in 1630 by Claes Jansz. Visscher, see *Diversae insectarum volatilium icones ad vivum accuratissime depictae per celeberrimum pictorem D[ominum] J[oris] (or J[acob]) Hoefnagel*. It is unclear whether Joris or his son is being referenced on the title page, on which point see also Vignau-Wilberg, *Joris and Jacob Hoefnagel*, 518–19, no. F4.

15 The seventeenth-century shell carver Jan Bellekin employed Hoefnagel's insects on a handful of surviving nautilus cups. See, for example, the cup housed in the Yale University Art Museum, New Haven, inv. no. 1966.137.

16 The Polish naturalist Joannes Jonston, for instance, borrowed numerous insects from Hoefnagel for his 1657 publication without acknowledgment of their source. They appear as interior illustrations and as adornment to the work's title page. See Jonston, *Historiae naturalis*, esp. Tab. VII, VIII, and XIII, and, for a reproduction of the title page, Seelig et al., *Medusa's Menagerie*, 119.

17 See Francissen and Mol, *Augerius Clutius*, and Jorink, *Reading the Book of Nature*, 194–201, the latter with additional discussion of Cluyt's father, who had worked with Clusius in overseeing Leiden's botanical garden. For Rembrandt's painting (Mauritshuis, The Hague, inv. no. 146), see van der Wetering et al., *A Corpus*, 172–89, no. A51.

18 Pliny, *Naturalis historia*, 11:43: "Hypanis fluvius in Ponto circa solstitium . . . nec ultra unum diem vivit, unde hemerobion vocatur." Translation from Pliny, *Natural History*, 507. For further discussions of the *hemerobion* in antiquity, see Beevis, *Insects*, 88–89.

19 Clutius, *De hemerobio*, 100: "Caeterum Houfnaglius diligentissimus naturae perscrutator hemerobii quoque contemplationem graviter tractavit. Quippe in ripa fluminis Mechliniam praeterlabentis, Hemerobios catervatim volatus impetum absolvere, cum admiratione observavit."

20 On this anecdote, see Freedberg, "Science, Commerce, and Art," 388–89, Ruestow, *The Microscope*, 52–53, and Jorink, *Reading the Book of Nature*, 200. Ruestow alone assumes that Cluyt's reference is to Jacob rather than to Joris, arguing that the former was recognized as a natural historian in the seventeenth-century Netherlands on the basis of Swammerdam's repeated reference

to his images in his *Historia insectorum* (e.g., 70: "Soo bevinden wy ons ook verbonden aan den seer naukeurigen Jacob Hoefnagel"). Yet Swammerdam was writing over thirty years after Jacob's death, whereas Cluyt would have plausibly met the younger Hoefnagel in person, or known via Constantijn Huygens (who studied miniature painting with Jacob) that it was Joris who was responsible for the insect studies that his son published. See Huygens, "Fragment eener autobiographie," 65.

21 Neri, *The Insect and the Image*, xi and passim.

22 "Posuit oculum suum deus, super corda hominum ostendere illis magnalia operum suorum, ut nomen sanctificionis collaudet, et gloriam in mirabilibus ei." The original text from Ecclesiasticus 17:7–8 begins instead "posuit oculum ipsorum super corda illorum." Translation adapted from Edgar and Kinney, *The Vulgate Bible*, 3:913.

23 See *Ignis*, Folios VI, VIII, XVII, and XXXXII.

24 See Augustine, *De vera religione*, 238 (chapter 41), Berlekamp, *Wonder, Image, and Cosmos*, 37–46, and, more generally, Hawhee, *Rhetoric*, 89–112.

25 On the concepts of "wonder" and "curiosity" in early modernity, see Daston and Park, *Wonders and the Order of Nature*, and Evans and Marr, *Curiosity and Wonder*.

26 Cicero, *Tusculanae Disputationes*, 4.37: "Quid ei potest videri magnum in rebus humanis, cui aeternitas omnis, totiusque mundi nota sit magnitudo?" See Ortelius, *Theatrum*, no. 1 ("Typus orbis terrarum"), and analysis in Nuti, "The World Map."

27 See Berthier et al., "Butterfly Inclusions," for technical analysis confirming the use of this technique.

28 This anecdote is recounted in Weyerman, *Levens-beschryvingen*, 3:211. See discussion in Grootenboer, "Sublime Still Life," esp. 11–12.

29 See discussion of the "Dürer Renaissance" in chapter 5.

30 J. Paul Getty Museum, Los Angeles, inv. no. 83.GC.214. See Koreny, *Albrecht Dürer*, 119–21, no. 36, where the attribution is discussed in light of the numerous sixteenth-century copies of the beetle.

31 Staatliche Museen, Kupferstichkabinett, Berlin, inv. no. KdZ. 4807. See Vignau-Wilberg, *In Europa zu Hause*, 257, no. D33; Neri, *The Insect and the Image*, 5–10; and Vignau-Wilberg, *Joris and Jacob Hoefnagel*, 111, no. A6b (with color illustration).

32 Relevant to this point is a copy of Dürer's *Stag Beetle* by Hans Hoffmann now in Budapest, dated 1574, which already begins to elaborate on the shadow. See Koreny, *Albrecht Dürer*, 122–23, no. 37.

33 Erasmus, *Adagia*, 3.2.45.

34 "Cornubus armatus generat se cantharus ipsum. / Christus homo suimet, solus origo fuit." The initials for "A[nselmus] S[tockelius]" follow directly after the second line. For more on the scarab's significance in classical and Egyptian tradition, see especially Beevis, *Insects*, 157–64; Valeriano, *Hieroglyphica*, 59v–61v; and Pliny the Elder, *Naturalis historia*, 32.124.

35 Staatliche Museen, Kupferstichkabinett, Berlin, inv. no. KdZ. 4806. See also Vignau-Wilberg, *In Europa zu Hause*, 262, no. D38, and Vignau-Wilberg, *Joris and Jacob Hoefnagel*, 110, no. A6a. Koreny, *Albrecht Dürer*, 126, assumes that what is now Folio V of *Ignis* (the scarab modeled after Dürer) was previously Folio VI, but this clearly was not the case. Given that the other loose sheet in Berlin of an open-winged scarab and scorpion (see n31 above) is labeled Folio VII, the lone scarab was almost certainly the original Folio VIII within the volume.

36 Vignau-Wilberg, *Archetypa*, 98–99 (I.1).

37 Moffett, *Insectorum*, 152: "Cantharorum lege faeminam non habet, sed ipse suae sibi faber est formae; faetum solo sibi genitum producit, quod Jo[a]ch[im] Camerarius f[ilius] non inscite expressit, cum ad Pennium huius insecti iconem é Ducis Saxoniae rerum naturalium penu mitteret." In the English-language edition of Moffett's work, *iconem* is translated more ambiguously as "shape," which has led to the erroneous surmise that Camerarius may have sent Penny either an image or the actual specimen. The Latin original clearly indicates that it was the former. See Moffett, *Theater*, 1009, and Neri, *The Insect and the Image*, 47–49.

38 See chapter 6, n47, and Vignau-Wilberg, "*In minimis maxime*," 234–36.

39 See Harrison, *The Description*, 337.

40 Ortelius, *Epistulae*, 331–33, no. 144 (Abraham Ortelius to Jacob Coels, Antwerp, 9 January 1586), esp. 332: "Phalangium habeo, ab Italis tarantala dictum, fortasse illi non visum, mihi Neapoli missum. Est aranei generis . . . Observandum in hoc insecti genere, quod quatuor oculos habeat, in fronte. De quo, oculi mei testes. Alias ex aliorum ore minime crediturus. Pennaei dicti institutum summopere laudo. Argumentum enim est laudabile, et a nemine, quod sciam, hactenus tentatum."

41 Psalms 110:9–10. Translation from Edgar and Kinney, *The Vulgate Bible*, 3:459.

42 On the phoenix's regeneration, see van den Broek, *The Myth of the Phoenix*, 186–232.

43 Moffett, *Insectorum*, 152: "Moritur enim semel quotannis, suaque ipse ex putrilagine solis beneficio (phaenicis instar) renascitur." See also discussion in Vignau-Wilberg, "*In minimis maxime*," 238, and Leonhard, *Bildfelder*, 130–31.

44 See the attempted justification in Hendrix, "Joris Hoefnagel," and Hendrix, "Hirsutes and Insects."

45 See chapter 5.

46 Bachelard, *The Psychoanalysis of Fire*, 7.

47 Peters, *The Marvelous Clouds*, 115–64, esp. 116.

48 Joel 2:30: "Dabo prodigia in caelo et in terra, sanguinem et ignem et vaporem fumi." Translation from Edgar and Kinney, *The Vulgate Bible*, 5:59. On the fantastical locust, which traces back to a 1556 woodcut by the Monogrammist HW (title *Natürliche Contrafeyhung des gewaltigen Flugs der Hewschrecken*), see Sammlung von Johann Jakob Wick (Ms F 13, 80), Central Library of Zurich; Ritterbush, "Art and Science," 563, fig. 1; and Baadj, *Jan van Kessel*, 111–13.

49 Erasmus, *Adagia*, 2.1.89: "prius locusta bovem."

50 For a rare prior discussion of this aspect of *Ignis*, see Stumpel, "De schaduw."

51 In comparison, see Spary, "Scientific Symmetries," for a probing analysis of how symmetry would instead become an organizational tactic in eighteenth-century images of natural history collections.

52 See Delbeke, "The Pope."

53 "Ipsa dies aperit, conficit ipsa dies." Adapted from Ausonius, "De rosis nascentibus." See Clausen et al., *Appendix Vergiliana*, 178, line 40. On insects as predators in still-life painting, see especially Berger, *Caterpillage*.

54 Staatliche Museen, Kupferstichkabinett, Berlin, inv. no. KdZ. 4816.

55 Laertius, *Lives*, 1.2.

56 See, for instance, Paradin, *Devises heroiques*, 77–78.

57 Erasmus, *Adagia*, 1.4.47: "aranearum telas texis; in frivolo anxius."

58 Francis Bacon would later take up the association of spiders with scholastic reasoning. See Rossi, "Ants, Spiders, Epistemologists," 253–54.

59 "Ne humanis rationibus divina opera curiosius excutiam? Sed ex operibus manuducti, admiremur artificem." Adapted from Joannes Chrysostomus, *Gen. Homil. II*, 1.

60 The poem is titled "Petrus Gonsalus alumnus regis Gallorum, ex insulis Canariae ortus" and reads, "Me Teneriffa tulit, villos sed corpore toto / sparsit opus mirum naturae. Gallia, mater / altera, me puerum nutrivit adusque virilem / aetatem: docuitque feros deponere mores, / ingenuasque artes, linguamque sonare Latinam. / Contigit et forma praestanti munere divum / coniunx, et thalami charissima pignora nostri. / Cernere naturae licet hinc tibi munera: nati / quod referunt alii matrem formaque colore, / ast alii patrem vestiti crine sequuntur." Below, Hoefnagel has

inscribed the place and date: "Comparavit Monachii boiorum a[nn]o 1582."

61 On Gonsalus and the portraits of him and his family members, see Hendrix, "Of Hirsutes and Insects," esp. 375–79, and Hertel, "Hairy Issues."

62 Psalms 113:1; 112:1.

63 "Pronaque cum spectent animalia caetera terram, / os homini sublime dedit caelumque tueri / iussit et erectos ad sydera tollere vultus." Adapted from Ovid, *Metamorphosis*, 1.84–86.

64 Here I paraphrase Hoefnagel's own words in the opening sonnet of *Patience*. See chapter 2, n23.

EPILOGUE

1 Hugh of Saint-Victor, *The Didascalicon*, 101 (3.20): "delicatus ille est adhuc cui patria dulcis est; fortis autem iam, cui omne solum patria est; perfectus vero, cui mundus totus exsilium est."

2 Auerbach, "The Philology," 264–65.

3 Ibid., 264.

4 Vignau-Wilberg, *Archetypa*, 164–65 (III.8).

5 The lower verses are from Martial, *Epigrammata*, 7.25.

6 "Ampliat aetatis spatium tutissima virtus. Omne solum forti patria est, ut piscibus aequor."

7 Martial, *Epigrammata*, 10.23, lines 7 8: "Ampliat aetatis spatium sibi vir bonus: hoc est / vivere bis, vita posse priore frui."

8 Ovid, *Fasti*, 1.493.

9 see chapter 2, n67.

10 Huizinga, "Dutch Civilisation," 104.

11 For an excellent translation of Merian's autobiographical introduction to her *Metamorphosis Insectorum Surinamensium* (1705), see Freedberg, "Science, Commerce, and Art," 377–81. A good starting point for the growing literature on Merian is Reitsma, *Maria Sibylla Merian & Daughters*.

12 Huygens, "Fragment eener autobiographie," 11: "neque adeo, extorris patria bonisque omnibus exutus, egregio Dei dono tanquam viatico coelesti familiam peregre sustentare erubuit."

13 J. Paul Getty Museum, Los Angeles, ms. 20 (86.MV.527), and Kunsthistorisches Museum, Vienna, inv. no. 975. On the former, see Hendrix and Vignau-Wilberg, *Mira calligraphiae monumenta*, and Hendrix, "An Introduction." On the latter, the most thorough study remains Vignau-Schuurman, *Die emblematischen Elemente*, passim.

14 Hendrix and Vignau-Wilberg, *Mira calligraphiae monumenta*, 182–83, fol. 65r.

15 On Hoefnagel's imaginary insects, see Neri, *The Insect and the Image*, 10–23, and Hendrix and Vignau-Wilberg, *Mira calligraphiae monumenta*, passim.

16 Guicciardini, *Descrittione*, unpaginated double-page engraving between 81 and 82 ("La forma naturale del palazzo dei signori").

17 Calvete de Estrella, *El felicissimo viaje*, 224r.

18 The connection to Philip was observed already in Vignau-Schuurman, *Die emblematischen Elemente*, 1:133, though without reference to the text borrowed from Calvete de Estrella.

19 Psalms 101:7–11. Translation from Edgar and Kinney, *The Vulgate Bible*, 3:421.

Bibliography

MANUSCRIPT SOURCES

Hoefnagel, Joris. *Animalia Aquatilia et Conchiliata (Aqua)*. 1987.20.7. National Gallery of Art, Washington, DC.

———. *Animalia Quadrupedia et Reptilia (Terra)*. 1987.20.6. National Gallery of Art, Washington, DC.

———. *Animalia Rationalia et Insecta (Ignis)*. 1987.20.5. National Gallery of Art, Washington, DC.

———. *Animalia Volatilia et Amphibia (Aier)*. 1987.20.8. National Gallery of Art, Washington, DC.

———. *Patientia*. MS Leber 2961. Bibliothèque Municipale, Rouen.

Van Meteren, Emanuel. MS Douce 68 (21642). Bodleian Library, Oxford.

Moffett, Thomas to Carolus Clusius. VUL 101. Leiden University Library.

Ortelius, Abraham. MS LC.2.113. Pembroke College, Cambridge University.

Radermacher, Daniël. KW 133 M 42. National Library of the Netherlands, The Hague.

Radermacher, Johannes. MS 2465. Ghent University Library.

Rogers, Daniel. HM 31188. Henry E. Huntington Library and Art Gallery. San Marino, CA.

Van Vaernewijck, Marcus. Ms. 2469. Ghent University Library.

Van Veen, Otto. KB, Hs. II 874. Royal Library of Belgium, Brussels.

Vinslerus, Josias to Bonaventura Vulcanius. VUL 106·1 Leiden University Library.

Vivianus, Johannes. KB, 74 F 19 National Library of the Netherlands, The Hague.

Vulcanius, Bonaventura. MS II, 1166. Royal Library of Belgium, Brussels.

———. VUL 36. Leiden University Library.

PUBLISHED PRIMARY AND SECONDARY SOURCES

Adams, Alison. *Webs of Allusion: French Protestant Emblem Books of the Sixteenth Century*. Geneva: Librairie Droz, 2003.

Adams, Alison, and Anthony J. Harper, eds. *The Emblem in Renaissance and Baroque Europe*. Leiden: Brill, 1992.

Agricola, Georg. *De ortu et causis subterraneorum, libri V*. Basel: Froben, 1546.

———. *De re metallica*. Edited and translated by Herbert Clark Hoover and Lou Henry Hoover. New York: Dover Publications, 1950.

Aitken, James M. *The Trial of George Buchanan before the Lisbon Inquisition*. Edinburgh: Oliver & Boyd, 1939.

Albus, Anita. *Paradies und Paradox: Wunderwerke aus fünf Jahrhunderten*. Frankfurt am Main: Eichborn, 2002.

Alciato, Andrea. *Emblemata*. Lyon: apud Mathiam Bonhomme, 1550.

Aldrovandi, Ulisse. *De animalibus insectis libri septem: cum singulorum iconibus ad vivum expressis*. Bologna: apud Ioan. Bapt. Bellagambam, 1602.

Almási, Gábor. *The Uses of Humanism: Johannes Sambucus (1531–1584), Andreas Dudith (1533–1589), and the Republic of Letters in East Central Europe*. Leiden: Brill, 2009.

Almási, Gábor, and Farkas Gábor Kiss. *Humanistes du bassin des Carpates II: Johannes Sambucus*. Turnhout: Brepols, 2014.

Alpers, Svetlana. *The Art of Describing: Dutch Art in the Seventeenth Century*. Chicago: University of Chicago Press, 1983.

Alsteens Stijn, and Hans Buijs. *Paysages de France dessinés par Lambert Doomer et les artistes hollandais et flamands des XVIe et XVIIe siècles*. Paris: Fondation Custodia, 2008.

Apian, Peter. *Petri Apiani Cosmographia*. Antwerp: Arnold Birckmann and Gilles Coppens van Diest, 1540.

Aristotle. *The Complete Works of Aristotle: The Revised Oxford Translation*. Edited by Jonathan Barnes. 2 vols. Princeton, NJ: Princeton University Press, 1995.

Arnade, Peter. *Beggars, Iconoclasts, and Civic Patriots: The Political Culture of the Dutch Revolt*. Ithaca, NY: Cornell University Press, 2008.

———. "The City in a World of Cities: Antwerp and the *Civitates orbis terrarum*." In *The Power of Space in Late Medieval and Early Modern Europe: The Cities of Italy, Northern France, and the Low Countries*, edited by Marc Boone and Martha Howell, 197–215. Turnhout: Brepols, 2013.

Ashcroft, Jeffrey, ed. *Albrecht Dürer: Documentary Biography*. 2 vols. New Haven, CT: Yale University Press, 2017.

Ashworth, William B. "Emblematic Natural History of the Renaissance." In *Cultures of Natural History*, edited by N. Jardine, J. A. Secord, and E. C. Spary, 17–37. Cambridge: Cambridge University Press, 1996.

———. "Marcus Gheeraerts and the Aesopic Connection in Seventeenth-Century Scientific Illustration." *Art Journal* 44.2 (1984): 132–38.

———. "Natural History and the Emblematic World View." In *Reappraisals of the Scientific Revolution*, edited by David C. Lindberg and Robert S. Westman, 303–32. Cambridge: Cambridge University Press, 1990.

Aston, Margaret. *The King's Bedpost: Reformation and Iconography in a Tudor Group Portrait*. Cambridge: Cambridge University Press, 1993.

Auerbach, Erich. *Mimesis: The Representation of Reality in Western Literature*. Princeton, NJ: Princeton University Press, 2003.

———. "The Philology of World Literature." In *Time, History, and Literature: Selected Essays by Erich Auerbach*, edited by James I. Porter,

translated by Jane O. Newman, 253–65. Princeton, NJ: Princeton University Press, 2014.

Augustine. *De civitate dei*. Corpus Christianorum. Vol. 48: Aurelii Augustini opera, pars XIV, 2. Turnhout: Brepols, 1955.

———. *De vera religione*. Corpus Christianorum. Vol. 32: Aurelii Augustini opera, pars IV, 1. Turnhout: Brepols, 1962.

Baadj, Nadia. *Jan van Kessel I (1626–79): Crafting a Natural History of Art in Early Modern Antwerp*. Turnhout: Brepols, 2016.

Bachelard, Gaston. *The Psychoanalysis of Fire*. Translated by Alan C. M. Ross. Boston: Beacon Press, 1964.

Backhouse, Marcel. *Beeldenstorm en bosgeuzen in het westkwartier (1566–1568). Bijdrage tot de geschiedenis van de godsdiensttroebelen der Zuidelijke Nederlanden in de XVIe eeuw*. Kortwijk: Koninklijke Geschied- en Oudheidkundige Kring, 1971.

Baelde, M. "The Pacification of Ghent in 1576: Hope and Uncertainty in the Netherlands." *Low Countries Historical Yearbook* 11 (1978): 1–17.

Bakker, Boudewijn. *Landscape and Religion from van Eyck to Rembrandt*. Farnham, UK: Ashgate, 2012.

Balis, Arnout. "Het lot van Antwerpen: halfmenselijke zeewezens in de kunst der Nederlanden van de middeleeuwen tot de barok." In *Van sirenen en meerminnen*, edited by Arnout Balis et al., 112–27. Brussels: ASLK-Gallerij, 1992.

Ballon, Hilary, and David Friedman. "Portraying the City in Early Modern Europe: Measurement, Representation, and Planning." In *Cartography in the European Renaissance*, edited by David Woodward, 680–704. Chicago: University of Chicago Press, 2007.

Barker, William. "Alciato's Emblems and the Album Amicorum: A Brief Note on Examples in London, Moscow, and Oxford." https://www.mun.ca/alciato/album.html.

Bartilla, Stefan. "Die Wildnis: visuelle Neugier in der Landschaftsmalerei. Eine ikonologische Untersuchung der niederländischen Berg- und Waldlandschaften und ihre Naturbegriffes um 1600." Ph.D. diss., Albert-Ludwigs-Universität zu Freiburg: 2005.

Bartrum, Giulia, ed. *Albrecht Dürer and His Legacy: The Graphic Work of a Renaissance Artist*. Princeton, NJ: Princeton University Press, 2002.

Bartsch, Tatjana, and Peter Seiler, eds. *Rom zeichnen: Maarten van Heemskerck (1532–1536/37)*. Berlin: Gebr. Mann Verlag, 2012.

Bass, Marisa. "Hieronymus Bosch and His Legacy as 'Inventor.'" In *Beyond Bosch: The Afterlife of a Renaissance Master in Print*, edited by Marisa Bass and Elizabeth Wyckoff,

11–33. St. Louis: St. Louis Art Museum, 2015.

———. *Jan Gossart and the Invention of Netherlandish Antiquity*. Princeton, NJ: Princeton University Press, 2016.

———. "Justus Lipsius and His Silver Pen." *Journal of the Warburg and Courtauld Institutes* 70 (2007): 157–94.

———. "Mimetic Obscurity in Joris Hoefnagel's *Four Elements*." In *Emblems and the Natural World*, edited by Karl A. E. Enenkel and Paul J. Smith, 521–47. Leiden: Brill, 2017.

———. "Patience Grows: The First Roots of Joris Hoefnagel's Emblematic Art." In *The Anthropomorphic Lens: Anthropomorphism, Microcosmism, and Analogy in Early Modern Thought and Visual Arts*, edited by Walter S. Melion, Bret Rothstein, and Michel Weemans, 145–78. Leiden: Brill, 2015.

———. "The *Transi* Tomb and the *Genius* of Sixteenth-Century Netherlandish Funerary Sculpture." *Nederlands Kunsthistorisch Jaarboek*, 67 (2017): 159–83.

Bass, Marisa, and Elizabeth Wyckoff. *Beyond Bosch: The Afterlife of a Renaissance Master in Print*. St. Louis: St. Louis Art Museum, 2015.

Bauer, Rotrand, Herbert Haupt, and Erwin Neuman. "Die Kunstkammer Kaiser Rudolfs II in Prag, ein Inventar aus den Jahren 1607–1611." *Jahrbuch der kunsthistorischen Sammlungen in Wien* 72 (1976): xi–191.

Becanus, Johannes Goropius. *Origines Antwerpianae, sive Cimmeriorum Becceselana, novem libros complexa*. Antwerp: ex officina Christophori Plantini, 1569.

Becker, Jochen. "Hochmut kommt vor dem Fall. Zum Standbild Albas in der Zitadelle von Antwerpen 1571–1574." *Simiolus* 5.1/2 (1971): 75–115.

———. "Zur niederländischen Kunstliteratur des 16. Jahrhunderts: Lucas de Heere." *Simiolus* 6.2 (1972–73): 113–27.

Beckwith, Marc. "Barnabe Googe's *Zodiake of Life*: A Translation Reconsidered." *Journal of the Rocky Mountain Medieval and Renaissance Association* 7 (1986): 97–107.

Bedell, Rebecca. *The Anatomy of Nature: Geology and American Landscape Painting, 1825–1875*. Princeton, NJ: Princeton University Press, 2001.

Beevis, Ian C. *Insects and Other Invertebrates in Classical Antiquity*. Exeter: University of Exeter, 1988.

Bell, Gary M. *A Handlist of British Diplomatic Representatives, 1509–1688*. London: Offices of the Royal Historical Society, 1990.

Belon, Pierre. *De aquatilibus, libri duo, cum eiconibus ad vivam ipsorum effigiem, quoad eius fieri potuit, expressis*. Paris: apud Carolum Stephanum, Typographum Regium, 1553.

Benesch, Otto, ed. *Die Zeichnungen der Niederländischen Schulen des XV. und XVI.*

Jarhunderts. Vienna: Verlag von Anton Schroll & Co., 1928.

Benjamin, Walter. "Doctrine of the Similar (1933)." *New German Critique* 17 (1979): 65–69.

———. "On the Mimetic Faculty." In *Reflections: Essays, Aphorisms, Autobiographical Writings*, translated by Peter Demetz, 333–36. New York: Schocken Books, 1986.

———. "The Work of Art in the Age of Mechanical Reproduction." In *Illuminations*, edited by Hannah Arendt, translated by Harry Zohn, 217–51. New York: Schocken Books, 1969.

Bennett, Jim. "Instruments and Ingenuity." In *Robert Hooke: Tercentennial Studies*, edited by Michael Cooper and Michael Hunter, 65–76. Aldershot, UK: Ashgate, 2006.

Berger, Harry, Jr. *Caterpillage: Reflections on Seventeenth-Century Dutch Still-Life Painting*. New York: Fordham University Press, 2011.

Bergström, Ingvar. "On Georg Hoefnagel's Manner of Working with Notes on the Influence of the *Archetypa* Series of 1592." In *Netherlandish Mannerism: Papers Given at a Symposium in Nationalmuseum Stockholm, September 21–22, 1984*, edited by Görel Cavalli-Björkman, 176–88. Stockholm: Nationalmuseum Stockholm, 1984.

Berlekamp, Persis. *Wonder, Image, and Cosmos in Medieval Islam*. New Haven, CT: Yale University Press, 2011.

Berlin, Isaiah. *The Hedgehog and the Fox: An Essay on Tolstoy's View of History*. London: Weidenfeld & Nicolson, 1953.

Berman, David. "Spinoza's Spiders, Schopenhauer's Dogs." *Philosophical Studies* 29 (1982–83): 202–9.

Berns, Andrew D. *The Bible and Natural Philosophy in Renaissance Italy: Jewish and Christian Physicians in Search of Truth*. Cambridge: Cambridge University Press, 2015.

Berthier, S., et al. "Butterfly Inclusions in Van Schrieck Masterpieces: Techniques and Optical Properties." *Applied Physics* 92 (2008): 51–57.

Bertolotti, Antonio. "Don Giulio Clovio principe dei miniatori." *Atti e memorie delle RR. Deputazioni di storia patria per le provincie dell'Emilia* 7 (1882, nuova ser.): 259–79.

Besse, Jean-Marc. "Le voyage, le témoignage, l'amitié: Abraham Ortelius et Georg Hoefnagel en Italie (hiver 1577–1578)." In *Regardeurs, flâneurs et voyageurs dans la peinture*, edited by Anne-Laure Imbert, 129–45. Paris: Publications de la Sorbonne, 2015.

Bettini, Maurizio. *Voci: antropologia sonora del mondo antico*. Turin: G. Einaudi, 2008.

Bevers, Holm. *Das Rathuis von Antwerpen (1561–1565): Architektur und Figurenprogramm*. Hildesheim: Georg Olms Verlag, 1985.

Blair, Ann. *The Theater of Nature: Jean Bodin and Renaissance Science.* Princeton, NJ: Princeton University Press, 1997.

———. *Too Much to Know: Managing Scholarly Information before the Modern Age.* New Haven, CT: Yale University Press, 2010.

Blok, P. J., and P. C. Molhuysen. *Nieuw Nederlandsch biografisch woordenboek.* 10 vols. Leiden: A. W. Sijthoff, 1911–37.

Blouw, Paul Valkema. "Plantin's betrekkingen met Hendrik Niklaes." *De Gulden Passer* 66/67 (1988): 121–62.

Boaistuau, Pierre. *Het wonderijcke Schadt-Boeck der historien: begrijpende vele seldsame, vreemde ende wonderbaerlijcke geschiedenissen bevonden inde Natuere, hare cracht en werckinghen.* Dordrecht: door Jasper Troyen, 1592.

Bodin, Jean. *Method for the Easy Comprehension of History.* Translated by Beatrice Reynolds. New York: Norton, 1945.

———. *Methodus ad facilem historiarum cognitionem.* Paris: apud Martinum Iuvenem, 1566.

Boon, Karel Gerard. *Netherlandish Drawings of the 15th and 16th Centuries (Catalogue of the Dutch and Flemish Drawings in the Rijksmuseum).* 2 vols. The Hague: Government Publishing Office, 1978.

———. "*Patientia* dans les gravures de la Réforme aux Pays-Bas." *Revue de l'art* 56 (1982): 7–24.

Bostoen, Karel. *Bonis in bonum. Johan Radermacher de Oude (1538–1617), humanist en koopman.* Hilversum: Verloren, 1997.

———. *Dichterschap en koopmanschap in de zestiende eeuw. Omtrent de dichters Guillaume de Poetou en Jan vander Noot.* Deventer: Sub Rosa, 1987.

———. *Kaars en bril: de oudste Nederlandse grammatica.* Archief van het Koninklijk Zeeuwsch Genootschap der Wetenschappen (1984): 1–47.

Bostoen, Karel J. S., et al., eds. *Het album J. Rotarii. Tekstuitgave van het werk van Johan Radermacher de Oude (1538–1617) in het* album J. Rotarii, *Handschrift 2465 van de Centrale Bibliotheek van de Rijksuniversiteit te Gent.* Hilversum: Verloren, 1999.

Bourque, Monique. "'There is nothing more divine than these, except Man': Thomas Moffett and Insect Sociality." *Quidditas: Journal of the Rocky Mountain Medieval and Renaissance Association* 29 (1999): 137–54.

Bracke, Wouter. *Joris Hoefnagel: gezicht op Sevilla, 1573.* Brussels: Koninklijke Bibliotheek van België, 2014.

Braun, Georg. *Catholicorum Tremoniensium adversus Lutheranicae ibidem factionis praedicantes defensio.* Cologne: apud Bernardum Gualtherum, 1605.

Braun, Georg, and Frans Hogenberg. *Civitates orbis terrarum.* 6 vols. Cologne: apud Bertramum Bochholtz, 1572–1617.

Bredekamp, Horst, Vera Dünkel, and Birgit Schneider. *The Technical Image: A History of Styles in Scientific Imagery.* Chicago: University of Chicago Press, 2015.

Brink, Claudia, and Wilhelm Hornbostel, eds. *Pegasus und die Künste.* Munich: Deutscher Kunstverlag, 1993.

Brisman, Shira. *Albrecht Dürer and the Epistolary Mode of Address.* Chicago: University of Chicago Press, 2017.

Van den Broecke, Marcel. *Abraham Ortelius (1527–1598): Life, Works, Sources and Friends.* Bilthoven: Cartographica Neerlandica, 2015.

Van den Broecke, Marcel, Peter van der Krogt, and Peter Meurer, eds. *Abraham Ortelius and the First Atlas: Essays Commemorating the Quadricentennial of His Death, 1598–1998.* 't-Goy: HES Publishers, 1998.

Van den Broek, R. *The Myth of the Phoenix according to Classical and Early Christian Traditions.* Leiden: Brill, 1972.

Brouwer, René. "Stoic Sympathy." In *Sympathy: A History,* edited by Eric Schliesser, 15–35. Oxford: Oxford University Press, 2015.

Browne, Sir Thomas. *Pseudodoxia epidemica, or Enquiries into Very Many Received Tenets and Commonly Presumed Truths.* London: Printed by J. R. for Nath. Ekins, 1672.

Van Bruaene, Anne-Laure. "Revolting Beasts: Animal Satire and Animal Trials in the Dutch Revolt." In *The Anthropomorphic Lens: Anthropomorphism, Microcosmism and Analogy in Early Modern Thought and Visuals Arts,* edited by Walter S. Melion, Bret Rothstein, and Michel Weemans, 23–42. Leiden: Brill, 2015.

Brummel, L. *Twee ballingen 's lands tijdens onze opstand tegen Spanje: Hugo Blotius (1534–1608), Emanuel van Meteren (1535–1612).* The Hague: Martinus Nijhoff, 1972.

Bubenik, Andrea. *Reframing Albrecht Dürer: The Appropriation of Art, 1528–1700.* Burlington, VT: Ashgate, 2013.

Buchanan, George. *Paraphrasis psalmorum Davidis poetica.* Antwerp: ex officina Christophori Plantini, 1566.

Buchanan, Iain. "Dürer and Abraham Ortelius." *Burlington Magazine* 124 (1982): 734–41.

———. "An Unknown Double-Portrait by Joris Hoefnagel of Emanuel van Meteren and His Wife Hester van Corput." *Burlington Magazine* (February 2019): forthcoming.

Buchelius, Arnoldus. *Diarium van Arend van Buchell.* Edited by G. Brom and L. A. van Langeraad. Amsterdam: J. Müller, 1907.

Burke, Peter. "Humanism and Friendship in Sixteenth-Century Europe." In *Friendship in Medieval Europe,* edited by Julian Haseldine, 262–74. Stroud: Sutton, 1999.

———. "Notes for a Social History of Silence in Early Modern Europe." In *The Art of Conversation,* 123–41. Cambridge: Polity Press, 1993.

Burrow, Colin. "Re-embodying Ovid: Renaissance Afterlives." In *The Cambridge Companion to Ovid,* edited by Philip Hardie, 301–19. Cambridge: Cambridge University Press, 2002.

Caldwell, Dorigen. "The Paragone between Word and Image in Impresa Literature." *Journal of the Warburg and Courtauld Institutes* 63 (2000): 277–86.

Calvete de Estrella, Juan Christóval. *El felicíssimo viaje del muy alto y muy poderoso principe don Phelippe.* Antwerp: en casa de Martin Nucio, 1552.

Camerarius, Joachim, the Younger. *Symbola et emblemata tam moralia quam sacra: Die handschriftlichen Embleme von 1587.* Edited by Wolfgang Harms and Gilbert Heß. Tübingen: Max Niemeyer, 2009.

———. *Symbolorum et emblematum ex animalibus quadrupedibus desumtorum centuria altera collecta.* Noribergae: excudebat Paulus Kaufmann, 1595.

Camille, Michael. *The Gothic Idol: Ideology and Image-Making in Medieval Art.* Cambridge: Cambridge University Press, 1989.

Campana, Joseph. "The Bee and the Sovereign? Political Entomology and the Problem of Scale." *Shakespeare Studies* 41 (2013): 94–113.

Castan, Auguste. *Monographie du Palais Granvelle à Besançon.* Besançon: Imprimerie de Dodivers, 1867.

Cato, and Desiderius Erasmus. *Catonis disticha moralia, cum scholiis D. Erasmi Roterdami.* Zurich: apud Christophorum Froschoverum, 1561.

Cave, Terence. *The Cornucopian Text: Problems of Writing in the French Renaissance.* Oxford: Clarendon Press, 1979.

Cazes, Hélène, ed. *Bonaventura Vulcanius, Works and Networks: Bruges 1538–Leiden 1614.* Leiden: Brill, 2010.

Cazes, Hélène. "Démonstrations d'amitié et d'humanisme: *alba,* adages, et emblèmes chez les petits-enfants d'Érasme." In *Acta Conventus Neo-Latini Monasteriensis: Proceedings of the Fifteenth International Conference of Neo-Latin Studies,* edited by Astrid Steiner-Weber and Karl A. E. Enenkel, 18–49. Leiden: Brill, 2015.

Chen-Morris, Raz. "Imagination, Passions, and the Production of Knowledge in Early Modern Europe: from Lipsius to Descartes." In *Knowledge and Religion in Early Modern Europe: Studies in Honor of Michael Heyd,* edited by Asaph Ben-Tov, Yaacov Deutsch, and Tamar Herzig, 49–85. Leiden: Brill, 2013.

Chmelarz, Eduard. "Georg und Jakob Hoefnagel." In *Jahrbuch der kunsthistorischen Sammlungen des allerhöchsten Kaiserhauses Wien* 17 (1896): 275–90.

Chotzen, Th. M. "De '*Histoires prodigieuses*' van Boaistuau en voortzetters, en haar

Nederlandse vertalers." *Het Boek* 14 (1936–37): 235–56.

Christian, Kathleen Wren. "Poetry and 'Spirited' Ancient Sculpture in Renaissance Rome: Pomponio Leto's Academy to the Sixteenth-Century Sculpture Garden." In *Aeolian Winds and Spirit in Renaissance Architecture: Academia Eolia Revisited*, edited by Barbara Kenda, 103–24. London: Routledge, 2006.

Christman, Victoria. *Pragmatic Toleration: The Politics of Religious Heterodoxy in Early Reformation Antwerp, 1515–1555*. Rochester, NY: University of Rochester Press, 2015.

Claassen, Jo-Marie. *Displaced Persons: The Literature of Exile from Cicero to Boethius*. London: Duckworth, 1999.

Clausen, Wendel Vernon, et al., eds. *Appendix Vergiliana*. Oxford: Clarendon Press, 1966.

Clutius, Augerius. *De hemerobio sive emphemero insecto, et majali verme*. Amsterdam: typis Jacobi Charpentier, 1634.

Van der Coelen, Peter, et al. *Images of Erasmus*. Rotterdam: Museum Boijmans van Beuningen, 2008.

Colding, Torben Holck. *Aspects of Miniature Painting, Its Origins and Development*. Copenhagen: E. Munksgaard, 1953.

Cole, Michael, and Diletta Gamberini. "Vincenzo Danti's Deceits." *Renaissance Quarterly* 69.4 (2016): 1296–342.

Colerus, John. *The Life of Benedict de Spinoza*. London: printed by D. L., 1706.

Comenius, J. A. *Lexicon atriale, Latino-Latinum. Simplices et nativas rerum nomenclationes*. Amsterdam: apud Janssonio-Waesbergios, 1686.

Conley, Tom. *An Errant Eye: Poetry and Topography in Early Modern France*. Minneapolis: University of Minnesota Press, 2011.

Conti, Natale. *Mythologiae sive explicationum fabularum libri X*. Venice: al segno della Fontana, 1581.

———. *Natalis Comitum Veneti de venatione, libri IIII. Hieronymi Ruscellii scholiis brevissimis illustrati*. Venice: Aldi filii, 1551.

Coornaert, Émile. "Anvers et le commerce Parisien au XVIe siècle." *Mededelingen van de Koninklijke Academie voor Wetenschappen, Letteren en Schone Kunsten van België, Klasse der Wetenschappen* 12.2 (1950): 3–30.

Couvreur, Walter. "Galle en Hoefnagels stadsplattegronden en de Antwerpse verdedigingswerken van September 1577 tot februari 1581." *De Gulden Passer* 61–63 (1983–85): 519–45.

Cranz, F. Edward, and Charles B. Schmitt. *A Bibliography of Aristotle Editions, 1501–1600*. Baden-Baden: Verlag Valentin Koerner, 1984 (1971).

Curran, Brian A. *The Egyptian Renaissance: The Afterlife of Ancient Egypt in Early Modern Italy*. Chicago: University of Chicago Press, 2007.

Curschmann, Michael. "Imagined Exegesis: Text and Picture in the Exegetical Works of Rupert of Deutz, Honorius Augustodunensis, and Gerhoch of Reichersberg." *Traditio* 44 (1988): 145–69.

Curtis, Todd. "Author, Argument and Exegesis: A Rhetorical Analysis of Galen's *In Hippocratis de natura hominis commentaria tria*. In *Ancient Concepts of the Hippocratic: Papers Presented at the XIIIth International Hippocrates Colloquium, Austin, Texas, August 2008*, edited by Lesley Dean-Jones and Ralph M. Rosen, 399–420. Leiden: Brill, 2016.

Daly, Peter M. *The Emblem in Early Modern Europe: Contributions to the Theory of the Emblem*. Farnham, UK: Ashgate, 2014.

Van Dam, Frederica. "Lucas d'Heere als schilder in Engeland." In *Lucas d'Heere*, Tableau poetique: *verzen van een Vlaamse migrant-kunstenaar voor de entourage van de Seymours op Wolf Hall*, edited by Frederica Van Dam and Werner Waterschoot, 3–88. Ghent: Koninklijke Academie voor Nederlandse Taal- en Letterkunde, 2016.

Daston, Lorraine. "Epistemic Images." In *Vision and Its Instruments*, edited by Alina Payne, 13–35. Princeton, NJ: Princeton University Press, 2016.

Daston, Lorraine, and Katharine Park. *Wonders and the Order of Nature, 1150–1750*. New York: Zone Books, 1998.

Davis, Natalie Zemon. *The Gift in Sixteenth-Century France*. Oxford: Oxford University Press, 2000.

Degler, Anna. *Parergon: Attribut, Material und Fragment in der Bildästhetik des Quattrocento*. Paderborn: Wilhelm Fink, 2015.

Dekker, Rudolf M. "Egodocuments in the Netherlands from the Sixteenth to the Nineteenth Century." *Dutch Crossing* 23.2 (1999): 255–85.

Delbeke, Maarten. "The Pope, the Bust, the Sculptor, and the Fly." *Bulletin de l'Institut Historique Belge de Rome* 70 (2000): 179–223.

De Dene, Eduard, and Marcus Gheeraerts. *De warachtige fabulen der dieren*. Bruges: Pieter de Clerck, 1567.

Dennis, Flora. "Scattered Knives and Disremembered Song: Cutlery, Music and the Rituals of Dining." *Renaissance Studies* 24.1 (2010): 156–84.

Depuydt, Joost. "De brede kring van vrienden en correspondenten rond Abraham Ortelius." In *Abraham Ortelius (1527–1598), cartograaf en humanist*, edited by Robert W. Karrow et al., 117–40. Turnhout: Brepols, 1998.

———. "New Letters for a Biography of Abraham Ortelius." *Imago Mundi* 68.1 (2016): 67–78.

Derrida, Jacques. *The Truth in Painting*. Translated by Geoff Bennington and Ian McLeod. Chicago: University of Chicago Press, 1987.

Descola, Philippe. *Beyond Nature and Culture*. Translated by Janet Lloyd. Chicago: University of Chicago Press, 2013.

Detienne, Marcel, and Jean Pierre Vernant. *Cunning Intelligence in Greek Culture and Society*. Chicago: University of Chicago Press, 1978.

Van Deursen, A. Th. "Marnix van St. Aldegonde, een calvinistisch propagandist." In *Een intellectuele activist. Studies over leven en werk van Philips van Marnix van Sint Aldegonde*, edited by Henk Duits and Ton van Strien, 23–27. Hilversum: Verloren, 2001.

Dodoens, Rembert. *Cruijdeboeck*. Antwerp: Jan van der Loo, 1554.

Van den Doel, Marieke. *Ficino en het voorstellingsvermogen: phantasia en imaginatio in kunst en theorie van de Renaissance*. Haarlem: St. Hooft-Hart-Handen, 2008.

Doherty, Meghan C. "Discovering the 'True Form': Hooke's *Micrographia* and the Visual Vocabulary of Engraved Portraits." *Notes & Records of the Royal Society* 66 (2012): 211–34.

Van Dorsten J. A. *Poets, Patrons, and Professors: Sir Philip Sidney, Daniel Rogers, and the Leiden Humanists*. Leiden: Leiden University Press, 1962.

———. *The Radical Arts: First Decade of an Elizabethan Renaissance*. Leiden: Leiden University Press, 1970.

Dreyer, Peter. "Zeichnungen von Hans Verhagen dem Stummen von Antwerpen: ein Beitrag zu den Vorlagen der Tierminiaturen Hans Bols und Georg Hoefnagels." *Jahrbuch der kunsthistorischen Sammlungen in Wien* 82/83 (1986–87): 115–44.

Dubravius, Johannes. *Historia Boiemica*. Basel: apud Petrum Pernam, 1575.

Duits, Henk, and Ton van Strien, eds. *Een intellectuele activist. Studies over leven en werk van Philips van Marnix van Sint Aldegonde*. Hilversum: Verloren, 2001.

Duke, Alastair. *Dissident Identities in the Early Modern Low Countries*. Edited by Judith Pollmann and Andrew Spicer. Farnham, UK: Ashgate, 2009.

———. "Dissident Propaganda and Political Organization at the Outbreak of the Revolt of the Netherlands." In *Reformation, Revolt and Civil War in France and the Netherlands, 1555–1585*, edited by Philip Benedict et al., 115–32. Amsterdam: Royal Netherlands Academy of Arts and Sciences, 1999.

———. "Posters, Pamphlets and Prints: The Ways and Means of Disseminating Dissident Opinion on the Eve of the Dutch Revolt." *Dutch Crossing* 27 (2003): 23–44.

———. *Reformation and Revolt in the Low Countries*. London: Hambledon and London, 2003.

Durme, M. van. *Antoon Perrenot, bisschop van Atrecht, kardinaal van Granvelle, minister van Karel V en van Filips II (1517–1586)*. Brussels: Paleis der Academiën, 1953.

Dürr, Hans Peter. *Obzönität und Gewalt. Der Mythos vom Zivilisationsproceß*. Vol. 3. Frankfurt am Main: Suhrkamp, 1993.

Duval, Edwin M. *The Design of Rabelais's* Pantagruel. New Haven, CT: Yale University Press, 1991.

Ebben, Maurits, et al. *Alba: General and Servant to the Crown*. Rotterdam: Karwansaray Publishers, 2013.

Eden, Kathy. *Friends Hold all Things in Common: Tradition, Intellectual Property, and the* Adages *of Erasmus*. New Haven, CT: Yale University Press, 2001.

———. *The Renaissance Rediscovery of Intimacy*. Chicago: University of Chicago Press, 2012.

Edgar, Swift, and Angela M. Kinney, eds. *The Vulgate Bible: Douay-Rheims Version*. 6 vols. Cambridge, MA: Harvard University Press, 2010–13.

Egmond, Florike. "Observing Nature: The Correspondence Network of Carolus Clusius (1526–1609)." In *Communicating Observations in Early Modern Letters (1500–1675): Epistolography and Epistemology in the Age of the Scientific Revolution*, edited by Dirk van Miert, 43–72. London: Warburg Institute, 2013.

———. *Het visboek: de wereld volgens Adriaen Coenen, 1514–1587*. Zutphen: Walburg Pers, 2005.

———. *The World of Carolus Clusius: Natural History in the Making, 1550–1610*. London: Taylor & Francis, 2010.

Egmond, Florike, and Peter Mason. "Skeletons on Show: Learned Entertainment and Popular Knowledge." *History Workshop Journal* 41 (1996): 92–116.

Eichholz, D. E. "Aristotle's Theory of the Formation of Metals and Minerals." *Classical Quarterly* 43.3/4 (1949): 141–46.

Emison, Patricia A. *Creating the 'Divine' Artist from Dante to Michelangelo*. Leiden: Brill, 2004.

Enenkel. Karl A. E. "Camerarius's Quadrupeds (1595): A Plinius Emblematicus as a Mirror of Princes." In *Emblems and the Natural World*, edited by Karl A. E. Enenkel and Paul J. Smith, 91–148. Leiden: Brill, 2017.

———. "The Neo-Latin Emblem: Humanist Learning, Classical Antiquity, and the Virtual 'Wunderkammer.'" In *Companion to Emblem Studies*, edited by Peter M. Daly, 129–53. New York: AMS Press, 2008.

Enenkel, Karl A. E., and Arnoud S. Q. Visser, eds. *Mundus emblematicus: Studies in Neo-Latin Emblem Books*. Turnhout: Brepols, 2003.

Erasmus, Desiderius. *The Collected Works of Erasmus*. Toronto: University of Toronto Press, 1974–.

———. *Opera omnia Desiderii Erasmi Roterodami*. Amsterdam: North Holland Pub. Co., 1969–.

———. *Opus epistolarum Des. Erasmi Roterodami*. Edited by P. S. Allen. 12 vols. Oxford: in typographaeo Carlendoniano, 1906–58.

Evans, Mark. "The Pedigree of the Portrait Miniature: European Sources of an English Genre." In *Hans Holbein und der Wandel in der Kunst des frühen 16. Jahrhunderts*, edited by Bodo Brinkmann and Wolfgang Schmid, 229–52. Turnhout: Brepols, 2005.

Evans, R.J.W. *Rudolf II and His World: A Study in Intellectual History, 1576–1612*. Oxford: Clarendon Press, 1973.

Evans, R.J.W., and Alexander Marr. *Curiosity and Wonder from the Renaissance to the Enlightenment*. Aldershot, UK: Ashgate, 2006.

Falkenburg, Reindert L. *Joachim Patinir: Landscape as an Image of the Pilgrimage of Life*. Amsterdam: John Benjamins Publishing Company, 1988.

———. "Marginal Motifs in Early Flemish Landscape Paintings." In *Herri met de Bles: Studies and Explorations of the World Landscape Tradition*, edited by Norman E. Muller, Betsy J Rosasco, and James H. Marrow, 153–69. Turnhout. Brepols, 1998.

Felfe, Robert. "'Acarnan fecit': Warum der Fossilienkundler sich als Künstler sah." In *Wissenschaft, Berge, Ideologien: Johann Jakob Scheuchzer (1672–1733) und die frühneuzeitliche Naturforschung*, edited by Simona Boscani Leoni, 107–26. Basel: Schwabe Verlag, 2010.

———. "Figurationen im Gestein: Ko-Produktionen zwischen Kunst und Natur." In *Paragone als Mitstreit*, edited by Joris van Gastel, Yannis Hadjinicolaou, and Markus Rat, 153–75. Berlin: Akademie Verlag, 2014.

———. *Naturform und bildnerische Prozesse: Elemente einer Wissensgeschichte in der Kunst des 16. und 17. Jahrhunderts*. Berlin: Walter de Gruyter, 2015.

Ferguson, Margaret W. "Saint Augustine's Region of Unlikeness: The Crossing of Exile and Language." In *Innovations of Antiquity*, edited by Ralph Hexter and Daniel Selden, 69–94. New York: Routledge, 1992.

Ferino-Pagden, Sylvia, ed. *Arcimboldo (1526–1593)*. Milan: Skira Editore, 2007.

Filedt Kok, Jan Piet, W. Halsema-Kubes, and W. Th. Kloek, eds. *Kunst voor de beeldenstorm*. Amsterdam: Rijksmuseum, 1986.

Findlen, Paula. "Jokes of Nature and Jokes of Knowledge: The Playfulness of Scientific Discourse in Early Modern Europe." *Renaissance Quarterly* 43.2 (1990): 292–331.

———. "The Museum: Its Classical Etymology and Renaissance Genealogy." *Journal of the History of Collections* 1 (1989): 59–78.

———. "Natural History." In *The Cambridge History of Science*, vol. 3, *Early Modern Science*, edited by Katharine Park and Lorraine Daston, 435–68. Cambridge: Cambridge University Press, 2006.

———. *Possessing Nature: Museums, Collecting, and Scientific Culture in Early Modern Italy*. Berkeley: University of California Press, 1994.

Fischel, Angela. "Collections, Images and Form in Sixteenth-Century Natural History: The Case of Conrad Gessner." *Intellectual History Review* 20.1 (2010): 147–64.

———. *Natur im Bild: Zeichnung und Naturerkenntnis bei Conrad Gessner und Ulisse Aldrovandi*. Berlin: Gebr. Mann, 2009.

Fisher, Alexander J. *Music, Piety, and Propaganda: The Soundscapes of Counter-Reformation Bavaria*. Oxford: Oxford University Press, 2014.

Fishman, Jane Susanna. *'Boerenverdriet': Violence between Peasants and Soldiers in Early Modern Netherlandish Art*. Ann Arbor, MI: UMI Research Press, 1982.

Fissel, Mary E. "Imagining Vermin in Early Modern England." In *The Animal/Human Boundary: Historical Perspectives*, edited by Angela N. H. Creager and William Chester Jordan, 77–114. Rochester, NY: University of Rochester Press, 2002.

Forster, Leonard. *Janus Gruter's English Years. Studies in the Continuity of Dutch Literature in Exile in Elizabethan England*. Leiden: Leiden University Press, 1967.

Foucault, Michel. *The Order of Things: An Archaeology of the Human Sciences*. New York: Pantheon Books, 1971.

Fracchia, Carmen. "The Urban Slave in Spain and New Spain." In *The Slave in European Art, from Renaissance Trophy to Abolitionist Emblem*, edited by Elizabeth McGrath and Jean Michel Massing, 195–215. London: Warburg Institute, 2012.

Francissen, Frans P. M., and Ad W. M. Mol. *Augerius Clutius and His 'De hemerobio': An Early Work on Ephemeroptera*. Marburg an der Lahn: Basilisken-Press, 1984.

Franz, Heinrich Gerhard. "Beiträge zum Werk des Hans Bol." *Kunsthistorisches Jahrbuch Graz* 14 (1979): 199–208.

Frederickx, Eddy, and Toon van Hal. *Johannes Goropius Becanus (1518–1573): Brabants arts en taalfanaat*. Hilversum: Verloren, 2015.

Freedberg, David. "Art and Iconoclasm, 1525–1580—the Case of the Northern Netherlands." In *Kunst voor de Beeldenstorm*, edited by J. P. Filedt Kok, W. Halsema-Kubes, and W. Th. Kloek, 69–84. Amsterdam: Rijksmuseum, 1986.

———. *The Eye of the Lynx: Galileo, His Friends, and the Beginnings of Modern Natural History*. Chicago: University of Chicago Press, 2002.

———. "The Hidden God: Image and Interdiction in the Netherlands in the

Sixteenth Century." *Art History* 5.2 (1982): 133–53.

———. *Iconoclasm and Painting in the Revolt of the Netherlands, 1566–1609*. New York: Garland Publishing, 1988.

———. "Science, Commerce, and Art: Neglected Topics at the Junction of History and Art History." In *Art in History, History in Art: Studies in Seventeenth Century Dutch Culture*, edited by D. Freedberg and J. de Vries, 376–428. Los Angeles: The Getty Center, 1991.

Frisch, Andrea. *The Invention of the Eyewitness: Witnessing and Testimony in Early Modern France*. Chapel Hill: University of North Carolina Press, 2004.

Fuchs, Leonhart. *New Kreüterbuch*. Basel: Michael Isengrin, 1543.

Fučíková, Eliška, ed. *Rudolf II and Prague: The Court and the City*. London: Thames and Hudson, 1997.

Fučíková, Eliška, et al. *Prag um 1600: Beiträge zur Kunst und Kultur am Hofe Rudolfs II.* 2 vols. Freren: Luca Verlag, 1988.

Füssel, Stephan, ed. *Civitates Orbis Terrarum: Cities of the World. 363 Engravings Revolutionize the View of the World. Complete Edition of the Colour Plates of 1572–1617*. Cologne: Taschen, 2008.

Füssel, Stephan. "Natura Sola Magistra: The Evolution of City Iconography in the Early Modern Era." In *Civitates Orbis Terrarum: Cities of the World. 363 Engravings Revolutionize the View of the World. Complete Edition of the Colour Plates of 1572–1617*, edited by Stephan Füssel, 8–41. Cologne: Taschen, 2008.

Gaertner, Jan Felix, ed. *Writing Exile: The Discourse of Displacement in Greco-Roman Antiquity and Beyond*. Leiden: Brill, 2007.

Galen. *On the Elements according to Hippocrates*. Edited and translated by Phillip De Lacy. Berlin: Akademie Verlag, 1996.

Gamboni, Dario. *The Destruction of Art: Iconoclasm and Vandalism since the French Revolution*. New Haven, CT: Yale University Press. 1997.

Garani, Myrto. *Empedocles redivivus: Poetry and Analogy in Lucretius*. New York: Routledge, 2007.

Garin, Eugenio. *History of Italian Philosophy*. Vol. 1. Translated by Giorgio Pinton. Amsterdam: Rodopi, 2008.

Gehring, Ulrike, and Peter Weibel, eds. *Mapping Spaces: Networks of Knowledge in 17th-Century Landscape Painting*. Munich: Hirmer, 2014.

Geirnaert, Dirk, and Paul J. Smith. "Tussen fabel en embleem: *De warachtighe fabulen der dieren* (1567)." *Literatuur* 9 (1992): 22–33.

Geisberg, Max. *The German Single-Leaf Woodcut, 1500–1550*. Edited by Walter L. Strauss. 4 vols. New York: Hacker Art Books, 1974.

Génard, Pierre. *La furie espagnole. Documents pour server à l'histoire du sac d'Anvers en 1576*.

Antwerp: Annales de l'Académie d'archéologie de Belgique, 1875.

Gerszi, Teréz. *The New Ideal of Beauty in the Age of Pieter Bruegel: Sixteenth-Century Netherlandish Drawings in the Museum of Fine Arts, Budapest*. Budapest: Szépművészeti Múzeum, 2012.

Gesner, Conrad. *De rerum fossilium, lapidum et gemmarum maxime, figuris et similitudinibus liber*. Tiguri: excudebat Jacobus Gesnerus, 1565.

———. *Historiae animalium*. 5 vols. Tiguri: apud C. Froschoverum, 1551–87.

Geurts, P.A.M. *De Nederlandse Opstand in de pamfletten, 1566–1584*. Nijmegen: Centrale Drukkerij, 1956.

Van den Gheyn, J. *Album amicorum de Otto Venius: reproduction intégrale en fac-similé*. Brussels: Imprimé pour la Sociéte des Bibliophiles et Iconophiles de Belgique, 1911.

Giamatti, A. Bartlett. *Exile and Change in Renaissance Literature*. New Haven, CT: Yale University Press, 1984.

Gibson, Walter S. *Mirror of the Earth: The World Landscape in Sixteenth-Century Flemish Painting*. Princeton, NJ: Princeton University Press, 1989.

Ginzburg, Carlo. "Our Words, and Theirs: A Reflection on the Historian's Craft, Today." In *Historical Knowledge: In Quest of Theory, Method and Evidence*, edited by Susanna Fellman and Marjatta Rahikainen, 97–119. Newcastle upon Tyne, UK: Cambridge Scholars Publishing, 2012.

Goclenius, Rudolph. *Lexicon philosophicum, quo tanquam clave philosophiae fores aperiuntur*. Frankfurt: Typis viduae Matthiae Beckeri, 1613.

Goedde, Lawrence. *Tempest and Shipwreck in Dutch and Flemish Art: Convention, Rhetoric, and Interpretation*. University Park: Pennsylvania State University Press, 1989.

Goldberg, Gisela. "Zur Ausprägung der Dürer-Renaissance in München." *Münchner Jahrbuch der bildenden Kunst* 31 (1980): 129–75.

Gombrich, E. H. *Art and Illusion: A Study in the Psychology of Pictorial Representation*. Princeton, NJ: Princeton University Press, 1960.

Goosens, Aline. *Les inquisitions modernes dans les Pays-Bas méridionaux, 1520–1633*. 2 vols. Brussels: Editions de l'Université de Bruxelles, 1997–98.

Göttler, Christine. "Affectionate Gifts: Rubens's Small Curiosities on Metallic Supports." In *Munuscula amicorum: Contributions on Rubens and His Colleagues in Honour of Hans Vlieghe*, edited by Katlijne Van der Stighelen, 47–66. Turnhout: Brepols, 2006.

———. "Vulcan's Forge: The Sphere of Art in Early Modern Antwerp." In *Knowledge and Discernment in the Early Modern Arts*, edited

by Sven Dupré and Christine Göttler, 52–87. London: Routledge, 2017.

Gouwens, Kenneth. "What Posthumanism Isn't: On Humanism and Human Exceptionalism in the Renaissance." In *Renaissance Posthumanism*, edited by Joseph Campana and Scott Maisano, 37–63. New York: Fordham University Press, 2016.

Grafton, Anthony. *Commerce with the Classics: Ancient Books and Renaissance Readers*. Ann Arbor: University of Michigan Press, 1997.

Grafton, Anthony, April Shelford, and Nancy Siraisi. *New Worlds, Ancient Texts: The Power of Tradition and the Shock of Discovery*. Cambridge, MA: Harvard University Press, 1992.

Grafton, Anthony, and Nancy Siraisi, eds. *Natural Particulars: Nature and the Disciplines in Renaissance Europe*. Cambridge: MIT Press, 1999.

Graham, David. "'Emblema multiplex'. Towards a Typology of Emblematic Forms, Structures and Functions." In *Emblem Scholarship: Directions and Developments. A Tribute to Gabriel Hornstein*, edited by Peter M. Daly, 131–58. Imago Figurata Studies 5. Turnhout: Brepols, 2005.

Grapperhaus, Ferdinand H. M. *Alva en de tiende penning*. Zutphen: Walburg Pers, 1982.

Greene, Thomas. "The Flexibility of the Self in Renaissance Literature." In *The Disciplines of Criticism: Essays in Literary Theory, Interpretation, and History*, edited by Peter Demetz, Thomas Greene, and Lowry Nelson, Jr., 241–64. New Haven, CT: Yale University Press, 1968.

———. *The Light in Troy: Imitation and Discovery in Renaissance Poetry*. New Haven, CT: Yale University Press, 1982.

Greer, Margaret R., Walter D. Mignolo, and Maureen Quilligan. *Rereading the Black Legend: The Discourses of Religious and Racial Difference in the Renaissance Empires*. Chicago: University of Chicago Press, 2007.

Gregorius, Giraldus Lilius. *Libelli duo, in quorum altero aenigmata pleraque antiquorum*. Basel: per Ioannem Opinorum: 1551.

Van Grieken, Joris. "'View of the Strait of Messina': A Rediscovered Drawing after Pieter Bruegel the Elder. A New Acquisition for the Print Room of the Royal Library of Belgium." *In Monte Artium* 4 (2011): 209–19.

Groen, Petra, ed. *De Tachtigjarige Oorlog: van opstand naar geregelde oorlog, 1568–1648*. Amsterdam: Boom, 2013.

Groenveld, Simon. *De Tachtigjarige Oorlog: opstand en consolidatie in de Nederlanden (ca. 1560–1650)*. Zutphen: Walburg Pers, 2008.

Groenveld, Simon, et al. *De kogel door de kerk? De opstand in de Nederlanden en de rol van de*

Unie van Utrecht, 1559–1609. Zutphen: De Walburg Pers, 1979.

Grootenboer, Hanneke. "Sublime Still Life: On Adriaen Coorte, Elias van den Broeck, and the *Je ne sais quoi* of Painting." *Journal of Historians of Netherlandish Art* 8.2 (2016): https://jhna.org/articles/sublime-still-life -adriaen-coorte-elias-van-den-broeck-je-ne -sais-quoi-painting/.

Groys, Boris. *On the New.* Translated by G. M. Goshgarian. London: Verso, 2014.

Guicciardini, Ludovico. *Descrittione di tutti i Paesi Bassi, altrimenti detti Germania Inferiore.* Antwerp: apresso Guglielmo Silvio, Stampatore Regio, 1567.

Van Haecht, Godevaert. *De kroniek van Godevaert van Haecht over de troebelen van 1565 tot 1574 te Antwerpen en elders.* Edited by Rob. van Roosbroeck. 2 vols. Antwerp: De Sikkel, 1929–33.

Hamilton, Alastair. *The Family of Love.* Cambridge: J. Clarke, 1981.

Hand, John Oliver, et al. *The Age of Bruegel: Netherlandish Drawings in the Sixteenth Century.* Washington, DC: National Gallery of Art, 1986.

Hankins, John Erskine. *Backgrounds of Shakespeare's Thought.* Hamden, CT: Archon Books, 1978.

Harkness, Deborah E. *The Jewel House: Elizabethan London and the Scientific Revolution.* New Haven, CT: Yale University Press, 2007.

———. "Maps, Spiders, and Tulips: The Cole-Ortelius-L'Obel Family and the Practice of Science in Early Modern London." In *From Strangers to Citizens: The Immigrant Communities in Britain, Ireland and Colonial America, 1550–1750,* edited by Randolph Vigne and Charles Littleton, 184–96. Brighton, UK: Sussex Academic Press, 2001.

Harley, J. B. *The New Nature of Maps: Essays in the History of Cartography.* Edited by Paul Laxton. Baltimore: Johns Hopkins University Press, 2001.

Harline, Craig. *Pamphlets, Printing, and Political Culture in the Early Dutch Republic.* Dordrecht: Martinus Nijhoff, 1987.

Harms, Wolfgang, and Gilbert Heß. "Einleitung." In Joachim Camerarius the Younger, *Symbola et emblemata tam moralia quam sacra: Die handschriftlichen Embleme von 1587,* edited by Wolfgang Harms and Gilbert Heß, vii–xxv. Tübingen: Max Niemeyer, 2009.

Harris, Jason. "Het *album amicorum* van Abraham Ortelius: codicologie en verzameling." *De Gulden Passer* 83 (2005): 117–35.

———. "The Practice of Community: Humanist Friendship during the Dutch Revolt." *Texas Studies in Literature and Language* 47.4 (2005): 299–325.

Harrison, Peter. "The 'Book of Nature' and Early Modern Science." In *The Book of Nature in Early Modern and Modern History,* edited by Klaas van Berkel and Arjo Vanderjagt, 1–26. Leuven: Peeters, 2006.

Harrison, William. *The Description of England: The Classic Contemporary Account of Tudor Social Life,* edited by Georges Edelen. New York: Dover Publications, 1994.

Harvey, E. Ruth. *The Inward Wits: Psychological Theory in the Middle Ages and the Renaissance.* London: Warburg Institute, 1975.

Harwood, John T. "Rhetoric and Graphics in *Micrographia.*" In *Robert Hooke: New Studies,* edited by Michael Hunter and Simon Schaffer, 119–47. Woodbridge, UK: The Boydell Press, 1989.

Haskell, Yasmin "Poetic Flights or Retreats? Latin Lucretian Poems in Sixteenth-Century Italy." In *Lucretius and the Early Modern,* edited by David Norbrook, Stephen Harrison, and Philip Hardie, 91–121. Oxford: Oxford University Press, 2016.

Hassig, Debra. *Medieval Bestiaries: Text, Image, Ideology.* Cambridge: Cambridge University Press, 1995.

Haupt, Herbert, and Manfred Staudinger, eds. *Le Bestiaire de Rodolphe II: cod. min. 129 et 130 de la Bibliothèque Nationale d'Autriche.* Paris: Éditions Citadelles, 1990.

Hauschke, Sven. "Scientific Instruments, the 'Kunstkammer' and the Invention of the Renaissance 'Kunstschrank.'" In *Who Needs Scientific Instruments? Conference on Scientific Instruments and Their Users, 20–22 October 2005,* edited by Bart Grob and Hans Hooijmaijers, 49–55. Leiden: Museum Boerhaave, 2006.

Hautekeete, Stefaan. "New Insights into the Working Methods of Hans Bol." *Master Drawings* 50.3 (2012): 329–56.

Havens, Earle. *Commonplace Books: A History of Manuscripts and Printed Books from Antiquity to the Twentieth Century.* New Haven, CT: Beinecke Rare Book and Manuscript Library, 2001.

Haverkamp-Begemann, Egbert, et al. *Fifteenth- to Eighteenth-Century European Drawings in the Robert Lehmann Collection: Central Europe, the Netherlands, France, England.* New York: Metropolitan Museum of Art, 1999.

Hawhee, Debra. *Rhetoric in Tooth and Claw: Animals, Language, Sensation.* Chicago: University of Chicago Press, 2017.

Heal, Felicity. *The Power of Gifts: Gift Exchange in Early Modern England.* Oxford: Oxford University Press, 2014.

Healy, John F. *Pliny the Elder on Science and Technology.* Oxford: Oxford University Press, 1999.

De Heere, Lucas. *Beschrijving der Britsche eilanden.* Edited by Th. M. Chotzen and A.M.E. Draak. Antwerp: De Sikkel, 1937.

———. *Beschryvinghe van het ghene dat vertoocht wierdt ter incomste van d'Excellentie des princen van Oraengien binnen der stede van Ghendt, den xxix Decembris 1577.* Ghent: de weduwe van Pieter de Clerck, 1578.

———. *Den hof en boomgaerd der poësien.* Edited by Werner Waterschoot. Zwolle: W.E.J. Tjeenk Willink, 1969.

———. *Lucas d'Heere, Tableau poetique: verzen van een Vlaamse migrant-kunstenaar voor de entourage van de Seymours op Wolf Hall.* Edited by Frederica Van Dam and Werner Waterschoot. Ghent: Koninklijke Academie voor Nederlandse Taal- en Letterkunde, 2016.

———. *Het vierde deel van het wout van wonder.* In *Het wonderijcke Schadt-Boeck der historien: begrijpende vele seldsame, vreemde ende wonderbaerlijcke geschiedenissen bevonden inde Natuere, hare cracht en werckinghen,* by Pierre Boaistuau, 1r–18v. Dordrecht: door Jasper Troyen, 1592.

Heesakkers, Chris L., ed. *Een network aan de basis van de Leidse universiteit: het album amicorum van Janus Dousa.* Leiden: Leiden University Library, 2000.

Hegel, G.W.F. *Hegel's Philosophy of Right.* Edited and translated by Sir Thomas Malcolm Knox. Oxford: Oxford University Press, 1952.

Heiberg, Steffan, ed. *Christian IV and Europe: The 19th Art Exhibition of the Council of Europe.* Copenhagen: Foundation for the Christian IV Year 1988, 1988.

Heidegger, Martin. "The Age of the World Picture (1938)." In *Off the Beaten Track,* translated by Julian Young and Kenneth Haynes, 57–73. New York: Cambridge University Press, 2002.

———. "The Origin of the Work of Art." In *Poetry, Language, Thought,* translated by Albert Hofstadter, 17–87. New York: Harper Collins, 1971.

Helgerson, Richard. *Forms of Nationhood: The Elizabethan Writing of England.* Chicago: University of Chicago Press, 1992.

Heller-Roazen, Daniel. *The Inner Touch: Archaeology of a Sensation.* New York: Zone Books, 2007.

Hendrix, Lee. "An Introduction to Hoefnagel and Bocskay's *Model Book of Calligraphy* in the J. Paul Getty Museum." In *Prag um 1600: Beiträge zur Kunst und Kultur am Hofe Rudolfs II,* 110–17. Freren: Luca Verlag, 1988.

———. "Joris Hoefnagel and the *Four Elements*: A Study in Sixteenth-Century Nature Painting." Ph.D. diss., Princeton University: 1984.

———. "Natural History Illustration at the Court of Rudolf II." In *Rudolf II and Prague:*

The Court and the City, edited by Eliška Fučíková, 157–71. London: Thames and Hudson, 1997.

———. "Of Hirsutes and Insects: Joris Hoefnagel and the Art of the Wondrous." *Word & Image* 11 (1995): 373–90.

Hendrix, Lee, and Thea Vignau-Wilberg, eds. *Mira Calligraphiae Monumenta: A Sixteenth-Century Calligraphic Manuscript Inscribed by Georg Bocskay and Illuminated by Joris Hoefnagel*. Malibu, CA: J. Paul Getty Museum, 1992.

Henkel, Arthur, and Albrecht Schöne, eds. *Emblemata: Handbuch zur Sinnbildkunst des XVI. und XVII. Jahrhunderts*. Stuttgart: J. B. Metzler, 1967.

Heras Santos, José Luis de las. *La justicia penal de los Austrias en la corona de Castilla*. Salamanca: Ediciones Universidad de Salamanca, 1991.

Herrin, Amanda K. "Pioneers of the Printed Paradise: Maarten de Vos, Jan Sadeler I and Emblematic Natural History in the Late Sixteenth Century." In *Zoology in Early Modern Culture: Intersections of Science, Theology, Philology, and Political and Religious Education*, edited by K.A.E. Enenkel and P. J. Smith, 329–400. Leiden: Brill, 2014.

Hertel, Christiane. "Hairy Issues: Portraits of Petrus Gonsalus and His Family in Archduke Ferdinand II's *Kunstkammer* and Their Contexts." *Journal of the History of Collections* 13.1 (2001): 1–22.

Heuer, Christopher. *The City Rehearsed: Object, Architecture, and Print in the Worlds of Hans Vredeman de Vries*. London: Routledge, 2009.

Hodnett, Edward. *Marcus Gheeraerts the Elder of Bruges, London, and Antwerp*. Utrecht: Haentjens Dekker & Gumbert, 1971.

Hogenberg, Frans, and Abraham Hogenberg. *Geschichtsblätter*. Edited by Fritz Hellwig. Nördlingen: Verlag Dr. Alfons Uhl, 1983.

Hollingsworth, Cristopher. *Poetics of the Hive: The Insect Metaphor in Literature*. Iowa City: University of Iowa Press, 2001.

Hollstein, F.W.H. *Dutch and Flemish Etchings, Engravings, and Woodcuts, ca. 1450–1700*. 72 vols. Amsterdam: Menno Hertzberger, 1949–2010.

Homer. *Deerste twaelf boecken Odysseae, dat is de dolinghe van Ulysse, bescreven int Griecx door den poeet Homerum, vadere ende fonteyne alder poeten*. Translated by Dirck Volckertsz. Coornhert. Haarlem: Jan van Zuren, 1561.

Honig, Elizabeth A. *Jan Brueghel and the Senses of Scale*. University Park: The Pennsylvania State University Press, 2016.

———. *Painting and the Market in Early Modern Antwerp*. New Haven, CT: Yale University Press, 1998.

Horapollo, *The Hieroglyphics of Horapollo*. Edited and translated by George Boas. Princeton, NJ: Princeton University Press, 1993.

Horst, Daniel R. *De Opstand in zwart-wit: propagandaprenten uit de Nederlandse Opstand, 1566–1584*. Zutphen: Walburg Pers, 2003.

Houtzager, H. L. "Andreas Vesalius and the Occo Medals of Augsburg: Evidence of a Professional Friendship." *Vesalius* 6.1 (2000): 20–31.

Hugh of Saint-Victor. *The Didascalicon of Hugo of St. Victor: A Medieval Guide to the Arts*. Translated by Jerome Taylor. New York: Columbia University Press, 1991.

Huizinga, Johan H. "Dutch Civilisation in the Seventeenth Century." In *Dutch Civilisation in the Seventeenth Century and Other Essays*, selected by Pieter Geyl and F.W.N. Hugenholtz, translated by Arnold J. Pomerans, 9–104. New York: Harper Torchbooks, 1968.

Hülsen, Christian, and Hermann Egger. *Die Römischen Skizzenbücher von Marten van Heemskerck*. 2 vols. Berlin: Julius Bard, 1913–16.

Hurka, Florian. *Die Asinaria des Plautus: Einleitung und Kommentar*. Munich: Verlag C. H. Beck, 2010.

Huygens, Constantijn. *Mijn jeugd*. Edited and translated by C. L. Heesakkers. Amsterdam: Em. Querido's Uitgeverij, 1994.

———. "Fragment eener autobiographie van Constantijn Huygens." Edited by J. A. Worp. *Bijdragen en Mededeelingen van het Historisch Genootschap* 18 (1897): 1–122.

Ilardi, Vincent. *Renaissance Vision from Spectacles to Telescopes*. Philadelphia: American Philosophical Society, 2007.

Ilsink, Matthijs. *Bosch en Bruegel als Bosch. Kunst over kunst bij Pieter Bruegel (c. 1528–1569) en Jheronimus Bosch (c. 1450–1516)*. Nijmegen: Radhoud Universiteit Nijmegen, 2009.

———, ed. *Hieronymus Bosch: Painter and Draughtsman: Catalogue raisonné*. New Haven, CT: Yale University Press, 2016.

Irmscher, Günter. "*Hermathena* in der Hofkunst Prags und Münchens um 1600." In *München—Prag um 1600*, edited by Beket Bukovinská and Lubomir Konečný, 77–101. Prague: Artefactum, 2009.

Isager, Jacob. *Pliny on Art and Society: The Elder Pliny's Chapters on the History of Art*. London: Routledge, 1991.

Israel, Jonathan. *The Dutch Republic: Its Rise, Greatness, and Fall, 1477–1806*. Oxford: Oxford University Press, 1995.

Jacoby, Joachim. "*Salus generis humani*: Some Observations on Joris Hoefnagel's Christianity." In *Hans von Aachen in Context: Proceedings of the International Conference, Prague, 22–25 September 2010*. Edited by Lubomir Konečný and Štěpán Vácha, 102–25. Prague: Artefactum, 2012.

Janson, H. W. "The Image 'Made by Chance' in Renaissance Thought." In *De artibus opuscula XL: Essays in Honor of Erwin Panofsky*, edited by Millard Meiss, 1:254–66, 2:87–88. 2 vols. New York: New York University Press, 1961.

Janssen, Geert H. *The Dutch Revolt and Catholic Exile in Reformation Europe*. Cambridge: Cambridge University Press, 2014.

Janssens, Gustaaf. "Cardinal Granvelle and the Revolt of the Netherlands: The Evolution of His Thought on a Desirable Political Approach to the Problem, 1567–1578." In *Les Granvelles et les anciens Pays-Bas*, edited by Krista De Jonge and Gustaaf Janssens, 135–56. Leuven: Universitaire Pers, 2000.

———. *Don Fernando Álvarez de Toledo, Tercer duque de Alba y los Países Bajos*. Brussels: Ministerio de la Comunidad Flamenca, 1993.

———. "'Verjaagd uit Nederland'. Zuidnederlandse emigratie in de zestiende eeuw: een historiografisch overzicht (ca. 1968–1994)." *Nederlands Archief voor Kerkgeschiedenis* 75 (1995): 102–19.

Jeck, Udo Reinhold. "Miraculum calcis: eine naturphilosophische Paradoxie bei Augustin." In *Umbrüche: historische Wendepunkte der Philosophie von der Antike bis zur Neuzeit: Festschrift für Kurt Flasch zu seinem 70. Geburtstag*, edited by Klaus Kahnert and Burkhard Mojsisch, 33–41. Amsterdam: B. R. Grüner, 2001.

Joby, Christopher. *The Dutch Language in Britain (1550–1702): A Social History of the Use of Dutch in Early Modern Britain*. Leiden: Brill, 2015.

Jonckheere, Koenraad. *Antwerp Art after Iconoclasm: Experiments in Decorum, 1566–1585*. Brussels: Mercatorfonds, 2012.

———. "Images of Stone: The Physicality of Art and the Image Debates in the Sixteenth Century." *Nederlands Kunsthistorisch Jaarboek* 62 (2012): 116–47.

———. "The Power of Iconic Memory: Iconoclasm as a Mental Marker." *Low Countries Historical Review* 131.1 (2016): 141–54.

———. "Repetition and the Genesis of Meaning: An Introductory Note." In *Art after Iconoclasm: Painting in the Netherlands between 1566 and 1585*, edited by Koenraad Jonckheere and Ruben Suykerbuyk, 7–19. Turnhout: Brepols, 2012.

Jonckheere, Koenraad, and Ruben Suykerbuyk, eds. *Art after Iconoclasm: Painting in the Netherlands between 1566 and 1585*. Turnhout: Brepols, 2012.

De Jonge, Krista. "Le palais Granvelle à Bruxelles: premier exemple de la renaissance romaine dans les anciens Pays-Bas?" In *Les Granvelles et les anciens Pays-Bas*, edited by Krista De Jonge and Gustaaf Janssens, 341–87. Leuven: Universitaire Pers, 2000.

———. "De tuinen van kardinaal Granvelle in Brussel en Sint-Joost-ten-Node:

Kanttekeningen bij zijn briefwisseling." *Het tijdschrift van Dexia Bank* 55 (2001): 69–78.

Jonston, Joannes. *Historiae naturalis*. Vol. 3 (*De insectis*). Amsterdam: apud Joannem Jacobi filium Schipper, 1657.

Jordan-Gschwend, Annemarie. *The Story of Süleyman: Celebrity Elephants and Other Exotica in Renaissance Portugal*. Philadelphia: Pachyderm, 2010.

Jorink, Eric. "Between Emblematics and the 'Argument from Design': The Representation of Insects in the Dutch Republic." In *Early Modern Zoology: The Construction of Animals in Science, Literature and the Visual Arts*, edited by Karl A. E. Enenkel and Paul J. Smith, 147–75. Leiden: Brill, 2007.

———. "Beyond the Lines of Apelles: Johannes Swammerdam, Dutch Scientific Culture and the Representation of Insect Anatomy." *Nederlands Kunsthistorisch Jaarboek* 61 (2011): 148–83.

———. "Outside God, There Is Nothing: Swammerdam, Spinoza, and the Janus-Face of the Early Dutch Enlightenment." In *The Early Enlightenment in the Dutch Republic, 1650–1750: Selected Papers of a Conference Held at the Herzog August Bibliothek, Wolfenbüttel, 22–23 March 2001*, edited by Wiep van Bunge, 81–107. Leiden: Brill, 2003.

———. *Reading the Book of Nature in the Dutch Golden Age, 1575–1715*. Translated by Peter Mason. Leiden: Brill, 2010.

Jorissen, Theodorus. "Genealogie van Hoefnagel." *De Navorscher* 22 (1872): 260–69.

Junius, Franciscus. *The Painting of the Ancients. 'De pictura veterum' according to the English translation (1638)*. Edited by Keith Aldrich, Philipp Fehl, and Raina Fehl. The Literature of Classical Art, vol. 1. Berkeley: University of California Press, 1987.

Kagan, Richard L. *Urban Images of the Hispanic World, 1493–1793*. New Haven, CT: Yale University Press, 2000.

Kaliardos, Katharina Pilaski. *The Munich Kunstkammer: Art, Nature, and the Representation of Knowledge in Courtly Contexts*. Tübingen: Mohr Siebeck, 2013.

Kanz, Roland. *Die Kunst des Capriccio: Kreativer Eigensinn in Renaissance und Barock*. Munich: Deutscher Kunstverlag, 2002.

Kaplan, Benjamin J. *Divided by Faith: Religious Conflict and the Practice of Toleration in Early Modern Europe*. Cambridge, MA: Belknap Press of Harvard University Press, 2007.

Karrow, Robert W. *Mapmakers of the Sixteenth Century and Their Maps: Bio-Bibliographies of the Cartographers of Abraham Ortelius*. Chicago: Speculum Orbis Press, 1993.

Karrow, Robert W., et al. *Abraham Ortelius (1527–1598): cartograaf en humanist*. Antwerp: Museum Plantin-Moretus, 1998.

Kaschek, Bertram. "Bruegel in Prag: Anmerkungen zur Rezeption Peter Bruegel d.Ä. um 1600." *Studia Rudolphina* 7 (2007): 44–58.

Kaufmann, Thomas DaCosta. *Arcimboldo: Visual Jokes, Natural History, and Still-Life Painting*. Chicago: University of Chicago Press, 2009.

———. "Christian IV and Europe: The 19th Art Exhibition of the Council of Europe, Denmark 1988." *Konsthistorisk Tidskrift* 58.1 (1989): 19–22.

———. *Drawings from the Holy Roman Empire, 1540–1680: A Selection from North American Collections*. Princeton, NJ: Art Museum, Princeton University, 1982.

———. "The Eloquent Artist: Towards an Understanding of the Stylistics of Painting at the Court of Rudolf II." *Leids Kunsthistorisch Jaarboek* 1 (1982): 119–48.

———. "Hermeneutics in the History of Art: Remarks on the Reception of Dürer in the Sixteenth and Seventeenth Centuries." In *New Perspectives on the Art of Renaissance Nuremberg: Five Essays*, edited by Jeffrey Chipps Smith, 23–39. Austin, TX: The Archer M. Huntington Art Gallery, 1985.

———. *The Mastery of Nature: Aspects of Art, Science, and Humanism in the Renaissance*. Princeton, NJ: Princeton University Press, 1993.

———. "The Nature of Imitation: Hoefnagel on Dürer." *Jahrbuch der Kunsthistorischen Sammlungen in Wien* 82/83 (1986/87): 163–77.

———. *The School of Prague: Painting at the Court of Rudolf II*. Chicago: University of Chicago Press, 1988.

Kaufmann, Thomas DaCosta, and Virginia Roehrig Kaufmann. "The Sanctification of Nature: Observations on the Origins of Trompe l'oeil in Netherlandish Book Painting of the Fifteenth and Sixteenth Centuries." *J. Paul Getty Museum Journal* 19 (1991): 43–64.

Kavaler, Ethan Matt. *Pieter Bruegel: Parables of Order and Enterprise*. Cambridge: Cambridge University Press, 1999.

Kayser, Petra. "The Intellectual and the Artisan: Wenzel Jamnitzer and Bernard Palissy Uncover the Secrets of Nature." *Australian and New Zealand Journal of Art* 7.2 (2006): 45–61.

Keil, Robert, and Richard Keil. *Die deutschen Stammbücher des sechzehnten bis neunzehnten Jahrhunderts: Ernst und Scherz, Weisheit und Schwank in Original Mittheilungen zur deutschen Kultur-Geschichte*. Berlin: G. Grote'sche Verlagsbuchhandlung, 1893.

Keller, Vera. "Forms of Internationality: The *Album amicorum* and the Popularity of John Owen (1564–1622)." In *Forms of Association: Making Publics in Early Modern Europe*, edited

by Paul Yachnin and Marlene Eberhart, 220–34. Amherst: University of Massachusetts Press, 2015.

———. "Painted Friends: Political Interest and the Transformation of International Learned Sociability." In *Friendship in the Middle Ages and Early Modern Times*, edited by Marilyn Sandidge and Albrecht Classen, 674–705. Berlin: Walter de Gruyter Press, 2010.

Kemp, Martin. "From 'Mimesis' to 'Fantasia': The Quattrocento Vocabulary of Creation, Inspiration, and Genius in the Visual Arts." *Viator* 8 (1977): 347–98.

———. "The 'Super-Artist' as Genius: The Sixteenth-Century View." In *Genius: The History of an Idea*, edited by Penelope Murray: 33–53. Oxford: Basil Blackwell, 1989.

Kemperdick, Stephan, and Friso Lammertse, eds. *The Road to van Eyck*. Rotterdam: Museum Boijmans van Beuningen, 2012.

Kentmann, Johannes. *Nomenclaturae rerum fossilium, quae in Misnia praecipue, et in aliis quoque regionibus inveniuntur*. In *De omni rerum fossilium genere, gemmis, lapidibus, metallis, et huiusmodi, libri aliquot, plerique nunc primum editi*, edited by Conrad Gesner, A3r–M7v. Tiguri: excudebat Jacobus Gesnerus, 1565.

Kilgour, Maggie. *Milton and the Metamorphosis of Ovid*. Oxford: Oxford University Press, 2012.

Kirk, R. E. G., and Ernest F. Kirk, eds. *Returns of Aliens Dwelling in the City and Suburbs of London from the Reign of Henry VIII to that of James I*. Vol. 1. Aberdeen: The University Press, 1900.

Klein, Jürgen. "Genius, Ingenium, Imagination: Aesthetic Theories of Production from the Renaissance to Romanticism." In *The Romantic Imagination: Literature and Art in England and Germany*, edited by Frederick Burwick and Jürgen Klein, 19–62. Amsterdam: Rodopi, 1996.

Klinkert, Christi M. *Nassau in het nieuws: nieuwsprenten van Maurits van Nassaus militaire ondernemigen uit de periode 1590–1600*. Zutphen: Walburg Pers, 2005.

Klose, Wolfgang. *Corpus alborum amicorum: CAAC. Beschreibendes Verzeichnis der Stammbücher des 16. Jahrhunderts*. Stuttgart: Anton Hiersemann, 1988.

———, ed. *Stammbücher des 16. Jahrhunderts*. Wiesbaden: Otto Harrassowitz, 1989.

Koeman, Cornelis. *Collections of Maps and Atlases in the Netherlands: Their History and Present State*. Leiden: Brill, 1961.

———. *The History of Abraham Ortelius and His Theatrum orbis terrarum*. Lausanne: Sequoia, 1964.

———. *Koeman's Atlantes Neerlandici*. Compiled by Peter van der Krogt. 9 vols. 't Goy-Houten: HES Publishers, 1997–2012.

Koeman, Cornelis, et al. "Commercial Cartography and Map Production in the Low Countries, 1500–ca. 1672." In *Cartography in the European Renaissance*, edited by David Woodward, 1296–383. Chicago: University of Chicago Press, 2007.

Koerner, Joseph Leo. *Bosch and Bruegel: From Enemy Painting to Everyday Life*. Princeton, NJ: Princeton University Press, 2016.

———. *The Reformation of the Image*. Chicago: University of Chicago Press, 2003.

Konečný, Lubomír. "Joris Hoefnagel's 'Emblematic' Signature Reconsidered." *Journal of the Warburg and Courtauld Institutes* 61 (1998): 267–72.

———. "Migration, Entfremdung, Aemulatio: Die Prager Künstler und ihre darstellerischen Modi." *Kunstchronik* 70.6 (2017): 294–97.

Kongsted, Ole. "Archivalische Quellen zum Wirken von Heinrich Schütz in Kopenhagen." In *Heinrich Schütz und die Musik in Dänemark zur Zeit Christians IV*, edited by Anne Ørbæk Jensen and Ole Kongsted, 33–41. Copenhagen: Engstrøm & Sødring, 1989.

Koreny, Fritz. *Albrecht Dürer and the Animal and Plant Studies of the Renaissance*. Translated by Pamela Marwood and Yehuda Shapiro. Boston: Little, Brown and Company, 1985.

———. *Hieronymus Bosch: Die Zeichnungen: Werkstaat und Nachfolge bis zum Ende des 16. Jahrhunderts*. Turnhout: Brepols, 2012.

Koreny, Fritz, and Sam Segal. "Hans Hoffmann: Entdeckungen und Zuschreibungen." *Jahrbuch der Kunsthistorischen Sammlungen in Wien* 85/86 (1989–90): 57–65.

Korey, Michael. *The Geometry of Power, the Power of Geometry: Mathematical Instruments and Princely Mechanical Devices from around 1600*. Berlin: Deutscher Kunstverlag, 2007.

Kossman, E. H., and A. F. Mellink, eds. *Texts concerning the Revolt of the Netherlands*. Cambridge: Cambridge University Press, 1974.

Krämer, Fabian, and Helmut Zedelmaier. "Instruments of Invention in Renaissance Europe: The Cases of Conrad Gesner and Ulisse Aldrovandi." *Intellectual History Review* 24.3 (2014): 321–41.

Kraye, Jill. "Moral Philosophy." In *Cambridge History of Renaissance Philosophy*, edited by Charles B. Schmitt et al., 303–86. Cambridge: Cambridge University Press, 1988.

———. "The Revival of Hellenistic Philosophies." In *The Cambridge Companion to Renaissance Philosophy*, edited by James Hankins, 97–112. Cambridge: Cambridge University Press, 2007.

Kris, Ernst. "Georg Hoefnagel und der wissen-schaftliche Naturalismus." In *Festschrift für Julius von Schlosser zum 60 Geburtstag*, edited by Arpad Weixlgärtner and Leo Planiscig, 244–53. Zurich: Amalthea Verlag, 1927.

Kris, Ernst, and Otto Kurz. *Legend, Myth, and Magic in the Image of the Artist: A Historical Experiment*. New Haven, CT: Yale University Press, 1979.

Kuiper, E. T., and P. Leendertz Jr., eds. *Het Geuzenliedboek naar de oude drukken*. 2 vols. Zutphen: W. J. Thieme & Cie, 1924.

Kunkler, Stephan. *Zwischen Humanismus und Reformation: der Humanist Joachim Camerarius (1500–1574) im Wechselspiel von pädagogischem Pathos und theologischem Ethos*. Hildesheim: Olms, 2000.

Kusukawa, Sachiko. "Conrad Gessner on an 'ad vivum' Image." In *Ways of Making and Knowing: The Material Culture of Empirical Knowledge*, edited by Pamela H. Smith, Amy R. W. Meyers, and Harold J. Cook, 330–56. Ann Arbor: University of Michigan Press, 2014.

———. *Picturing the Book of Nature: Image, Text, and Argument in Sixteenth-Century Human Anatomy and Medical Botany*. Chicago: University of Chicago Press, 2011.

———. "The Sources of Gessner's Pictures for the *Historia animalium*." *Annals of Science* 67.3 (2010): 303–28.

Lagrée, Jacqueline. "Constancy and Coherence." In *Stoicism: Traditions and Transformations*, edited by Steven K. Strange and Jack Zupko, 148–76. Cambridge: Cambridge University Press, 2004.

Lampsonius, Dominicus. *Pictorum aliquot celebrium Germaniae inferioris effigies*. Antwerp: apud viduam Hieronymi Cock, 1572.

Landtsheer, Jeanine De. "Benito Arias Montano and the Friends from His Antwerp Sojourn." *De Gulden Passer* 80 (2002): 39–61.

Landwehr, John. *Emblem Books in the Low Countries, 1554–1949: A Bibliography*. Utrecht: Haentjens Dekker & Gumbert, 1970.

Langer, Ullrich, "Invention." In *The Cambridge History of Literary Criticism*, vol. 3, *The Renaissance*, edited by Glyn P. Norton, 136–44. Cambridge: Cambridge University Press, 1999.

Laudan, Rachel. *From Mineralogy to Geology: The Foundations of a Science, 1650–1830*. Chicago: University of Chicago Press, 1987.

Lausberg, Heinrich. *Handbook of Literary Rhetoric: A Foundation for Literary Study*. Translated by Matthew T. Bliss, Annemiek Jansen, and David E. Orton. Edited by David E. Orton and R. Dean Anderson. Leiden: Brill, 1998.

Lavin, Irving. "Divine Grace and the Remedy of the Imperfect: Michelangelo's Signature on the St. Peter's *Pietà*." *Artibus et Historiae* 34 (2013): 277–328.

Leach, Elizabeth Eva. *Sung Birds: Music, Nature, and Poetry in the Later Middle Ages*. Ithaca, NY: Cornell University Press, 2007.

Lechner, Joan Marie. *Renaissance Concepts of the Commonplaces*. Westport, CT: Greenwood Press, 1962.

Leonardo da Vinci. *Leonardo on Painting: An Anthology of Writings by Leonardo da Vinci, with a Selection of Documents Relating to His Career as an Artist*. Edited by Martin Kemp. Translated by Martin Kemp and Margaret Walker. New Haven, CT: Yale University Press, 2001.

Leonhard, Karin. *Bildfelder: Stilleben und Naturstücke des 17. Jahrhunderts*. Berlin: Akademie Verlag, 2013.

Leu, Urs B., Raffael Keller, and Sandra Weidmann. *Conrad Gessner's Private Library*. Leiden: Brill, 2008.

Leuschner, Eckhard, ed. *Rekonstruktion der Gesellschaft aus Kunst: Antwerpener Malerei und Graphik in und nach den Katastrophen des späten 16. Jahrhunderts*. Petersberg: Michael Imhof Verlag, 2016.

Levy, J. J. "Daniel Rogers as Antiquary." *Bibliothèque d'Humanisme et Renaissance* 27.2 (1965): 444–62.

Lewis, Rhodri. "Francis Bacon and Ingenuity." *Renaissance Quarterly* 67.1 (2014): 113–63.

Liebaers, Herman. *Vijftien jaar aanwinsten sedert de eerste steenlegging tot de plechtige inwijding van de Bibliotheek*. Brussels: Koninklijke Bibliotheek Albert I, 1969.

Limberger, Michael. *Sixteenth-Century Antwerp and Its Rural Surroundings: Social and Economic Changes in the Hinterland of a Commercial Metropolis (ca. 1450—ca. 1570)*. Turnhout: Brepols, 2008.

Lindeman, Ruud, Yvonne Scherf, and Rudolf Dekker. *Reisverslagen van Noord-Nederlanders van de zestiende tot begin negentiende eeuw: een chronologische lijst*. Rotterdam: Erasmus Universiteit Rotterdam, 1994.

Lipsius, Justus. *De constantia libri duo*. Antwerp: Christopher Plantin, 1584.

L'Obel, Matthias de. *Plantarum, sive stirpium historia*. Antwerp: ex officina Christophori Plantini, 1576.

Lochman, Daniel T., and Maritere López. "The Emergence of Discourses: Early Modern Friendship." In *Discourses and Representations of Friendship in Early Modern Europe, 1500–1700*, edited by Daniel T. Lochman, Maritere López, and Lorna Hutson, 1–26. Farnham, UK: Ashgate, 2011.

Loh, Maria H. *Still Lives: Death, Desire, and the Portrait of the Old Master*. Princeton, NJ: Princeton University Press, 2015.

Lohr, Charles. "Metaphysics and Natural Philosophy as Sciences: The Catholic and Protestant Views in the Sixteenth and Seventeenth Centuries." In *Philosophy in*

the Sixteenth and Seventeenth Centuries: Conversations with Aristotle, edited by Constance Blackwell and Sachiko Kusukawa, 280–95. Aldershot, UK: Ashgate, 1999.

Lomazzo, Giovanni Paolo. The Idea of the Temple of Painting. Edited and translated by Jean Julia Chai. University Park: Pennsylvania State University Press, 2013.

———. Scritti sulle arti. Edited by Roberto Paolo Ciardi. 2 vols. Florence: March & Bertolli, 1973–74.

Lombaerde, Piet, and Katelijne Geerts. Antwerpen verbeeld: de Gouden Eeuw in kaart en prent. Antwerp: Museum Plantin-Moretus, 2015.

Lundin, Matthew. Paper Memory: A Sixteenth-Century Townsman Writes His World. Cambridge, MA: Harvard University Press, 2012.

Lüthy, Christoph, and Alexis Smets. "Words, Lines, Diagrams, Images: Towards a History of Scientific Imagery." Early Science and Medicine 14.1/3 (2009): 398–439.

Lyne, Raphael. "Love and Exile after Ovid." In The Cambridge Companion to Ovid, edited by Philip Hardie, 288–300. Cambridge: Cambridge University Press, 2002.

Lyons, John D. Before Imagination: Embodied Thought from Montaigne to Rousseau. Stanford, CA: Stanford University Press, 2005.

Van Mander, Karel. Den Grondt der edel vry Schilder-const. Edited by Hessel Miedema. 2 vols. Utrecht: Haentjens Dekker & Gumbert, 1973.

———. The Lives of the Illustrious Netherlandish and German Painters from the First Edition of the Schilder-boeck (1603–1604). Edited by Hessel Miedema. 6 vols. Doornspijk: Davaco, 1994–99.

Mango, Cyril, and Stephan Yerasimos. Melchior Lorich's Panorama of Istanbul, 1559. Bern: Ertug & Kocabıyık, 1999.

Mann, Sir James. Wallace Collection Catalogues: European Arms and Armour. 2 vols. London: William Clowes and Sons Ltd., 1962.

Marnef, Guido. Antwerp in the Age of Reformation: Underground Protestantism in a Commercial Metropolis, 1550–1577. Translated by J. C. Grayson. Baltimore: Johns Hopkins University Press, 1996.

Marnix van Sint-Aldegonde, Philips van. De bijenkorf der H. Roomsche Kerke, met inleiding en varianten. Edited by A. Lacroix and A. Willems. 2 vols. Brussels: Fr. van Meenen, 1858.

———. Godsdienstige en kerkelijke geschriften, voor het eerst of in herdruk uitgegeven met historische inleiding en taalkundige opheldering. Edited by J. J. van Toorenenbergen. 4 vols. The Hague: Martinus Nijhoff, 1871–91.

Marr, Alexander. "Knowing Images." Renaissance Quarterly 69 (2016): 1000–1013.

———. "Pregnant Wit: ingegno in Renaissance England." British Art Studies 1 (2015): https://doi.org/10.17658/issn.2058-5462/issue-01/amarr.

Martin, Craig. Renaissance Meteorology: Pomponazzi to Descartes. Baltimore: Johns Hopkins University Press, 2011.

Marzano, Annalisa. Harvesting the Sea: The Exploitation of Marine Resources in the Roman Mediterranean. Oxford: Oxford University Press, 2013.

Maselis, Marie-Christiane, Arnout Balis, and Roger H. Marijnissen. The Albums of Anselmus de Boodt (1550–1632): Natural History Painting at the Court of Rudolph II in Prague. Ramsen: Antiquariat Bibermühle, 1999.

Matthes, Melissa M. The Rape of Lucretia and the Founding of Republics: Readings in Livy, Machiavelli, and Rousseau. University Park: Pennsylvania State University Press, 2000.

Matzke, Michael. "Weltgeschichte in der Hand: Münzen und Medaillen." In Die grosse Kunstkammer: bürgerliche Sammler und Sammlungen in Basel, edited by Sabine Söll-Tauchert, Raphael Beuing, and Burkhard von Roda, 167–84. Basel: Historisches Museum Basel, 2011.

Mauss, Marcel. The Gift: Forms and Functions of Exchange in Archaic Societies. Translated by Ian Cunnison. New York: W. W. Norton, 1967.

Maxwell, Susan. The Court Art of Friedrich Sustris: Patronage in Late Renaissance Bavaria. Farnham, UK: Ashgate, 2011.

Mayor, Adrienne. The First Fossil Hunters: Paleontology in Greek and Roman Times. Princeton, NJ: Princeton University Press, 2000.

McConica, James K. "The Riddle of 'Terminus.'" Erasmus in English 2 (1971): 2–7.

McLean, Matthew. The 'Cosmographia' of Sebastian Münster: Describing the World in the Reformation. Aldershot, UK: Ashgate, 2007.

Meerhof, Kees, and Hans Oranje. "Bonaventura Vulcanius als 'netwerker' in de woedende baren van zijn tijd." Neolatinisten Nieuwsbrief 23 (2010): 25–34.

Meganck, Tine Luk. Erudite Eyes: Friendship, Art and Erudition in the Network of Abraham Ortelius (1527–1598). Leiden: Brill, 2017.

———. Pieter Bruegel the Elder: 'The Fall of the Rebel Angels': Art, Knowledge, and Politics on the Eve of the Dutch Revolt. Brussels: Royal Museum of Fine Arts of Belgium, 2014.

Melion, Walter S. "Prodigies of Nature, Wonders of the Hand: Political Portents and Divine Artifice in Haarlem ca. 1600." In The Anthropomorphic Lens: Anthropomorphism, Microcosmism, and Analogy in Early Modern Thought and Visual Arts, edited by Walter S. Melion, Bret Rothstein, and Michel Weemans, 277–322. Leiden: Brill, 2015.

———. Shaping the Netherlandish Canon: Karel van Mander's "Schilder-Boeck." Chicago: University of Chicago Press, 1991.

Melissus, Paul. Melissi schediasmatum poeticorum pars altera. Paris: apud Arnoldum Sittartum, 1586.

Menestrier, P.C.F. Devises des princes, cavaliers, dames, scavans, et aures personnages illustres de l'Europe, ou la philosophie des images. Paris: chez Robert J. B. de la Caille, 1683.

Meurer, Peter H. Fontes cartographici Orteliani: Das "Theatrum orbis terrarum" von Abraham Ortelius und seine Kartenquellen. Weinheim: VCH, 1991.

Michalsky, Tanja. Projektion und Imagination: Die niederländischer Landschaft der Frühen Neuzeit im Diskurs von Geographie und Malerei. Munich: Wilhelm Fink, 2011.

Mielke, Hans. Pieter Bruegel: Die Zeichnungen. Turnhout: Brepols, 1996.

Mielke, Ursula, and Ger Luijten, eds. Frans Hogenberg: Broadsheets. The New Hollstein: Dutch & Flemish Etchings, Engravings and Woodcuts, 1450–1700. 2 vols. Rotterdam: Sound & Vision Interactive, 2009.

———. Remigius and Frans Hogenberg. The New Hollstein: Dutch & Flemish Etchings, Engravings and Woodcuts, 1450–1700. Rotterdam: Sound & Vision Interactive, 2009.

Minges, Klaus. Das Sammlungswesen der frühen Neuzeit: Kriterien der Ordnung und Spezialisierung. Münster: Lit Verlag, 1998.

Mitchell, W.J.T. Image Science: Iconology, Visual Culture, and Media Aesthetics. Chicago: University of Chicago Press, 2015.

Moffett, Thomas. Insectorum sive minimorum animalium theatrum. London: ex officina typographica Thom. Cotes, 1634.

———. The Theater of Insects or Lesser Living Creatures. London: printed by E. Cotes, 1658.

Monballieu, A. "Joris Hoefnagel bij Obertus Gyfanius te Orleans en te Bourges (1560–62)." Jaarboek van het Koninklijk Museum voor Schone Kunsten Antwerpen (1980): 99–112.

More, Thomas. Latin Poems. In The Complete Works of St. Thomas More, edited by Clarence H. Miller, 3:2. New Haven, CT: Yale University Press, 1984.

Morello, Nicoletta. "The Question on the Nature of Fossils in the 16th and 17th Centuries / La questione della natura dei fossili nel Cinquecento e Seicento." In Four Centuries of World Geology: Ulisse Aldrovandi 1603 in Bologna, edited by Gian Battista Vai and William Cavazza, 127–51. Bologna: Minerva Edizioni, 2003.

Morford, Mark. "The Stoic Garden." Journal of Garden History 7.2 (1987): 151–75.

———. *Stoics and Neostoics: Rubens and the Circle of Lipsius.* Princeton, NJ: Princeton University Press, 1991.

Moritz, Arne, ed. *Ars imitator naturam: Transformationen eine Paradigmas menschlicher Kreativität im Übergang vom Mittelalter zur Neuzeit.* Münster: Aschendorff Verlag, 2010.

Moss, Ann. *Latin Commentaries on Ovid from the Renaissance.* Signal Mountain, TN: Summertown Texts, 1998.

———. *Printed Commonplace-Books and the Structuring of Renaissance Thought.* Oxford: Clarendon Press, 1996.

Mout, M.E.H.N., et al. *Willem van Oranje: om vrijheid van geweten.* Amsterdam: Rijksmuseum, 1984.

Mout, Nicolette. *Bohemen en de Nederlanden in de zestiende eeuw.* Leiden: Universitaire Pers, 1975.

———. "Political and Religious Ideas of Netherlanders at the Court of Prague." *Acta historiae Neerlandicae* 9 (1976): 1–29.

Moxey, Keith. *Pieter Aertsen, Joachim Beuckelaer, and the Rise of Secular Painting in the Context of the Reformation.* New York: Garland Publishing, 1977.

Müller, Johannes. *Exile Memories and the Dutch Revolt: The Narrated Diaspora, 1550–1750.* Leiden: Brill, 2016.

Müller, Jürgen, and Bertram Kaschek. "'Diese gottheiten sind den gelehrten heilig'. Hermes und Athena als Leitfiguren nachreformatorischer Kunsttheorie." In *Die Masken der Schönheit: Hendrick Goltzius und das Kunstideal um 1600*, edited by Jürgen Müller, Petra Roettig, and Andreas Stolzenburg, 27–32. Hamburg: Hamburger Kunsthalle, 2002.

Müller, Karsten, and Regine Kränz. *Verführungskunst: Jan Massys 'Flora'.* Hamburg: Hamburg Kunsthalle, 2003.

Müller Hofstede, Justus. "Zur Interpretation von Pieter Bruegels Landschaft: Ästhetischer Landschaftsbegriff und Stoische Weltbetrachtung." In *Pieter Bruegel und seine Welt*, edited by Otto von Simson and Matthias Winner, 73–142. Berlin: Gebr. Mann Verlag, 1979.

Münster, Sebastian. *Cosmographiae universalis lib. VI, in quibus, iuxta certioris fidei scriptorum traditionem describuntur, omnium habitabilis orbis partiuum situs, propriaeque dotes.* Basel: apud Henrichum Petri, 1550.

Murray, Penelope, ed. *Genius: The History of an Idea.* Oxford: Basil Blackwell, 1989.

Musvik, Victoria. "Word and Image: Alciato's *Emblemata* as Dietrich Georg Von Brandt's *album amicorum*." *Emblematica* 12 (2002): 141–63.

Nalis, Henk, and Peter Fuhring, eds. *The Van Doetecum Family.* The New Hollstein: Dutch & Flemish Etchings, Engravings and Woodcuts, 1450–1700. Rotterdam: Sound & Vision Interactive, 1997.

Nelles, Paul. "Reading and Memory in the Universal Library: Conrad Gessner and the Renaissance Book." In *Ars reminiscendi: Mind and Memory in Renaissance Culture*, edited by Donald Beecher and Grant Williams, 147–69. Toronto: Center for Reformation and Renaissance Studies, 2009.

Neri, Janice. *The Insect and the Image: Visualizing Nature in Early Modern Europe, 1500–1700.* Minneapolis: University of Minnesota Press, 2011.

Nevison J. L. "Emanuel van Meteren, 1535–1612." *Proceedings of the Huguenot Society of London* 19.4 (1956): 128–35.

Nickson, M.A.E. *Early Autograph Albums in the British Museum.* London: British Museum, 1970.

Van Nierop, Henk. "And Ye Shall Hear of Wars and Rumours of Wars: Rumour and the Revolt of the Netherlands." In *Public Opinion and Changing Identities in the Early Modern Netherlands*, edited by Judith Pollmann and Andrew Spicer, 69–86. Leiden: Brill, 2007.

———. "A Beggars' Banquet: The Compromise of the Nobility and the Politics of Inversion." *European History Quarterly* 21 (1991): 419–43.

Nissen, Claus. *Die Zoologische Buchillustration: ihre Bibliographie und Geschichte.* Vol. 10.2. Stuttgart: Anton Hiersemann, 1972.

Nitzsche, Jane Chance. *The Genius Figure in Antiquity and the Middle Ages.* New York: Columbia University Press, 1975.

De Nolhac, Pierre. *Un poète Rhénan ami de la Pléiade: Paul Melissus.* Paris: Librairie Ancienne Honoré Champion, 1923.

Nora, Pierre. *Les lieux de mémoire.* 3 vols. Paris: Gallimard, 1984–92.

Norberg-Schulz, Christian. *Genius loci: Towards a Phenomenology of Architecture.* New York: Rizzoli, 1980.

Nuti, Lucia. "The Mapped Views by Georg Hoefnagel: The Merchant's Eye, the Humanist's Eye." *Word & Image* 4 (1988): 545–70.

———. "The World Map as Emblem: Abraham Ortelius and the Stoic Contemplation." *Imago Mundi* 55 (2003): 38–55.

O'Brien, Denis. *Empedocles' Cosmic Cycle: A Reconstruction from the Fragments and Secondary Sources.* Cambridge: Cambridge University Press, 1969.

Occo, Adolphus. *Imperatorum Romanorum numismata a Pompeio Magno ad Heraclium.* Antwerp: ex officina Christophori Plantini, 1579.

Oestreich, Gerhard. *Neostoicism and the Early Modern State.* Edited by Brigitta Oestreich and H. G. Koenigsberger. Translated by David McLintock. Cambridge: Cambridge University Press, 1982.

Ogilvie, Brian W. "Nature's Bible: Insects in Seventeenth-Century European Art and Science." *Tidsskrift for kulturforskning* 7.3 (2008): 5–21.

———. *The Science of Describing: Natural History in Renaissance Europe.* Chicago: University of Chicago Press, 2006.

Van Ommen, Kasper, ed. *The Exotic World of Carolus Clusius, 1526–1609: Catalogue of an Exhibition on the Quatercentenary of Clusius' Death.* Leiden: Leiden University Library, 2009.

Orenstein, Nadine. *Pieter Bruegel the Elder: Drawings and Prints.* New York: Metropolitan Museum of Art, 2001.

Orenstein, Nadine, and Manfred Sellink, eds. *Pieter Bruegel the Elder.* The New Hollstein Dutch & Flemish Etching, Engravings and Woodcuts, 1450–1700. Ouderkerk aan den Ijssel: Sound & Vision Interactive, 2006.

Ortelius, Abraham. *Abrahami Ortelii (geographi Antverpiensis) et virorum eruditorum ad eundem et ad Jacobum Colium Ortelianum (Abrahami Ortelii sororis filium) Epistulae.* Edited by Joannes Henricus Hessels. Osnabrück: Otto Zeller, 1967 (reprint of 1887 edition).

———. *Album amicorum Abraham Ortelius.* Edited by Jean Puraye. Amsterdam: A. L. van Gendt & Co, 1969.

———. *Aurei saeculi imago, sive Germanorum veterum.* Antwerp: apud Philippum Galleaum, 1596.

———. *Deorum dearumque capita, ex vetustis numismatibus in gratiam antiquitatis studiosorum effigiata et edita.* Antwerp: Philippus Gallaeus excudebat, 1573.

———. *Theatrum orbis terrarum.* Antwerp: apud Aegidium Coppenium Diesth, 1570.

———. *Thesaurus geographicus.* Antwerp: ex officina Christophori Plantini, 1587.

Ortelius, Abraham, and Johannes Vivianus. *Itinerarium per nonnullas Galliae Belgicae partes.* Antwerp: Ex officina Christophori Plantini, 1584.

Ovid. *Tristia. Ex ponto.* Translated by A. L. Wheeler. Revised by G. P. Goold. Cambridge, MA: Harvard University Press, 1996.

Palingenius Stellatus, Marcellus. *The Zodiake of Life.* Translated by Barnabe Googe. London: for Raufe Newberie, 1576.

———. *La zodiaque de la vie (Zodiacus vitae), XII livres.* Geneva: Librairie Droz, 1996.

Panofsky, Erwin. "Artist, Scientist, Genius: Notes on the 'Renaissance-Dämmerung.'" In *The Renaissance: Six Essays by Wallace Ferguson and Others*, 121–82. New York: Harper Torchbooks, 1962.

———. "Erasmus and the Visual Arts." *Journal of the Warburg and Courtauld Institutes* 32 (1969): 200–277.

———. *Idea: A Concept in Art Theory*. Columbia: University of South Carolina Press, 1968.

Papenbrock, Martin. *Landschaften des Exils: Gillis van Coninxloo und die Frankenthaler Maler*. Cologne: Böhlau Verlag, 2001.

Papy, Jan. "Joachim Camerarius's *Symbolorum et emblematum centuriae quatuor*: From Natural Sciences to Moral Contemplation." In *Mundus emblematicus: Studies in Neo-Latin Emblem Books*, edited by K.A.E. Enenkel and A.S.Q. Visser, 201–34. Turnhout: Brepols, 2003.

Paradin, Claude. *Devises heroïques*. Lyons: Jean de Tournes and Guillaume Gazeau, 1557.

Park, Katharine, and Lorraine Daston. "Introduction: The Age of the New." In *The Cambridge History of Science*, vol. 3, *Early Modern Science*, edited by Katharine Park and Lorraine Daston, 1–17. Cambridge: Cambridge University Press, 2006.

Parker, Deborah. *Bronzino: Renaissance Painter as Poet*. Cambridge: Cambridge University Press, 2000.

Parker, Geoffrey. *The Dutch Revolt*. London: Penguin, 2002.

Parshall, Peter. "Graphic Knowledge: Albrecht Dürer and the Imagination." *Art Bulletin* 95.3 (2013): 393–410.

———. "Imago contrafacta: Images and Facts in the Northern Renaissance." *Art History* 16.4 (1993): 554–79.

———. "Portrait Prints and Codes of Identity in the Renaissance: Hendrik Goltzius, Justus Lipsius, and Michel de Montaigne." *Word & Image* 19 (2003): 22–37.

———. "The Print Collection of Ferdinand, Archduke of Tyrol." *Jahrbuch der Kunsthistorischen Sammlungen in Wien* 78 (1982): 139–84.

Pérez, Antonio Dávila. "New Documents on Benito Arias Montano (ca 1525–1598) and Politics in the Netherlands." In *Between Scylla and Charybdis: Learned Letter Writers Navigating the Reefs of Religious and Political Controversy in Early Modern Europe*, edited by Jeanine de Landtsheer and Henk Nellen, 233–62. Leiden: Brill, 2011.

Pérez, Yolanda Rodríquez. *The Dutch Revolt through Spanish Eyes: Self and Other in Historical and Literary Texts of Golden Age Spain (c. 1548–1673)*. Bern: Peter Lang, 2008.

Peters, John Durham. *The Marvelous Clouds: Toward a Philosophy of Elemental Media*. Chicago: University of Chicago Press, 2015.

Pettegree, Andrew. "Religion and the Revolt." In *The Origins and Development of the Dutch Revolt*, edited by Graham Darby, 66–83. London: Routledge, 2001.

Pfisterer, Ulrich. *Donatello und die Entdeckung der Stile, 1430–1445*. Munich: Hirmer Verlag, 2002.

Pico della Mirandola, Giovanni Francesco. "On Imitation." In *Ciceronian Controversies*, edited by JoAnn DellaNeva, 16–43. Cambridge, MA: Harvard University Press, 2007.

———. *Oration on the Dignity of Man*. Edited and translated by Francesco Borghesi, Michael Papio, and Massimo Riva. Cambridge: Cambridge University Press, 2012.

Pipkin, Amanda C. *Rape in the Republic, 1609–1725: Formulating Dutch Identity*. Leiden: Brill, 2013.

Plantin, Christopher. *Thesaurus Theutonicae linguae. Schat der Neder-duytscher spraken*. Antwerp: ex officina Christophori Plantini, 1573.

Pleij, Herman. *Dreaming of Cockaigne: Medieval Fantasies of the Perfect Life*. Translated by Diane Webb. New York: Columbia University Press, 2001.

Plessis-Mornay, Philippe du. *Tractaet ofte handelinge van de Kercke: daer in gheleerdelick ende treffelick ghedisputeert wordt op alle de bysonderste questien die in onse tijden hebben opgheworpen gheweest*. Translated by Lucas de Heere. Antwerp: by Jaspar Troyens, 1580.

Pliny the Elder. *Natural History, Volume III: Books 8–11*. Translated by H. Rackham. Loeb Classical Library. Cambridge MA: Harvard University Press, 1940.

Pollard, John Graham. *Renaissance Medals*. Vol. 2, *France, Germany, the Netherlands, and England*. Princeton, NJ: Princeton University Press, 2007.

Polleichtner, Wolfgang. "The Bee Simile: How Vergil Emulated Apollonius in His Use of Homeric Poetry." *Göttinger Forum für Altertumswissenschaft* 8 (2005): 115–60.

Pollmann, Judith. *Religious Choice in the Dutch Republic: The Reformation of Arnoldus Buchelius (1565–1641)*. Manchester: Manchester University Press, 1999.

Poole, William. *The World Makers: Scientists of the Restoration and the Search for the Origins of the Earth*. Oxford: Peter Lang, 2010.

Popham A. E. "Georg Hoefnagel and the Civitates Orbis Terrarum." *Maso Finiguerra* 1 (1936): 183–201.

———. "On a Letter of Joris Hoefnagel." *Oud Holland* 53 (1936): 145–51.

Porter, Roy. *The Making of Geology: Earth Science in Britain 1660–1815*. Cambridge: Cambridge University Press, 1977.

Prögler, Daniela. *English Students at Leiden University, 1575–1650: 'Advancing your Abilities in Learning and Bettering your Understanding of the World and State Affairs'*. Farnham, UK: Ashgate, 2013.

Pseudo-Boethius, *De disciplina scolarium: édition critique, introduction et notes*. Edited by Olga Weijers. Leiden: Brill, 1976.

Van Putten, Jasper. "The City Book and the Emergence of the Artist-Chorographer."

In *Mapping Spaces: Networks of Knowledge in 17th-Century Landscape Painting*, edited by Ulrike Gehring and Peter Weibel, 164–81. Munich: Hirmer, 2014.

Quiccheberg, Samuel. *The First Treatise on Museums: Samuel Quiccheberg's Inscriptiones, 1565*. Edited and translated by Mark A. Meadow and Bruce Robertson. Los Angeles: The Getty Research Institute, 2013.

Rabelais, François. *Oeuvres complètes*. Edited by Mireille Huchon and François Moreau. Paris: Gallimard, 1994.

Raffles, Hugh. *Insectopedia*. New York: Vintage Books, 2010.

Rahlenbeck, Charles A. "Quelques notes sur les réformés flamands et wallons de 16e siècle refugiés en Angleterre." *Proceedings of the Huguenot Society of London* 4 (1891–93). 22–44.

De Ram, P.F.X., ed. *Caroli Clusii Atrebatis ad Thomam Redigerum et Joannem Cratonem epistolae*. Brussels: excudebat M. Hayez, 1847.

Ramakers, Bart. "Art and Artistry in Lucas de Heere." *Nederlands Kunsthistorisch Jaarboek* 59 (2009): 165–92.

Ramsay, George Daniel. *The Queen's Merchants and the Revolt of the Netherlands: The End of the Antwerp Mart, Part II*. London: Manchester University Press, 1986.

Reitsma, Ella. *Maria Sibylla Merian & Daughters: Women of Art and Science*. Zwolle: Waanders, 2008.

Reitz, Evelyn. *Discordia concors: Kulturelle Differenzerfahrung und ästhetische Einheitsbildung in der Prager Kunst um 1600*. Berlin: Walter de Gruyter, 2015.

Rekers, Ben. *Benito Arias Montano (1527–1598)*. London: Warburg Institute, 1972.

Rentiis, Dina de. "Der Beitrag der Bienen: Überlegungen zum Bienengleichnis bei Seneca und Macrobius." *Rheinisches Museum für Philologie* 141.1 (1998): 30–44.

Reusch, Fr. Heinrich. *Die Indices librorum prohibitorum des sechzehnten Jahrhunderts*. Tübingen: gedruckt für den Litterarischen Verein in Stuttgart, 1886.

Ribouillault, Denis. "Regurgitating Nature: On a Celebrated Anecdote by Karel van Mander about Pieter Bruegel the Elder." *Journal of Historians of Netherlandish Art* 8.1 (2016): https://jhna.org/wp-content/uploads/2017/08/JHNA_8.1_Ribouillault.pdf.

Richardson, Todd M. *Pieter Bruegel the Elder: Art Discourse in the Sixteenth-Century Netherlands*. Farnham, UK: Ashgate, 2011.

Rijks, Marlise. "Defenders of the Image: Painted Collectors' Cabinets and the Display of Display in Counter-Reformation Antwerp." *Nederlands Kunsthistorisch Jaarboek* 65 (2015): 54–83.

Rikken, Marrigje. "Abraham Ortelius as Intermediary for the Antwerp Animal

Trailblazers." *Jahrbuch für Europäische Wissenschaftskultur* 6 (2011): 95–128.

———. "Dieren verbeeld. Diervoorstellingen in tekeningen, prenten en schilderijen door kunstenaars uit de Zuidelijke Nederlanden tussen 1550 en 1630." Ph.D. diss., Leiden University, 2016.

———. "A Spanish Album of Drawings of Animals in a South-Netherlandish Context: A Reattribution to Lambert Lombard." *Rijksmuseum Bulletin* 62 (2014): 106–23.

Ritterbush, Philip C. "Art and Science as Influences on the Early Development of Natural History Collections." *Proceedings of the Biological Society of Washington* 82 (1969): 561–78.

Robey, Jessica Chiswick. "From the City Witnessed to the Community Dreamed: The *Civitates orbis terrarum* and the Circle of Abraham Ortelius and Joris Hoefnagel." Ph.D. diss., University of California, Santa Barbara, 2006.

Robison, Jon. "The Slippery Truth of George Buchanan's Autobiography." *Sixteenth Century Journal* 39.1 (2008): 71–87.

Rogers, Daniel. *De laudibus Antverpiae, oda sapphica*. Antwerp: Ex officina Christophori Plantini, 1565.

Rogge, H. C. "Het album van Emanuel van Meteren." *Oud Holland* 15 (1897): 159–92.

Rolet, Anne. *Les questions symboliques d'Achille Bocchi: symbolicae quaestiones, 1555.* 2 vols. Tours: Presses universitaires François-Rabelais, 2015.

Rolet, Anne, and Stéphane Rolet. *André Alciat (1492–1550): un humaniste au confluent des saviors dans l'Europe de la Renaissance.* Turnhout: Brepols, 2013.

Rollenhagen, Gabriel. *Nucleus emblematum selectissimorum, quae Itali vulgo impresas vocant privata industria studio singulari, undique conquisitus.* Cologne: e Musaeo coelatorio Crispiani Passaei, 1611.

Van Roosbroeck R. *Patientia: 24 politieke emblemata door Joris Hoefnagel.* Antwerp: De Sikkel, 1935.

Roose, Lode. *Religieuze poëzie van Cornelis Crul.* Zwolle: W.E.J. Tjeenk Willink, 1954.

Rosenheim, Max. "The *album amicorum*." *Archaeologia or, Miscellaneous Tracts Relating to Antiquity* 62 (1910): 251–308.

Rosenthal, Earl. "The Invention of the Columnar Device of Emperor Charles V and the Court of Burgundy in Flanders in 1516." *Journal of the Warburg and Courtauld Institutes* 36 (1973): 198–230.

———. "Plus Ultra, Non Plus Ultra, and the Columnar Device of Emperor Charles V." *Journal of the Warburg and Courtauld Institutes* 34 (1971): 204–28.

Rossi, Paolo. "Ants, Spiders, Epistemologists." In *Francis Bacon: terminologia e fortuna nel XVII secolo, seminario internationale Roma, 11–13 marzo 1984*, edited by Marta Fattori, 245–60. Rome: Edizioni dell'Ateneo, 1984.

———. *The Dark Abyss of Time: The History of the Earth and the History of Nations from Hooke to Vico.* Translated by Lydia G. Cochrane. Chicago: University of Chicago Press, 1984.

Rowlands, John. "Terminus, the Device of Erasmus of Rotterdam: A Painting by Holbein." *Bulletin of the Cleveland Museum of Art* 67.2 (1980): 50–54.

Rudwick, Martin J. *The Meaning of Fossils: Episodes in the History of Palaeontology.* Chicago: University of Chicago Press, 1985.

Ruestow, Edward G. *The Microscope in the Dutch Republic: The Shaping of Discovery.* Cambridge: Cambridge University Press, 1996.

Russell, Daniel. *Emblematic Structures in Renaissance French Culture.* Toronto: University of Toronto Press, 1995.

Salutati, Coluccio. *Epistolario di Coluccio Salutati.* Edited by Francesco Novati. 4 vols. Rome: Fonti per la storia d'Italia, 1891–1911.

Sambucus, Johannes. *Die Briefe des Johannes Sambucus (Zsámboky), 1554–1584.* Edited by Hans Gerstinger. Vienna: Österreichische Akademie der Wissenschaften, 1968.

———. *Emblemata, cum aliquot nummis antiqui operis.* Antwerp: ex officina Christophori Plantini, 1564.

Sandys, John Edwin. *Latin Epigraphy: An Introduction to the Study of Latin Inscriptions.* Cambridge: Cambridge University Press, 1927.

Santmire, H. Paul, and John B. Cobb Jr. "The World of Nature according to the Protestant Tradition." In *The Oxford Handbook of Religion and Ecology*, edited by Roger S. Gottlieb, 115–46. Oxford: Oxford University Press, 2006.

Saunders, Jason Lewis. *Justus Lipsius: The Philosophy of Renaissance Stoicism.* New York: Liberal Arts Press, 1955.

Sawyer, Andrew. "The Tyranny of Alva: The Creation and Development of a Dutch Patriotic Image." *De zeventiende eeuw* 19 (2003): 181–211.

Schapiro, Meyer. "The Still Life as a Personal Object—A Note on Heidegger and van Gogh." In *The Reach of Mind: Essays in Memory of Kurt Goldstein*, edited by Marianne L. Simmel, 134–42. New York: Springer Publishing, 1968.

Scheerder, J. *De Beeldenstorm.* Bussum: De Haan, 1974.

Scheller, Robert W. "Joris Hoefnagel: twee zelf-portreten." In *"Gij zult niet feestbundelen": 34 bijdragen voor Peter Hecht*, edited by Jonathan Bikker et al., 177–82. Zwolle: Uitgeverij Waanders, 2016.

Schilling, Heinz. *Niederländische Exulanten im 16. Jahrhundert: Ihre Stellung im Sozialgefüge und im religiösen Leben deutscher und englischer Städte.* Gütersloh: Gerd Mohn, 1972.

Schlosser, Julius. "Two Portrait Miniatures from Castle Ambras." *Burlington Magazine for Connisseurs* 41 (1922): 194–98.

Schlueter, June. *The Album Amicorum and the London of Shakespeare's Time.* London: British Library, 2011.

Schlugleit, Dora. "Alphabetische naamlijst op de goud- en zilversmeden te Antwerpen voor 1600." *Bijdragen tot de geschiedenis* 27 (1936): 6–69.

Schmidt, Benjamin. *Innocence Abroad: The Dutch Imagination and the New World, 1570–1670.* Cambridge: Cambridge University Press, 2001.

Schmitt, Annegrit. *Der Meister der Tiermusterbuchs von Weimar.* Munich: Biering & Brinkmann, 1997.

Schmitt, Charles B. *Aristotle and the Renaissance.* Cambridge, MA: Harvard University Press, 1983.

Schnabel, Werner Wilhelm. *Das Stammbuch: Konstitution und Geschichte einer textsortenbezogenen Sammelform bis ins erste Drittel des 18. Jahrhunderts.* Tübingen: M. Niemeyer, 2003.

Schoch, Rainer, Matthias Mende, and Anna Scherbaum. *Albrecht Dürer: Das druckgraphische Werk.* Vol. 1. Munich: Prestel, 2001.

Schouteet, Albert. *Marcus Gerards: The 16th Century Painter and Engraver.* Bruges: Brugge-Zeebrugge Port Authorities, 1985.

Seelig, Gero, et al. *Medusa's Menagerie: Otto Marseus van Schrieck and the Scholars.* Schwerin: Staatliches Museum, 2017.

Seifertová, Hana. *Malby na kameni: umělecký experiment v 16. a na začátku 17. století / Painting on Stone: An Artistic Experiment in the 16th and early 17th Centuries.* Prague: Národní Galerie, 2007.

Seipel, Wilfried, ed. *Kaiser Ferdinand I. 1503–1564: das Werden der Habsburgermonarchie.* Vienna: Kunsthistorisches Museum, 2003.

Sellink, Manfred. *Bruegel: The Complete Paintings, Drawings and Prints.* Ghent: Ludion, 2007.

———. *Cornelis Cort.* Edited by Huigen Leeflang. The New Hollstein: Dutch & Flemish Etchings, Engravings and Woodcuts, 1450–1700. 3 vols. Rotterdam: Sound & Vision Interactive, 2000.

———. *Cornelis Cort: constich plaedt-snijder van Horne in Holland / Accomplished Plate-Cutter from Hoorn in Holland.* Rotterdam: Museum Boijmans van Beuningen, 1994.

Serebrennikov, Nina Eugenia. "Imitating Nature/ Imitating Bruegel." *Nederlands Kunsthistorisch Jaarboek* 47 (1996): 223–46.

Serjeantson, Richard. "Francis Bacon and the 'Interpretation of Nature' in the Late Renaissance." *Isis* 105 (2014): 681–705.

Siegert, Bernhard. *Cultural Techniques: Grids, Filters, Doors, and Other Articulations of the*

Real. New York: Fordham University Press, 2015.

Silcox, Mary V. "*Ornament of the Civill Life*: The Device in Puttenham's *The Arte of English Poesie*." In *Aspects of Renaissance and Baroque Symbol Theory, 1500–1700*. Edited by Peter M. Daly and John Manning, 39–49. New York: AMS Press, 1999.

Silver, Larry. *Peasant Scenes and Landscapes: The Rise of Pictorial Genres in the Antwerp Art Market*. Philadelphia: University of Pennsylvania Press, 2006.

Silverblatt, Irene. "The Black Legend and Global Conspiracies: Spain, the Inquisition, and the Emerging Modern World." In *Rereading the Black Legend: The Discourses of Religious and Racial Difference in the Renaissance Empires*, edited by Margaret R. Greer, Walter D. Mignolo, and Maureen Quilligan, 99–116. Chicago: University of Chicago Press, 2007.

Skelton, R. A. *Civitates orbis terrarum. 1572–1618*. 3 vols. Cleveland: World Publishing Co., 1965.

———. "Introduction." In *Civitates orbis terrarum. 1572–1618*, edited by R. A. Skelton, 1:vii–xxi. Cleveland: World Publishing Co., 1965.

Skulsky, Harold. *Metamorphosis: The Mind in Exile*. Cambridge, MA: Harvard University Press, 1981.

Slavin, Arthur J. "Daniel Rogers in Copenhagen, 1588: Mission and Memory." In *Politics, Religion, and Diplomacy in Early Modern Europe: Essays in Honor of De Lamar Jensen*, edited by Malcolm R. Thorp and Arthur J. Slavin, 245–66. Kirksville, MO: Sixteenth Century Journal Publishers, 1994.

Smith, Jamie L. "*Als ich can*: How Jan van Eyck Extended the Vernacular from Dutch Poetry to Oil Painting." In *The Transformation of Vernacular Expression in Early Modern Arts*, edited by Todd M. Richardson and Joost M. Keizer, 273–312. Leiden: Brill, 2011.

Smith, Pamela H. *The Body of the Artisan: Art and Experience in the Scientific Revolution*. Chicago: University of Chicago Press, 2004.

Smith, Paul J. "Joachim Camerarius's Emblem Book on Birds (1596), with an Excursus on America's Great Seal." In *Emblems and the Natural World*, edited by Karl A. E. Enenkel and Paul J. Smith, 149–83. Leiden: Brill, 2017.

———. *Het schouwtoneel der dieren: embleemfabels in de Nederlanden (1567–ca. 1670)*. Hilversum: Uitgeverij Verloren, 2006.

Smits-Veldt, Mieke B. "Susanna Hoefnagel, de moeder van Constantijn Huygens (1561–1633)." In *Vrouwen rondom Huygens*, edited by Els Kloek, Frans Blom, and Ad Leerintveld. *De Zeventiende Eeuw* 25 (2009): 13–24.

Smolderen, Luc. *Jacques Jonghelinck: sculpteur, médailleur et graveur de sceaux (1530–1606)*.

Louvain-la-Neuve: Publications d'histoire de l'art et d'archéologie de l'Université Catholique de Louvain, 1996.

Snyder, Jon R. *Dissimulation and the Culture of Secrecy in Early Modern Europe*. Berkeley: University of California Press, 2009.

Soen, Violet. "Más allá de la leyenda negra? Léon van der Essen y la historiografía reciente en torno al castigo de las ciudades rebeldes en los Países Bajos (siglos XIV a XVI)." In *El Ejército Español en Flandes 1567–1584*, edited by Léon van der Essen et al., 45–72. Yuste: Fundación Academia Europea de Yuste, 2008.

Soly, Hugo. "De bouw van de Antwerpse citadel (1567–1571): sociaal-economische aspecten." *Belgisch Tijdschrift voor Militaire Geschiedenis* 21 (1976): 549–78.

———. "L'urbanisation d'Anvers au XVIe siècle." *Revue du Nord* 63 (1981): 391–413.

Spadafora, Mirella. *Habent sua fata libelli: gli alba amicorum e il loro straordinario corredo iconografico (1545–1630 c.)*. Bologna: CLUEB, 2009.

Spary, Emma C. "Scientific Symmetries." *History of Science* 62 (2004): 1–46.

Spicer, Andrew. "Medium and Message: Political Prints in the Dutch Republic, 1568–1632." In *Public Opinion and Changing Identities in the Early Modern Netherlands*, edited by Judith Pollmann and Andrew Spicer, 163–87. Leiden: Brill, 2007.

Spicer, Joaneath. "Referencing Invention and Novelty in Art and Science at the Court of Rudolf II in Prague." In *'Novità'. Neuheitskonzepte in den Bildkünsten um 1600*, edited by Ulrich Pfisterer and Gabriele Wimböck, 410–24. Zurich: Diaphanes, 2011.

Spohnholz, Jesse. "Confessional Coexistence in the Early Modern Low Countries." In *A Companion to Multiconfessionalism in the Early Modern World*, edited by Thomas Max Safley, 47–73. Leiden: Brill, 2011.

Sprengius, Johannes. *Metamorphoses Ovidii, argumentis quidem soluta oratione, enarrationibus autem et allegoriis elegiaco versu accuratissime expositae*. Frankfurt: apud Georgium Corvinum, Sigismundum Feyerabent, & haeredes Wygandi Galli, 1563.

Stagl, Justin. *A History of Curiosity: The Theory of Travel, 1550–1800*. Chur, Switzerland: Harwood Academic Publishers, 1995.

Stewart, Susan. *On Longing: Narratives of the Miniature, the Gigantic, the Souvenir, the Collection*. Durham, NC: Duke University Press, 1993.

Stockelius, Anselmus. *Narcissus philautiae typus*. Munich: excudebat Adamus Berg., 1575.

Stumpel, Jeroen. "The Foul Fowler Found Out: On a Key Motif in Dürer's 'Four Witches.'" *Simiolus* 30.3/4 (2003): 143–60.

———. "De schaduw van de kever: Joris Hoefnagel, 1542–ca. 1600." *Kunstschrift* 1 (2008): 18–27.

Summers, David. *The Judgment of Sense: Renaissance Naturalism and the Rise of Aesthetics*. Cambridge: Cambridge University Press, 1987.

Swammerdam, Jan. *Historia insectorum generalis, ofte algemeene verhandeling van de bloedeloose dierkens*. Utrecht: Meinardus van Dreunen, 1669.

Swan, Claudia. "*Ad vivum, naer het leven*, From the Life: Defining a Mode of Representation." *Word & Image* 11.4 (1995): 353–72.

———. *Art, Science, and Witchcraft in Early Modern Holland: Jacques de Gheyn II (1565–1629)*. Cambridge: Cambridge University Press, 2005.

Swart, K. W. "The Black Legend during the Eighty Years War." In *Britain and the Netherlands*, vol. 5, *Some Political Mythologies*, edited by J. S. Bromley and E. H. Kossmann, 36–57. Dordrecht: Springer Netherlands, 1975.

———. *William of Orange and the Revolt of the Netherlands, 1572–84*. Introduction by Alastair Duke and Jonathan I. Israel. Edited by R. P. Fagel et al. Translated by J. C. Grayson. Aldershot, UK: Ashgate, 2003.

Tamen, Miguel. *Friends of Interpretable Objects*. Cambridge, MA: Harvard University Press, 2001.

Tanis, James. "Joris Hoefnagel and the Revolt of the Netherlands." In *Images of Discord: A Graphic Interpretation of the Opening Decades of the Eighty Years' War*, edited by James Tanis and Daniel Horst, 10–23. Bryn Mawr, PA: Bryn Mawr College Library, 1993.

Tassy, Pascal. *The Message of Fossils*. Translated by Nicholas Hartmann. New York: McGraw-Hill, Inc., 1993.

Taussig, Michael T. *Mimesis and Alterity: A Particular History of the Senses*. New York: Routledge, 1993.

Taylor, Paul. "Karel van Mander. *The Lives of the Illustrious Netherlandish and German Painters*." *Oud Holland* 115 (2001–2): 131–54.

Thomassen, Kees, et al. *Alba amicorum: vijf eeuwen vriendschap op papier gezet: het album amicorum en het poëziealbum in de Nederlanden*. The Hague: Rijksmuseum Meermanno-Westreenianum, 1990.

———. *In vriendschap verbonden: het liber amicorum of vriendenboekje in de 16e en de 17e eeuw in de Nederlanden*. Antwerp: Rockoxhuis, 2013.

Thoss, Dagmar. "Georg Hoefnagel und seine Beziehungen zur Gent-Brügger Buchmalerei." *Jahrbuch der Kunsthistorischen Sammlungen in Wien* 82/83 (1986–87): 199–211.

Tournoy, Gilbert. "Latin Inscriptions by Justus Lipsius in *alba amicorum*." In *Acta Conventus Neo-Latini Monasteriensis: Proceedings of the Fifteenth International Conference of Neo-Latin Studies*, edited by Astrid Steiner-Weber and Karl A. E. Enenkel, 563–71. Leiden: Brill, 2015.

Town, Edward. "A Fête at Bermondsey: An English Landscape by Marcus Gheeraerts the Elder." *Burlington Magazine* 157 (2015): 309–17.

Tschetschik, Ksenija. "Monogramme Albrecht Dürers auf den Zeichnungen des Nürnberger Künstler Hans Hoffmann: Fälschung oder Täuschung?" In *Fälschung—Plagiat—Kopie: Künstlerische Praktiken in der Vormoderne*, edited by Birgit Ulrike Münch et al., 40–51. Petersberg: Michael Imhof Verlag, 2014.

De Tuy, Lucas. *Lucae Tudensis de altera vita*. Edited by Emma Falque Rey. Corpus Christianorum. Turnhout: Brepols, 2009.

Uppenkamp, Barbara. "The Influence of Hans Vredeman de Vries on the Cityscape Constructed like a Picture." In *Hans Vredeman de Vries and the Artes Mechanicae Revisited*, edited by Piet Lombaerde, 117–28. Turnhout: Brepols, 2005.

Uppenkamp, Bettina, ed. *Erstarrte Lebendigkeit. Ernst Kris: Zwei Untersuchungen*. Zurich: Diaphanes, 2012.

Vaernewijck, Marcus van. *Van die beroerlicke tijden in die Nederlanden en voornamelick in Ghendt 1566–1568*, edited by Ferd. Vanderhaeghen. 5 vols. Ghent: C. Annoot-Braeckman, 1872–81.

Valeriano, Piero. *Hieroglyphica sive de sacris Aegyptiorum literis commentarii*. Basel: Michael Isengrin, 1556.

Vallini, Cristina. "*Genius/ingenium*: derive semantiche." In *Ingenium propria hominis natura: atti del convegno internazionale di studi (Napoli, 22–24 maggio 1997)*, edited by Stefano Gensini and Arturo Martone, 3–26. Naples: Liguori, 2002.

Vandenbroeck, Paul. "Bubo significans: Die Eule als Sinnbild von Schlechtigkeit und Torheit, vor allem in der niederländischen und deutschen Bilddarstellung und bei Jheronimus Bosch I." *Jaarboek Koninklijk Museum voor Schone Kunsten* (1985): 19–135.

———. "Over Jheronimus Bosch, met een toelichting bij de tekst op tekening KdZ 549 in het Berlijnse Kupferstichkabinett." *Archivum artis Lovaniense: bijdragen tot de geschiedenis van de kunst der Nederlanden* (1981): 151–88.

Vanhaelen Angela. *The Wake of Iconoclasm: Painting the Church in the Dutch Republic*. University Park: Pennsylvania State University Press: 2012.

Vasari, Giorgio. *Le vite de' più eccellenti pittori, scultori ed architettori*. Edited by Gaetano Milanesi. 9 vols. Florence: G. C. Sansoni, 1878–85.

Verduyn, Wouter Dirk. *Emanuel van Meteren: bijdrage tot de kennis van zijn leven, zijn tijd en het onstaan van zijn geschiedwerk*. The Hague: Martinus Nijhoff, 1926.

Vergara, Alejandro. *Patinir: Essays and Critical Catalogue*. Madrid: Museo Nacional del Prado, 2007.

Verhaak, Els. "'Emblemata nobilitati et vulgo scitu digna'. Een embleemboek uit 1592 als album amicorum van Jean le Seur." *Bulletin van het Rijksmuseum* 49.2/3 (2001): 140–51.

Verhoeven, Gerrit. *Europe within Reach: Netherlandish Travellers on the Grand Tour and Beyond (1585–1750)*. Leiden: Brill, 2015.

Vérin, Hélène. *La gloire des ingenieurs: l'intelligence technique du XVIe au XVIIIe siècle*. Paris: Albin Michel, 1993.

Verwey, Herman de la Fontaine. "The Family of Love: Radical Spiritualism in the Low Countries." *Quaerendo* 6 (1976): 219–71.

Vignau-Schuurman, T.A.G.W. *Die emblematischen Elemente im Werke Joris Hoefnagels*. 2 vols. Leiden: Universitaire Pers, 1969.

Vignau-Wilberg, Thea. *Archetypa studiaque patris Georgii Hoefnagelii, 1592: Natur, Dichtung und Wissenschaft in der Kunst um 1600*. Munich: Staatliche Graphische Sammlung, 1994.

———. "Dichter, Denker, Diplomaten: Daniel Rogers' Ode auf Frankenthal aus dem Jahr 1578." In *Kunst, Kommerz, Glaubenskampf: Frankenthal um 1600*, edited by Edgar J. Hürkey, 48–52. Worms: Wernersche Verlagsgesellschaft, 1995.

———. "Freundschaft für die Ewigkeit: Joris Hoefnagels unbekannte Miniatur für Johannes Radermacher." In *Libellus amicorum Beket Bukovinská*, edited by Lubomír Konečný and Lubomír Slavíček, 113–25. Prague: Artefactum, 2013.

———. *In Europa zu Hause: Niederländer in München um 1600 / Citizens of Europe: Dutch and Flemish Artists in Munich c. 1600*. Munich: Hirmer Verlag, 2006.

———. "*In minimis maxime conspicua*: Insektendarstellungen um 1600 und die Anfänge der Entomologie." In *Early Modern Zoology: The Construction of Animals in Science, Literature and the Visual Arts*, edited by Karl A. E. Enenkel and Paul J. Smith, 217–43. Leiden: Brill, 2007.

———. *Joris and Jacob Hoefnagel: Art and Science around 1600*. Berlin: Hatje Cantz Verlag, 2017.

———. "Joris Hoefnagel, the Illuminator." In *Mira Calligraphiae Monumenta: A Sixteenth-Century Calligraphic Manuscript Inscribed by Georg Bocskay and Illuminated by Joris Hoefnagel*, edited by Lee Hendrix and Thea Vignau-Wilberg, 15–28. Malibu, CA: J. Paul Getty Museum, 1992.

———. "Joris Hoefnagels Tätigkeit in München." *Jahrbuch der Kunsthistorischen Sammlungen in Wien* 81 (1985): 103–67.

———. "Nederlandse tekeningen uit de collectie van Hendrik van Limborch in de Staatliche Graphische Sammlung München: kunsthandel en diplomatie in achttiende-eeuws Den Haag, Mannheim en München." In *Kunst op papier in de achttiende eeuw: liber amicorum aangeboden aan Charles Dumas ter gelegenheid van zijn 65ste verjaardag*, edited by Edwin Buijsen and Mària van Berge-Gerbaud, 240–55. The Hague: RKD, 2014.

———. "Neues zu Jacob Hoefnagel." *Studia Rudolphina* 10 (2010): 196–211.

———. "Patientia: Humanistsche Überlegungsstrategie im. 16. Jahrhundert." In *Emblems from Alciato to the Tattoo*, edited by Peter M. Daly et al., 137–61. Turnhout: Brepols, 2001.

———. "Qualche deseigni d'importancia: Joris Hoefnagel als Zeichnungssammler." *Münchner Jahrbuch der bildenden Kunst* 38 (1987): 185–214.

Visser, Arnoud. "Escaping the Reformation in the Republic of Letters: Confessional Silence in Latin Emblem Books." *Church History and Religious Culture* 88.2 (2008): 139–67.

———. *Joannes Sambucus and the Learned Image: The Use of the Emblem in Late-Renaissance Humanism*. Leiden: Brill, 2005.

———. "Name-Dropping and Networking: Dedications as a Social Instrument in the Emblems of Joannes Sambucus." In *Polyvalenz und Multifunktionalität der Emblematik. Multivalence and Multifunctionality of the Emblem*, edited by Wolfgang Harms and Dietmar Peil, 355–68. Frankfurt am Main: Peter Lang, 2002.

Voet, Léon. *The Golden Compasses: A History and Evaluation of the Printing and Publishing Activities of the Officina Plantiniana at Antwerp*. 2 vols. Amsterdam: Van Gendt, 1969–72.

Voges, Ramon. "Power, Faith, and Pictures: Frans Hogenberg's Account of the *Beeldenstorm*." *Low Countries Historical Review* 131.1 (2016): 121–40.

Voltelini, Hans von, ed. "Urkunden und Regesten aus dem K.U.K. Haus-, Hof- und Staats-Archiv in Wien." *Jahrbuch der kunsthistorischen Sammlungen des Allerhöchsten Kaiserhauses* 13 (1892): xxvi–clxxiv.

Van der Voort, Hieronymus. *Een schoon profijtelik boeck ghenaemt den benauden veriaechden vervolchden Christen*. Haarlem: door Daniel Keyser, 1612.

Walker, Hope. "Netherlandish Immigrant Painters and the Dutch Reformed Church of London, Austin Friars, 1560–1580." *Nederlands Kunsthistorisch Jaarboek* 63 (2013): 58–81.

Waterschoot, Werner. "Leven en betekenis van Lucas d'Heere." *Verslagen en Mededelingen van de Koninklijke Academie voor Nederlandse Taal- en Letterkunde* 1 (1974): 16–126.

———. "Lucas d'Heere und Johannes Sambucus." In *The Emblem in Renaissance and Baroque Europe: Tradition and Variety*, edited by Alison Adams and Anthony J. Harpers, 45–52. Leiden: Brill, 1992.

Watson, Foster. *The Zodiacus vitae of Marcellus Palingenius Stellatus: An Old School-Book.* London: Philip Wellby, 1908.

Weddigen, Tristan. "Italienreise als Tugendweg: Hendrick Goltzius's *Tabula Cebetis.*" *Nederlands Kunsthistorisch Jaarboek* 54 (2005): 90–139.

Weemans, Michel. *Herri met de Bles: les ruses du paysage au temps de Bruegel et d'Érasme.* Paris: Éditions Hazan, 2013.

Wegg, Jervis. *The Decline of Antwerp under Philip of Spain.* London: Methuen & Co., 1924.

Wegner, Wolfgang. *Kurfürst Carl Theodor von der Pfalz als Kunstsammler: zur Entstehung und Gründungsgeschichte des Mannheimer Kupferstich- und Zeichnungskabinetts* Mannheim: Gesellschaft der Freunde Mannheims, 1960.

Wesseling, Ari. "Devices, Proverbs, Emblems: Hadrianus Junius' *Emblemata* in Light of Erasmus' *Adagia.*" In *The Kaleidoscopic Scholarship of Hadrianus Junius (1511–1575): Northern Humanism at the Dawn of the Dutch Golden Age*, edited by Dirk van Miert, 214–59. Leiden: Brill, 2011.

———. "Testing Modern Emblem Theory: The Earliest Views of the Genre (1564–1566)." In *The Emblem Tradition in the Low Countries: Selected Papers of the Leuven International Emblem Conference 18–23 August, 1996*, edited by John Manning, Karel Porteman, and Marc van Vaeck, 3–22. Turnhout: Brepols, 1999.

Weststeijn, Thijs. "From Hieroglyphs to Universal Characters: Pictography in the Early Modern Netherlands." *Nederlands Kunsthistorisch Jaarboek* 61 (2011): 238–80.

Van der Wetering, Ernst, et al. *A Corpus of Rembrandt Paintings II: 1631–1634.* Dordrecht: Martinus Nijhoff, 1986.

Weyerman, Jacob Campo. *De levens-beschryvingen der Nederlandsche konst-schilders en konst-schilderessen: met een uytbreyding over de schilder-konst der ouden.* 4 vols. The Hague: By de wed. E. Boucquet, etc., 1729–69.

Wiepen, Eduard. *Bartholomäus Braun der Ältere und Georg Braun.* Cologne: Verlag des Kölnischen Geschichtsvereins, 1916.

Williams, Gareth D. *Banished Voices: Readings in Ovid's Exile Poetry.* Cambridge: Cambridge University Press, 1994.

———. *Pietro Bembo on Etna: The Ascent of a Venetian Humanist.* Oxford: Oxford University Press, 2017.

Willughby, Francis, and John Ray. *The ornithology of Francis Willughby of Middleton.* London: printed by A. C. for John Martyn, 1678.

Wilson, Bronwen. "Social Networking: The 'album amicorum' in Early Modern Public Making." In *Beyond the Public Sphere: Opinions, Publics, Spaces in Early Modern Europe*, edited by Massimo Rosposcher: 205–23. Bologna: Società editrice il Mulino, 2012.

Wilson, Bronwen, and Paul Yachnin, eds. *Making Publics in Early Modern Europe: People, Things, Forms of Knowledge.* New York: Routledge, 2010.

Wilson, Catherine. *The Invisible World: Early Modern Philosophy and the Invention of the Microscope.* Princeton, NJ: Princeton University Press, 1995.

Wind, Edgar. "Aenigma Termini." *Journal of the Warburg Institute* 1.1 (1937): 66–69.

Wither, George. *A Collection of Emblemes, Ancient and Moderne.* London: A. M. for John Grismond, 1635.

Witt, Ronald G. *Hercules at the Crossroads: The Life, Works, and Thought of Coluccio Salutati.* Durham, NC: Duke University Press, 1983.

Wood, Christopher S. "Art History Reviewed VI: E.H. Gombrich's 'Art and Illusion: A Study in the Psychology of Pictorial Representation', 1960." *Burlington Magazine* 151 (2009): 836–39.

Woodall, Joanna. "For Love and Money: The Circulation of Value and Desire in Abraham Ortelius's *Album amicorum.*" In *Ut pictura amor: The Reflexive Imagery of Love in Artistic Theory and Practice, 1500–1700*, edited by Walter Melion, Michael Zell, and Joanna Woodall, 649–703. Leiden: Brill, 2017.

Woods-Marsden, Joanna. *Renaissance Self-Portraiture: The Visual Construction of Identity and the Social Status of the Artist.* New Haven, CT: Yale University Press, 1998.

Woolfson, Jonathan. "The Renaissance of Bees." *Renaissance Studies* 24.2 (2009): 281–300.

Worp, J. A. "Constantyn Huygens over de schilders van zijn tijd." *Oud Holland* 9.1 (1891): 106–36.

Wouk, Edward H. *Frans Floris (1519/20–1570): Imagining a Northern Renaissance.* Leiden: Brill, 2018.

Yates, Frances A. *The Valois Tapestries.* London: Warburg Institute, 1959.

Zenkert, Astrid. "The Owl and the Birds: Speeches, Emblems, and Fountains." In *Emblems and the Natural World*, edited by Karl A. E. Enenkel and Paul J. Smith, 548–609. Leiden: Brill, 2017.

Zilsel, Edgar. *Die Entstehung des Geniebegriffes. Ein Beitrage zur Ideengeschichte des Antike und des Frühkapitalismus.* Tübingen: Mohr, 1926.

Index

Illustration Credits

© Albertina, Vienna (fig. 52, fig. 55, fig. 96)

© Bayerische Staatsbibliothek, Munich (fig. 112)

© Beinecke Rare Book and Manuscript Library, Yale University, New Haven (fig. 93)

© Bibliothèque Municipale de Rouen (fig. 25, fig. 26, fig. 27, fig. 28, fig. 31, fig. 33, fig. 34, fig. 35, fig. 37, fig. 40, fig. 42, fig. 45)

© Bijzondere Collecties, Universiteit van Amsterdam (fig. 12, fig. 19, fig. 44, fig. 47, fig. 48, fig. 50, fig. 51, fig. 53, fig. 54, fig. 56, fig. 57, fig. 59, fig. 60, fig. 61, fig. 62, fig. 63, fig. 64, fig. 70, fig. 75, fig. 82, fig. 91, fig. 98, fig. 107, fig. 110)

© Bodleian Library (fig. 68, fig. 69, fig. 71, fig. 72)

© bpk Bildagentur / Hamburger Kunsthalle / Elke Walford / Art Resource, NY (fig. 41, fig. 43)

© bpk Bildagentur / Kupferstichkabinett der Staatlichen Museen zu Berlin / Jörg P. Anders / Art Resource, NY (fig. 6, fig. 7, fig. 20, fig. 88, fig. 89, fig. 94, fig. 95, fig. 106, fig. 109, fig. 111)

© bpk Bildagentur / Kupferstichkabinett der Staatlichen Museen zu Berlin / Volker-H. Schneider / Art Resource, NY (fig. 14)

© British Museum, London (fig. 29, fig. 99)

© Cambridge University Library, Cambridge (fig. 73, fig. 74, fig. 79, fig. 81)

© Courtauld Institute, London (fig. 38)

© Digital image courtesy of the Getty's Open Content Program / J. Paul Getty Museum, Los Angeles (fig. 97, fig. 108, fig. 113)

© Erich Lessing / Art Resource, NY (fig. 87)

© Gemäldegalerie der Staatlichen Museen zu Berlin—Preußischer Kulturbesitz / photo: Christoph Schmidt (fig. 21)

© Gent Universiteitsbibliotheek, Ghent (fig. 103)

© Historisches Museum, Basel / photo: P. Portner (fig. 4)

© image courtesy of Sothebys (fig. 16)

© KHM-Museumsverband / Kunsthistorisches Museum, Vienna (fig. 76, fig. 114)

© Det Kongelige Bibliotek, Copenhagen (fig. 22, fig. 23)

© Koninklijke Bibliotheek van België, Brussels (fig. 17, fig. 18, fig. 77, fig. 78)

© Koninklijke Bibliotheek, the Hague (fig. 104)

© Koninklijk Museum voor Schone Kunsten Antwerpen—www.lukasweb.be—Art in Flanders / photo: Hugo Maertens (fig. 15, fig. 58)

© Kunsthalle Bremen / Der Kunstverein in Bremen / Department of Prints and Drawings / Lars Lohrisch (fig. 11)

© Kunsthistorisches Museum Wien, Kunstkammer (fig. 114)

© The Metropolitan Museum of Art, New York (fig. 32, fig. 36, fig. 65, fig. 66, fig. 86)

© Museum Boijmans van Beuningen, Rotterdam (fig. 85)

© National Gallery of Art, Washington, DC (fig. 5, fig. 13, fig. 90, Pls. 1–39)

© Österreichische Nationalbibliothek, Vienna (fig. 92)

© Plantin Moretus Museum, Antwerp (fig. 83)

© Rijksmuseum, Amsterdam (fig. 2, fig. 3, fig. 10, fig. 24, fig. 30, fig. 39, fig. 46, fig. 49, fig. 67, fig. 80, fig. 102)

© RMN-Grand Palais / Musée du Louvre, Paris / Martine Beck-Coppola (fig. 105)

© RMN-Grand Palais / Musée du Louvre, Paris / Michel Urtado (fig. 8, fig. 9)

© Universiteitsbibliotheek, Leiden (fig. 1, fig. 100, fig. 101)

© Zeeuws Museum, Middelburg (fig. 84)

A NOTE ON THE TYPE

Janson is a seventeenth-century Dutch old-style type. For many years, it was mistakenly attributed to Anton Janson, a Dutch printer who lived in Leipzig, Germany, during the seventeenth century. The typeface was actually designed by a Hungarian priest and schoolteacher named Miklós Kis who was sent to Amsterdam to help print a translation of the Bible. The style he developed was based on French typefaces of the previous century, but with a higher-contrast, sharper effect, later called the "Dutch taste" (*goût hollandois*).

Kis's original matrices, labeled "Holländische Antiqua" (Dutch Roman), were found in Germany and acquired by the Stempel foundry in 1919. Hermann Zapf revised the design in 1951 for Linotype. This version of Janson was issued by Linotype in digital form in 1985 and was prepared under the supervision of Swiss type designer Adrian Frutiger, based on Kis's originals and on Zapf's Linotype machine version.

Avenir, which means "future" in French, was developed by the Swiss type designer Adrian Frutiger. He wanted to create a sans-serif that was a shift from the rigid form of the early twentieth-century geometric typefaces like Futura, toward a more organic and humanistic interpretation. Avenir is more even in color and suitable for extended text, with details like vertical strokes that are thicker than the horizontals, an "o" that is not a perfect circle, and shortened ascenders. These nuances aid in legibility and give Avenir a harmonious and sensible appearance for both texts and headlines.

Avenir was originally released by Linotype in 1988. Frutiger and Akira Kobayashi reworked the family in 2004 to broaden the range of weights and features, and the expanded family was renamed Avenir Next.